Advanced
Photoshop
Elements
For Digital
Photographers

WITHDRAWN
FOR SALE

2005

Philip Andrews

TO RENEW PLEASE QUOTE

BORROWER No

AMSTERDAM • BOSTON • HEIDELBERG • LONDON • NEW YORK • OXFORD
PARIS • SAN DIEGO • SAN FRANCISCO • SINGAPORE • SYDNEY • TOKYO

ELSEVIER

Focal Press is an imprint of Elsevier

Focal Press
An imprint of Elsevier
Linacre House, Jordan Hill, Oxford OX2 8DP
200 Wheeler Road, Burlington MA 01803

First published 2004

Permissions may be sought directly from Elsevier's Science and Technology Rights Department in Oxford, UK: phone: (+44) (0) 1865 843830; fax: (+44) (0) 1865 853333; e-mail: permissions@elsevier.co.uk. You may also complete your request on-line via the Elsevier homepage (www.elsevier.com), by selecting 'Customer Support' and then 'Obtaining Permissions'

British Library Cataloguing in Publication Data
A catalogue record for this book is available from the British Library

Library of Congress Cataloguing in Publication Data
A catalogue record for this book is available from the Library of Congress

ISBN 0 240 51940 X

For information on all Focal Press publications visit our website at: www.focalpress.com

Printed and bound in Italy

Acknowledgements
Karen for your support, love and patience always and Adrian and Ellena for keeping me balanced. And as always, my thanks goes to the great team at Focal Press, especially Marie Hooper, Christina Donaldson, Margaret Denley and Jane Read - you always make me look good.

Cheers to Ken McMahon for his technical comments and direction and to the supportive staff at Adobe in the UK, Australia and USA offices - you were right 'Photoshop Elements is a great program and yes they do love it!' Much appreciation to Mike Leavy, Adobe Engineering Manager for Photoshop Elements and Nigel Atherton, editor 'What Digital Camera' and Better Digital Photography' magazines for your kind words of introduction to this text - I am grateful for your support and commitment to the production of quality publishing that can be appreciated by the millions who love taking and making pictures.

Picture credits

Contents

Foreword *vi*
Introduction *viii*

1 The Next Level **1**
Elements basics *4*
Basic Elements workflow *8*

2 Scanner and Camera Techniques **9**
The basics – resolution *10*
2.01 How many pixels do I need? *12*
The basics – color depth *14*
2.02 More colors equals better quality *16*
Digital shooting technique *17*
2.03 Exposure Compensation *19*
Frame-by-frame control *20*
2.04 Contrast *20*
2.05 Color saturation *21*
2.06 Image sharpness *22*
2.07 White balance control *23*
2.08 Applying fine-tuning automatically *27*
2.09 Customizing your white balance *28*
2.10 Shooting RAW for ultimate control *29*
2.11 Shooting workflows *34*
Film and print scanners *35*
2.12 Scanning resolution *36*
2.13 Color depth *37*
2.14 Multi-sample *38*
2.15 Highlight and shadow capture *39*
2.16 Color cast correction *40*
2.17 Dust and scratches *41*
2.18 Noise reduction technologies *42*
2.19 Color regeneration features *43*
2.20 Scanning workflow *44*
Fixing common shooting problems *45*
Fixing common scanning problems *47*

3 Image Changes – Beyond the Basics **49**
Advanced selection techniques *50*
3.01 Adding to and subtracting from selections *50*
3.02 Saving and loading selections *51*
3.03 Modifying selections *51*
3.04 Transforming a selection *53*
3.05 Precise control of selection size *55*
Understanding layers *56*
Masking techniques *60*
3.06 Painting masks with the Selection Brush *61*
3.07 Fill and adjustment layer masks *61*
3.08 Using selections with layer masks *63*
3.09 'Group with Previous' masks *63*
3.10 Changing the mode to grayscale *64*
3.11 Desaturate the color file *65*
Advanced dodging and burning-in *67*
3.12 Using selections to change tone *68*
3.13 Erase back through tonal layers *70*
Enhance your poorly exposed pictures *72*
3.14 Screening image layers to enhance tones *72*
3.15 Adding detail to highlights and shadows *75*

CONTENTS

Tinted monochromes 76
3.16 Using Hue and saturation to tone your pictures 77
Split toning 79
3.17 Select and tone 79
3.18 Two-layer erase 81
Black and white and color 82
3.19 Layer mask and gradient map 82
Border techniques 83
3.20 Simple borders 83
3.21 Sophisticated edges using grayscale masks 85
Adding texture 87
3.22 Add Noise filter 87
3.23 Grain filter 88
3.24 Non-destructive textures 89

4 Darkroom Techniques on the Desktop 91
4.01 Diffusion printing 92
4.02 Instant film transfer effect 94
4.03 Using the Unsharp Mask filter to add contrast 99
4.04 Lith printing technique 102
4.05 Correcting perspective problems 104
4.06 Add emphasis with saturation 107
4.07 Restoring color to faded images 109
4.08 Cross-processing effects 112
4.09 Digital hand coloring 114
4.10 Realistic depth of field effects 117
4.11 Beyond the humble drop shadow 121
4.12 Ring flash shadow 125
4.13 Hidden 'Curves' features 126
4.14 Dust and scratches be gone 129
4.15 Combining images seamlessly 131

5 Making Better Panoramas 135
Advanced shooting techniques 139
5.01 Positioning the camera 139
5.02 Camera support 140
5.03 Exposure 143
5.04 Focus and zoom 144
5.05 Depth of field 144
5.06 White balance 147
5.07 Timing 147
5.08 Ensuring consistent overlap 148
5.09 Dealing with the moving subject 149
5.10 Fixing misaligned picture parts 151
5.11 Coping with extremes of brightness 151
5.12 Creating artificially increased DOF 154
5.13 Correcting exposure differences 155
5.14 Adjusting for changes in color balance 156
5.15 Vertical panoramas 158
5.16 High resolution mosaics 159
5.17 Panoramic printing 160
5.18 Spinning panorama movies 162
5.19 Panorama workflow 164

6 Extending Your Web Abilities 165
Building websites – the basics 167
6.01 Web Photo Gallery websites 169
6.02 Customizing Web Photo Gallery templates 171
Creating individual web assets using Photoshop Elements 172
6.03 Optimizing photos for the web 173

6.04 Button creation 175
6.05 Effective headings 176
6.06 Making seamless backgrounds 178
6.07 Creating downloadable slide shows 179
6.08 Assembling the site 180
6.09 Uploading the site 182

7 Producing Effective Graphics 183

Revisiting painting and drawing basics 184
7.01 Controlling brush characteristics 185
7.02 Changing an existing brush 188
7.03 Creating a new brush 190
7.04 Text 192
7.05 Adding styles to text layers 195
7.06 Customizing shapes 198
7.07 Adding pictures to shapes 200
Text and pictures 202
7.08 Images in text 202
7.09 Text in images 204
7.10 Realistic text and image montages 207
7.11 Hand drawn logos 210
7.12 Reducing your picture's colors 213
7.13 Posterized pictures 214
7.14 Kaleidoscopic images 216
7.15 Presentation backgrounds 219

8 Finely Crafted Output 223

Printing basics 224
The inkjet printer 226
Laser 228
Dye sublimation 228
Other printing processes 229
Image resolution vs printer resolution 230
8.01 Basic print steps 231
8.02 Creating contact sheets 234
8.03 Multiple prints on a page 235
Ensuring color consistency between devices 236
8.04 Setting up a color managed workflow 240
8.05 Calibrating your screen – Adobe Gamma 244
8.06 Calibrating your screen – ColorVision Spyder 246
Getting intimate with your printer 248
8.07 Calibrating your printer – resolution, color and tone tests 248
8.08 Calibrating your printer – ColorVision PrintFIX 252
8.09 Making great black and white prints 254
8.10 Preparing your images for professional outsourcing 259
8.11 Shoot small print big 261
8.12 Printing workflow 264

Appendices 265

Jargon buster 266
Keyboard shortcuts 271
Elements/Photoshop feature equivalents 274

Index 275

Foreword

Nearly without exception, human beings the world over are fascinated by the photograph. A photograph is a timeless, compelling, emotive and honest representation of our world; of the places we've been, the events we've witnessed, the people we've met and loved. The photograph is a reflection of our world and ourselves; our mind's eye projected onto cotton vellum or computer screen. The persistence of vision *ex machina*. Indeed, the photographic image is the true iconography of the modern world.

For the photography enthusiast, these are very exciting times. In the span of less than 10 years, we have witnessed the evolution of photography from a mostly silver halide film-based process to a completely digital process. The individual photographer now has the capability to shoot, "develop", and create prints using an entirely digital workflow, and completely within the comfortable confines of his or her own study.

This new–found freedom from film and the complicated processing thereof is largely due (of course) to the ready availability of affordable digital cameras and photo-quality printers; but it is due also, in no small part, to the efforts of the people at Adobe Systems. Adobe is committed to empowering the digital photographer by providing the most powerful and excellent tools available for rendering, manipulating and printing digital images. Among the most popular and successful of these tools is Adobe Photoshop Elements.

Although one of the original design intents behind Photoshop Elements was to make many of the most common image enhancement tools more readily available and noticeable to the novice user, there is still much depth behind this initial surface. Fortunately for both Adobe and its customers, talented writers such as Philip Andrews have resolved to explore this depth and, in easy-to-understand language and step-by-step guidance, provide access to you, the reader.

Advanced Photoshop Elements for Digital Photographers is a beautifully rendered and compellingly written exploration of the advanced features and techniques that can be accomplished with Photoshop Elements. Through the use of many sample photographs, screen shots and clearly illustrated examples, Mr. Andrews provides us the tools to turn our images into exciting and compelling works of art.

From careful and thoughtful descriptions of the basics of tonal adjustments and camera and scanner settings to detailed explanations for creating traditional photographic effects such as lith print style reproductions, *Advanced Photoshop Elements for Digital Photographers* will provide you with an entire arsenal of tools for adding emphasis, detail, and clarity to your images and for exposing and enhancing their inherent beauty.

If you love photography as much as I do, you are in luck with this book.

Enjoy.

Mike Leavy
Engineering Manager for Photoshop Elements
Adobe Systems, Inc.

Introduction

When Photoshop Elements came out it was assumed by many that, because it was so inexpensive, it would be the sort of program that you could master in a couple of hours – it certainly wouldn't require a huge learning curve and probably, let's face it, a chunky manual to get to grips with it, as its professional sibling, Photoshop, does. But how wrong we were. Budget certainly doesn't mean basic in this case, and Adobe has packed so much into Photoshop's little brother that you really do need an expert guide to get the best out of it, to lead you through all those nooks and crannies and show you all the cool tricks that are not obvious to the casual user.

But who to choose to be that guide? Well for me there's only one person, and luckily for you it's the one whose name is on the cover of this book. Philip Andrews is an enigma. As editor of two of the UK's leading digital photography magazines I require two main qualities from my contributors: they have to be real experts who possess a truly in-depth knowledge of their subject, and they have to be able to communicate that knowledge in simple layman's terms that anyone can understand. (They also have to be reliable and hand their copy in on time, but that's another story!) Well there are plenty of experts and plenty of communicators, but you'd be amazed at how rare it is to find someone who is both, as Philip is.

Philip Andrews knows Elements better than anyone else I know. He also writes in a friendly, entertaining and non–academic style – despite the fact that he is a senior lecturer in photography. He has a great understanding of the needs of the end user and his knowledge and enthusiasm for digital imaging (and photography in general) shine from every sentence. He's an accomplished photographer too, so he not only talks the talk but walks the walk, and uses many of his own excellent images to illustrate his points.

Having already covered the fundamentals of Elements in his last book Philip now moves on to more complex themes and ideas, things which you might (wrongly) have considered a bit ambitious for Elements. As before he puts the software into the wider context of digital imaging in general and explains the why as well as the how. Once again there's a great linked website that allows you to download some of the images used in the book and try the techniques out for yourself.

With Philip as your guide you'll be using Elements like a pro and making great images in no time.

Good luck.

Nigel Atherton
Editor *What Digital Camera*
 Better Digital Photography

1

The Next Level

There is no doubt that when Adobe decided to release Photoshop Elements that photographers the world over rejoiced. Not content with their offerings for entry and intermediate users in the past and ever conscious of the growing digital camera user base, the Adobe boffins created the new package with you, the digital photographer, firmly in their mind. Despite the rumours started by the 'Photoshop Snobs' that the product was just another cut down version of Adobe's professional package and that any serious editing will need to be completed in Photoshop, users the world over are realizing just how well this offering fits their needs.

A true photographer's tool

Adobe had finally heard the cries of the mortals and produced an image manipulation package that has the strength of Photoshop with the price tag more equal to most budgets. Elements gives desktop image-makers top quality image editing tools that can be easily used for preparing pictures for printing or web work. Features like the panoramic stitching option, called Photomerge, and the File Browser palette are firm favorites and were featured in this package before they ever appeared in Photoshop. The color management and vector text and shape tools are the same robust technology that drives Photoshop itself, but Adobe has cleverly simplified the learning process by providing an easier to use interface and options like step-by-step interactive recipes for common image manipulation tasks. These, coupled with features like Fill Flash, Adjust Backlighting and the Red Eye Brush tool, make the package a digital photographer's delight.

As a photographer, teacher and author I was captivated by the simplicity and strength that Adobe has crammed into the package and knew that this was just the sort of image editing program that would satisfy the demands of the digital camera users I met every day. So to accompany Elements version 1.0, I released a new book which was an introduction to the package and digital imaging in general. Titled *Adobe Photoshop Elements – A visual introduction to digital imaging.* It quickly became a best seller and was followed up with a completely revised and updated edition to accompany version 2.0 of the program.

As Elements users became more familiar with the concepts and tools used in the program it wasn't long before I started to receive requests for more advanced techniques than those presented in this introductory text. These were quickly followed by queries about how to position Elements as the key ' image editing component' in a high quality photographic workflow that encompassed capture, manipulation and output activities.

Beyond the companion introduction title >>
This book is the result of many requests to provide a 'next step' that will take Elements users beyond the basic concepts and skills outlined in the introductory text, Adobe Photoshop Elements–A visual introduction to digital imaging. (a) Edition 2. (b) Edition 1.

Elements is central >>
Photoshop Elements is the pivot point for all editing and enhancement tasks involved in the production of quality photographic images. The digital production process involves three distinct steps – (a) capture, (b) manipulation and (c) output.

This book is my answer to these requests. With well over 100 new techniques it provides professional tips aimed at advancing your Elements skills beyond the basics. It is presented in a series of highly illustrated step-by-step color tutorials that show you what can be achieved. The techniques are discussed in the greater context of professional quality workflows that cover camera and scanner capture, panorama production and quality print production.

Each technique is cross-referenced with related skills and ideas in the book and there are on-line resources at the book's website -

www.adv-elements.com.

Here you can download and practise with many of the example images and resources used in the production of the book. Key settings for important dialog boxes are presented along with the illustrated steps needed for you to complete each technique. By working side-by-side with this text, your favorite image editing program and the associated web resources, you will quickly build both your Elements skills and your general understanding of the processes involved in creating quality photographic images.

3.02 Saving and loading selections
Suitable for Elements – 1.0, 2.0 | Difficulty level – Intermediate Resources – web image 3.02 | Related Techniques – 3.01, 3.03, 3.04, 3.05 Tools used – Selection tools | Menus used – Select

Photoshop Elements thankfully gives you the option to save all your hard selecting work... can be used again later.
With...

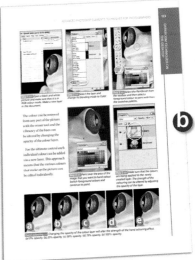

Step-by-step >> *The techniques in the book are presented in a highly illustrated step-by-step fashion that will progressively build your Elements skills.*
(a) Cross-referenced techniques.
(b) Step-by-step illustrations.

Elements basics

Most digital image-makers find that there are several enhancing steps that they always perform on a newly acquired picture. These changes are often among the first skills that the new Elements user learns. Despite the fact that this book is designed to build upon such basic techniques I thought that it would be best to revisit them briefly to ensure that we are all working from the same game plan.

For the most part these changes follow a predictable sequence – *Import, Orientate or Straighten, Crop, Adjust Tones, Alter Color, Apply Sharpness and Save.*

These basic alterations take an image captured by a camera or scanner and tweak the pixels so that resultant picture is cast free, sharp and displays a good spread of tones.

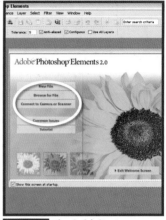

Step 1 >> *The Quick Start screen provides simple and easy access to images captured via scanners or digital cameras.*

Importing from a camera or scanner

When opening Elements for the first time the user is confronted with the Quick Start or Welcome screen containing several options. Images can be created from scratch, opened (if previously saved) or acquired from scanner, or digital camera, sources. Clicking the Connect option will provide the user with a list of image sources. The same list can be found in the Import section of the File menu. So long as your camera, or scanner's, twain driver is correctly installed, there should be an item on the list for each of your peripherals. Some cameras are provided with a plug-in that will cause them to be listed here as well. You can also choose to Browse for a suitable image from those already stored on your hard drive. The file browser contained in Elements is a sophisticated searching tool that can also be displayed via the File Browser option in the Window menu (Window>File Browser). Double click the image to open.

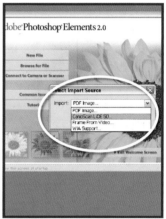

Step 2 >> *Your capture devices (cameras, scanners) are listed in the Elements Connect list.*

Changing a picture's orientation

Turning your camera to shoot images in portrait mode will produce pictures that need to be rotated to vertical after importing into your editing program. Elements provides a series of dedicated Rotate options under the Image menu. Here the picture can be turned to the right, or left, in 90 degree increments or to custom angles, using the Canvas Custom feature.

Step 3 >> *Alternatively you can select a picture to work on from those displayed as thumbnails in the Elements file browser.*

Cropping and straightening

Most editing programs provide tools that enable the user to crop the size and shape of their images. Elements provides two such methods. The first is to select the rectangular marquee tool and draw a selection on the image the size and shape of the required crop. Next choose Image>Crop from the menu bar. The area outside of the marquee is removed and the area inside becomes the new image. The second method uses the dedicated Crop tool that is located just below the Lasso in the tool box. Just as with the marquee tool, a rectangle is drawn around the section of the image that you want to retain. The selection area can be resized at any time by clicking and dragging any of the handles positioned in the corners of the box. To crop the image click the OK button in the options bar or double click inside the selected area.

An added benefit to using the Crop tool is the ability to rotate the selection by click and dragging the mouse when it is positioned outside the box. To complete the crop click the OK button in the options bar, but this time the image is also straightened based on the amount that the selection area was rotated. As well as this manual method, Elements provides an automatic technique for cropping and straightening crooked scans. The bottom two options in the Rotate menu, Straighten Image and Straighten and Crop Image, are specifically designed for this purpose.

Spreading your image tones

When photographers produces their own monochrome prints they aim to spread the image tones between maximum black and white. So too should the digital image-maker ensure that their pixels are spread across the whole of the possible tonal range. In a 24 bit image, this means from a value of 0 (black) to 255 (white). Elements provides both manual and automatic techniques for adjusting tones. The Auto Contrast and Auto Levels options are both positioned under the Enhance menu.

Both features will spread the tones of your image automatically, the difference being that the Auto Levels function adjusts the tones of each of the color channels individually whereas the Auto Contrast command ignores differences between the spread of the Red, Green and Blue components. If your image has a dominant cast then using Auto Levels can sometimes neutralize this problem. The

Step 4 >> *There are several picture orientation options in the Rotate section of the Image menu.*

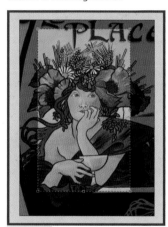

Step 5 >> *The Crop tool gives the user the ability to crop and straighten selected areas of the image.*

Step 6 >> *The Auto Levels and Auto Contrast functions spread the tones of your image automatically.*

THE NEXT LEVEL

results can be unpredictable though, so if after using the feature the colors in your image are still a little wayward, undo the changes and use the Auto Contrast feature instead.

If you want a little more control over the placement of your pixel tones then Adobe has also included the slider based Contrast/ Brightness and Levels features used in Photoshop in their entry-level software. Both these features, levels in particular, take back the control for the adjustment from the program and place it squarely in the hands of the user.

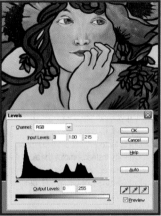

Step 7 >> *The Levels feature provides manual control of the position of white, mid and black tones in your image.*

Ridding your pictures of unwanted color casts

Despite the quality of modern digital cameras, White Balance systems, images shot under mixed lighting conditions often contain strange color casts. The regularity of this problem led Adobe to include the specialized Color Cast tool (Enhance>Color>Color Cast) in Elements. Simply click the eyedropper on a section of your image that is meant to be gray (an area that contains equal amounts of red, green and blue) and the program will adjust all the colors accordingly.

This process is very easy and accurate, if you have a gray section in your picture. For those images without the convenience of this reference, the Variations feature (Enhance>Color>Variations) provides a visual 'ring around' guide to cast removal.

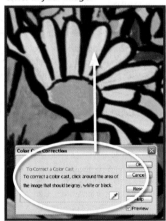

Step 8 >> *The Color Cast tool uses an eyedropper feature to neutralize color casts in your images.*

Applying some sharpening

The nature of the capture or scan process means that most digital images can profit from a little careful sharpening. I say careful, because the overuse of this tool can cause image errors, or artifacts, that are very difficult to remove. Elements provides several sharpening choices, most automatic, and one with a degree of manual control.

The Sharpen, Sharpen More and Sharpen Edges features found in the Sharpen selection of the Filter menu provide automatic techniques for improving the clarity of your images. The effect is achieved by altering the contrast of adjacent pixels and pixel groups. The Sharpen and Sharpen More options apply the effect to all pixels in the image, whereas the Sharpen Edges only uses the filter on areas where the program detects edges.

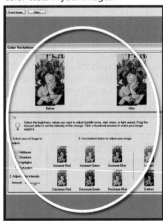

Step 9 >> *The Variations control provides a ring around approach to cast removal.*

Take manual control of your tones >>

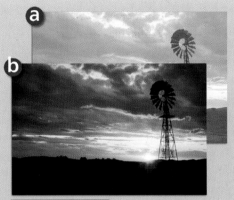

One of the most basic, yet critical, tasks for any digital photographer involves adjusting the contrast and brightness of their images. This action is often one of the first undertaken by novices and professionals alike when enhancing newly shot pictures. Well executed contrast and brightness adjustments can take an 'okay' image and turn it into a dramatic picture.

Though at first glance making these changes seems like a simple task, don't be too eager to play with the Brightness/Contrast sliders. These controls are far too coarse for quality work. Careful manipulation of the pixels is the key to making quality images and these features don't allow the subtlety of adjustment that is necessary to achieve good results. Instead, employ the aid of the Levels feature (Enhance>Adjust Brightness/Contrast>Levels) when making these changes. Professional digital photographers prefer to use this tool as it not only provides sliders to alter brightness and contrast but also shows a visual (and objective) representation of the spread of the pixels within the image.

Levels adjustments >> *Levels is an Elements feature that provides fine control over the contrast and brightness of your pictures. (a) Before. (b) After.*

Advanced tonal control

The first step in taking charge of your pixels is to become aware of where they are situated in your image and how they are distributed between black and white points. The Histogram palette (Image>Histogram) displays the same graph of your picture's pixels as the Levels feature. Viewing the histogram can be one of the quickest ways to diagnose the source of brightness and contrast problems in your pictures.

The left hand side represents the black values, the right the white end of the spectrum and the center area the mid tones. As you may be already aware, in a 24 bit image there are a total of 256 levels of tone possible from black to white – each of these values are represented on the graph. The number of pixels in the image with a particular brightness or tone value is displayed on the graph by height. Where the graph is high there are many pixels of this tone present in the image. In contrast, low areas of the graph mean that few pixels of this tone can be found in the picture.

Knowing your images

After a little while of viewing the histograms of your images you will begin to see a pattern in the way that certain styles of photographs are represented. Overexposed pictures will display a large grouping of pixels to the right end of the graph, whereas underexposure will be represented by most pixels bunched to the left. Flat images or those taken on an overcast day will show all pixels grouped around the middle tones and contrasty pictures will display many pixels at the pure white and black ends of the spectrum.

These tonal problems can be fixed automatically by applying one of the standard correction features, such as Auto Contrast or Auto Levels, found in Elements. Both these commands re-map the pixels so that they sit more evenly across the whole of the tonal range of the picture. Viewing the histogram of a corrected picture will show you how the pixels have been redistributed. If you want to take more control of the process than is possible with the auto solutions, open the Levels dialog.

Using the Levels control

Looking very similar to the histogram this feature allows you to interact directly with the pixels in your image. As well as a graph, the dialog contains two slider bars. The one directly beneath the graph has three triangle controls for black, mid tones and white and represents the input values of the picture. The slider at the bottom of the box shows output settings and contains black and white controls only.

To adjust the tones, drag the input shadow and highlight controls until they meet the first set of pixels at either end of the graph. When you click OK the pixels in the original image are redistributed using the new white and black points. Be careful though as moving the black point slider beyond the first pixels in the graph will convert these tones to straight black, losing any shadow detail that was present. Similarly dragging the white point too far towards the middle will change delicate highlight details to pure white. Moving the mid tone slider will change the brightness of the middle values of the image without changing the black and white points in the image. Altering the output black and white points will flatten, or decrease, the picture's contrast.

Basic changes >> *(a) To add contrast drag white and black input sliders inwards. (b) To reduce contrast drag white and black output sliders inwards. (c) To darken mid tones drag mid input slider to the right. (d) To lighten mid tones drag mid input slider to the left.*

Pro's Tip: Hold down the Alt (Option–Mac) key whilst moving the black or white input slider and you will see a reversed version of the image showing the pixels that are being converted to black or white by the action.

The fourth option, the Unsharp Mask filter, provides the user with manual control over which pixels will be changed and how strong the effect will be. The key to using this feature is to make sure that the changes made by the filter are previewed in both the thumbnail and full image at 100 percent magnification. This will help to ensure that your pictures will not be noticeably over-sharpened.

Saving your images

The final step in the process is to save all your hard work. The format you choose determines a lot of the functionality of the file. If you are unsure of your needs always use the native PSD or Photoshop format. These files maintain layers and features such as editable text and saved selections, and do not lose any picture details due to compression. If space is a premium, and you want to maintain the best quality in your pictures, then you may decide to use a compressed version of TIF or Tagged Image File Format. JPEG and GIF should only be used for web work or when you need to squeeze you files down to the smallest possible size. Both these formats lose image quality in the reduction process, so keep a PSD or TIF version as a quality backup.

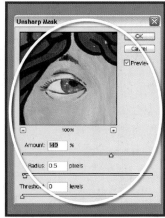

Step 10 >> *Unsharp Masking improves the overall appearance of sharpness in the image by increasing the contrast of adjacent pixels.*

Step 11 >> *Elements provides a range of file formats that can be used to save your images.*

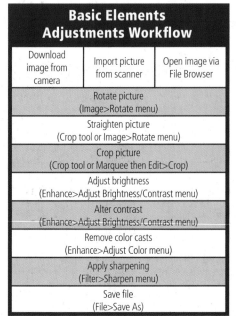

Basic Elements Adjustments Workflow		
Download image from camera	Import picture from scanner	Open image via File Browser
Rotate picture (Image>Rotate menu)		
Straighten picture (Crop tool or Image>Rotate menu)		
Crop picture (Crop tool or Marquee then Edit>Crop)		
Adjust brightness (Enhance>Adjust Brightness/Contrast menu)		
Alter contrast (Enhance>Adjust Brightness/Contrast menu)		
Remove color casts (Enhance>Adjust Color menu)		
Apply sharpening (Filter>Sharpen menu)		
Save file (File>Save As)		

Basic Elements workflow

These steps should be the first changes and enhancements you make to new digital photographs. It is upon these basics that the rest of the book will build. So make sure that the sequence and skills included here are second nature before moving onto extending your Elements knowledge.

2

Scanner and Camera Techniques

SCANNER AND CAMERA TECHNIQUES

There is no way to get around the fact that the quality of your final digital pictures is dependent on how well they were captured initially. Poorly photographed or badly scanned images take their problems with them throughout the whole production process and end up as poor quality prints. One of the best ways to increase the level of your work is to ensure that you have the skills and knowledge necessary to create the best digital file possible at the time of capture. This is true for those of you who are shooting with a digital camera as well as those who are converting existing photographic images to digital with a scanner.

To help gain this level of control let's go back to the basics and see how factors like resolution and numbers of colours affect the quality of image capture.

The basics – resolution

Most of us, no matter how new to digital photography, are aware that resolution has a direct link with picture quality. It is true that this factor along with the numbers of colors (bit depth) saved in the file, or captured by the camera, help determine the overall quality of the image.

The rule of thumb that most new users adhere to goes something like this, 'the higher the resolution and the greater the bit depth the better the image will be', and to a large extent this is true. High resolution images with lots of colors are generally better quality than those with a limited color range and fewer pixels, but to understand how integral resolution is to making great digital images we must look a little deeper.

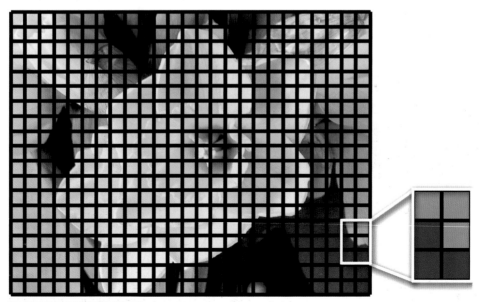

Digital photography basics >> *All digital photographs are constructed of a grid of colored pixels which when seen at a distance combine to form the appearance of a continuous color and tone picture.*

Image capture – input resolution

Computers can only work with digital files. The world as we view it, and as we capture it in silver based photographs, is not in a digital format. Tones and colors merge gradually from one extreme to another. For the computer to be able to work with such images they must be changed from this 'analog' or continuous tone format to a digital one. Scanners and digital cameras make this change as part of the capturing process.

The scene or print is tested, or sampled, at regular intervals and a specific color and brightness allocated for each sample area. The testing continues in a grid pattern all over the scene, gradually building a pattern of the image which is made up of discrete areas of specific color/brightness. Each of these areas, or samples, becomes a pixel in the resultant digital file.

Resolution at this capturing stage refers to the frequency that samples are made of the image. Generally this measurement is represented as the number of samples taken in a one inch space; for this reason it is sometimes called 'Samples Per Inch' or spi. Unfortunately most scanner software does not use this terminology but prefers to refer to this setting as 'Dots Per Inch' (dpi). This is a hangover from language used in the printing industry and does more to confuse than clarify the situation.

If you are using a digital camera to capture your image then the resolution will be determined by the sensor which has a specific number of CCDs set into a grid that is used to digitize the image. Scanner users, on the other hand, are able to control the sampling rate by changing the settings in the scanner's dialog box.

A high sampling rate will result in a higher quality image with a much greater file size. A low SPI will provide a smaller file of less quality. These facts lead a lot of new users to a situation where all images are scanned at the highest resolution possible. Do this and your hard drive will soon be completely used up. High-resolution scans require huge amounts of storage space.

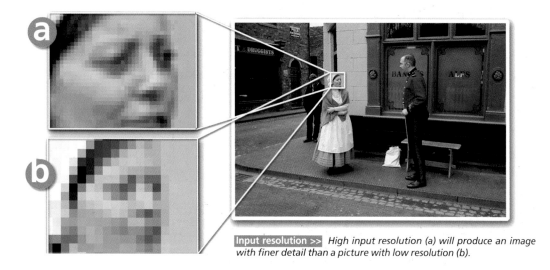

Input resolution >> *High input resolution (a) will produce an image with finer detail than a picture with low resolution (b).*

Input resolutions should be decided on the basis of what the image's final use will be. If the image is to be printed the size of a postage stamp then there is no point scanning at a resolution that will result in a file large enough to print an A2 poster. Remember the end usage determines the scanning resolution, or to put it in a way more easily remembered, 'Know where you are going before you start the journey'.

2.01 How many pixels do I need?

Suitable for Elements – 1.0, 2.0 | Difficulty level – Intermediate | Resources – Web worksheet 201
Related techniques – 2.02, 2.12, 2.13, 8.07

The trick to knowing how many pixels you require is to think carefully about the end product you want to create. As an example, if you want to produce a 10 x 8 inch photographic quality print and you know that the lab you will use to output the image suggests a resolution of 250 dpi, then you have all the information to determine the number of pixels you will need to capture.

Essentially the lab is saying that to produce photographic quality they need 250 pixels for every inch of the print. For the photograph to be 10 inches high then your file must contain a minimum of 2500 pixels for this dimension and to ensure the 8 inch width, you will need 2000 pixels. With this knowledge you can adjust the settings on you scanner so that you will end up with a picture file that contains the minimum pixel dimensions of 2500 x 2000.

For digital camera shooters understanding this concept will not only give you an indication of the maximum print size available from your camera's sensor, but will also allow you to accurately select the correct resolution, or more precisely the correct pixel dimension, setting on your camera for specific tasks. The table below will give you a good starting point.

Chip pixel dimensions:	Chip resolution: (1 million = 1 megapixel)	Print size at 200 dpi: (e.g. photo print)	Image size at 72 dpi: (e.g. web use)
640 x 480 pixels	0.30 million	3.2 x 2.4 inches	8.8 x 6.6 inches
1440 x 960 pixels	1.38 million	7.4 x 4.8 inches	20.0 x 13.2 inches
1600 x 1200 pixels	1.90 million	8.0 x 6.0 inches	22.0 x 16.0 inches
2048 x 1536 pixels	3.15 million	10.2 x .7.6 inches	28.4 x 21.3 inches
2304 x 1536 pixels	3.40 million	11.5 x 7.5 inches	32.0 x 21.3 inches
2560 x 1920 pixels	4.92 million	12.8 x 9.6 inches	35.5 x 26.6 inches
2000 x 3000 pixels	6.0 million	10 x 15 inches	27.7 x 41.6 inches

The suggested output resolution changes for different end uses. For you to accurate capture enough pixels for the end result you desire, you will need to be aware of the resolution requirements for different end products. The table below indicates some of the resolution requirements for different uses.

Proposed Use	Suggested Image Resolution
Screen or web use	72 dpi
Draft quality inkjet	150 dpi
Photo quality inkjet	200 – 300 dpi
Photo lab output (min)	250 dpi
Photo lab output (max)	400 dpi
Offset printing (good quality)	300 dpi

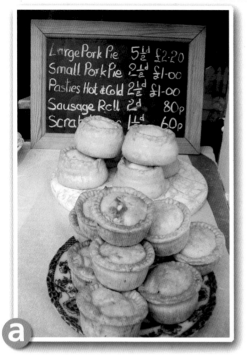

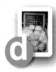

Spreading the pixels >> *In the example, the digital file has dimensions of 800 x 1200 pixels. Though the number of pixels remains the same, each of the prints range in size because of the numbers of pixels used to print each inch. (a) 16 x 24 inch printed at 50 pixels per inch (ppi). (b) 8 x 12 inch printed at 100 ppi. (c) 4 x 6 inch printed at 200 ppi. (d) 2 x 3 inch printed at 400 ppi.*

Pro's Tips:

• Know where you are going before you start the journey – Your scanner resolution should be based on the end use of the digital file. A poster will need a higher resolution initial scan, and a bigger file, than a postcard.

• Balance print quality with practical file sizes – Test your printer to see at what image resolution increases in print quality cease to be perceived. Make this your base image resolution and scan your files according to this setting.

Once you know the image resolution needed for the printer, the final size of the print and the size of your original you can easily calculate the scanning resolution and the total pixel dimensions you need for your digital file. Use the formula in the table below to give yourself an indication of the number of pixels you need for any size print job.

	Pro's Scanning Resolution Formulas				
1.	*Final image dimensions (pixels)*	*=*	*Original image dimensions (inches)*	*x*	*Scanning resolution (samples per inch)*
e.g.	*3000 x 2400 pixels*	*=*	*10 x 8 inch print*	*x*	*300 samples per inch*
e.g.	*6000 x 4000 pixels*	*=*	*1.5 x 1 inch (135 mm film)*	*x*	*4000 samples per inch*
2.	*Print size (inches)*	*=*	*Image dimensions (pixels)*	*/*	*Image resolution (pixels per inch)*
e.g.	*15 x 12 inches*	*=*	*3000 x 2400 pixels*	*/*	*200 pixels per inch*
e.g.	*20 x 13.33 inches*	*=*	*6000 x 4000 pixels*	*/*	*300 pixels per inch*

The basics – color depth

This growing understanding of how important resolution is to high quality imaging underpins the continual push by digital consumers for higher pixel output from their cameras. In the last couple of years sensor sizes have pole vaulted from the diminutive 1.5 megapixels to the more commonplace 5.0 and even 6.0 megapixel models that now fill the shelves of many photographic suppliers. The power to create truly photographic quality output up to A3 size is well within our grasp.

But high resolution is only half the 'image quality' story. The number of colors in an image is also a factor that contributes to the overall quality of the photograph.

Discrete colors (or levels)

Photographs in either print or negative (or slide) form contain a range of subtle tones and colors that blend smoothly into each other. These are referred to as continuous tone images. For instance, in a traditional black and white print it is difficult to see where one shade of gray starts and another one finishes. The effect is a smooth transition from the deepest shadows through to the most delicate highlights.

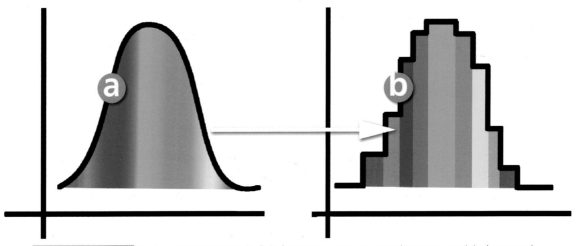

Analog to digital >> _In the capture process, via digital camera or scanner, a continuous tone original or scene is converted into discrete colors that can be represented by a series of numbers. (a) Analog original containing continuous tones. (b) Digital version containing discrete colors._

In contrast, a digital image is made up of discrete tones and colors. When a scene or a print is captured by a device such as a camera or scanner the continuous original is converted into a digital file. The file describes the image as a series of numbers representing these discrete colors and tones. When we scan a negative or slide, or photograph a scene, we make this conversion by sampling the picture at regular intervals. At each sample point, a specific color is chosen to represent the hue found in the original. In this way, a grid of colors is put together to form a digital version of the continuous tone original.

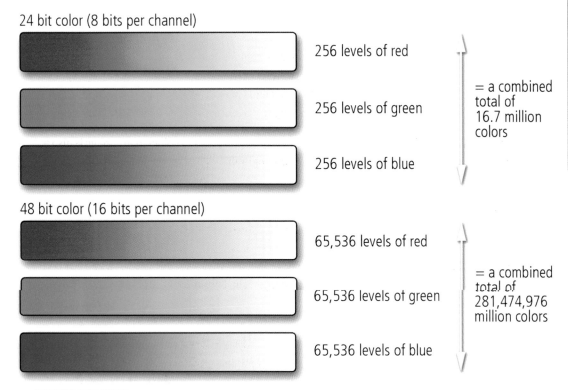

24 bit color (8 bits per channel)

256 levels of red

256 levels of green

256 levels of blue

= a combined total of 16.7 million colors

48 bit color (16 bits per channel)

65,536 levels of red

65,536 levels of green

65,536 levels of blue

= a combined total of 281,474,976 million colors

8 bit versus 16 bit >> *Digital photographs captured in 16 bit per channel mode contain a greater number of colors than those captured with 8 bits.*

Comparing bits

Each digital file you create (capture or scan) is capable of representing a specific number of colours. This capability, usually referred to as the 'mode' or 'color depth' of the picture, is expressed in terms of the number of 'bits'. Most images these days are created in 24 bit mode. This means that each of the three color channels (red, green and blue) are capable of displaying 256 levels of color (or 8 bits) each. When the channels are combined, a 24 bit image can contain a staggering 16.7 million discrete tones/hues.

This is a vast amount of colors and would be seemingly more than we could ever need, see, or print, but many modern cameras and scanners are now capable of capturing 16 bits per channel or 'high bit' capture. This means that each of the three colors can have 65,536 different levels and the image itself a whooping 281,474,976 million colors (last time I counted!). But why would we need to capture so many colors?

2.02 More colors equals better quality

Suitable for Elements – 1.0, 2.0 | Difficulty level – Intermediate
Related techniques – 2.13

Most readers would already have a vague feeling that a high bit file is 'better' than a low bit alternative, but understanding why is critical for ensuring the best quality in your own work. The main advantage is that capturing images in high bit mode provides a larger number of colors for your camera or scanner to construct your image with. This in turn leads to better color and tone in the digital version of the continuous tone original or scene.

'Fantastic!' you say, 'No more 8 bit capture for me, I'm a 16 bit fanatic from here on in'. But there is a catch (you knew there had to be).

Despite the power and sophistication of Photoshop Elements the program does not allow editing of 16 bit files. When opening a picture that was captured in 16 bit mode the program displays a dialog warning that it doesn't support this mode and it asks if you would like to change the picture to an 8 bit form. This fact leads many shooters to believe that there is no point using the high bit capture features of their cameras or scanners. Not true.

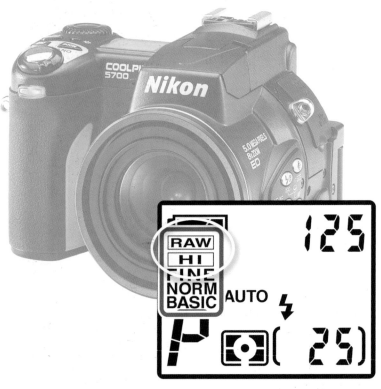

You will still gain quality benefits (though not as many) by making the original capture in full 16 bit glory and then allowing Photoshop Elements to selectively down sample the file. The greater color range contained in the original 16 bit palette gives Elements more details to play with when creating the 8 bit file.

Pro's Tip: Capture all images in the highest color depth possible. This will help to ensure the best possible detail, tone and color in your pictures.

Capture commandment >> *If you want the best quality pictures always make sure that your scanner or camera captures in 16 bit per channel or 48 bit mode. On most cameras this is referred to as the Tiff or Raw setting. See technique 2.10 for more details on RAW files.*

Digital shooting technique

With the basics out of the way let's now look at how to manipulate some of your camera's technology in order to create the best digital files possible.

Exposure

Good exposure is one of the cornerstones of great imaging. Whether it be traditional silver based photography, or the new pixel centered picture making, getting your exposure right will ensure that you capture the most information possible.

Photographs that result from the sensor receiving too much light are said to be 'overexposed'. They typically have little or no details in the highlight portions of the image and the mid tone regions are far too bright. In contrast, pictures that have been captured with too little light are referred to as being 'underexposed'. In these images it is the shadow areas that lose details and in this scenario the mid tones are too dark.

The perfect exposure will produce a picture that contains

• A good spread of tones from light to dark,
• Details in the shadow areas, and
• Details in the highlight areas.

For most shooters, exposure is something that the camera does automatically. You frame the image in the viewfinder, or via the preview screen, push the button down halfway and the camera focuses and adjusts the exposure for the scene. Push the button down fully and the image is captured using the exposure settings selected by the camera.

Generally speaking, letting the camera do the work produces great results, but in some circumstances where the lighting is a little tricky, the 'auto' exposure route can result in images that are either 'under' or 'over' exposed. It's here that the photographer needs to 'step in' and make some adjustments to the exposure settings. Modern cameras have a range of features designed to override the camera's auto exposure settings.

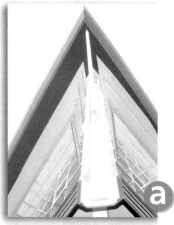

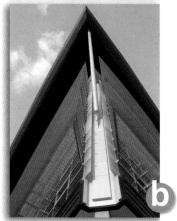

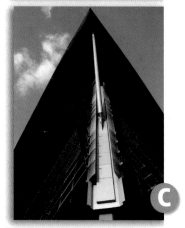

Over- and underexposure >> *The cornerstone of all good photography is accurate exposure. (a) Overexposed images are too light and lose details in the highlights and mid tone areas. (b) Well exposed pictures have a good distribution of tones over a range from dark to light. (c) Underexposed images have little or no shadow detail as these areas are converted to pure black.*

Exposure control

Two devices – the shutter and the aperture – control the amount of light that hits your camera's sensor.

The shutter is either an electrical or mechanical device that controls the length of time that the light falls upon the sensor. The longer the shutter is 'open' the more exposure the sensor will receive and conversely the shorter the shutter speed the less exposure is received. Shutter speeds have traditionally been measured in fractions of a second and are represented by a number sequence of halves and doubles. One step either way in the sequence is referred to as a change of a 'full stop'.

The aperture works in a similar way to the iris in your eyes. The amount of light hitting the sensor, or entering your eye, is controlled by the size of the aperture, or iris, hole. Using a large hole will transmit more light than when a small aperture is in place. Again a series of numbers represent a doubling or halving of the amount of light entering through a given aperture. This sequence is called F-stops and causes some confusion with new camera users as the scale equates the biggest aperture hole with the smallest F-stop number.

By varying the combination of aperture and shutter speed the camera, or photographer, can adjust the amount of light entering the camera to suit the sensitivity of the sensor. In bright conditions it is normal to use a fast shutter speed coupled with a large aperture number (small hole). Conversely, in low light situations a slow shutter speed and small aperture number (large hole) would be selected.

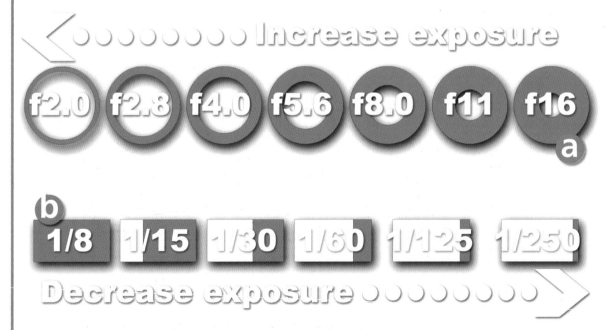

Mechanics of exposure >> *Aperture and shutter in combination control the amount of light that hits the sensor.*
(a) The aperture opens to allow more light into the camera and closes to reduce exposure.
(b) The length of time the shutter is opened is displayed in fractions of a second.

2.03 Exposure compensation

Suitable for Elements – 1.0, 2.0 | Difficulty level – Intermediate
Related techniques – 2.02

One of the real advantages of photographing digitally is the ability to review your efforts immediately after shooting via the built-in screen on the back of the camera. With this tool it is easy to determine the times when the auto exposure system is producing images that are not quite the perfect exposure. When this occurs you can increase or decrease the amount of light reaching the sensor by using the Exposure Compensation feature.

This control effectively changes the shutter speed or aperture selected in steps of an third of a F-stop (sometimes also called EV – exposure value). Most cameras allow changes of up to plus, or minus, 3 stops. In tricky lighting scenarios I generally shoot a test image, review the results, adjust my exposure compensation settings and shoot again. I continue this process of shooting and reviewing until I am satisfied with the exposure.

A more precise way to determine over- or underexposure is to consult the histogram display of your camera. The histogram can be accessed from your camera's playback menu and it visually graphs the spread of the pixels in the image. This feature takes the guesswork out of determining whether your image has exposure problems.

A bunching of pixels to the left hand end of the graph usually indicates underexposure and the need for more light, whereas a grouping to the right signals overexposure and requires a reduction in either the aperture or shutter speed setting.

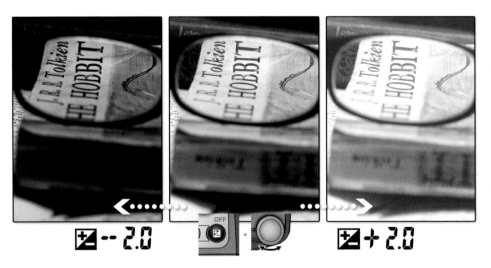

Exposure compensation >> *Many digital cameras contain a special feature that can be used to modify your exposure settings without altering the aperture or shutter speed values directly. This 'Exposure Compensation' control allows you to increase or decrease the overall exposure of the picture.*

Frame-by-frame control

Apart from the absence of film, the typical digital camera has many familiar features. Experienced shooters on the whole have no difficulty understanding technology such as the shutter, aperture, or ISO sensitivity as these options have their traditional counterparts, but most new digital cameras contain several often overlooked functions that are designed to help you produce the 'ultimate images – shot by shot'.

Some of these features include –
• Contrast control,
• Saturation adjustment, and
• In-built Sharpness control.

These controls are now found on all but the most basic entry-level models and provide a level of flexibility that was never possible in the days when 'film was king'.

2.04 Contrast

Suitable for Elements – 1.0, 2.0 | Difficulty level – Basic

The contrast control is one of the most useful features for the digital camera owner. When you are faced with shooting a beach, or snow scene, on a sunny day the range of brightness between the lightest and darkest areas can be extremely wide. Set to normal your camera's sensor will probably lose detail in both the highlight and shadow areas of the scene. Delicate tones will either be converted to white or black. Changing the setting to 'less contrast' will increase your camera's ability to capture the extremes of the scene and preserve, otherwise lost, light and dark details. In the opposite scenario, sometimes your subject will not contain enough difference between

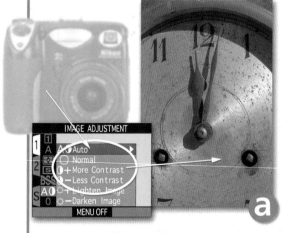

In–camera contrast adjustment >> *Altering the way that your camera records the contrast or the extremes of brightness in a scene can help to ensure that you capture important highlight and shadow details. (a) Less contrast setting. (b) Normal contrast setting. (c) More contrast setting.*

shadows and highlights. This situation results in a low contrast or 'flat' image. Typically pictures made on an overcast winter's day will fall into this category. Altering the camera's setting to 'more contrast' will spread the tonal values of the scene over the whole range of the sensor so that the resultant picture will contain acceptable contrast.

'How do I know if my scene has either too much or too little contrast?' The beauty of shooting digitally is that we can preview our image immediately. In particular check the shadow and highlight areas using the camera's histogram feature. If the display contains pixels bunched at either end of the graph then the picture is too contrasty and will warrant a contrast change and a re-shoot. Pixels concentrated in a group in the center of the graph indicate an image that is too flat and needs to be re-shot using a higher contrast setting.

Pro's Tip: Contrast correction that is applied via your favorite image editing software package is possible and often used, but it is always preferable to capture the image with the best contrast at the time of shooting. This will guarantee you are making images of the best quality.

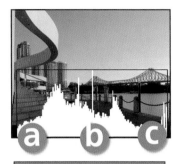

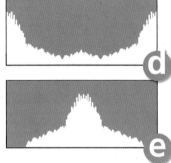

Histograms >> *Mid to high range cameras usually contain a histogram function which displays the spread of the tones in the image. This feature is very useful for determining if a picture is exposed correctly or contains too much or too little contrast. (a) Shadow tones. (b) Middle tones. (c) Highlight tones. (d) High contrast picture. (e) Low contrast picture.*

2.05 Color saturation
Suitable for Elements – 1.0, 2.0 | Difficulty level – Basic

The saturation, or vividness, of color within your images can either make or break them. Sometimes color is the cornerstone of a picture, providing both the focal point and the design for the whole photograph. In these circumstances, desaturated or pastel hues will only serve to weaken the strength of the picture. In contrast, strong color elements can distract from important subject matter, causing the viewer to concentrate on the color rather than the subject of the picture.

Digital shooters can take more control of the color content of their images by selecting just how dominant or vivid the hues will be in their pictures. For shots that rely on their color the vividness can be increased, for those that work more effectively with subdued hues, the color strength can be reduced by way of the camera's saturation control.

Again, the effectiveness or suitability of each setting should be previewed and if necessary, several images with different color settings can be captured and the final choice made later. Though not as critical for retention of details as the contrast settings, it is important to capture as much color information as possible when shooting. This does not mean that you shoot all subjects

with maximum saturation; it is just a reminder that if color is important, consider changing the saturation settings to suit your needs and your picture.

Pro's Tip: Always shoot in color mode even if the photograph is to be used as a black and white. The picture can easily be converted to black and white in your image editing program at any time and you have the advantage of a color version if ever you need it.

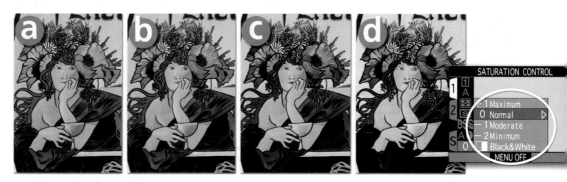

In-camera saturation adjustment >> *Using the saturation control in your camera you can alter the strength of the colors in your pictures. (a) Black and white. (b) Minimum saturation setting. (c) Normal saturation setting. (d) Maximum saturation setting.*

2.06 Image sharpness
Suitable for Elements – 1.0, 2.0, | Difficulty level – Basic

The digital equivalent of film is a grid of sensors situated behind the lens in your camera. Each of these sensors records the light and color of the image that is focused upon it. In doing so a digital version of the scene is constructed. Despite the high resolution of modern sensors and specially developed lenses like the one contained in the Nikon Coolpix 5400 the final image contains a degree of softness that is the direct result of this capturing process.

To help create crisper images the camera manufacturers include in-camera sharpening as one of their auto enhancement tools. Designed to improve the appearance of sharpness across the picture these features enhance the edge of objects by increasing the difference in tones between adjacent pixels. Sound confusing? Just remember that the act of sharpening changes the pixels in your image and just like the other image enhancement tools, too much sharpening can destroy you picture.

How do I know what settings to use? There are two schools of thought for deciding when and where to apply sharpening to your images. Some shooters apply a little sharpening in camera, using either the minimum or auto setting. Others prefer to leave their images untouched and will use the sharpening tools built into their favorite image editing program to enhance their pictures. I lean towards the second option, as it offers me the greatest control over the sharpening effects and where they occur in my photographs.

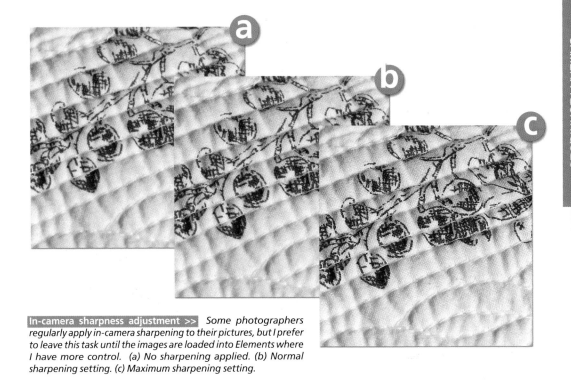

In-camera sharpness adjustment >> *Some photographers regularly apply in-camera sharpening to their pictures, but I prefer to leave this task until the images are loaded into Elements where I have more control. (a) No sharpening applied. (b) Normal sharpening setting. (c) Maximum sharpening setting.*

Pro's Tip: When sharpening in your editing program always view the image to be sharpened at 100 percent so that you can see the effects of the filter at the magnification that the picture will be used at.

2.07 White balance control
Suitable for Elements – 1.0, 2.0 | Difficulty level – Basic

Our eyes are extremely complex and sophisticated imaging devices. Without us even being aware they adjust automatically to changes in light color and level. For instance, when we view a piece of white paper outside on a cloudy day, indoors under a household bulb or at work with fluorescent lights, the paper appears white. Without realizing it our eyes have adapted to each different light source. Unfortunately digital sensors, including those in our cameras, are not as clever. If I photographed the piece of paper under the same lighting conditions, the pictures would all display a different color cast. Under fluorescent lights the paper would appear green, lit by the household bulb (incandescent) it would look yellow and when photographed outside it would be a little blue. This situation occurs because camera sensors are designed to record images without casts in daylight only. As the color balance of the light for our three examples is different to daylight, that is, some parts of the spectrum are stronger and more dominant than others, the pictures record with a cast. The color of the light source illuminating the subject in your picture determines the cast that will result.

When is white light not white? >> *The color of white light varies from source to source. Our eyes adjust to these changes but the camera will record the differences as a color cast in your pictures. The white balance feature is designed to rid your images of these casts. (a) Candle. (b) Household bulb. (c) Daylight. (d) Flash. (e) Cloud. (f) Skylight (no sun). (g) White fluorescent. (h) 'Daylight White' fluorescent. (i) 'Daylight' fluorescent.*

Traditional shooters have been aware of this problem for years and because of the limitations of film, most photographers carried a range of color conversion filters to help change the light source to suit the film. Digital camera producers, on the other hand, are addressing the problem by including 'White Balance' functions in their designs. These features adjust the captured image to suit the lighting conditions it was photographed under. The most basic models usually provide automatic white balancing, but it is when you start using some of the more sophisticated models that the choices for white balance correct can become a little confusing.

Cameras like Nikon's Coolpix 5400 provide a vast array of options that should have you shooting 'cast free' in any lighting conditions. The selections include –

• Auto,
• Fine or Daylight,
• Incandescent,
• Fluorescent,
• Cloudy,
• Speed light or Flash, and
• White Balance Preset.

Color casts from different light sources >> *Camera sensors are balanced for daylight. Shooting pictures under non-daylight light sources will result in the color casts we see above. (a) Daylight. (b) Fluorescent. (c) Household bulb or incandescent. (d) Flash. (e) Cloudy day.*

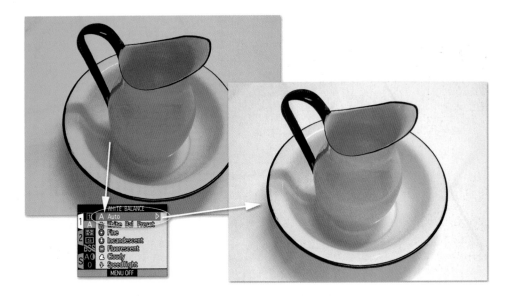

Auto white balance >> *The modern digital camera has a highly developed auto white balance system. It performs well under most lighting scenarios and should be your first choice when shooting under difficult conditions.*

Auto white balance

The Auto function assesses the color of the light in the general environment and attempts to neutralize the mid tones of the image. As with most 'auto' camera features, this setting works well for the majority of 'normal' scenarios. The feature does a great job with scenes that contain a range of colors and tones, but you may strike some difficulty with subjects that are predominantly one color, or are lit from behind. Also keep in mind that some subjects, such as cream lace, are meant to have a slight color shift and the use of the Auto feature in this case would remove the subtle hue of the original.

Apart from these exceptions most camera's Auto features produce great results that require little or no post-shooting color correction work. So it's my suggestion that if in doubt try the Auto setting first. Check the results on the preview screen of the camera and if there is a color cast still present then move onto some more specific white balance options.

Light source white balance settings

The Daylight (Fine), Incandescent, Fluorescent, Cloudy and Flash (Speed light) options are designed for each of these light types. The manufacturers have examined the color from a variety of each of these sources, averaged the results and produced a white balance setting to suit. If you know the type of lighting that your subject is being lit by, then selecting a specific white balance setting is a good move.

Again, for the majority of circumstances these options provide great results, but for those times when the source you are using differs from the 'norm', companies like Nikon have included a fine-tuning adjustment. With the light source set the command dial is turned to adjust the color settings.

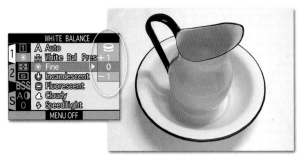

Fine tuning white balance >>
With some models white balance settings can be fine-tuned to suit specific lighting scenarios. With this camera plus values add blue to the picture and negative values add red.

For Daylight, Incandescent, Cloudy and Flash options selecting positive values will increase the amount of blue in the image. Alternatively, negative numbers will increase the red content.

If you have selected Fluorescent as your light source then the fine-tuning feature will allow you to select one of three different white balance settings. FL1 is suitable for tubes marked 'white', FL2 should be used with 'Daylight White' fluorescents and FL3 is for those labelled 'Daylight'.

2.08 Applying fine-tuning automatically

*Suitable for Elements – 1.0, 2.0 | Difficulty level – Intermediate
Related techniques – 2.07*

If you are like me and find manually fine-tuning hampers the flow of your photography – shoot, stop, switch to menu, fine - tune white balance, shoot again, stop, switch to menu ... you get the idea – then the check to see if you camera has an Auto White Balance Bracketing option. This feature automatically shoots a series of three images starting with the standard white balance settings and then adding a little blue and finally a little red.

I find white balance bracketing particularly useful when shooting difficult subjects like the hand blown colored glass in the example. As three separate images are saved I can make decisions about the most appropriate color by previewing them on my work station's large color calibrated monitor later rather than the small preview screen on the back of my camera in the field.

Auto fine tuning >> *The White Balance Bracketing option automatically captures several pictures with slightly different color settings. (a) Standard setting. (b) + Red. (c) + Blue.*

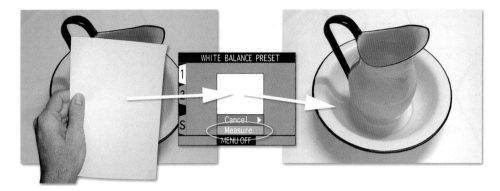

Preset white balance options >> *You can obtain a precise white balance setting under mixed lighting conditions by using the preset or customize option in your camera. When the feature is activated the camera will analyze a white (or mid gray) card in the scene, neutralize any casts that are present and set the white balance according to the analysis. The images now photographed with this preset white balance setting will be cast free.*

2.09 Customizing your white balance

Suitable for Elements – 1.0, 2.0 | Difficulty level – Intermediate
Related techniques – 2.07, 2.08

In a perfect world the scene you want to shoot will always be lit by a single source. In reality most scenarios are illuminated by a variety of different colored lights.

For instance, what seems like a simple portrait taken in your lounge could have the subject partially lit by the incandescent lamp stand in the corner, the fluorescent tube on the dining room ceiling and the daylight coming through the windows. Because of the mixed light sources a specific white balance setting is not appropriate. Instead, you should use the customize, or preset, white balance option on your camera.

Based on video technology, this feature works by measuring the light's combined color as it falls onto a piece of white paper. The camera then compares this reading with a reference white swatch in its memory and designs a white balance setting specifically for your shooting scenario. With the process complete you are now set to shoot your portrait secure in the knowledge that you will produce cast-free images. Always remember though, because this is a customized process if you decide to turn a light off, or move your subject to another position in the room, then you will need to remeasure and reset you white balance.

This way of working is by far the most accurate way to correct the color casts resulting from mixed lighting sources in your pictures.

It takes into account changes in color that result from:

• light reflecting off brightly painted walls,
• bulbs getting older,
• mixed light sources,
• light streaming through colored glass, and
• shooting through colored filters.

2.10 Shooting RAW for ultimate control

Suitable for Elements – 1.0, 2.0 | Difficulty level – Intermediate /Related techniques – 2.02

More and more medium to high end cameras are being released with the added feature of being able to shoot and save your pictures in RAW format. For most users this option on the camera's file menu has no real significance, but there are a growing number of photographers who having tried the new file type vow never to go back to using any other format. They boast of the extra quality and control that is achievable when using RAW for their image making and probably most impressive of all often refer to images in this format as being the closest thing to a digital 'negative' that we have yet seen. But why all this talk about RAW? What does the term actually mean and how can it help me take better pictures?

RAW files >> *Unlike TIFF and JPEG formats, RAW files contain the unprocessed image and shooting data. In many cameras the visual information is laid in the Bayer pattern of the original sensor.*

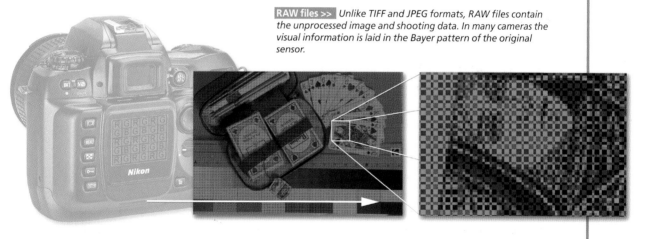

Back to the beginning

To start to understand the importance of RAW formats we need to go back to the beginning of the capture process. All single shot digital cameras (except those using the Foveon chip) contain a sensor that is made up of a grid of light sensitive sites. Each site responds to the amount of light that hits its surface. By recording and analyzing each of these responses a tone is attributed to each sensor site in the grid. In this way a digital picture can be created from the range of scene brightnesses that are focused through the lens onto the sensor's surface. Fantastic though this is, this process only results in a monochrome (black, white and gray) picture as the CCD or CMOS sensors by themselves cannot record the color of the light, only the amount.

To produce a digital color photograph a small filter is added to each of the sensors. In most cameras these filters are a mixture of the three primary colors Red, Green and Blue and are laid out in a special design called a Bayer pattern. It contains 25% red filters, 25% blue and 50% green with the high percentage of green present in order to simulate the human eye's sensitivity to this part of the visible spectrum. In their raw, or unprocessed, format the output from these sensors is made up of a grid of red, green and blue patches (pixels) of varying tones. And yes this does mean that in any individual picture only 25% of the sensor sites are actually capturing information about the red or blue objects in the scene.

Interpolated color

I hear you saying 'But the images that I download from my camera are not split into discrete RGB colors'. This is true. What emerges from the camera is a full color picture which contains 100% Red, 100% Blue and 100% Green pixels. This occurs because as an integral part of the capture process the raw RGB data that comes from the sensor is interpolated to create a full color image. Using special algorithms, the extra detail for a non-red site, for instance, is created using the information from the surrounding red, green and blue sites. This process is called interpolation and though it seems like a lot of 'smoke and mirrors' it works extremely well on most cameras.

When you opt to save your images in JPEG or TIFF formats this capture and interpolation process happens internally in the camera each time you push the shutter button. In addition your camera will also reduce the number of colors and tones from the 16 bit color depth that was captured to the 8 bits that are stored in the file. Selecting a RAW format stops the camera from processing the color separated (primary) data from the sensor and reducing the image's bit depth, and saves the picture in this unprocessed format. This means that the full description of what the camera 'saw' is saved in the image file and is available to you for use in the production of quality images.

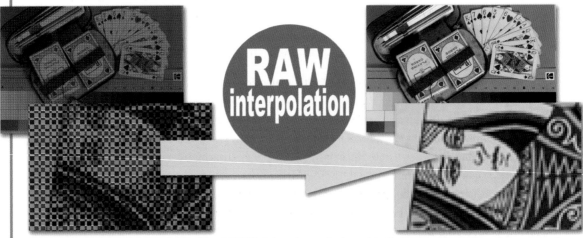

RAW Images >> *The image stored in a RAW file is based upon the base data that comes directly from the sensor and needs to be interpolated to create the full color digital file we normally associate with camera output.*

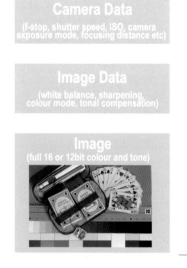

RAW files make-up >> *The RAW file is composed of three separate sections: Camera Data, Image Data and the Image itself. By keeping these components separate it is possible to edit variables like white balance and color mode which are usually a fixed part of the file format.*

DIY RAW processing

Sounds great, doesn't it? All the quality of an information-rich image file to play with, but what is the catch? Well RAW files have to be processed before they can be used in a standard image editing application like Photoshop Elements. It is true that the latest version of the program does allow you to import RAW photographs, but the program quickly converts these files to standard pictures with a lot of the potential for great image enhancement lost in the haste of the conversion process.

To access the full power of these digital negatives you will need to employ a special dedicated RAW editor. There are several on the market with Adobe providing its own specialist editor as a plug-in that functions with both Photoshop Elements and Photoshop. Designed specifically to allow you to take the unprocessed RAW data directly from your camera's sensor and convert it into a usable image file, these editors also provide access to other image characteristics that would otherwise be locked into the file format. Variables such as color space, white balance mode, image sharpness and tonal compensation (contrast and brightness) can all be accessed, edited and enhanced as a part of the conversion process. Performing this type of editing on the full high bit (16 bit), RAW data provides a better and higher quality result than attempting these changes after the file has been processed and saved in a non-RAW format.

RAW processing in action

When you open a RAW file you are presented with a full color, interpolated preview of the Bayer file. Using a variety of menu options, dialogs and image tools you will be able to interactively adjust image data factors such as tonal distribution and color saturation. Many of these changes can be made with familiar editing tools like levels and curves controls. The results of your editing can be reviewed immediately via the live preview image and associated histogram graphs. The Adobe plug-in also uses the new three-color histogram featuring separate graphs for red, green and blue picture content. After these general image editing steps have taken place you can apply some enhancement changes such as filtering for sharpness using an Unsharp Mask tool, removing Moiré effect and applying some smoothing.

The final phase of the process involves selecting the color space, color depth, pixel dimensions and image resolution with which the processed file will be saved. Clicking the OK button sets the program into action, applying your changes to the RAW file whilst at the same time interpolating the Bayer data to create a full color image.

The real advantages of editing and enhancing at the RAW stage are that these changes are made to the file at the same time as the primary image data is being interpolated to form the full color picture. Editing after the file is processed (saved by the camera in 8 bit versions of the JPEG and TIFF format) means that you will be applying the changes to a picture with less tones and colors. A second bonus for the dedicated RAW shooter is that actions like switching from the white balance option selected when shooting to another choice when processing are performed without any image loss. This is not the case once the file has been processed with the incorrect white balance setting. As anyone who has inadvertently left the tungsten setting switched on whilst shooting in daylight can tell you.

For the production photographer most RAW editing programs also contain several batch processing options. These allow the user to set up general parameters for a group of images and then instruct the program to process and save each file in turn automatically. This is a real time saver when you have to edit a bunch of pictures taken under the same shooting circumstances.

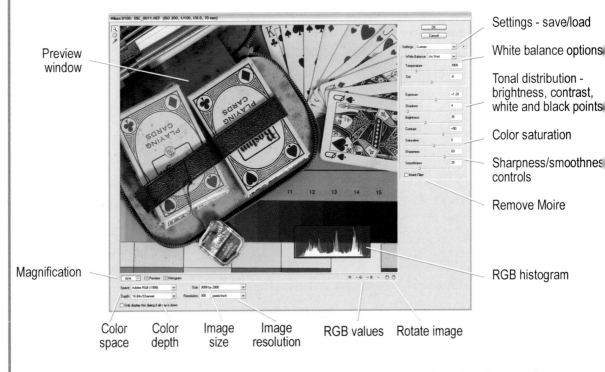

Preview window

Magnification

Settings - save/load

White balance options

Tonal distribution - brightness, contrast, white and black points

Color saturation

Sharpness/smoothness controls

Remove Moire

RGB histogram

Color space Color depth Image size Image resolution RGB values Rotate image

RAW editing >> *The Adobe RAW editor can be purchased separately and installed as a plug-in into Elements. When you attempt to open a RAW file into the program the plug-in is activated. It provides a range of sophisticated controls for the enhancement and conversion of your RAW files. When you have finished making your changes, you click OK, the plug-in closes and the interpolated file is placed into the Elements workspace.*

Camera based
RAW processing

TIFF
JPEG

RAW file

Computer based
RAW processing

TIFF
JPEG
PSD

Capture workflow >> *Selecting JPEG or TIFF as your picture's file format means that the image processing is handled by the camera. In contrast choosing the RAW format removes this task from the camera and places it firmly with you and your computer. Working this way means that you have a say in decisions about white balance, contrast, brightness, sharpness and color mode.*

Adobe Photoshop RAW Plug-in

Most cameras that are capable of capturing RAW files are supplied with simple editing software. Some manufacturers provide other programs designed specifically for their camera's files that contain more sophisticated options at an extra cost.

Adobe, realizing the significance of the file format, also provides an extra piece of software for RAW editing. Designed to act as a plug-in for both Photoshop and Photoshop Elements, the Adobe RAW converter starts when you open a RAW file from inside either program. This editor is lightning fast, easy to use, has a great preview and it is very well laid out. The workflow is simple. Move through the controls and tabs on the right hand side of the screen from top to bottom, select your output size, color space and bit depth, press OK and you're done. The software works with Canon, Fuji, Minolta, Nikon and Olympus generated files. If you want to take your image capture to the next level RAW is the way to go.

2.11 Shooting workflows

Having an understanding of all these techniques is one thing but putting them together when you are out shooting is another. To capture the most detail and in the best quality that your camera offers is a multi-step process. The following table summarizes the steps involved in three different approaches to capturing images using the techniques discussed above. The highest quality is obtained by shooting with a RAW file which is then enhanced using a dedicated editor. If your camera doesn't contain RAW capabilities then the next best option is to shoot TIFF and make your adjustments in Elements. If neither option is available then using 'best quality' JPEG will give good results.

Recommended Digital Camera Workflow

Before Shooting	Select Highest resolution		
	Pick best color depth (16 bit per channel or 48 bit overall)		
	Select file format – **JPEG**	Select file format – **TIFF**	Select file format – **RAW**
	Choose finest quality (least compression)	No compression	No compression
	Set Color Mode (sRGB for web work, AdobeRGB for print work)		
	Set Saturation		
	Set White balance (Either for the dominant light source or using the customize option)		
During Shooting	Arrange composition		
	Adjust Focus (Check Depth of Field)		
	Set exposure (Check Histogram)		
After Shooting	Adjust Highlight and Shadow (Elements)		Adjust Highlight and Shadow (Adobe RAW plug-in)
	Alter contrast (Elements)		Alter contrast (Adobe RAW plug-in)
	Remove color casts (Elements)		Remove color casts (Adobe RAW plug-in)
	Apply some sharpening (Elements)		Apply some sharpening (Adobe RAW plug-in)
	Save processed file (Elements)		Save processed file (Elements)
Image Quality	Good	Better	Best

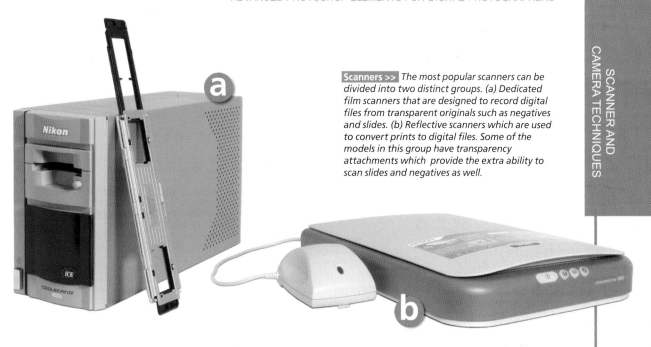

Scanners >> *The most popular scanners can be divided into two distinct groups. (a) Dedicated film scanners that are designed to record digital files from transparent originals such as negatives and slides. (b) Reflective scanners which are used to convert prints to digital files. Some of the models in this group have transparency attachments which provide the extra ability to scan slides and negatives as well.*

Film and print scanners

It was not too long ago that an activity like scanning was the sole responsibility of the repro house. The photographer's job was finished the moment that the images were placed on the art director's desk. But as we all know the digital revolution has changed things forever, and scanning is one place where things will never be the same.

Desktop scanners that are capable of high-resolution color output are now so cheap that some companies will throw them in as 'freebies' when you purchase a complete computer system. The proliferation of these devices has led to a large proportion of the photographic community now having the means to change their prints, negatives or slides into digital files. But as all photographers know, having the equipment is only the first step to making good images.

For the most part, scanners can be divided into three distinct varieties – print, film and the more recent hybrid or combination scanner.

Dedicated film – This device is set up specifically for negative or slide capture and is usually restricted to a single format (135 mm/120 mm/5 x 4 inch). The hardware is not capable of reflective scanning. If your business involves the repeated capture of images of the one film type, a dedicated scanner is a good investment.

Hybrid – These scanners are capable of both reflective and transmission scanning. This means that the one device can capture both film and print images. Starting life as flatbeds

with added transparency adapters, these scanners have developed into multi-unction devices that are capable of producing quality files from both types of originals.

Dedicated print – The scanners in this category are the most affordable and easily obtainable of the three types. If you can't afford a digital camera of the quality that you desire and you have loads of prints in boxes lying around the house then spending a couple of hundred dollars here will have you enhancing high quality digital versions of your pictures in no time.

2.12 Scanning resolution – 'Know where you are going before you start the journey'

*Suitable for Elements – 1.0, 2.0 | Difficulty level – Intermediate | Resources – Web worksheet 201
Related techniques – 2.01*

Just as is the case with camera based capture, the quality of the digital picture that results from our scanning activities is based primarily on resolution and color depth. It is critical that these two factors are carefully considered before any scanning capture takes place.

Scanning resolution, as opposed to image or printing resolution, is determined by the number of times per inch that the scanner will sample your image. The number of pixels generated by a digital camera has an upper limit that is fixed by the number of sensors in the camera. This is not the case for scanner capture. By altering the number of samples taken for each inch of the original print or negative you can change the total number of pixels created in the digital file. This figure will affect both the 'enlargement' potential of the final scan and it's file size. The general rule is the higher the resolution the bigger the file and the bigger the printed size possible (before seeing pixel blocks or digital grain).

Scanning resolution (samples per inch)	Image size to be scanned	Output size (pixels)	Output size (inches for print @ 200 dpi)	File size (Mb)
4000	35 mm film frame (24 mm x 36 mm)	4000 x 6000	20 x 30	72.00
2900	35 mm	2900 x 4350	14.5 x 21.75	37.80
1200	35 mm	1200 x 1800	6 x 9	6.40
600	35 mm	600 x 900	3 x 4.5	1.62
400	5 x 4 inch print	2000 x 1600	10 x 8	9.60
1000	5 x 4 inch print	5000 x 4000	25 x 20	60.00
400	10 x 8 inch print	4000 x 3200	20 x 16	38.40

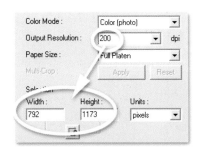

Scanning resolution > *Adjusting the resolution that you scan at will directly affect the pixel dimensions of your final file. High scanning resolution will create more pixels in the files which translates into bigger prints.*

Does this mean that we always scan at the highest resolution possible? The intelligent answer is NO! The best approach is to balance your scanning settings with your printing needs. If you are working on a design for a postage stamp you will need less pixels to play with than if you want your masterpiece in poster format. For this reason it is important to consciously set your scanning resolution keeping in mind your required output size. See section 2.01 for more details about resolution.

Some scanning software will give you an indication of resolution, file size and print size as part of the dialog panel but for those of you without this facility use the table above as a rough guide.

2.13 Color depth

Suitable for Elements – 1.0, 2.0 | Difficulty level – Basic | Related techniques – 2.02

As we have seen already color depth refers to the number of possible colors that make up the digital file upon the completion of scanning. If you have the choice always select 16 bit scanning mode (sometimes called 48 bit – 16 bits for red + 16 bits for green + 16 bits for blue) instead of 8 bit as this provides you with the opportunity to capture as much information from your photographic original as possible.

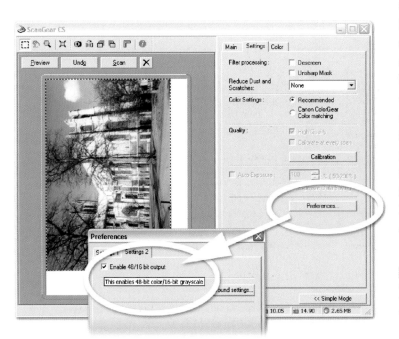

Remember this is true even though Elements converts these files to 8 bit immediately upon opening. The more accurately the image is scanned in the first place the better quality the down sampled file will be after Elements has made the conversion.

Scan in 16 bit mode >> *To capture the best detail, colour and tone always scan in 16 bit mode.*

2.14 Multi-sample

Suitable for Elements – 1.0, 2.0 | Difficulty level – Intermediate

Scanners in the mid to high end range often contain another feature that is designed to increase the quality of digital capture, especially in the darkest parts of the negative or print. Called Multi-Sample Scanning, it is a process where the image is sampled or scanned several times and the results averaged. This approach is particularly helpful when the scanner is trying to penetrate the shadow areas of a print or the highlight parts of a negative. It is these parts of the picture that a single pass scan will most likely provide a 'noisy' result.

You can reduce this noise by making several scans of the same area and then averaging the result. The theory is that the level of noise reduction is directly proportional to the number of samples to be averaged. Therefore machines that offer a multi-sample rate of '16x' will produce better results than those that only contain a '4x' version.

The down side to the technology is that all this extra scanning and averaging does take time. For instance the Minolta Dimage Dual III set to 8x Multi-Sample can take up to 14 times longer to make a high resolution, high bit scan of a 35 mm negative. For most well exposed and processed negatives or prints there will be little extra quality to gain from this procedure but for those troublesome images that seem to have areas of dark impenetrable detail using multi-sample will definitely produce a better overall result.

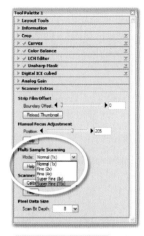

Multi-sample scan >>
Some scanners offer the option of 'multi-scanning' your film original. Select this setting for the best overall capture of difficult negatives or slides, but be warned using this feature dramatically increases your scanning time.

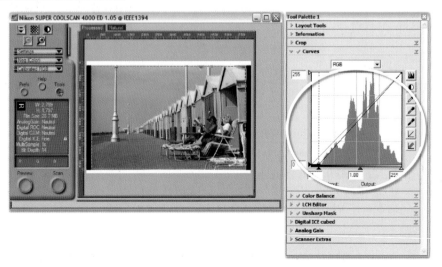

Highlight and shadow adjustment >> *Using the levels or curves feature in your scanner driver adjust the capture to ensure that delicate highlight and shadow details are maintained and tones are well spread.*

Contrast changes >> *Flat pictures can be corrected at scanning time by adjusting black and white using the brightness or contrast tools in the scanner driver.*

2.15 Highlight and shadow capture
Suitable for Elements – 1.0, 2.0 | Difficulty level – Basic

With resolution and color depth set we can now scan the image – well almost! Just as exposure is critical to making a good photograph, careful exposure is extremely important for achieving a good scan.

All but the most basic scanners allow some adjustment in this respect. Preview images are supplied to help judge exposure and contrast, but be wary of making all your decisions based on a visual assessment of these often small and pixelated images. If you inadvertently make an image too contrasty then you will lose shadow and highlight detail as a result. Similarly a scan that proves to be too light or dark will also have failed to capture important information from your print or film original.

It is much better to adjust the contrast, sometimes called 'gamma', and exposure settings of your scan based on more objective information. For this reason a lot of desktop scanner companies provide a method of assessing what is the darkest, and lightest parts, of the image to be scanned. Often looking like the Info palette in Elements these features give you the opportunity to move

around the preview image pegging the highlight and shadow areas. Other scanner drivers include their own version of the Histogram which you can use to diagnose and correct brightness and contrast problems. With these tools you can set the black and white points of the image to ensure that no details are lost in the scanning process.

For those readers whose scanning software doesn't contain this option, try to keep in mind that it is better to make a slightly flat scan than risk losing detail by adjusting the settings so that the results are too contrasty. The contrast can be altered later when you edit the picture in Elements.

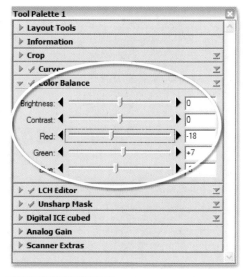

Color cast correction >> *Color casts can be removed from scanned originals using the slider controls found in the scanner driver.*

2.16 Color cast correction

Suitable for Elements – 1.0, 2.0
Difficulty level – Intermediate

Despite our best abilities some photographs are captured with a dominant color cast that pervades the whole picture. Using the scanner driver's own color adjustment feature you can neutralize this tint at the time of capture. Frequently the scanner software provides a before and after thumbnail of you color adjustments so that you can preview your changes before committing the final settings. Now when the picture is scanned the color balance is adjusted and the color cast removed.

It is true that this process can be handled by Elements using the Color Cast or Color Variations features but, as we have already seen with the camera techniques above, the best quality images are generated when adjustments such as these are made at the capture stage.

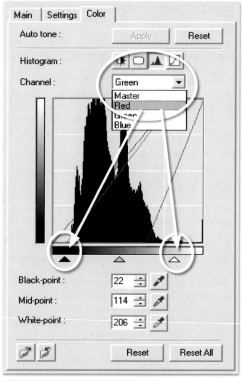

Removing casts with histograms >> *In the absence of dedicated cast removal sliders careful adjustment of the histogram for each channel can achieve the same results. See technique 4.07 for details.*

2.17 Dust and scratches
Suitable for Elements – 1.0, 2.0
Difficulty level – Basic

One of the hidden enemies of quality scans is dust. Though the presence of dust won't reduce the ability of the scanner to record highlight and shadow detail accurately it does decrease the overall quality of the file because the affected area must be retouched later in Elements. No matter how proficent the retouching is, the 'rebuilt' section of the picture that is created to cover the dust mark will never be the same as the detail that existed in the original negative, slide or print. More importantly, especially for the photographer with hundreds of scans to complete, is the massive amount of time needed to retouch these dusty areas.

Some scanner models will include features designed to remove dust (and scratches) automatically from the picture during the scanning process. This technology when applied carefully can produce truly amazing results. One example is the Digital ICE technology produced by Applied Science Fiction (www.asf.com). Unlike post-capture processing where the dust mark is covered over using samples of other picture detail that surrounds the area, ICE isolates the marks during the

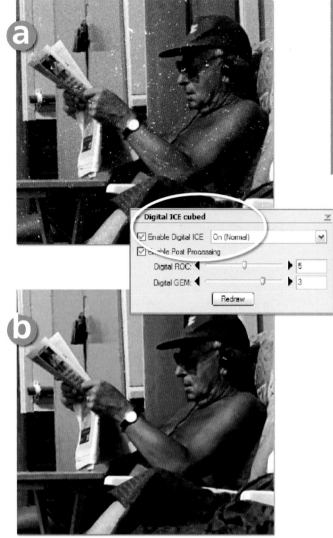

Auto dust removal >> *Features like ASF's Digital ICE can remove dust and scratch marks automatically at the time of scanning. (a) Before Digital ICE. (b) After Digital ICE.*

scanning process and then proceeds to erase the defects from the picture. As the process is directly linked to the scanning hardware the Digital ICE technology cannot be applied to a dust affected image after it has been captured.

If you are considering buying a scanner then it is worth considering a make and model that incorporates the ASF Digital ICE feature. It's true that the defect detecting and erasing processes do add to the overall scanning time, but the retouching time saved more than makes up for it.

2.18 Noise Reduction technologies

Suitable for Elements – 1.0, 2.0 | Difficulty level – Basic
Resources – Web link

As part of the process of scanning an image, visual errors are introduced into the file that were not part of the original. This is true to varying degrees for both entry level and high end scanners. The most noticeable of these errors is called 'noise' and usually shows up in shadow or highlight areas of the picture as brightly colored random pixels or speckles. Image noise can be caused by a variety of factors including high speed film grain (high ISO), under- or overexposed negatives or slides, lighting conditions with brightness extremes, image enlargement as well as the CCD sensor itself. At its worst, high levels of noise within a picture cause the image to appear unsharp and less detailed and has the potential to distract a viewer's attention away from the content of the image.

Cameras and noise

Scanners are not the only capture devices that can introduce noise into a digital photograph. The sensors in cameras can suffer from the same problems as those found in scanners.

Generally noise is at its worst in photographs taken with high ISO (equivalent) settings or when the shutter speed is longer than 1 second.

To help remove the noise in camera captured pictures ASF also produce a plug-in version of their GEM software that can be activated via the filter menu in Elements.

This version of the software provides a little more control than that provided as part of the scanner driver as it allows separate adjustments for highlight and shadow noise as well as a slider control to alter the sharpness of the picture.

Readers whose scanner driver doesn't contain the GEM filter can use the Elements plug-in as a neat 'work around' that will provide similar results.

To help correct or more accurately minimize the impact of noise in our digital photographs scanner manufacturers like Kodak, Minolta, Nikon and Umax have banded together with software producer Applied Science Fiction(www.asf.com) to include ASF's Digital GEM product in their scanning software. GEM reduces image noise and grain during the scanning process and should be used when standard scanner settings produce noisy results.

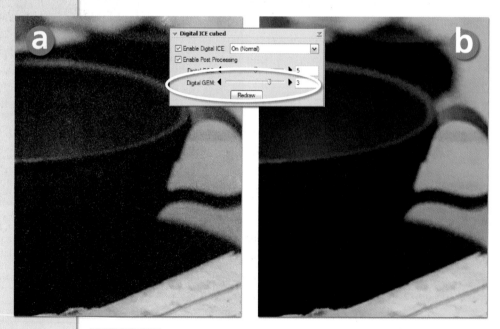

Digital GEM >> *Using a technology such as ASF's Digital GEM feature will reduce the appearance of grain in your picture whilst maintaining the sharpness and clarity of the photograph. (a) Noise before Digital GEM. (b) Noise after Digital GEM.*

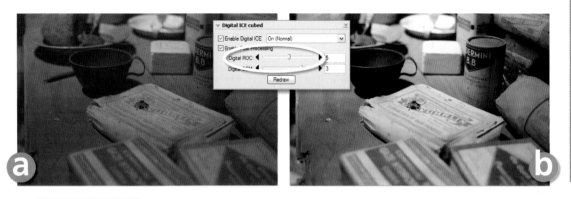

Recreation of color >> *ASF's Digital ROC feature recreates the color lost in original pictures due to fading or incorrect color balance at the time of shooting. (a) Before and (b) after color regeneration.*

2.19 Color regeneration features

*Suitable for Elements – 1.0, 2.0, 3.0 | Difficulty level – Basic
Resources – Web link*

The last feature in the Applied Science Fiction trinity of scanning products is Digital ROC. Starting life as a feature designed specifically for use in the restoration of faded negatives or prints, many scanner operators now regularly leave the ROC option turned on for their non-restoration jobs as well. It provides a fast and effective way to automatically adjust the scanned image to account for over- and underexposure, color casts and, of course, fading. The feature analyzes the data from the blue, green and red layers, identifying areas of loss and carefully recreating density and detail. ROC can also be used to restore density to faded black and white prints or negatives if the original is scanned in RGB mode initially.

The product is available as a plug-in for Elements or as part of your scanner software. Most scanners that included ICE and GEM also contain the ROC feature as well. The plug-in offers more control over the color regeneration process by providing slider adjustments for the red–cyan, green–magenta and blue–yellow tints.

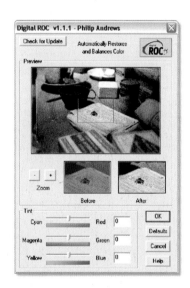

Digital ROC for cameras >> *The ROC and GEM components of the Digital ICE suite are also available as plug-ins for Photoshop Elements providing grain reduction and color balancing options for camera based images.*

2.20 Scanning workflow

Making sure that your negatives/ prints are clean before scanning can save a lot of time spent removing marks from the picture later. Use a soft cloth or a blower brush to remove surface particles before placing the film strip into the holder or the print on the platen. Don't forget to clean the glass of the scanner as well.

Check with your scanner manual to see which way the film should be placed in the holder. Inserting the film the wrong way round will mean that any writing in the picture will be back to front. Place the film in the holder ensuring the strip aligns with holder edges. Insert the film holder into the scanner. For flatbed scanners, place the photograph face down on the glass surface making sure that the edges are parallel with the scanner's edge.

Start the scanner software. You can do this from inside Elements. Simply select the scanner name from the Import (Photoshop Elements: File>Import) menu. This will open the software that controls the scanner. Some scanners are supplied with a stand-alone version of this software that you can access from your program's menu without having to open an editing package first.

Recommended Scanning Workflow

Before Scanning	Select resolution to suit print needs (samples per inch)	
	Pick best color depth (16 bit per channel or 48 bit overall)	
	Set Color Mode (sRGB for web work, AdobeRGB for print work)	
	Set media type (reflection – print or transmission – negative, slide)	
	Set original type (negative, slide, print)	
After Preview Scan	Flip or Rotate (if necessary)	
	Crop out unwanted detail (if necessary)	
	Adjust Focus (Manual or Auto)	
	Set exposure (Check Histogram)	
	Remove Color Cast (if necessary)	
	Turn off Dust and Scratch removal feature	Turn on Dust and Scratch removal feature (if necessary)
	Turn off Color restoration feature	Turn on Color restoration feature (if necessary)
	Set Single Sample mode (Single Pass)	Set Multi-Sample mode
After Scanning in Elements	Adjust Highlight and Shadow	
	Alter contrast	
	Remove color casts	
	Apply some sharpening	
	Save processed file	
Image Quality	Good	Best

Fixing common shooting problems

Use the guide below to help diagnose and solve shooting problems.

1. Focus not on main subject

Problem: The main subject in the image is not sharply focused.

Cause: This is usually caused by not having the auto focus area on the main subject at the time of shooting.

Solution: If your subject is off to one side of the frame make sure that you lock focus (pressing the shutter button down always) on this point before re-composing and releasing the shutter button.

2. Picture too light

Problem: The photograph appears washed out or too light with no detail in the light areas of the print.

Cause: This is caused by too much light entering the camera causing the overexposure.

Solution: You can resolve this problem by adjusting the camera's exposure compensation control so that it automatically reduces the overall exposure by 1 stop. Shoot again and check exposure. If still overexposed, change the compensation to 2 stops. Continue this process until the exposure is acceptable.

3. Picture too dark

Problem: The photograph appears muddy or too dark with no detail in the shadow areas of the print.

Cause: Again this is a problem of exposure. This time not enough light has entered the camera.

Solution: Adjust the exposure compensation control to add more light or alternatively use a flash to help light your subject.

4. Subject too blurry

Problem: The main subject, or the whole picture, appears blurry and unsharp.

Cause: When images appear blurry it is usually the result of the subject, or the photographer, moving during a long exposure.

Solution: Use a tripod to reduce the risk of camera shake and try photographing the subject at a point in the activity when there is less movement.

5. Flash off glass

Problem: This problem results from the flash bouncing straight back from the glass into the lens of the camera.

Cause: The flash travels directly from your camera hitting the glass and bouncing directly back into the lens.

Solution: Using available light rather than the flash is one solution. Another is to move a little to one side so that the flash angles off the glass surface away from the camera.

6. Portrait too dark

Problem: Instead of a clear picture of your subject framed by the window you end up with a silhouette effect, where the subject is too dark but the window is well exposed.

Cause: When your subject is sitting against an open window the meter is likely to adjust exposure settings for the light around your subject.

Solution 1: Move the subject so that the light from the window falls onto them from the front or side rather than behind.

Solution 2: Use the camera's flash system, set to 'fill flash mode', to add some more light to the subject.

Solution 3: Move closer to the subject until it fills the frame. Take an exposure reading here (by holding the shutter button down halfway) and then reposition yourself to make the exposure using the saved settings.

7. Portrait too light

Problem: The main subject is 'blown out' or too light (overexposed).

Cause: This problem is the reverse of what was happening in the example above. Here the meter is seeing the large dark areas within the frame and overcompensating for it, causing the main subject to be too bright.

Solution 1: Manually compensate for the overexposure by adjusting the camera's exposure compensation mechanism so that the sensor is receiving 1, 2 or 3 stops less light.

Solution 2: Move close to the subject until it fills the frame. Take an exposure reading here and then reposition yourself to take the picture using the saved settings.

Fixing common scanning problems:

Use the guide below to help diagnose and solve scanning problems.

1. Marks on the picture

Problem: The photograph contains marks on the surface after scanning.

Cause: This usually occurs because of dust or scratches on the glass plate on the top of the scanner or on the photograph or negative.

Solution: Clean the glass plate and photograph carefully before placing and scanning your picture. If you still have marks use a retouching tool to remove them (see the Removing unwanted details in the software section for more details).

2. Color picture appears black and white

Problem: After scanning a colour picture it appears black and white on screen.

Cause: The 'original' or 'media' option in the scanner software is set to black and white and not color.

Solution: Re-scan the picture making sure that the software is set to color original or color photograph.

3. Picture is too bright

Problem: The picture looks too bright overall. Light areas of the photograph appear to be completely white with no details.

Cause: The picture has been scanned with the wrong 'exposure' or 'brightness' setting.

Solution: Re-scan the picture, but this time move the brightness or exposure slider towards the dark end of the scale before scanning.

4. Picture is too dark

Problem: The picture looks too dark overall. There is no detail in the shadow parts of the photograph.

Cause: The picture has been scanned with the wrong 'exposure' or 'brightness' setting.

Solution: Re-scan the picture, but this time slide the brightness or exposure slider towards the light end of the scale before scanning.

5. Picture looks washed out

Problem: The picture has no vibrant colors and looks washed out.

Cause: The contrast control in the scanner software is set too low.

Solution: Re-scan the photograph altering the scanner's contrast setting to a higher value.

6. Writing is back to front

Problem: The message on a billboard in the picture is back to front.

Cause: The negative or slide was placed into the scanner back to front.

Solution: Turn the film or slide over and scan again.

7. The picture has too much contrast

Problem: The delicate light areas and shadow details of the picture can't be seen and have been converted to completely white and completely black.

Cause: The contrast control in the scanner software is set too high.

Solution: Re-scan the photograph altering the scanner's contrast setting to a lower value.

8. When I print my scanned picture it is fuzzy

Problem: The print of a scanned image is fuzzy, not very clear or is made up of rectangular blocks of color.

Cause: To get the best quality prints from your scanned pictures you must make sure that you match the scan quality (resolution) with the output requirements. A fuzzy or unclear print is usually the result of using a scan quality setting that is too low.

Solution: Re-scan the picture using a higher scan quality setting (resolution).

3

Image Changes – Beyond the Basics

Advanced selection techniques

Many great image editing techniques are based on the 'selection' prowess of the photographer. Being able to manipulate the selection tools to isolate the precise pixels that you wish to edit is a key skill that we all should possess. The following techniques will help you build on your existing selection skills.

3.01 Adding to and subtracting from selections

Suitable for Elements – 1.0, 2.0 | Difficulty level – Basic
Related techniques – 3.02, 3.03, 3.04, 3.05 | Tools used – Magic Wand, Lasso, Marquee

It is a very rare occasion that you will be able to create the perfect selection with a single tool applied once. Most editing jobs require the building of selections using multiple tools creating new selections that are either added to, or subtracted from, existing selections. Photoshop Elements provides a range of features that are designed for just this purpose.

When a selection tool is in use four selection modes are available in the Option bar. By switching between these modes whist making additional selections you can:

• create a new selection each time the tool is applied,
• add to an existing selection,
• subtract from an existing selection or
• make a selection from the intersection of the new and old selections.

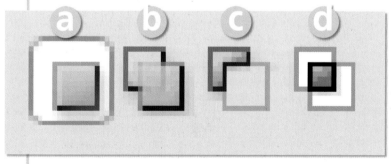

The modes are available for all selection tools with the New Selection option being the default. Complex areas of a picture can be isolated by making a series of selections choosing the necessary tool (Lasso, Marquee or Magic Wand) and mode (new, add to, subtract from, intersection of) as you go. The mode of the current tool can also be changed using a keyboard shortcut whilst selecting. Hold down the Shift key to add to a selection or the Alt key (Option – Macintosh) to subtract.

Adding to selections >> *Modify your selections by switching selection modes using the buttons found in the options menu.*
(a) New selection.
(b) Add to selection.
(c) Subtract from selection.
(d) Make new selection from the intersection.

3.02 Saving and loading selections

Suitable for Elements – 1.0, 2.0 | Difficulty level – Intermediate
Resources – Web image 3.02 | Related techniques – 3.01, 3.03, 3.04, 3.05
Tools used – Selection tools | Menus used – Select

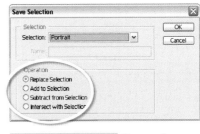

Photoshop Elements thankfully gives you the option to save
all your hard selecting work so that it can be used again later.
With your selection active choose the Save Selection option
from the Select menu. Your selection will now be saved as part
of the file. When you open the file later you can retrieve the
selection by choosing Load Selection from the same menu.

*Save Selection dialog >> You can also
choose to modify you selection via the
modes in the Save Selection dialog.*

This feature is particularly useful when making sophisticated multi-step selections, as you can
make sequential saves, marking your progress and ensuring that you never lose your work.

The Save Selection dialog also provides you with another way to modify your selections. Here you
will find the option to save a newly created selection in any of the four selection modes we looked at
earlier. This provides you with an alternative method for building complex selections which is based
on making a selection and then saving it as an addition. In this way you can create a sophisticated
selection one step at a time.

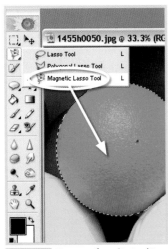

*Step 1 >> Use your favorite tool to
make your first selection.*

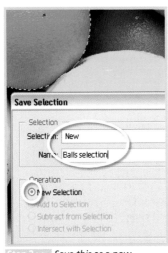

*Step 2 >> Save this as a new
selection using the Select>Save
Selection feature. Deselect (Ctrl + D).*

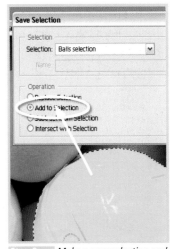

*Step 3 >> Make a new selection and
then save it using the Add to
Selection mode in the Save dialog.*

3.03 Modifying selections

Suitable for Elements – 1.0, 2.0 | Difficulty level – Intermediate | Resources – Web image 3.02
Related techniques – 3.01, 3.02, 3.04, 3.05 | Tools used – Selection tools | Menus used – Select

Apart from adding to and substracting from selections, Photoshop Elements also offers several
other ways to modify your selections. Nested under the Select menu, most of these options change
the positioning or character of the selection's edge. They can provide quick ways to adjust your
selections.

• *Feather* adjusts the smoothness of the transition between selected and non-selected areas. Low values are used for sharp edged selections and higher values for softer ones.

• *Modify>Border* creates a border of a specific pixel width at the selection's edge. Add color to this border using the Edit>Fill command. This option only creates soft edge borders. Use Edit>Stroke to create hard edged lines around a selection.

• *Modify>Smooth* searches for unselected pixels within the nominated radius. If these areas are surrounded by selected pixels then they will be included in the selection, if the surrounding areas are not selected then they will not be included.

• *Modify>Expand* increases the size of the selection evenly by the pixel amount selected.

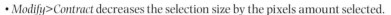

Feather >> *Use this option to create graduated edges to your selections.*

• *Modify>Contract* decreases the selection size by the pixels amount selected.

• *Grow* selects pixels adjacent to the selection that are within the tolerance range of the Magic Wand settings.

• *Similar* chooses all pixels throughout the picture that fall within the Magic Wand settings.

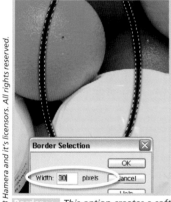

Border >> *This option creates a soft edged border, a specific number of pixels wide.*

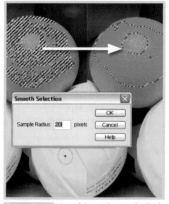

Smooth >> *Use this option to include random unselected pixels in an otherwise selected area.*

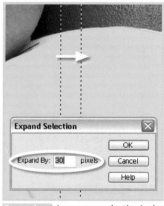

Expand >> *Increase a selection's size by a given number of pixels with this command.*

Contract >> *Reduce the size of the selection by a given number of pixels with this setting.*

Grow >> *Use this option to select all adjacent pixels that fall within the current Magic Wand settings.*

Similar >> *This command selects all other pixels in the whole image that fall within the Magic Wand settings.*

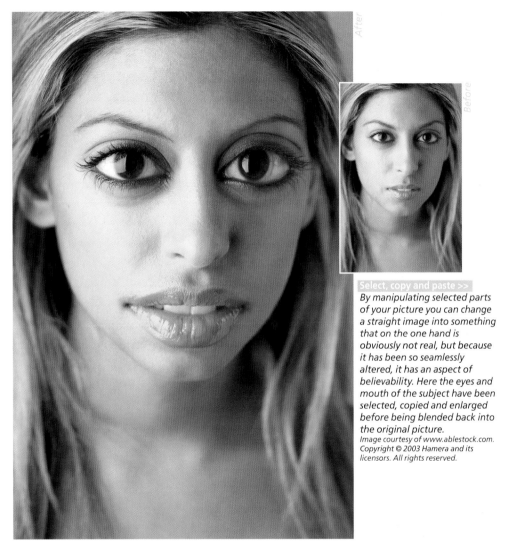

After

Before

Select, copy and paste >>
By manipulating selected parts of your picture you can change a straight image into something that on the one hand is obviously not real, but because it has been so seamlessly altered, it has an aspect of believability. Here the eyes and mouth of the subject have been selected, copied and enlarged before being blended back into the original picture.
Image courtesy of www.ablestock.com.

3.04 Transforming a selection

Suitable for Elements – 1.0, 2.0 | Difficulty level – Intermediate | Resources – Web image 3.04
Related techniques – 3.01, 3.02, 3.03, 3.05 | Tools used – Selection tools | Menus used – Image

By combining the abilities of the transformation tools that Photoshop Elements provides with several selection techniques you have the power to seamlessly change the way that your pictures look. The features grouped under the 'Transform' heading include tools that can alter the scale and rotation of your picture as well as those that can be used to skew, distort or apply perspective to the image. These changes can be made to the photograph as a whole, to the contents of a layer, to a selection or to a shape that you have drawn.

When a transformation tool is active the image area will be surrounded by a 'bounding box' containing several adjustment handles at its corners and sides. By click-dragging these handles you

will be able to manipulate the picture. Most experienced image editors use the Free Transform tool (Image>Transform>Free Transform) for all their transformation changes. With this one feature and a few different keyboard combinations you can perform all your image adjustments without selecting another feature. Use the guide below to help you use the Free Transform tool:

- *To scale* – drag on of the corner handles of the bounding box.
- *To maintain aspect ratio whilst scaling* – hold down the Shift key whilst dragging.
- *To rotate* – move the cursor outside the bounding box until it changes to a curved two-ended arrow, then click and drag to rotate the picture.
- *To distort* – hold down the Ctrl (Command – Mac) key whilst dragging any handle.
- *To skew* – hold down the Ctrl + Shift (Command + Shift – Mac) keys whilst dragging a side handle.
- *To apply a perspective change* – hold down Ctrl + Alt + Shift (Command + Option + Shift – Mac) whilst dragging a corner handle.
- *To commit changes* – double click inside the bounding box.

Transform >> *The Free Transform tool provides a fast and effective way to manipulate your pictures.*

In the example the exaggerated eyes and mouth were created by firstly selecting the face parts, feathering the edge of the selection (Select>Feather) and then copying (Edit>Copy) and pasting (Edit>Paste) each part onto a new layer. With the appropriate layer selected the parts were then enlarged using the Free Transform feature (Image>Transform>Free Transform) and distorted (Image>Transform>Distort) a little to suit the rest of the face. As a final step a soft edged eraser was used to remove sections of the face parts that didn't match the picture below. This step helped to blend changes into the original image.

Step 1 >> *Copy and paste onto new layers parts of the picture that were selected using a feather.*

Step 2 >> *Change the size of the face parts and apply some distortion using the Free Transform tool. Double click inside the bounding box to commit your changes.*

Step 3 >> *Carefully erase the edge of the transformed face parts to blend them with the rest of the original image below.*

3.05 Precise control of selection size

*Suitable for Elements – 1.0, 2.0 | Difficulty level – Intermediate
Related techniques – 3.01, 3.02, 3.03, 3.04 | Tools used – Marquee
Menus used – Window, Edit, View*

There will be times when you will need to know the precise
size of the selections you make. You can get this information
from the Info palette (Window>Info) where Elements
reports the width and height of your selection in the units
selected in the Units preferences (Edit>Preferences>Units
and Rulers). This dialog also shows the exact position of the
cursor. This can be helpful when you need to start and end a
selection at a set screen reference.

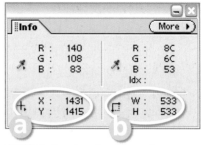

Info >> *The Info palette shows the position
of the cursor (a) as well as the size of the
selection (b).*

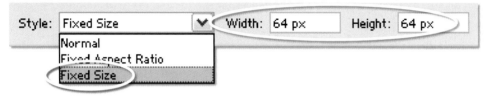

Fixed Size selections>> *Make precise selections by inserting the dimensions directly into the Marquee's option bar.*

If instead of just viewing the dimensions of the selection you actually want to specify the size you
can input these values into the Options bar of the Marquee tool. After selecting the tool, choose
Fixed Size from the Style drop-down menu in the Options bar. You can then enter the value for
width and height into the fields in the bar. Now when you click on the canvas with the Marquee
tool, a selection of the precise dimensions you input will appear on the picture. As with the Info

dialog the measurement units used
here are controlled by the settings in
the Units and Rulers preferences.

Another way to precisely control
the size of your selections is to use
the Elements Grid system as a guide.
Simply display the Grid over your
picture (View>Grid) and switch on
the Snap to Grid option (View>Snap
to Grid). Now as you are drawing a
selection the cursor will align itself
with the grid lines or intersections. The
interval of the grid lines and spacings
can be altered via the Grid preferences
(Edit>Preferences>Grid).

Grid as guide >> *Use the Elements grid option to help make precise
selection. Image courtesy of www.darranleal.com.au.*

Understanding layers

In a lot of ways traditional film based shooting is very similar to digital photography. After all, apart from a few useful additions such as a preview screen on the back and a slot for my memory card, my digital camera is not unlike my film camera (in fact they even share the same lenses). But thinking that these similarities extend to the pictures themselves can mean that you are missing out on some of the more powerful capabilities of your digital pictures.

Digital pictures are not always flat

The traditional photograph contains all the picture elements in a single plane. Digital images captured by a camera or sourced from a scanner are also flat files. And for a lot of new digital photographers this is how their files remain – flat. All editing and enhancing work is conducted on the original picture but things can be different.

Most image editing packages contain the ability to use layers with your pictures. This feature releases your images from having to keep all their information in a flat file. Different image parts, added text and certain enhancement tasks can all be kept on separate layers. The layers are kept in a stack and the image you see on screen in the work area is a composite of all the layers.

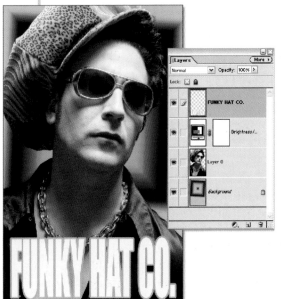

Sound confusing? Well try imagining for example that each of the image parts of a simple portrait photograph are stored on separate plastic sheets. These are your layers. The background sits at the bottom. The portrait is laid on top of the background and the text is placed on top. When viewed from above the solid part of each layer obscures the picture beneath. Whilst the picture parts are based on separate layers they can be moved, edited or enhanced independently of each other. If they are saved using a file format like Photoshop's PSD file (which is layer friendly) all the layers will be preserved and present next time the file is opened.

Types of layers

Image layers: This is the most basic and common layer type, containing any picture parts or image details. Background is a special type of image layer.

Text layers: Designed solely for text, these layers allow the user to edit and enhance the text after the layer has been made.

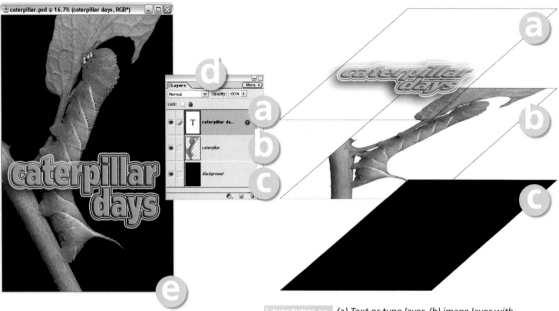

Layer types >> *(a) Text or type layer, (b) image layer with chequered transparent area, (c) background layer, (d) layer palette, (e) preview window with separate layers viewed as a composite image. Image courtesy of www.ablestock.com.*

Adjustment layers: These layers alter the layers that are arranged below them in the stack. They act as a filter through which the lower layers are viewed. You can use adjustment layers to perform many of the enhancement tasks that you would normally apply directly to an image layer without changing the image itself.

Background layers: An image can only have one background layer. It is the bottom-most layer in the stack. No other layers can be moved beneath this layer. You cannot adjust this layer's opacity or its blending mode. You can convert background layers to standard image layer's by double clicking the layer in the layers palette, setting your desired layer options in the dialog provided and then clicking OK.

Adding layers

When a picture is first downloaded from your digital camera or imported into Photoshop Elements it usually contains a single layer. It is a 'flat file'. By default the program classifies the picture as a background layer. You can add extra 'empty' layers to your picture by clicking the new layer button at the bottom of the layer's palette or choosing the Layer option from the New sub-menu in the Layer menu (Layer>New>Layer). The new layer is positioned above your currently selected layer.

Some actions, such as adding text with the type tool, automatically create a new layer for the content. This is true when adding adjustment and fill layers to your image. When selecting, copying and pasting image parts, Photoshop also creates a new layer for the copied portion of the picture.

Viewing layers

Photoshop Elements's layers palette displays all your layers and their settings in the one palette. If the palette isn't already on screen when opening the program, choose the option from the Window menu (Window>Layers).

Visible layers >> *When the eye icon is present the layer is visible. Clicking on the eye turns the icon off, removing the layer from the preview window.*

The individual layers are displayed, one on top of the other, in a 'layer stack'. The image is viewed from the top down through the layers. When looking at the picture on screen we see a preview of how the image looks when all the layers are combined. Each layer is represented by a thumbnail on the right and a name on the left. The size of the thumbnail can be changed, as can the name of the layer. By default each new layer is named sequentially (layer 1, layer 2, layer 3). This is fine when your image contains a few different picture parts, but for more complex illustrations it is helpful to rename the layers with titles that help to remind you of their content (portrait, sky, tree).

You can edit or enhance only one layer at a time. To select the layer that you want to change you need to click on the layer. At this point the layer will change to a different color from the rest in the stack. This layer is now the selected layer and can be edited in isolation from the others that make up the picture.

Layers can be turned off by clicking the eye symbol on the far right of the layer so that it is no longer showing. This action removes the layer from view but not from the stack. You can turn the layer back on again by clicking the eye space. Holding down the Alt whilst clicking on a layer's eye symbol will turn off or hide all other layers.

Layer styles >> *Layer styles can be used to quickly apply effects like drop shadows to any layer.*

Manipulating layers

Layers can be moved up and down the layer stack by click-dragging. Moving a layer upwards will mean that its picture content may obscure more of the details in the layers below. Moving downwards progressively positions the layer's details further behind the picture parts of the layers above.

You can reposition the content of any layers (except background layers) using the move tool. Two or more layers can be linked together so that when the content of one layer is moved the other details follow precisely. Simply click on the box on the right of the eye symbol in the layers to link together. The box will be filled with a chain symbol to indicate that this layer is now linked with the selected layer. Unwanted layers can be deleted by dragging them to the dustbin icon at the bottom of the layers palette.

Layer styles

In early image editing programs creating a drop shadow edge to a picture was a process that involved many steps. Thankfully Elements includes this as one of

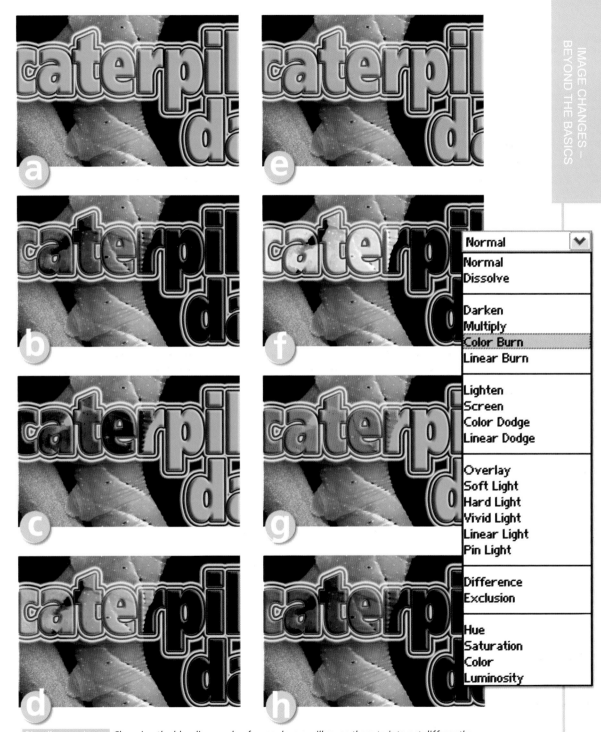

Blending modes >> *Changing the blending mode of upper layers will cause them to interact differently with the layers beneath. The example above shows how altering the blending mode of the text layer changes the way that it interacts with the image and background layers. (a) Normal mode. (b) Color Burn mode. (c) Difference mode. (d) Overlay mode. (e) Luminosity mode. (f) Color Dodge mode. (g) Exclusion mode. (h) Hue mode.*

the many built-in styles that can be quickly and easily applied to your layers. Users can add effects by clicking on the Layer Styles palette tab in the palettes dock and selecting a style from those listed. You can edit the style settings by double clicking on the small 'f' in the layers palette.

Blending modes and opacity

As well as layer styles, or effects, the opacity (how transparent a layer is) of each layer can be altered by dragging the opacity slider down from 100% to the desired level of translucency. The lower the number the more detail from the layers below will show through. The opacity slider is located at the top of the layers palette and changes the selected layer only.

On the left of the opacity control is a drop-down menu containing a range of blending modes. The default selection is 'normal' which means that the detail in upper layers obscures the layers beneath. Switching to a different blending mode will alter the way in which the layers interact.

Layer shortcuts

• *To display layers palette* – Choose Windows>Layers
• *To access layers options* – Click More button in the upper right–hand corner of the layers palette
• *To change the size of layer thumbnails* – Choose Palette options from the Layers Palette menu and select a thumbnail size
• *To make a new layer* – Choose Layer>New>Layer
• *To create a new adjustment layer* – Choose Layer>New Adjustment Layer and then select the layer type
• *To add a style or effect to a layer* – Select the layer and choose a style from those listed in the Layer Styles palette.

Masking techniques

Masking in traditional photography is used to physically protect part of the picture from development or exposure. In black and white darkrooms this process often involved the positioning of specially cut 'ruby' red sheets over the photographic paper which shielded this part of the picture from being exposed during the enlargement process.

The digital version of masking is also designed to restrict effects to only certain portions of an image. Photoshop Elements provides a variety of ways to employ a masking system when editing your pictures.

3.06 Painting masks with the Selection Brush

Suitable for Elements – 2.0, 3.0 | Difficulty level – Intermediate | Resources – Web image 3.06
Related techniques – 3.07, 3.08, 3.09| Tools used – Selection Brush

The Selection Brush was a welcome addition to the Photoshop Elements tools line up when it was added in revision 2.0 of the program, and although its primary purpose is to aid the creation of complex selections, it can also be used in a 'ruby lith' mask mode. Activate the mode by selecting the Mask option from the mode drop-down menu in the tools option bar. Now when the brush is dragged across the surface of a picture it will leave a red, semi-transparent mask behind it. The mask will protect these parts of the picture from the effects of filters, color changes and tonal correction.

The size and edge softness of the Selection Brush as well as the mask opacity (overlay opacity) and mask color can be altered in the options bar. Switching back to the Selection mode will turn off the mask and will make a selection from the parts of the picture that weren't painted. Whilst in Mask mode painting with the brush will add to the mask. Applying the brush in the Selection mode will add to the selection which effectively is removing masked areas.

You can also save carefully painted masks using the Save Selection option in the Select menu and pre-saved selections can be converted into a mask by loading the selection and then switching back to Mask mode.

Step 1 >> Choose the Selection Brush from the tool box and switch the brush to Mask mode.

Step 2 >> Paint on the parts of the picture that you want to shield from the editing process.

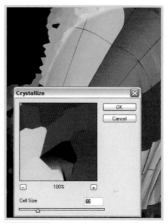

Step 3 >> Apply the editing changes to the non-masked areas. Here we applied the Crystallize filter.

3.07 Fill and adjustment layer masks

Suitable for Elements – 1.0, 2.0 | Difficulty level – Intermediate | Resources – Web image 3.06
Related techniques – 3.06, 3.08, 3.09 | Menus used – Layer

Another form of masking is available to Elements users via the fill and adjustment layers features. Each time you add one of these layers to an image two thumbnails are created in the layers palette.

The one on the left controls the settings for the adjustment layer. Double clicking this thumbnail brings up the dialog box and the settings used for the fill or adjustment layer. The thumbnail on the right represents the layer's mask.

The mask is a grayscale image. In its default state it is colored white, meaning that no part of the layer's effects are being masked or held back from the picture below. Conversely if the thumbnail is totally black then none of the layer's effects are applied to the picture. In this monochrome world shades of gray equate to various levels of transparency. With this in mind we can control which parts of the picture are altered by the fill or adjustment layer and which parts remain unchanged by painting (in black and white and gray) and erasing directly on the layer mask.

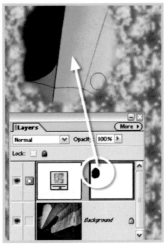 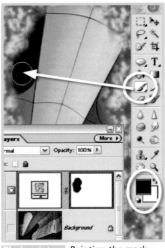 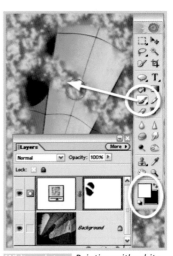

Eraser >> *Erasing parts of the fill layer reveals the picture beneath.*

Black paint >> *Painting the mask with black paint has the same effect as erasing.*

White paint >> *Painting with white paint restores the mask and the pattern.*

To start editing a layer mask, firstly apply a fill layer such as Pattern to the image. Check to see that the default colors (white and black) are selected for the Elements foreground and background colors. Next select the eraser tool, and with the fill layer selected in the layer palette, proceed to remove part of the layer. The pattern is removed and the picture beneath shows through and a black mark now appears in the layer thumbnail corresponding to your erasing actions.

Switch to the paint brush tool and select black as your foreground color and paint onto the patterned surface. Again this action masks the picture beneath from the effects of the fill layer and adds more black areas to the thumbnail. Painting with white as your foreground color restores the mask and paints back the pattern.

You can experiment with transparent effects by painting on the mask with gray. The lighter the gray the more the pattern will dominate, the darker the gray the less the pattern will be seen. A similar semi-transparent effect can be achieved if the opacity of the eraser or brush is reduced.

3.08 Using selections with layer masks

*Suitable for Elements – 1.0, 2.0 | Difficulty level – Intermediate | Resources –
Web image 3.06 | Related techniques – 3.07, 3.08, 3.09 | Tools used – Select*

In addition to employing painting and erasing tools to work
directly on the layer mask you can also use a selection in
conjunction with an adjustment or fill layer to restrict the area of
your image that is altered.

Make a selection in the normal way and then, with the selection
still active, create a new adjustment or fill layer. The selection
confines the changes made by the new adjustment/fill layer.

You will notice the selected area is colored white in the layer mask
thumbnail. A layer mask made in this way can be edited using the
same painting techniques as discussed above.

Selection >> *By having a selection
active when you make a new
adjustment or fill layer you immediately
restrict the effects of this layer to just
the confines of the selection.*

3.09 'Group with Previous' masks

*Suitable for Elements – 1.0, 2.0 | Difficulty level – Intermediate | Resources – Web image 3.06
Related techniques – 3.06, 3.07, 3.08 | Menus used – Layer*

The final masking technique that Photoshop Elements employs uses the special Group with Previous
command found in the layer menu. This command uses the transparency surrounding objects
on a layer as a mask for the content of any layers that are above it in the stack. In the example the
balloon image was placed above the test text layer. With the ballon layer active the Group with
Previous command (Layer>Group with Previous) was selected. The balloon now fills the text shape
but is masked from showing through the rest of the layer by the transparency surrounding the type.

This technique also
works with shapes
and filled selections
drawn on a separate
layer surrounded by
transparency.

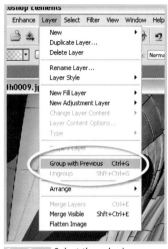

Step 1 >> *Create some bold text in a new document with a white background layer.*

Step 2 >> *Copy and paste a color image in a layer above the text.*

Step 3 >> *Select the color image layer and choose the Group with Previous command from the layers menu.*

Converting color to black and white

One of the real advantages of shooting digital is the ease with which you can convert color images to black and white. Gone are the days of having to carry two camera bodies, one loaded with color film the other black and white. Now you simply shoot color all the time and then convert selected images to black and white using a few simple steps.

3.10 Changing the mode to grayscale

Suitable for Elements – 1.0, 2.0 | Difficulty level – Basic | Resources – Web image 3.10 | Related techniques – 3.11 | Menus used – Image, Enhance

Increase contrast >> *By moving the black and white input sliders towards the center of the dialog you can increase the contrast of your picture.*

The simplest way to lose the colors in your picture is to convert the image to a grayscale. This process changes the photograph from having three color channels (red, green and blue) to being constructed of a single channel that contains the picture's detail only. Often this conversion produces a flat and lacklustre photograph and so a little manipulation of the tones is in order. My first point of call to help solve this problem would always be the Levels dialog (Enhance>Adjust Brightness and Contrast>Levels). Using this control you can make sure that your image tones are spread across the grayscale spectrum.

Most grayscale conversion pictures need a general contrast increase. You can achieve this by moving the black and white input sliders towards the center of the dialog. Holding the Alt key (Windows) or Option key (Macintosh) down whilst you are moving the slider will enable you to preview the pixels that are being converted to pure black or pure white. Your aim is to map the

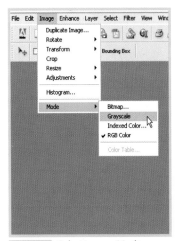

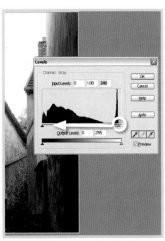

Step 1 >> *Select Image>Mode> Grayscale and then click on the OK button in the Discard Color warning box.*

Step 2 >> *Using the Levels control map the dark pixels to black by dragging the black point slider to the right.*

Step 3 >> *Correct the highlights by dragging the white point slider to the left.*

darkest pixels in the picture to black and the lightest ones to white. Work carefully here as a heavy handed approach will produce pictures where delicate shadow and highlight details are lost forever.

3.11 Desaturate the color file

Suitable for Elements – 1.0, 2.0 | Difficulty level – Basic | Resources – Web image 3.10 | Related techniques – 3.10 | Tools used – Dodge and Burn-in Menus used – Image

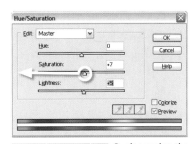

Saturation control >> *By decreasing the saturation of the colors in a picture completely you convert the image to just black and white.*

Photoshop Elements uses the term saturation to refer to the strength of the colors in a picture. Increasing saturation makes the colors in a picture more vivid, decreasing saturation makes the hues weaker. The program employs the Hue/Saturation (Enhance>Adjust Color>Hue Saturation) control to adjust the color's strength. If the saturation slider is moved all the way to the left of the dialog (to a setting of –100) then all color is removed from the picture. You are effectively left with a grayscale or black and white photograph that is very similar to the 'convert to grayscale' version above but with one important difference – the picture is still an RGB file.

This means that even though the photograph no longer contains any color, the file format it is stored in is capable of supporting color. So if you are wanting to try a little digital hand coloring, or experiment with pictures that contain monochrome as well as color components, then this is the technique for you. More details on these techniques can be found later in this chapter. Be warned though, once your picture is desaturated the color is lost for ever and so it is always a good idea to save a copy of the color version of the image before proceeding.

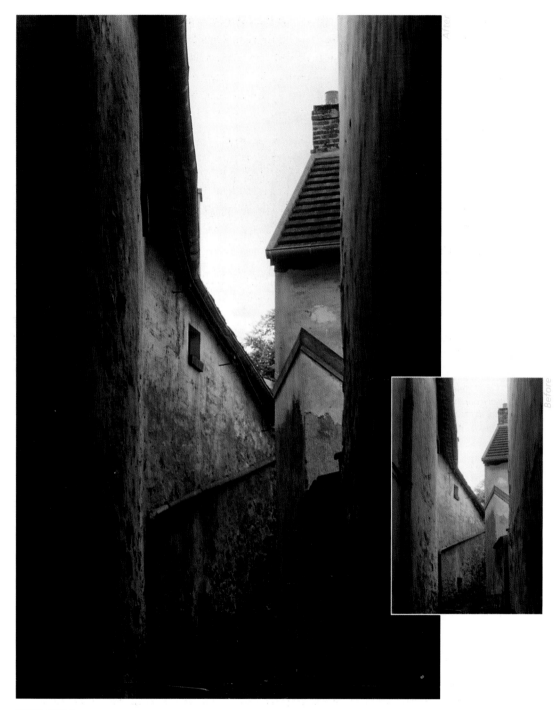

Grayscale >> *You can convert your color digital photographs to grayscale using two different methods in Adobe Photoshop Elements. The simplest is to change color modes from RGB to Grayscale. The alternative is to Desaturate the photograph. This process has the added advantage of leaving the black and white picture in RGB mode so that color can be added to the monochrome later. Images created with either process do benefit from some adjustment of tones after conversion.*

Once the picture has been desaturated you may need to tweak the shadow, highlight and mid tones using the levels feature. Finally add some drama to the picture by selectively lightening and darkening parts of the image using the dodging and burning-in tools. Used judiciously these devices can change the whole atmosphere of a photograph. In the example, I darkened the walls closest to the viewer and lightened those parts of the French alleyway that were in the background. These changes increased the sense of distance in the picture as well as helping to draw the viewer's eyes into the picture.

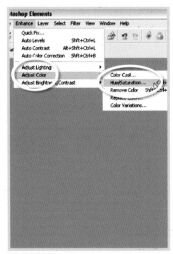

Step 1 >> *Select the Hue/Saturation control from the Adjust Color heading in the Enhance menu.*

Step 2 >> *Move the saturation slider completely to the left, removing all color from the picture.*

Step 3 >> *Use the dodging and burning-in tools to lighten and darken selected areas of the picture.*

Advanced dodging and burning-in

After years of my 'hit and miss' approach to dodging and burning in the darkroom I can still remember my reaction to seeing Photoshop performing real-time lightening and darkening – 'You are kidding!'. Not only could I paint in light and dark areas on my picture using a soft edged brush, I could also vary the strength of the effect and the size of the brush used for application. In addition, I could choose to alter shadow, mid tones or highlights separately and 'undo' my actions with a single keystroke. All this flexibility and with the lights on as well!

I would think that most new users to Photoshop Elements would experience much of the same excitement as I did, when they first discover the Dodge and Burn-in tools. For the majority of simple enhancement tasks a few quick strokes of these tools will provide plenty of control over your picture's tones, but there are occasions when you need a little more flexibility. I use the following techniques to provide a little more customization to my dodging and burning in my work.

3.12 Using selections to change tone

Suitable for Elements – 1.0, 2.0 | Difficulty level – Intermediate | Resources – Practice 3.12
RelatedtTechniques – 3.10, 3.11 | Tools used – Selection tools| Menus used – Select

You can evenly alter the tone of a large area of your picture quickly by making a feathered selection of the area first and then using the Levels control to darken or lighten the pixels. The amount you feather the selection will determine how soft the transition will be between dodged or burnt areas and the original picture. Using the Levels feature gives you great control over the brightness of shadow, mid tone and highlight areas.

By manipulating the input and output sliders you can selectively alter specific tones in your image. You can also decrease or increase the contrast of the selection as well.

Use the table below to help get you started.

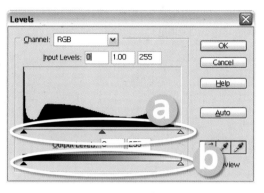

Input and output sliders >> *(a) Black, mid tone and white input sliders. (b) Black and white output sliders.*

Required image change	Action to take
To lighten the mid tones of a selected area	Move the midpoint input triangle to the left
To darken the mid tones of a selected area	Move the midpoint input triangle to the right
To lighten the mid tones and highlights	Move the white point input triangle to the left
To darken the mid tones and shadows	Move the black point input triangle to the right
To lighten the shadow tones	Move the black point output triangle to the right
To darken the highlight tones	Move the white point output triangle to the left
To decrease contrast	Move the white and black point output sliders closer together
To increase contrast	Move the white and black point input sliders closer together

Step 1 >> *Using one of the selection tools draw a rough selection around the area to dodge or burn-in.*

Step 2 >> *Inverse and feather the selection. Use a large pixel amount for high resolution pictures.*

Step 3 >> *With the selection still active manipulate the levels input and output sliders to darken/lighten tones.*

Pro's Tip: Non–destructive dodging and burning-in

If you want to dodge and burn but not make any permanent changes to the picture you can use the same feathered selection technique, but apply the changes through an adjustment layer. Make the selection as before, inversing (Select>Inverse) and feathering (Select>Feather) the edge. With the selection still active, click onto the Create New Adjustment layer button on the bottom of the layers palette and choose Levels. If the layers palette is not visible then you can perform the same action via the Layer menu (Layer>New Adjustment Layer). The Levels dialog appears and any changes made with the sliders alters the tones in the selected area of the picture just as before.

The difference with this approach is that the dodging and burning-in takes place via an adjustment layer, leaving the original picture unchanged in the layer beneath. The selection is used as a basis to form a mask in the adjustment layer. We view the levels changes through the clear areas of this mask only.

A second advantage to this approach is that the levels settings can be changed at a later date. Simply double click the thumbnail on the left–hand side of the layer and alter the levels settings.

Step 1 >> *With your feathered selection active click the New Adjustment Layer button.*

Step 2 >> *Select the Levels adjustment layer and adjust the dialog's settings to dodge and burn-in.*

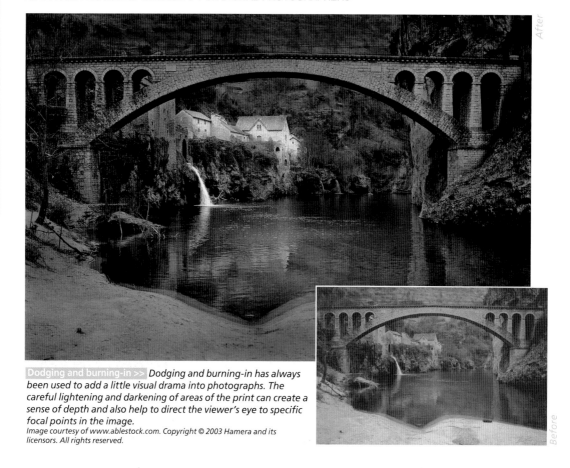

After

Before

Dodging and burning-in >> *Dodging and burning-in has always been used to add a little visual drama into photographs. The careful lightening and darkening of areas of the print can create a sense of depth and also help to direct the viewer's eye to specific focal points in the image.*
Image courtesy of www.ablestock.com. Copyright © 2003 Hamera and its licensors. All rights reserved.

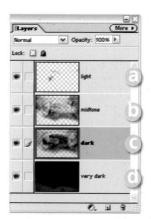

Dodge and burn via erase >>
Make creative tonal changes using the Eraser tool and several adjusted layer copies.
(a) Light copy.
(b) Mid tone/normal copy.
(c) Dark copy.
(d) Very dark copy.

3.13 Erase back through tonal layers

Suitable for Elements – 1.0, 2.0 | Difficulty level – Intermediate | Resources – Web image 3.12 | Tools used – Eraser| Menus used – Enhance, Layer

A more artistic approach to dodging and burning-in can be found in a technique that involves making several different copies of the base picture. The background layer can be copied by either choosing Layer>Duplicate Layer or by dragging the layer to the create new layer button at the bottom of the layer's palette.

Each copy is stored on a separate layer and the overall tone of the duplicate image is changed using the layers control. In the example, I have created four layers, labelled them *light, mid tone, dark* and *very dark* and changed their tones accordingly. Next I selected the Eraser tool, set the mode to brush, the edge option to soft and the opacity to 20%. I then clicked on the eye icon in both the light and mid tone layers and selected the dark layer. Using the Eraser in overlapping strokes, I gradually removed sections of the dark layer to reveal the very dark layer beneath. I then selected the mid

tone layer and performed the same action and finally I selected the light layer and erased sections to reveal the darker layers below. If this all sounds a little confusing, try thinking of the erasing action as actually painting the image darker, or burning the picture area in and take my advice, make sure that you name your layers as you create them.

This technique works particularly well if used with a graphics tablet as the opacity of the erasing stroke can be linked to the pressure on the stylus. Pressing harder with the stylus erases more of the layer and creates a greater change. Lighter strokes can be used to produce more subtle adjustments.

Step 1 >> *Make several copies of the basic image layer by dragging the layer to the create new layer button.*

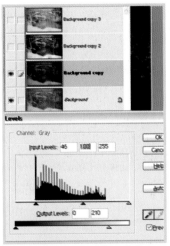

Step 2 >> *Select each layer in turn and alter the overall brightness using the Levels dialog.*

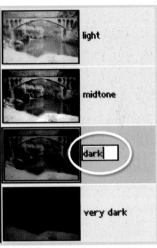

Step 3 >> *Rename the layers by double clicking the names in the layer's palette.*

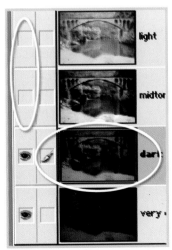

Step 4 >> *Turn off the eye icon for the light and mid tone layers and select the dark layer.*

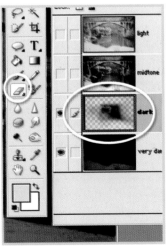

Step 5 >> *Using the Eraser tool remove parts of the dark layer to reveal the very dark picture below.*

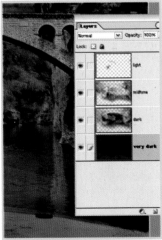

Step 6 >> *Work your way through the other layers gradually removing unwanted areas to build up the picture.*

Enhance your poorly exposed pictures

Good exposure is the cornerstone of great images. No matter how good your subject is, how well you have composed the image or how brilliantly you captured the scene, if your exposure is a little astray then you will be left with a less than perfect result. This is just as true for digital images as it was for traditional photographs. Overexposure leads to delicate highlight detail being recorded as pure white, underexposure on the other hand produces a picture with little detail in the shadow areas.

The best way to solve these problems is to re-shoot your picture using an aperture and shutter combination that will produce a well-exposed image, but as we all know some times a 're-shoot' is just not possible. So how can Photoshop Elements help us enhance our poorly exposed pictures? I have found the following techniques particularly helpful when trying to enhance, or should that be disguise, images that are suffering from bad exposure.

3.14 Screening image layers to enhance tones

*Suitable for Elements – 1.0, 2.0 | Difficulty level – Intermediate | Resources – Web image 3.14
Menus used – Layer, Enhance*

The shadow and mid tones of a picture are areas that suffer greatly when a photograph is underexposed. Valuable details are lost, the individual tones are too dark and the whole area is lacking in contrast. One way to help rectify this problem is to make an exact copy of the pictures and then combine the two images together in order to multiply the apparent detail and tone in the shadow areas. Photoshop Elements via layers and blending modes provides us with the tools necessary to perform these actions.

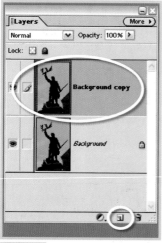

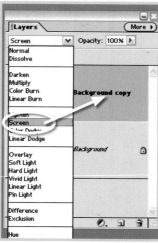

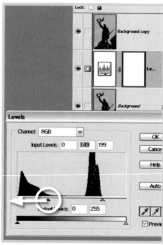

Step 1 >> *Copy the background layer by dragging it to the New Layer button in the Layers dialog.*

Step 2 >> *Select the copied layer and then change the blending mode to Screen.*

Step 3 >> *As a final touch insert a Levels Adjustment layer between the two layers. Peg the black and white points and lighten the mid tones by dragging the midpoint to the left.*

Firstly duplicate the background (image layer) by dragging it to the New Layer button at the bottom of the Layers dialog. Now with the copy layer selected change the layer blending mode to Screen. You should see an immediate brightening of the picture and the appearance of more detail in the shadow areas.

As a final tweaking of the image insert a Levels Adjustment layer between the two layers. Do this by clicking on the bottom layer first and then selecting Levels from the drop-down list found when clicking the Create New Adjustment layer button at the bottom of the layers palette. Peg the highlights and shadows of the picture by moving the black and white points towards the center until they meet the first pixels in the histogram. Next move the mid tone to the left to increase the overall brightness of the image.

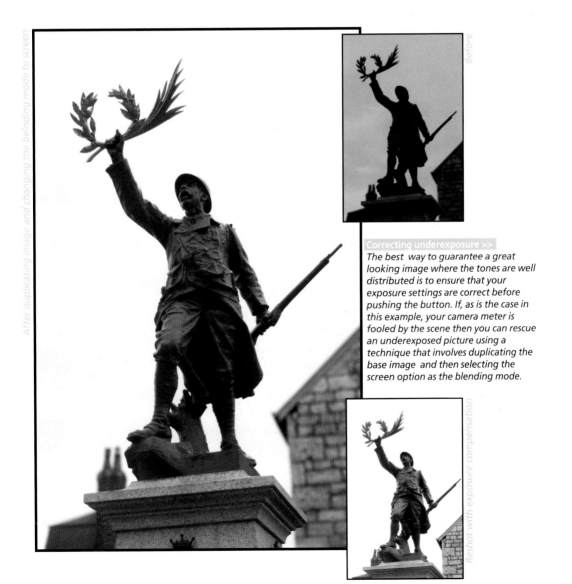

After duplicating image and changing the belnding mode to screen

Before

Correcting underexposure >>

The best way to guarantee a great looking image where the tones are well distributed is to ensure that your exposure settings are correct before pushing the button. If, as is the case in this example, your camera meter is fooled by the scene then you can rescue an underexposed picture using a technique that involves duplicating the base image and then selecting the screen option as the blending mode.

Reshot with exposure compensation

Those of you who are intimate with Elements will no doubt be asking 'Why not just use the Fill Flash feature to fix this underexposure problem?' and you are right to ask that question. The Fill Flash option is a great tool for lightening mid to dark tones that have plenty of details, but I have found that this 'duplication layers' technique provides a more pleasing result for underexposed images with little shadow information.

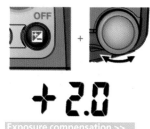

Solving exposure problems when shooting

The statue picture not only provides a great example for this technique but also demonstrates how such underexposure can occur. Set against a white overcast sky this dark statue was underexposed because the camera's meter was fooled by the bright sky behind the subject and therefore provided a shutter/aperture combination which was too dark. The thinking photographer would have predicted this problem and used the Exposure Compensation system on the camera to increase exposure

Exposure compensation >>
Use the camera's exposure compensation system to override your camera's settings.

by one to one and one-half stops to adjust for the back lighting. Most mid range digital cameras and above incorporate an exposure override system like this.

To try this for yourself the next time you encounter a back lit scene shoot two pictures, one with the camera set to auto and the other where you have added to the exposure. Compare the results later on the desktop, or better still, check your exposure in the field by examining the histogram graph of your image on you camera's monitor.

This graph works exactly the same way as the graph in the levels feature in Photoshop Elements. It displays the spread of tones of your image across a grayscale from black to white. Underexposure will result in a graph that bunches towards the black end of the spectrum whereas overexposure moves the pixels towards the white point. A simple check of this graph when shooting can indicate whether you need adjust you camera and re-shoot to compensate for an exposure problem.

Step 1 >> *With the image at 100% magnification apply the Add Noise filter with Uniform/Monochrome settings.*

Step 2 >> *Select burn-in tool, reduce exposure to 10% and choose mid tone range. Set brush size and edge softness.*

Step 3 >> *Burn-in the white area using several overlapping strokes to build up the effect. Change to Shadow range and repeat if necessary.*

Texture burn-in >> *(a) Original image with blown highlights. (b) Highlights burnt in using burn-in tool. (c) Highlights burnt in after adding a little texture.*

3.15 Adding detail to highlights and shadows

*Suitable for Elements – 1.0, 2.0 | Difficulty level – Intermediate
Tools used – Dodging and Burning-in tools| Menus used – Filter*

Sometimes, despite the utmost care on behalf of the photographer, digital images are captured with little or no shadow or highlight details. This scenario should ring true for any reader who has had the pleasure of photographing in very sunny countries. Along with the warmth, strong sun can provide a problem with contrast for the photographer. The deepest shadows and the brightest highlights are so far apart that even the best digital cameras have difficulty in recording all the tones. The result is a picture where either shadow or highlight detail (or in some extreme cases both) is not recorded. These parts of the picture are converted to pure black and white pixels in a process referred to as 'clipping'.

The same scenario can occur when using a scanner to convert slide or film originals into digital files. Incorrect scanner settings coupled with slides that are very dark or negatives that have been overdeveloped are the circumstances that most often produce 'clipped' files.

When presented with such pictures the experienced Elements user will attempt to restore detail in the highlight and shadow areas using the program's dodging and burning-in tools. But often such action only results in murky gray highlights and washed out shadow areas. The problem is that the program has no detail in these parts to actually lighten or darken. A solution to this scenario is to add a little (very little) texture to the image and then dodge and burn-in. The texture breaks up the pure white and pure black areas by filling these picture parts with random multi-tone (black, gray and white) pixels. This gives the tools some detail, albeit artificially created, to work on.

I use the Add Noise filter (Filter>Noise>Add Noise) to provide the texture and then select the dodging tool set to mid tones to work on the dark tones or you could use the burning-in tool also set to mid tones to work on the highlights. A low exposure value of around 10% is coupled with repeated strokes over the offending area. To restrict the the noise to just the highlight areas you could select these first using the magic wand and then apply the noise filter.

This technique does have its down side. It doesn't recreate lost details and you will need to degrade your image by making it more noisy before you can dodge and burn. So it can't be considered a magic 'cure all' for problem pictures but it can help you get a little detail into that annoyingly white highlight or that equally frustrating blocked shadow area.

Tinted monochromes

One of the most enduring techniques utilized by photographers the world over is the practice of toning or changing the color of their black and white prints. The Sepia tone (brown) look has come to be linked with quality image production partly because it was a process that increased the longevity of black and white pictures and partly because only committed photographers would take their work through this extra processing step. Digital photographers have the tools at hand to not only 'tone' their black and white images but also to apply this same technique to their color ones.

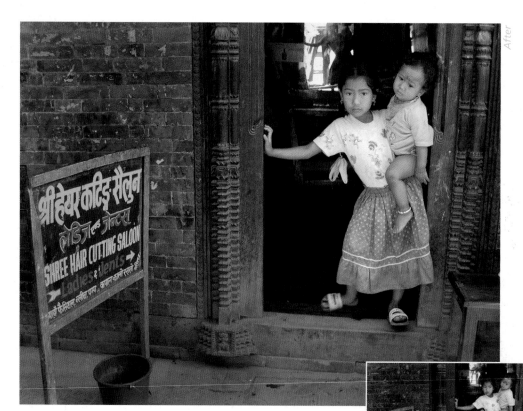

Toning >> *Use the Hue/Saturation control (Enhance>Adjust Color>Hue/ Saturation) to quickly and effectively add a tint to your color images.*

3.16 Using Hue and saturation to tone your pictures

Suitable for Elements – 1.0, 2.0 | Difficulty level – Intermediate | Resources – Web image 3.16
Related techniques – None | Menus used – Enhance

The simplest and fastest way to add color is to use the Hue/Saturation control (Enhance>Adjust>Color>Hue/Saturation). This can be applied directly to the whole image or as an Adjustment Layer (Layer>New Adjustment Layer>Hue Saturation). To change the feature into a toning tool click the

Colorize option in the bottom right of the box. The picture will switch to a single color monochrome (one color plus white and black). The hue slider now controls the color of your tone. The sepia look in the example is a value of 30 on the Hue slider. The Saturation slider varies the strength of the color. The saturation value used in the example was 25. The Lightness slider adjusts the brightness of the image but changes of this nature should be left for the Levels feature.

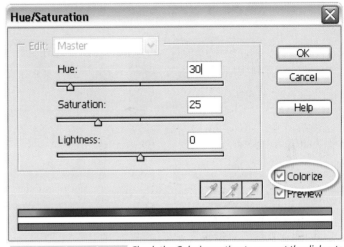

Hue/Saturation toning >> *Check the Colorize option to convert the dialog to toning mode.*

The predictability of this digital toning system means that you can achieve the same tint in each image for a whole series of pictures. The recipes for regularly used tones, or favorite colors, can easily be noted down for later use. You can even create a toning palette like the example on the next page, which provides a range of tint options as well as hue strengths.

Step 1 >> *Select the Hue/Saturation control from the Enhance menu. For grayscale images change the mode to RGB color first (Image>Mode>RGB Color).*

Step 2 >> *Place a tick in the Colorize and Preview check boxes.*

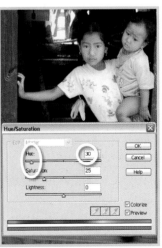

Step 3 >> *Adjust the Hue slider to change tint color and the Saturation slider to change tint strength.*

Toner recipes>>

Use the recipes for the tints below to help guide you when toning using the Hue/Saturation control. Simply plug in the following numbers for the Hue, Saturation and Lightness sliders.

(a) 0, 75, 0
(b) 0, 50, 0
(c) 0, 25, 0

(d) 30, 75, 0
(e) 30, 50, 0
(f) 30, 25, 0

(g) 80, 75, 0
(h) 80, 50, 0
(i) 80, 25, 0

(j) 190, 75, 0
(k) 190, 50, 0
(l) 190, 25, 0

(m) 250, 75, 0
(n) 250, 50, 0
(o) 0, 25, 0

Split toning

Once you have mastered the art of toning your pictures it is time to spread your 'tinting' wings a lit-tle. One of my favorite after printing effects back in my darkroom days was split toning. This process involved passing a completed black and white print through two differently colored and separate toning baths. This resulted in the print containing a mixture of two different tints.

For example, when an image is split toned with sepia first and then blue toner the resultant picture has warm (brown) highlights and mid tones and cool (blue) shadows. Getting the right toning balance between the two solutions was difficult and then trying to repeat the process uniformly over a series of images was even harder. Thankfully I can replicate the results of split toning in my digital picture with a lot less trouble and a lot more predictability.

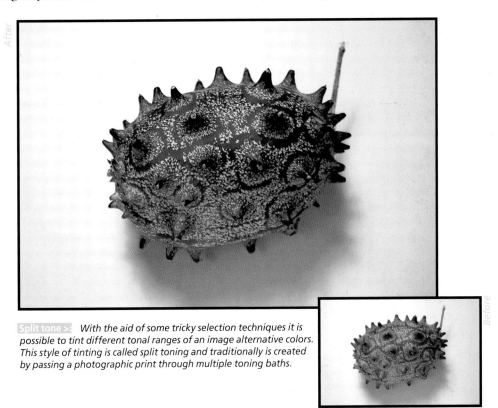

Split tone >> *With the aid of some tricky selection techniques it is possible to tint different tonal ranges of an image alternative colors. This style of tinting is called split toning and traditionally is created by passing a photographic print through multiple toning baths.*

3.17 Select and tone

Suitable for Elements – 1.0, 2.0 | Difficulty level – Intermediate| Resources – Web image 3.17
Related techniques – 3.16 | Tools used – Magic Wand | Menus used – Select, Enhance

In order to tint a select range of tones such as mid tones and shadows I must first select these areas of the image. The Magic Wand tool makes selections based on color and tone and so is perfectly placed for this type of selection. Normally we would use this tool with the 'Contiguous' option turned on so

Magic Wand settings >> *When using the Magic Wand to select a range of tones in an image be sure to turn off the 'Contiguous' setting, increase the 'Tolerance' value and then select your reference pixel.*

that the selection comprises pixels that sit next to each other. But for this task turn this option off. The 'Tolerance' value for the tool can range from 0 to 255. This setting determines how close to the selected pixel's tone the other pixels need to be before they too are included in the selection. The 0 setting is used to select other pixels in the image with exactly the same color and tone, whereas a setting of 20 will select other pixels that vary by as much as 20 tonal/color steps from the original.

With this in mind we can easily employ this tool to select just the shadow and mid tones of an image by setting the tolerance to a value of about 120 and then selecting the darkest part of the image (which we will assume has a value of 0 and therefore is black). The Magic Wand will then search the picture for pixels with a tonal value between 0 and 120. The resultant selection will include both shadows and mid tones. It is then a simple matter of using the Hue/Saturation control to Colorize these tones. To tint the rest of the pixels in the picture in an alternative color you must first invert the selection (Select>Inverse) and then repeat the Hue/Saturation toning procedure.

Pro's Tip: To soften the transition at the split of the two colors apply a feather of 1 or 2 pixels (Select>Feather) after your initial selection.

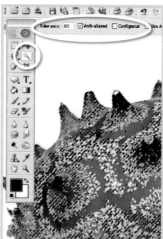

Step 1 >> *Select the Magic Wand tool, adjust the Tolerance value and deselect the Contiguous option.*

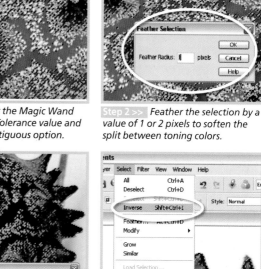

Step 2 >> *Feather the selection by a value of 1 or 2 pixels to soften the split between toning colors.*

Step 3 >> *Tone the selected areas using the Hue/Saturation control.*

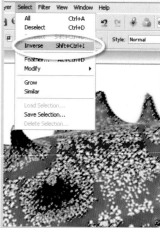

Step 4 >> *Inverse the selection and tone the remaining pixels using an alternative color.*

3.18 Two-layer erase

Suitable for Elements – 1.0, 2.0 | Difficulty level – Intermediate | Resources – Web image 3.18
Tools used – Eraser | Menus used – Layer, Enhance

You can extend the split toning idea beyond its darkroom origins by using this technique to create an image where one part of the picture is toned one color whilst the rest is colored in an alternative hue. To achieve this effect duplicate the image layer and then select and tone each layer in turn. Then use the eraser to remove parts of the upper layer to reveal the color of the layer beneath.

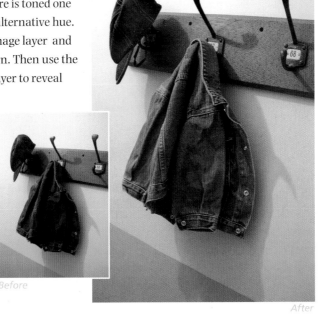

Erasing toned layers>> *By duplicating the image layer and then toning the two layers it is possible to erase through the upper layer to reveal the alternate colored layer below.*

Before

After

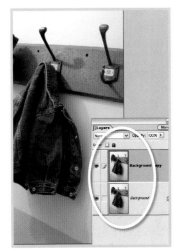

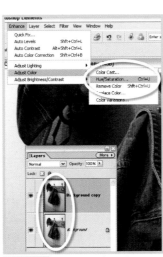

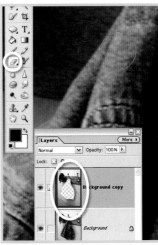

Step 1 >> *Duplicate the base image layer by dragging it to the New Layer button at the bottom of the Layers dialog.*

Step 2 >> *Select each layer in turn and tone using the Hue/Saturation control set to Colorize.*

Step 3 >> *Select the uppermost layer and then choose the Eraser tool. Use the tool to remove the parts of the picture which you want colored the alternate color.*

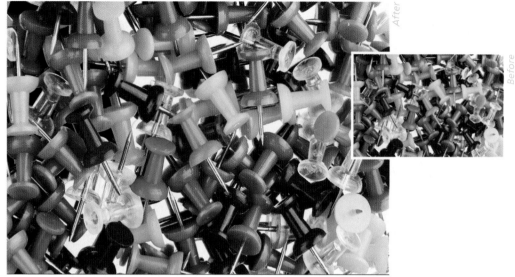

After

Before

Color and black and white together >> *By combining your selection skills, Elements' masking options and the features of the Gradient Map adjustment layers you can create an image where black and white and color happily coexist. Image courtesy of www.ablestock.com. Copyright © 2003 Hamera and its licensors. All rights reserved.*

Black and white and color

The same 'two-layer erase back' technique can be used for creating photographs which contain both color and black and white elements, but I prefer to use a different method based around Elements' masking options.

3.19 Layer mask and gradient map

Suitable for Elements – 1.0, 2.0 | Difficulty level – Intermediate | Resources – Web image 3.19
Tools used – Selection tools | Menus used – Select, Layer

With the color image open make a selection of the objects that will not be converted to black and white. In the example I used a combination of the Magnetic Lasso and the standard Lasso tools to select the three map pins, but you could also use the Selection Brush to achieve the same results. Next feather the selection (Select>Feather) slightly with a setting of 1 pixel to soften the edge of the effect. Invert the selection (Select>Inverse) so that the background, everything other than the map pins, is now selected. Then with the selection still active create a new Gradient Map adjustment layer (Layer>New Adjustment Layer>Gradient Map). When the Gradient Map dialog appears select the map with a smooth transition from black to white and click OK. Elements uses your selection to mask out the adjustment layer effects and restrict them from being applied to the originally selected map pins. You can create a multitude of other effects using the same process but different gradient maps or adjustment layers.

Pro's Tip: Make sure that you save your selections (Select>Save Selection) as you make them. This way you can always reload them later if you need to.

Step 1 >> *Make a selection of the parts of the image that you want to remain in color.*

Step 2 >> *Feather the selection by 1 pixel and then Inverse the selection.*

Step 3 >> *With the selection still active create a new Gradient Map adjustment layer.*

More effects >> *You can create other effects using the same masking technique with the Threshold (a), Posterize (b) and Invert (c) Adjustment Layers options.*

Border techniques

Creating a great border is one of those finishing touches that can really make your images stand apart from the crowd. Using Photoshop Elements you can easily create and apply a variety of different border styles to your photographs.

3.20 Simple borders

Suitable for Elements – 1.0, 2.0 | Difficulty level – Intermediate | Resources – Web image 3.20
Tools used – Marquee | Menus used – Select, Window, Edit

A basic line border can be created by selecting the whole image (Select>Select All) and then stroking (Edit>Stroke) the selection on the inside with the foreground color. See frame (a). For fancier styles Elements provides a range of Frame and Edge treatments in its Effects palette (Window>Effects), Some frames require you to make a selection first; others can be applied directly to the picture with no preliminary actions. See frames (b) and (c).

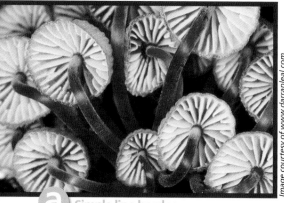

Image courtesy of www.darranleal.com.

a Simple line border

Step 1 >> Use the Eye dropper tool to select a suitable border color from the image. Ensure that this color is the Foreground color.

Step 2 >> Select all the picture (Select>Select All).

Step 3 >> Stroke the selection (Edit>Stroke) on the inside with the foreground color and a width of 10 pixels.

b Brushed aluminium frame effect

Step 1 >> Using the rectangular Marquee tool make a selection 2 cm inside the picture.

Step 2 >> Display the Effects palette (Window>Effects) and select the Brushed Aluminium Frame option from the list.

Step 1 >> Choose the Drop Shadow Frame option from the list in the Effects palette.

c Dropped shadow frame effect

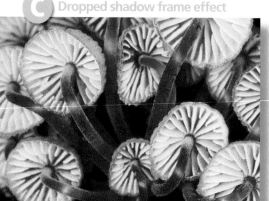

3.21 Sophisticated edges using grayscale masks

Suitable for Elements – 1.0, 2.0 | Difficulty level – Intermediate | Resources – Web image 3.20
Related techniques – 3.20 | Tools used – Paint Brush | Menus used – layer

You can create truly imaginative edges by using a grayscale mask to hide the edges of the picture. See frames (d) and (e). Start by using the Elements drawing tools to paint a black shape with rough edges on a white background. This is our grayscale mask. Ideally the dimensions of the painting should be the same as the picture to be framed. With both the picture and the mask open as separate documents, use the Move tool to drag the mask image on top of the picture. The mask will become a new layer. Use the Free Transform tool (Image>Transform>Free Transform) to scale the mask to fit the image precisely.

With the mask layer still active change the layer mode to Screen. This will cause the image from beneath to show through the black parts of the mask whilst the white areas of the mask hide the rest of the picture below.

Grayscale mask borders >> *You can use a grayscale mask to produce a creative border effect by stacking the mask on top and then changing the layer mode to Screen.*

This technique can also be used to create an image filled border by inverting the mask before changing modes. This way the center of the picture is hidden by the white portion of the mask and the edges are filled with the image from below.

Pro's Tip: Search the web for pre-made grayscale masks that can be downloaded and used directly in Elements.

Step 1 >> *Create or download grayscale mask. Open image and mask. Drag mask onto image as a new layer.*

Step 2 >> *With the mask layer selected use the transformation tool (Image>Transform>Free Transform) to scale the mask to fit the image.*

Step 3 >> *Switch the mask layer's mode to Screen to create the edge effect. To invert the effect select Image>Adjustments>Invert before changing the mode.*

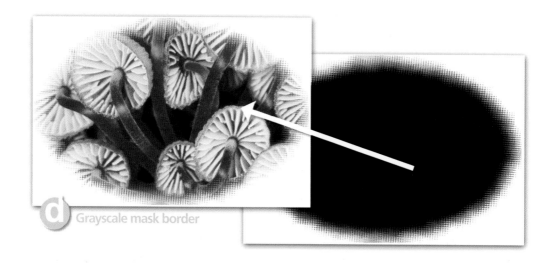

d Grayscale mask border

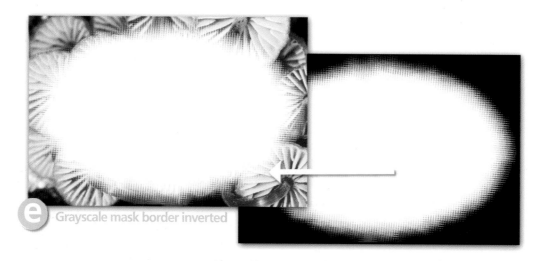

e Grayscale mask border inverted

Picture edges >> *More sophisticated masks of all manner of shapes, sizes and styles can be created using grayscale masks. By inverting the mask (Image>Adjustment>Invert) you can also create an edge filled with a picture rather than a picture surrounded by an edge.*

Adding texture

Texture is a traditional photographic visual element that is often overlooked when working digitally. All but the highest quality professional films have visible grain when they are printed. This is especially true when the print size goes beyond the standard 6 x 4 inches. In fact we are so familiar with the idea that grain is part of the photographic process that putting a little texture into an otherwise grainless digital picture can lend a traditional 'look and feel' to the image.

Many photographers add a little texture to their pictures as part of their regular image editing process. Some go beyond this and produce photographs with huge clumps of grain that resemble the results often seen with prints made from old style high ISO films.

3.22 Add Noise filter

Suitable for Elements – 1.0, 2.0 | Difficulty level – Intermediate | Resources – Web image 3.22
Related techniques – 3.23 | Menus used – Filter

The simplest method for adding texture to your picture is to use the Add Noise filter (Filter>Noise>Add Noise). The feature is provided with a preview dialog which allows you to alter the 'Amount' of noise that is added to the photograph, the style of noise – Gaussian or Uniform – and whether the noise is random colored pixels or just monochrome. As with most filters it is important to use this feature carefully as once the filter is applied and the file saved you will not be able to undo its effects. For this reason, it pays to make a duplicate file of your picture which you can texturize without risk of destroying the original image.

Pro's Tip: Be sure to preview the image at least 100 percent when adding noise to ensure that the effect is not too strong. If in doubt, make a test print of sections of the picture with different Add Noise settings to preview the hard copy results.

Step 1 >> *Zoom in so that the picture is at least at 100% view.*

Step 2 >> *Select the Add Noise filter from the Filter menu.*

Step 3 >> *Adjust the Amount slider to change the strength of the effect and pick the noise type and color.*

3.23 Grain filter

Suitable for Elements – 1.0, 2.0 | Difficulty level – Intermediate
Resources – Web image 3.22 | Related techniques – 3.22
Menus used – Filter

As an alternative that provides a few more options than the technique above you can use the Grain filter (Filter>Texture>Grain) to add your choice of 10 different grain textures to your picture. Ranging from 'regular' through 'horizontal' to 'speckle' this filter produces a spectacular variety of texture effects. The feature's dialog also provides an Intensity slider to govern the strength of the texture and a Contrast control.

The trick to creating good texture using this feature is the balancing of intensity and contrast settings. If the texture is too strong the shape and color of the original subject matter can be lost. If the contrast is too high then shadow and highlight details can be lost.

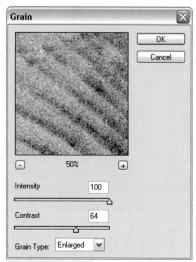

Adding grain >> *The Grain dialog provides a preview thumbnail, intensity and contrast sliders and a selection of 10 different grain types.*

Texture>Grain >> *The Grain filter provides a range of unique texture options that can be applied to your picture. (a) Regular. (b) Sprinkles. (c) Clumped. (d) Enlarged. (e) Stippled. (f) Horizontal. (g) Speckle.*
Image courtesy of www.ablestock.com. Copyright © 2003 Hamera and its licensors. All rights reserved.

3.24 Non-destructive textures

Suitable for Elements – 1.0, 2.0 | Difficulty level – Intermediate | Resources – Web image 3.24
Related techniques – 3.22, 3.23 | Menus used – Layer, Filter

As we have already seen adjustment layers are a great way to manipulate your pictures without actually altering the original image. This approach to image editing is referred to as 'non-destructive' as the integrity of the starting picture is always maintained. Mistakes or radical manipulations can always be reversed by switching off the adjustment layer leaving the untouched original below. Although there are no such things as 'filter adjustment layers' it would be handy to be able to use this same approach when making whole non-reversible image changes such as adding texture or noise to your pictures.

Such a technique was used in the following example. Despite the appearance of texture throughout the whole photograph the starting picture is still preserved at the bottom of the layer stack. To get the same results with your own pictures start by making a new layer (Layer>New>Layer) above the image. Next, fill this layer with 50 percent gray (Edit>Fill) and Add Noise (Filter>Noise>Add Noise) to the layer. Change the mode of the gray textured layer to either Soft Light, Hard Light, Linear Light or Vivid Light. Notice how the texture is now applied to the picture. To soften the effect reduce the opacity of the texture layer.

Using this technique you not only preserve the integrity of the original picture but you can also alter the strength of the effect at any time. In addition, it is also a great way to apply the same amount and style of grain to several layers in a stack without having to individually select and filter each layer.

Pro's Tip: To apply the same texture settings to a series of images of the same size simply drag and drop the gray texture layer to each of the open documents.

Step 1 >> *Create a new layer above the image layer or background.*

Step 2 >> *Fill the layer with 50% gray using the Edit>Fill command.*

Step 3 >> *Texture the layer with Add Noise and switch the layer mode to Vivid Light.*

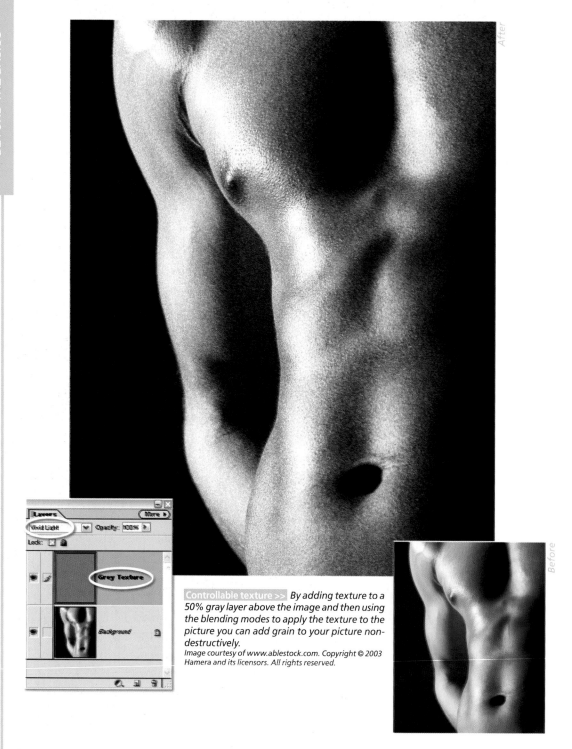

After

Before

Controllable texture >> *By adding texture to a
50% gray layer above the image and then using
the blending modes to apply the texture to the
picture you can add grain to your picture non-
destructively.*
*Image courtesy of www.ablestock.com. Copyright © 2003
Hamera and its licensors. All rights reserved.*

4

Darkroom Techniques on the Desktop

O nce you have mastered the basic editing and enhancement skills and techniques in Elements you will no doubt want to move on to some more challenging tasks that will extend and build upon what you already know. The group of techniques collected together here are loosely based on traditional photographic 'know how' that I have reworked in a digital fashion.

4.01 Diffusion printing

Suitable for Elements – 1.0, 2.0 | Difficulty level – Intermediate | Resources – Web image 401
Related techniques – 3.01, 3.02, 3.04, 3.05 | Tools used – Eraser | Menus used – Filter, Layer

Even though as image-makers we spend thousands of dollars on equipment that ensures that we make sharp photographs there is something enticing about a delicately softened picture. Especially when this lack of sharpness is contrasted against a well focused section of the picture. Diffusion printing is one traditional printing technique that played with this idea. Parts of the image were purposely blurred whilst other areas remained sharp.

With non-digital photography adding such an effect meant placing a 'mist' or 'fog' filter in front of the camera lens at the time of shooting. More recently, in an attempt to gain a little more control over the process, photographers have been placing diffusion filters below their enlarging lenses for part of the print's exposure time. This process gave a combination effect where sharpness and controlled blur happily coexisted in the final print.

Gaussian Blur filter >> *The diffusion printing technique is based around the careful application of the Gaussian Blur filter.*

Creating this style of picture using digital processes offers the image maker a lot more choice and control over the end results. The technique is based around the Gaussian Blur filter, which can be used to soften the sharp details of your photograph. A simple application of the filter to a base image produces a less than attractive result and one that doesn't combine the sharp and blurred imagery. Instead more control is possible if the filter is applied to a copy of the picture stored as a layer above the original image. This blurred layer is then combined with the original by either reducing the opacity of the blurred layer to allow the sharp original to show through, or by changing the blurred layer to a different blending mode such as Darken or Lighten.

Extending the technique

Blending mode or opacity changes provide control over the overall effect of the diffusion, but to fine-tune the results select the blur layer and use the eraser tool, set to a low opacity, to gently remove parts of the top layer to reveal the sharpness beneath.

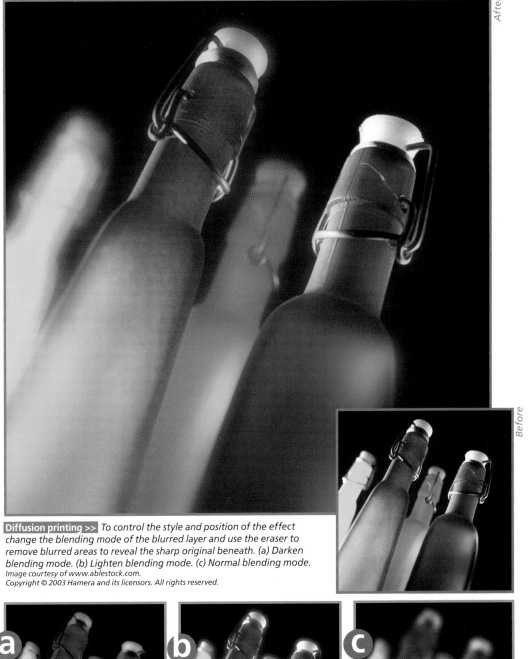

After

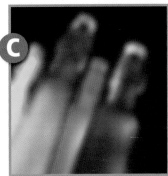

Before

Diffusion printing >> *To control the style and position of the effect change the blending mode of the blurred layer and use the eraser to remove blurred areas to reveal the sharp original beneath. (a) Darken blending mode. (b) Lighten blending mode. (c) Normal blending mode.*
Image courtesy of www.ablestock.com.

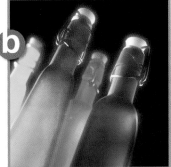

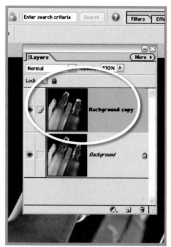

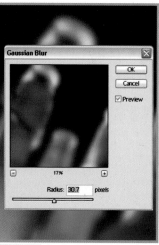

Step 1 >> *Duplicate the original picture by dragging it to the new layer button or choosing the Layer>Duplicate Layer option.*

Step 2 >> *Apply the Gaussian Blur filter (Filter>Blur>Gaussian Blur) to the upper, duplicated, layer.*

Step 3 >> *Control the way that the blurred layer interacts with the one beneath by adjusting the blending mode and/or using the eraser to remove unwanted blurred areas.*

4.02 Instant film transfer effect

*Suitable for Elements – 1.0, 2.0 | Difficulty level – Advanced | Resources – Web images 402-1, 402-2, 402-3
Related techniques – 3.01, 3.02, 3.04, 3.05 | Menus used – Filter, Layer, Enhance, Image*

Most readers will probably be familiar with Polaroid instant picture products – You push the button and the print is ejected and develops right before your eyes. For many years professional image-makers have been using the unique features of this technology to create wonderfully textured images. The process involved substituting watercolor paper for the printing surface supplied by Polaroid. As a result the image is transferred onto the roughly surfaced paper and takes on a distinctly different look and feel to a standard Polaroid print.

Much acclaimed for its artistic appeal, the technique was not always predictable and much to the frustration of photographers, it was often difficult to repeat the success of previous results. There were three main problems – dark areas of an image often didn't transfer to the new surface, colors and image detail would bleed unpredictably and it was difficult to control how dark or light the final print would be. I know these problems intimately as it once took me 16 sheets of expensive instant film to produce a couple of acceptable prints.

A digital solution

This success ratio is not one that my budget or my temperament can afford. So I started to play with a digital version of the popular technique. I wanted to find a process that was more predictable, controllable and repeatable. My first step was to list the characteristics of the Polaroid transfer print so that I could simulate them digitally.

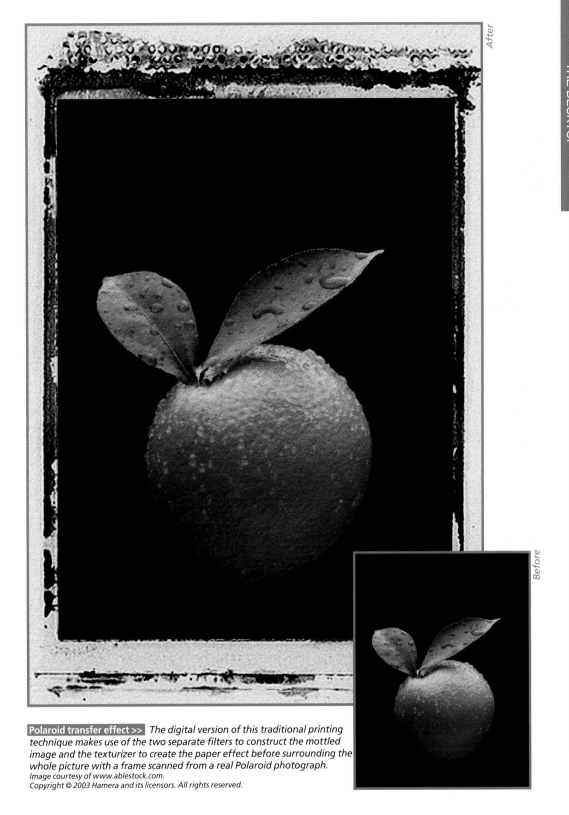

After

Before

Polaroid transfer effect >> *The digital version of this traditional printing technique makes use of the two separate filters to construct the mottled image and the texturizer to create the paper effect before surrounding the whole picture with a frame scanned from a real Polaroid photograph.*
Image courtesy of www.ablestock.com.

To me it seemed that there were four main elements:

• Desaturated colors,
• Mottled ink,
• Distinct paper texture and color, and
• The Polaroid film frame.

If I could duplicate these on my desktop then I would be able to make an image that captured the essence of the Polaroid transfer process.

Desaturate the image tones

The Polaroid technique requires the watercolor paper to be slightly wet at the time of transfer. The moisture, whilst helping the image movement from paper to paper, tends to desaturate the colors and cause fine detail to be lost. These characteristics are also the result of the coarse surface of the donor paper.

So the first step of the digital version of the process is to desaturate the color of our example image. In Elements this can be achieved by using the Hue/Saturation control from the Adjust Color section of the Enhance menu. With the dialog open carefully move the Saturation slider to the left. This action will decrease the intensity of the colors in your image.

Step 1 >> *Desaturate the image tones slightly using the Hue/ Saturation feature.*

Mottle the ink

The distinct surface and image qualities of Polaroid transfer prints combine both sharpness and image break-up in the one picture. To reproduce this effect digitally, I copied the original image onto a second layer. My idea was to manipulate one version so that it displayed the mottled effect of the transfer print whilst leaving the second version untouched. Then using the blending modes or opacity features of Elements' layers I could adjust how much sharpness or mottle was contained in the final result.

In practice, I started by duplicating the image layer. This can be achieved by selecting the layer to be copied and then using the Duplicate layer command located under the Layer menu. Alternatively you drag the layer to the Create New Layer button at the bottom of the layers palette.

With the upper layer selected, I then needed to find a method to simulate the mottle of the transfer print. Though not exactly right, I found that by combining the effects of the Paint Daubs and Palette Knife filters I could produce reasonable results. When using these filters yourself keep in mind that the settings used will vary with the style and size of your image. This part of the process is not an exact science. Play and experimentation is the name of the game. You might also want to try other options in the Artistic, Sketch or Texture selections of the Filter menu.

Step 2 >> *Duplicate the background layer by dragging it to the new layers button at the bottom of the dialog.*

Step 3 >> *Apply both the Paint Daubs and Palette Knife filters to the upper layer (duplicate).*

Step 4 >> *Reduce the opacity of the filtered upper layer to allow some of the sharp details of the original image to show through.*

The last step in this stage is to combine the characteristics of the two layers. This can be achieved by either changing the Blending mode of the uppermost layer or by adjusting its opacity, or both. For the example image a simple opacity change was all that was needed, but don't be afraid to try a few different blend/opacity combinations with your own work.

Apply a paper texture and color

The paper color and texture is a critical part of the appeal of the transfer print. These two characteristics extend throughout the image itself and into the area that surrounds the picture. For this to occur in a digital facsimile it is necessary to provide some space around the image using Elements' Canvas Size feature.

Unlike image size, this option allows the user to increase the size of the canvas so that all image layers (including

Step 5 >> *Check to see that the background color is set to white. Increase the size of the canvas to accommodate the Polaroid edge surround using the Canvas size command with a setting of 120 percent for width and 140 percent for height. Flatten the layers.*

Step 6 >> *Either use one of the pre-installed textures available in the Texturizer filter or download and install the watercolor paper.psd file (web image 402-2) from the book's website. Use the filter to add the texture to the surround.*

the background layer) are sitting upon without changing the image itself. In the example the canvas width was increased by 120 percent and the height by 140.

To add the texture to both image and surround I flattened the two image layers and the white background into a single layer. Next, I photographed a section of watercolor paper to use as a customized texture with the Texturizer filter. You can download and use this very file from the book's website. With the texture complete, I played with the overall color of the image using the Levels feature. I adjusted the blue and red channels independently and concentrated on the lighter tones of the image so that rather than the paper being stark white it took on a creamy appearance.

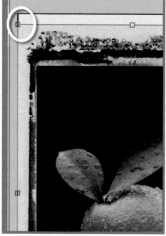

Step 7 >> *In the levels feature select the blue and red channels separately, dragging in the white output slider towards the center.*

Add the Polaroid frame

The last part of the process involves combining the final image with a photograph of a Polaroid film edge. The edge picture is nothing more complex than a scanned Polaroid print with the image removed. But rather than go to the trouble of making your own, you can download the edge I used for the example directly from the website (web image 402-3). Next, open the file as a separate Photoshop document. Click onto the edge layer and drag it onto your picture. The edge will automatically become a new layer on top of the existing image layer.

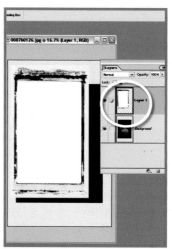

Step 8 >> *Open the edge file as a separate document and drag it onto the original picture.*

Step 9 >> *Switch the mode of the edge layer to multiply and use the Scale command to adjust its size to fit the picture below.*

With the edge layer selected change the layer's mode to multiply. Notice that the white areas of the layer are now transparent, allowing the picture beneath to show through. Finally use the Scale command to adjust the size of the edge to fit the image.

Though not an exact copy of the Polaroid transfer print, the digital version displays much of the character of the original and can be achieved for less cost and with more control.

4.03 Using the Unsharp Mask filter to add contrast

Suitable for Elements – 1.0, 2.0 | Difficulty level – Basic | Resources – Web image 403
Related techniques – 3.01, 3.02, 3.04, 3.05 | Tools used – Burning-in | Menus used – Filter

USM local contrast settings >> *Instead of using the modest Radius settings that we normally associate with the Unsharp Mask filter this technique requires the radius to be set to a high value.*

Most digital photographers have used the Unsharp Mask filter as a way to add some crispness to pictures that are a little soft. In another application this feature can be used to add some local contrast to flat images in much the same way that multi-contrast printing provides a boost to black and white prints.

The trick with this technique is to forget the way that you have been using the feature. Instead of selecting a high Amount and low Radius setting you do the opposite. You drag the amount downwards and the radius upwards. This produces a change in local contrast rather than a sharpening of individual pixels.

To use the technique as part of your standard enhancement process you would adjust highlight and shadow points to set the contrast of the whole picture first, then employ the Unsharp Mask filter to increase the local contrast and then use the filter a second time, with different settings, to increase the photograph's sharpness.

Step 1 >> *To change local contrast open the Unsharp Mask filter and select a low Amount value and a high Radius value.*

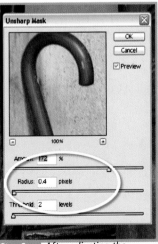

Step 2 >> *After adjusting the contrast sharpen the image using the Unsharp Mask filter in the normal fashion.*

Step 3 >> *The final step in the example image was to darken some of the tones around the door opening with the Burn tool.*

DARKROOM TECHNIQUES ON
THE DESKTOP

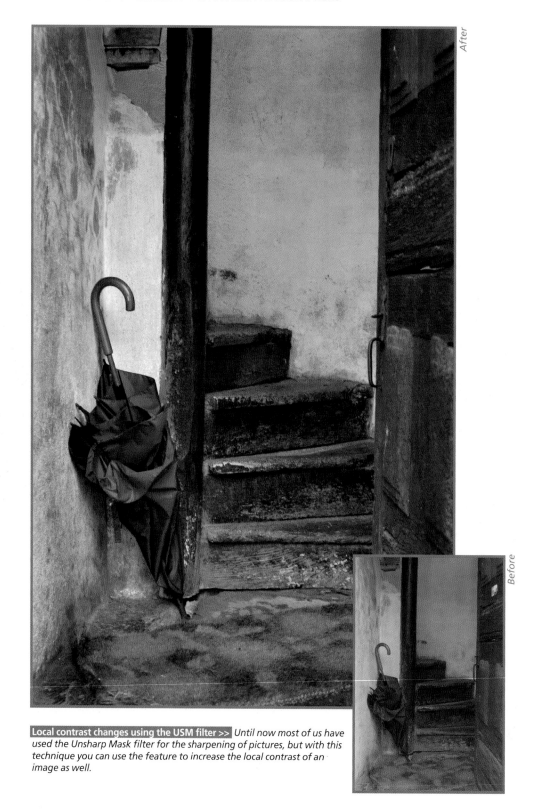

After

Before

Local contrast changes using the USM filter >> *Until now most of us have used the Unsharp Mask filter for the sharpening of pictures, but with this technique you can use the feature to increase the local contrast of an image as well.*

Recipes for USM contrast changes >>
(a) *Original image, no contrast change.*
(b) *Amount 30, Radius 80, Threshold 0.*
(c) *Amount 60, Radius 80, Threshold 0.*
(d) *Amount 90, Radius 80, Threshold 0.*
(e) *Amount 120, Radius 80, Threshold 0.*
(f) *Amount 30, Radius 20, Threshold 0.*
(g) *Amount 60, Radius 20, Threshold 0.*
(h) *Amount 90, Radius 20, Threshold 0.*
(i) *Amount 120, Radius 20, Threshold 0.*

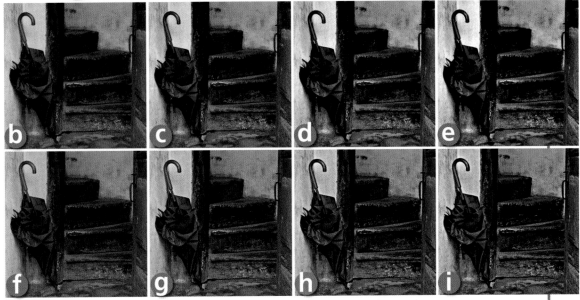

4.04 Lith printing technique

Suitable for Elements – 1.0, 2.0 | Difficulty level – Basic | Resources – Web image 404, Lith recipe
Related techniques – 3.01, 3.02, 3.04, 3.05 | Tools used – Dodging, Burning-in | Menus used – Enhance, Image, Filter

Just a few short years prior to the massive uptake of digital photography many professional and amateur image-makers alike were discovering the beauty of a whole range of craft printing processes. There was a resurgence in the techniques involved in the production of high quality black and white pictures and a growing interest in 'alternative' processes that could create stunningly different monochromes.

One such process was lith printing. The process involves the massive overexposure of chloro-bromide based papers coupled with development in a weak solution of lith chemistry. The resultant images are distinctly textured and richly colored and their origins are unmistakable. But rather than head back to the darkroom in pursuit of your first lith print you can use the following steps to recreate the results digitally.

Before

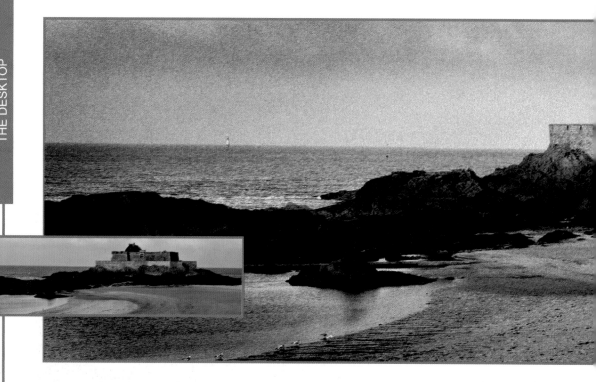

Most lith prints have strong, distinctive and quite atmospheric grain that is coupled with colors that are seldom seen in a black and white print. They range from a deep chocolate, through warm browns, to oranges and sometimes even pink tones. If our digital version is to seem convincing then the final print will need to contain all of these elements.

Select a picture where the composition is strong. It should contain a full range of tones, especially in the highlights and shadows and good contrast will help make a more striking print. The first task is to lose the color. We want to achieve this change whilst still keeping the picture in a color mode (RGB Color). This way later on we can add color back to the picture. If the original is a color picture use the Hue/Saturation slider (Enhance>Adjust Color>Hue/Saturation) with the saturation setting set to -100 to change it to black and white. If you are starting the project with a grayscale picture change the color mode to RGB Color (Image>Mode>RGB Color).

Perform all your tonal enhancement steps now. Use the Levels feature (Enhance>Adjust Brightness/Contrast>Levels) to ensure a good spread of tones and the burning and dodging tools to enhance specific parts of the picture. Add some texture to the image using the Add Noise filter (Filter>Noise>Add Noise)with the Gaussian and Monochrome options set. The final step is to add some color back to the picture. We can achieve this effect by selecting the Colorize option in the Hue/Saturation feature and then adjusting the Hue slider to select the color of the tint and the Saturation slider to alter the strength.

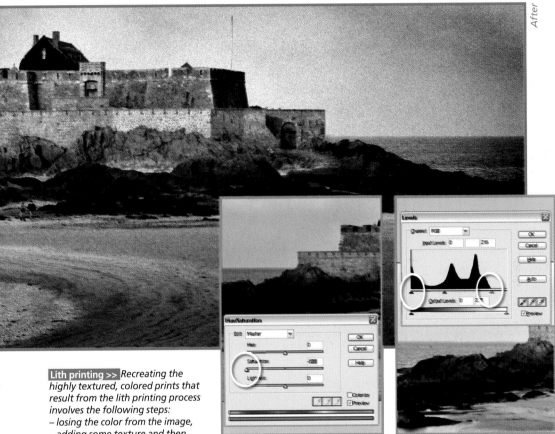

After

Lith printing >> *Recreating the highly textured, colored prints that result from the lith printing process involves the following steps:*
– losing the color from the image,
– adding some texture and then
– reapplying color to the picture.

Step 1 >> *Convert your color picture to black and white by dragging the Saturation slider in the Hue/ Saturation dialog to -100.*

Step 2 >> *Adjust your picture's black and white points and check the spread of tones using the Levels feature.*

Step 3 >> *Use the dodging and burning-in tools to add drama to specific areas of the picture.*

Step 4 >> *Add some texture to the image using the Add Noise filter set to Gaussian and monochrome.*

Step 5 >> *Apply some color using Hue slider and Colorize option in the Hue/Saturation feature .*

4.05 Correcting perspective problems

Suitable for Elements – 1.0, 2.0 | Difficulty level – Basic | Resources – Web image 405
Related techniques – 3.01, 3.02, 3.04, 3.05 | Tools used – Crop | Menus used – Image, View

You know the story: you're visiting a wonderful city on holiday wanting to capture as much of the local scenes and architecture as possible. You enter the local square and point you camera towards an impressive three-spired building on the other side of the road only to find that you must tilt your camera upwards to get the peaks into the picture. At the time you think nothing of it and you move onto the next location. It is only when you are back at home about to print your photograph that you realize that the innocent 'tilt' has caused the edges of the building to lean inwards.

Now to a certain extent this isn't a problem; even though it is not strictly accurate, we all know that most buildings have parallel walls and the majority of people who look at you picture will take this into account – won't they? Apart from a return trip and a re-shoot is there any way to correct these converging verticals? Well, I'm glad you asked. Armed with nothing except Elements and the steps detailed here, you can now straighten all those leaning architectural shots without the cost of the return journey.

After opening the offending image turn on the display grid (View>Grid). This will place a non-printing grid over the surface of the picture and will act as a guide for your adjustments. In most cases we need to move the two upper corners of the picture further apart to make them parallel. To achieve this we will use the Elements Perspective feature, which is designed to increase or decrease the perspective effect in images. Select the feature from the Transform part of the Image menu (Image>Transform> Perspective).

If your picture has been downloaded straight from you camera then a small warning sign will pop up to say that 'transformations (perspective changes) can only be applied to layers and would you like to make your picture into a layer?'. Answer OK and then name your new layer or leave it as Layer 0 as we have here. Now that your

Step 1 >> *With the picture open in Elements make the grid visible to help align your adjustments.*

Step 2 >> *Select the Perspective option from those listed in the Transform menu.*

picture is a layer the Perspective feature will be activated. You can tell this by the small boxes in the corners and sides of the picture. These handles allow you to manipulate the photograph's perspective. In our case we need to grab either of the top left or right handles and drag them outwards. This will move the sides of the building out as well. Continue dragging until the buildings edges line up with or are parallel to some grid lines. Double click on the picture to apply the transformation.

Before

After

Correcting perspective >>

*When shooting upwards with a
wide angle lens the sides of
buildings converge inwards rather
than remain parallel. You can
correct this problem using the
Perspective and Scale options in
Elements.*

To complete the correction we need to make the building a little taller as the tilted camera has artificially shortened the spires. If we stretch the picture upwards without providing some canvas space for the extra height then the top or bottom of the building will be cropped. So before extending the height we need to increase the vertical size of the canvas. Choose Canvas Size from the Resize menu (Image>Resize>Canvas Size) and input a new value into the height and width boxes. Here we have used 130 percent for both. Now we can select the Scale feature from the Resize section of the Image menu (Image>Resize>Scale) and click and drag the top or bottom handles to stretch the picture bigger. As a final step use the Crop tool to trim the unwanted sections of the picture away from the corrected image.

Step 3 >> *Click OK to the warning window and then label the converted background layer.*

Step 4 >> *Click on the corner handles and drag these outwards until the building edges are parallel with the grid lines. Double click to OK the changes.*

Step 5 >> *Increase the canvas size vertically to accommodate stretching the building upwards.*

Step 6 >> *Select the Scale option from the Resize menu.*

Step 7 >> *Click and drag the middle top and bottom handles upwards (and downwards) to increase the height of the image.*

Step 8 >> *Use the Crop tool to trim unwanted areas of the corrected picture.*

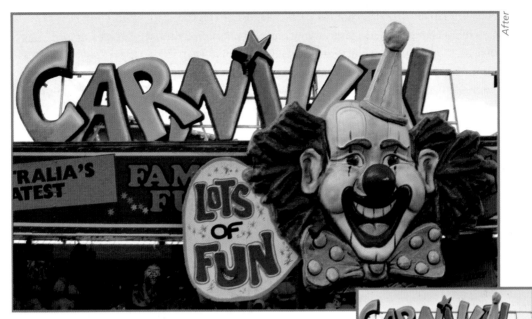

After

Before

Desaturate/saturate >> *Direct your viewer's gaze by increasing the saturation of important parts of the picture whilst reducing the color vibrancy of the rest of the image.*

4.06 Add emphasis with saturation

Suitable for Elements – 1.0, 2.0 | Difficulty level – Basic | Resources – Web image 406
Related techniques – 3.01, 3.02, 3.04, 3.05 | Tools used – Selection tools | Menus used – Enhance, Select

This technique, unlike the ones that we have looked at previously in this chapter, does not draw easy parallels from the world of traditional photography. Until digital came along it was not possible, at least not without a lot of professional smoke and mirrors, to change the vibrancy of the color in one part of the picture whilst maintaining or even boosting it in another part. It certainly wasn't an easy job to combine both black and white and full color in a single picture.

The Hue/Saturation feature has removed such limitations forever. When this tool is combined with a carefully created (and feathered) selection it is possible to desaturate one part of the picture and then using an inverted selection increase the saturation of the rest. Like dodging and burning this technique can direct the viewer's interest to a part of the picture that the photographer deems important. In fact it is when these two techniques, dodging and burning and saturation/ desaturation, are used in tandem that the desktop photographer can really start to create some dramatic pictures.

In the example image the clown's head was selected using a combination of the Magnetic and standard Lasso tools. Once completed the selection was feathered slightly (1–2 pixels) (Select>Feather) to soften the transition of the effect and saved (Select>Save Selection). With the

selection still active the Hue/Saturation feature was opened and the color vibrancy of the clown increased by moving the Saturation slider to the right. To add more contrast, the selection was then inverted (Select>Inverse) and the saturation of the background was decreased almost to the point of just being black and white.

An alternative way of working this technique is to create masked Hue/Saturation Adjustment layers using the saved selection. This would allow you to readjust the amount of saturation and desaturation at any point later in time and would keep the original picture intact.

Non-destructive version >>
Use masked Hue/Saturation layers to produce the same results with fine-tuning options.

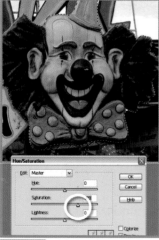

Step 1 >> *Carefully select the area to saturate/desaturate using your favorite selection tools.*

Step 2 >> *Feather the edge of the selection slightly so that the transition will be smoother.*

Step 3 >> *Save the selection so that you can use it or edit it later.*

Step 4 >> *With the selection still active use the Hue/Saturation feature to increase the saturation of the clown's face.*

Step 5 >> *Inverse the selection so that the rest of the picture is now selected.*

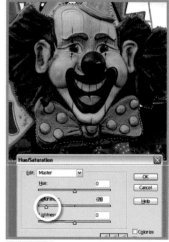

Step 6 >> *Use the Hue/Saturation slider to decrease the saturation and provide color contrast between the two picture parts.*

4.07 Restoring color to faded images

Suitable for Elements – 1.0, 2.0 | Difficulty level – Intermediate | Resources – Web image 407, Color Restore recipe
Related techniques – 3.01, 3.02, 3.04, 3.05 | Menus used – Enhance

Old images, whether they be captured on color films, negatives or slides, are prone to fading and color changes as the dyes they are constructed of break down. It is a source of concern for all photographers who have big collections of images stored away in attics, cupboards or under the bed. After all many of these photographs, though not valuable in the commercial sense, are irreplaceable as they hold glimpses of a family's history and echoes of days gone by.

Recently a loyal reader and avid Elements user emailed me with exactly this problem. Tom Edwards asked me If I had a solution for restoring the color to the hundreds of fading slides that he had taken in the Orient in the early 70s as they now all appear to be turning red.

The first step in any such restoration work is diagnosing the problem that is causing the color shift and fading. To get a good understanding of the cause I always turn to the Levels feature (Enhance>Adjust Brightness/Contrast>Levels) for help. It contains a descriptive display of the spread pixels in the image and also includes the tools needed to coax the picture back to life.

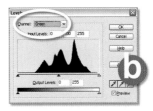

When the Levels feature is first opened it displays a graph of the combined red, green and blue pixels. This is signified by the RGB label in the Channels drop-down menu. To really see what is happening to the tones in your picture select and view the graph for each of the individual color channels. The graphs for each channel of Tom's example image can be seen to the right. Notice how the green and blue channels are fairly similar but the red channel has all the signs of being overexposed, that is, all the tones being pushed to the right end of the graph. This is where our problem lies.

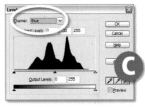

Restoring faded slides >>
When you look at the histogram for each of the red, green and blue channels separately it is easy to see why the faded slide appears so warm.
(a) Red channel.
(b) Green channel.
(c) Blue channel.
To restore the color in the image work on each channel separately, dragging the white and black points in to meet the first major group of pixels.
This will balance the distribution of the tones in each of the channels and restore the slide's color and contrast.

To help restore the original color and brightness of the photograph the tones of each of the color channels have to be adjusted individually. Starting with the red channel, drag the black input triangle towards the center of the graph until it meets the first major group of pixels. Do the same for the green and blue channels, but with these also adjust the white point input slider in the same way.

This action will help to restore the color and contrast of the picture and will give good results for all but the most faded slides or prints. Final adjustments to tone and the removal of any slight color casts that remain can be achieved using levels on the combined RGB channel setting and the Color Variations features.

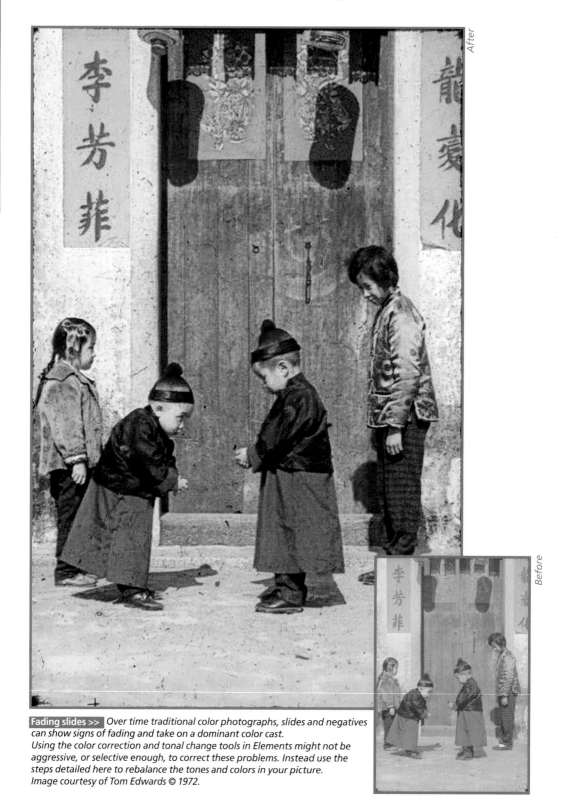

After

Before

Fading slides >> *Over time traditional color photographs, slides and negatives can show signs of fading and take on a dominant color cast.*
Using the color correction and tonal change tools in Elements might not be aggressive, or selective enough, to correct these problems. Instead use the steps detailed here to rebalance the tones and colors in your picture.
Image courtesy of Tom Edwards © 1972.

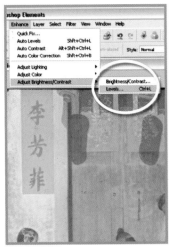

Step 1 >> *Open the Levels feature from the Enhance and Adjust/ Brightness menus.*

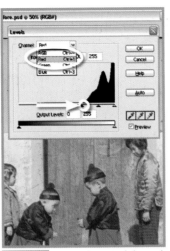

Step 2 >> *Start with the red channel and drag the black input triangle to meet the first group of pixels.*

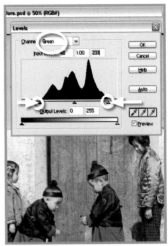

Step 3 >> *Next select the green channel and move both the white and black input sliders to the first group of pixels.*

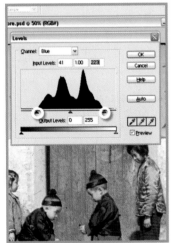

Step 4 >> *Make the same black and white point adjustments for the blue channel as well.*

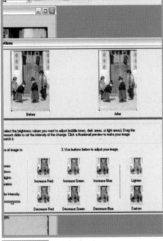

Step 5 >> *With the image now balanced you can use the Color Variations feature to remove any slight color casts that remain.*

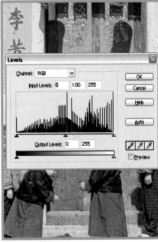

Step 6 >> *As a final check of the tones open the levels feature again and adjust white, middle and black points for the composite channel (RGB).*

Pro's Tip:
For those readers who have many images that need this type of color rebalancing and correction it may be worthwhile purchasing the Applied Science Fiction Digital ROC filter. Produced by the same company as the scanner tools that we looked at in the second chapter, Digital ROC is designed to restore and rebalance the faded color in old slides, negatives and prints.

Supplied with some scanners this technology is also available as a plug-in that installs in the Filters section of Photoshop Elements. Trial versions of the program are available from www.asf.com.

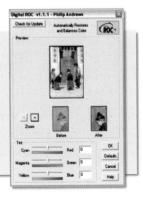

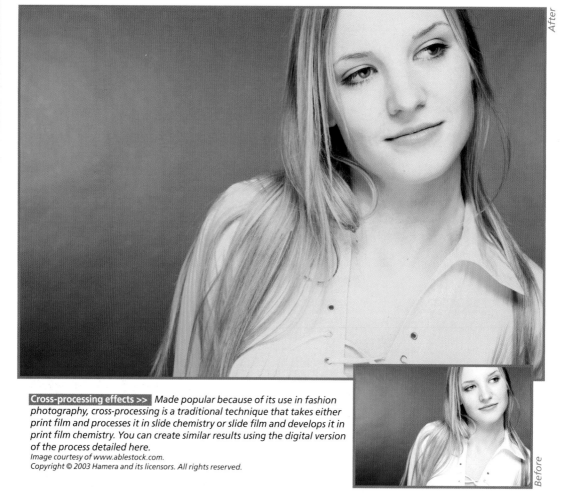

After

Before

Cross-processing effects >> *Made popular because of its use in fashion photography, cross-processing is a traditional technique that takes either print film and processes it in slide chemistry or slide film and develops it in print film chemistry. You can create similar results using the digital version of the process detailed here.*
Image courtesy of www.ablestock.com.

4.08 Cross-processing effects

Suitable for Elements – 1.0, 2.0 | Difficulty level – Intermediate | Resources – Web image 408
Related techniques – 3.01, 3.02, 3.04, 3.05 | Menus used – Enhance

Processing your film in the wrong chemistry sounds like an action that will guarantee disaster, but this is precisely the basis of the cross-processing technique. Print film is developed using slide chemistry or alternatively slide film is processed using print film chemistry. Whichever method you use the process results in distinctly recognizable images that have found their way into many fashion magazines in the last few years. As with many of these alternative techniques the process can be a little unpredictable, with strange color shifts and massive under- and overexposure problems, reducing the number of usable pictures resulting from any shooting session.

Four adjustment layers >>
This technique relies on the application of four different adjustment layers being stacked upon the original image.

Martin Evening of 'Adobe Photoshop for Photographers' Focal Press fame created a digital version of this process that uses a series of curve changes to create images that have a similar look and feel to those produced with the chemical cross-processing effect. Here I present an Elements friendly version of the technique that provides equally impressive results without using the Photoshop curves feature. In addition, as the technique uses a series of adjustment layers to create the effect the original picture remains unaltered throughout and the settings for each of the layers can be altered at any time to tweak the final result.

To recreate the look of cross-processing (print film developed in slide chemistry) we must change the image so that it contains creamy highlights, cyan shadows and is generally reduced in contrast. Start with a standard color image. Create a levels adjustment layer and select the yellow channel. Move the white output slider to the left to flatten the highlights and

Step 1 >> *To start the process open a colour image and create a Levels adjustment layer.*

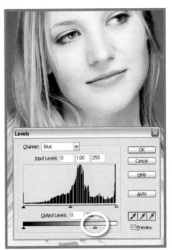

Step 2 >> *To make the yellow highlights select the blue channel of in the levels feature and drag down the white output slider. This adds some yellow to the highlights.*

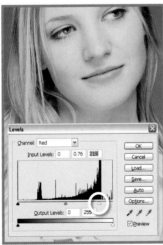

Step 3 >> *Create another levels adjustment layer, select the red channel and drag down the white input layer. This adds some warmth to the highlights.*

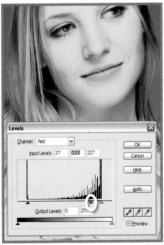

Step 4 >> *To add cyan to the shadow areas create another levels adjustment layer, select the red channel and move the mid tone input slider to the right.*

color them yellow. Create a second levels adjustment layer and with the red channel selected move the white output slider to the left as well. This adds some warmth. Next create another levels adjustment layer and select the red channel again. This time you need to move the mid point input slider to the right to make the shadows and mid tones cyan. With the Levels feature still open move the white and black input sliders till they meet the first group of pixels in the histogram. To fine-tune the overall tones you can add yet another levels adjustment layer and with the composite of all channels selected (RGB), alter contrast and brightness of the whole picture.

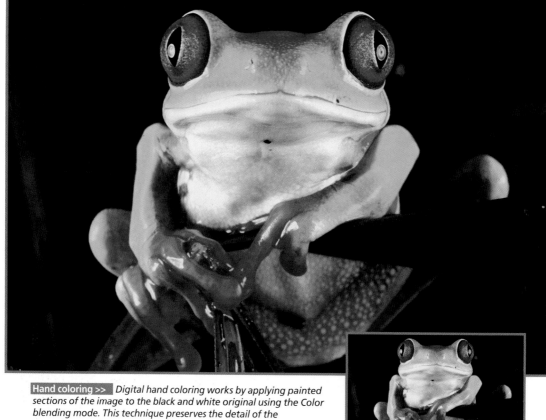

After

Before

Hand coloring >> *Digital hand coloring works by applying painted sections of the image to the black and white original using the Color blending mode. This technique preserves the detail of the monochrome picture and tints the surface with the color of the upper layer in much the same way as oil paint was used to tint black and white prints of old.*
Image courtesy of www.ablestock.com.
Copyright © 2003 Hamera and its licensors. All rights reserved.

4.09 Digital hand coloring

Suitable for Elements – 1.0, 2.0 | Difficulty level – Basic | Resources – Web image 409
Related techniques – 3.01, 3.02, 3.04, 3.05 | Tools used – Brush | Menus used – Layer

Before the advent of color film the only way to add a hue to a picture was to apply water or oil based paints over the top of a black and white print. Most of us will have old photographs of family weddings that are delicately colored in this way. There is a simplicity and subtlety about this approach that is worth recapturing in the digital age.

If you look at the old images you will notice that the detail of the black and white picture shows through the colored paint. The combination of these details and the applied color creates the hand colored effect. To simulate this technique digitally we can use the color blending mode in Elements. The color is applied to a separate layer using the paintbrush and then the mode of the layer is changed to 'Color'. This allows the details of the image beneath to show through the color above. Using the paintbrush in the normal mode will create large flat areas of color that hide the detail beneath.

Step 1 >> *Open a black and white picture and make sure that it is in RGB color mode. Make a new layer in the document.*

Step 2 >> *Select the layer and change its blending mode to Color.*

Step 3 >> *Select the Paintbrush from the toolbox and then select a foreground color to paint with from the swatches palette.*

The color can be removed from any part of the picture with the eraser tool and the vibrancy of the hues can be altered by changing the opacity of the color layer.

For the ultimate control each individual color can be added via a new layer. This approach means that the various colors that make up the picture can be edited individually.

Step 4 >> *Paint over the area of the image that you want to hand color. Switch foreground colors and continue to paint.*

Step 5 >> *Make sure that the colors are being applied to the newly created layer. The strength of the coloring can be altered by adjusting the opacity of the layer.*

Hand coloring >> *Changing the opacity of the color layer will alter the strength of the hand coloring effect. (a) 0% opacity. (b) 25% opacity. (c) 50% opacity. (d) 75% opacity. (e) 100% opacity.*

DARKROOM TECHNIQUES ON
THE DESKTOP

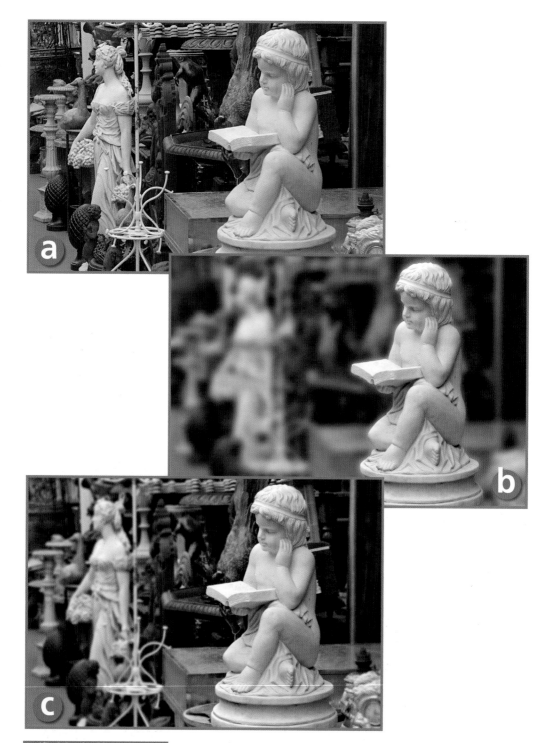

Artifical depth of field effects >>

It is possible to create realistic depth of field effects by making and blurring a series of selections that gradually increase in size. (a) Straight print. (b) Simple selection with Gaussian Blur. (c) Multiple selections with increasing Gaussian Blur values.

4.10 Realistic depth of field effects

Suitable for Elements – 1.0, 2.0 | Difficulty level – Advanced | Resources – Web image 410
Related techniques – 3.01, 3.02, 3.04, 3.05 | Tools used – Selection tools | Menus used – Filter, Select

The shallow depth of field effect that is created when you select a small F-stop number, use a long lens or get in very close to your subject, controls the way that a viewer sees your picture. The eye is naturally drawn to the sharpest part of the image and shallow depth of field restricts the sharpness in a photograph to often only a single subject. The Gaussian Blur filter can be used in a similar way to produce results that help to direct the viewer's gaze. Areas of an image can be selected and blurred so that our eyes will be redirected to the sharp part of the print. In a way, by blurring parts of an otherwise sharp picture, this process is creating artificial depth of field.

When the potential of the blur filter is first discovered many enthusiastic digital photographers take to the task of creating shallow DOF pictures from their sharp originals with gusto. The process they use is simple – select and blur. The results certainly provide a contrast in sharpness, but the pictures lack the sense of realism that is needed for the effect to be truly convincing.

To recreate shallow depth of field more effectively there needs to be a gradual decrease in sharpness as you move in front of, or behind, the main point of focus. Making a single selection doesn't provide the gradual change that is needed. In its place we need to use a series of overlapping selections that gradually move further away from the point of focus. Each selection is feathered to smooth the transition of the effect and then the selected area is blurred using the Gaussian Blur filter. The amount of blur is increased as the selection gets more distant from the point of focus.

Multiple selections >>
Convincing depth of field effects are based on the sequential blurring of multiple overlapping selections.

(a) First selection.
(b) Second selection.
(c) Third selection.
(d) Fourth selection.

This simulates lens based depth of field by surrounding the point of focus with the area of least blur and then gradually increasing the out of focus effect as the eye moves further from this part of the picture.

Start the process by creating a selection of the subject area that you want to remain sharp. Inverse (Select>Inverse) the selection so that the rest of the picture is selected. Feather (Select>Feather) the edge slightly to ensure that the transition between blurred and sharp picture parts is less obvious. Apply the Gaussian Blur filter (Filter>Blur>Gaussian Blur) to the selection using a low radius value

Step 1 >> *Carefully select the part of the picture that is to be your point of focus – the area that will remain sharp.*

Step 2 >> *Feather (1 or 2 pixels) and then save the selection.*

Step 3 >> *Use the Inverse command to select the rest of the picture.*

Step 4 >> *Apply a small Gaussian Blur to this initial selection. Here I have used a radius of 1.0 pixels.*

Step 5 >> *Reduce the area that is selected by selecting the Contract command from the Select menu.*

Step 6 >> *Feather the new selection by a greater amount. Here I have used 10 pixels. Save the selection.*

of 1 pixel. Now to recede the selection away from the point of focus. Here I have used the Contract command (Select>Contract) but you could just as easily draw another selection that is further away from the statue. The edge is feathered again, this time by a larger amount, and the whole thing blurred with a larger radius.

This process – contract, feather blur – is repeated as many times as is needed to ensure that the picture's background details are suitably unsharp. In the example image I used four selections to get the shallow depth of field effect.

Step 7 >> *Apply a larger Gaussian Blur (2 pixels) to this new section of the picture.*

Step 8 >> *Create a new smaller selection using the contract command set to 100 pixels.*

Step 9 >> *Feather and save the new selection. Here I have used a radius of 30 pixels.*

Step 10 >> *Blur the new selection with a higher Gaussian Blur setting.*

Step 11 >> *Contract the selection by 100 pixels and then again by another 100 pixels before feathering the edge by 60 pixels and saving the selection.*

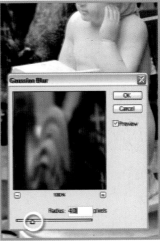

Step 12 >> *Apply the final Gaussian Blur to the selection using a radius of 4 pixels.*

After

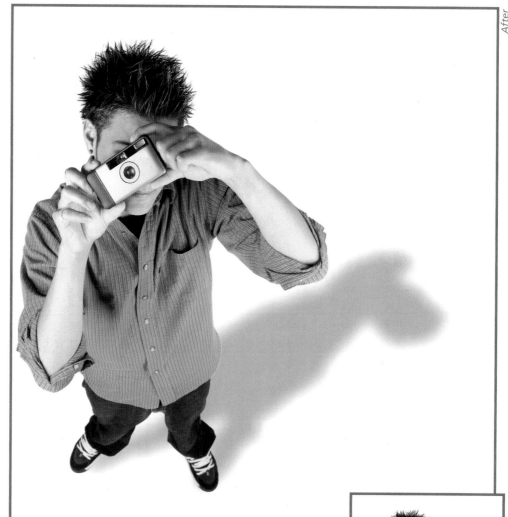

Before

Creating realistic shadows >> *Simple shadows can be applied to any layer using the Drop Shadow options in the Elements Styles palette. More complex shadows, like the one in the example that looks like it is falling on the ground, can be created by making a shadow layer beneath the image.*
Image courtesy of www.ablestock.com.

4.11 Beyond the humble drop shadow

Suitable for Elements – 1.0, 2.0 | Difficulty level – Advanced | Resources – Web image 411
Related techniques – 3.01, 3.02, 3.04, 3.05 | Tools used – Selection tools | Menus used – Edit, Filter, Image

The drop shadow effect has become very popular in the last few years as a way of making an image or some text stand out from the background. To coincide with this popularity Adobe created a series of drop shadow styles that can applied directly to any layer. These options are suitable for many applications and Elements users can even customize the look of the effect by altering variables like the direction of the light and the shadow distance using the Style Settings dialog (Layer>Layer Style>Style Settings).

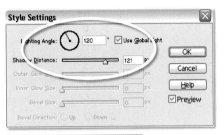

Drop shadow style settings >> *Alter the look of your drop shadows by changing the value of the options in the Style Settings dialog.*

But what if you want a more sophisticated shadow than these preset choices allow? Well then you will need to create your own shadows. Using the example image let's make a shadow that lies upon the ground that the model is standing on. To do so, we will need to revisit the steps that I used to use to create even the simplest drop shadow before the days of layer styles.

First select the subject with one of your favorite selection tools and copy it to memory (Edit>Copy). Next paste the picture (Edit>Paste) twice to form two new layers. Fill the background layer with white. Next fill the second image layer with black making sure that the Preserve Transparency option is turned on. This creates a silhouette exactly the same size and shape as the main picture. To allow for the shadow we will need to create some more space on the right hand side of the picture. Use the Canvas Size feature for this (Image>Resize>Canvas Size). Here I have anchored the canvas on the left side and set the option to percent and then increased the width to 150%.

With the shadow layer still selected I used the Distort feature (Image>Transform>Distort) to push the shadow downwards and to the right. Keep in mind that for this type of shadow to be convincing it must be consistent with the lighting in the image generally. In the example the main light is

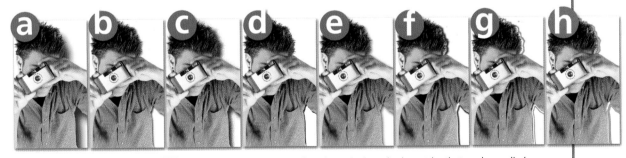

Elements' drop shadow styles >> *Elements provides a range of ready made drop shadow styles that can be applied directly to any layer. (a) High. (b) Low. (c) Noisy. (d) Hard edge. (e) Soft edge. (f) Outline. (g) Fill/outline. (h) Neon.*

DARKROOM TECHNIQUES ON THE DESKTOP

coming from the left and so the shadow should be projected to the right. Also make sure that the shadow is positioned so that it grows from where the subject touches the ground. In the example it is the feet. If need be, use the Move tool and even the Rotate feature (Image>Rotate>Free Rotate Layer) to orientate the shadow so that it meets the shoes.

Next we need to blur the edges of the shadow and adjust its transparency to complete the illusion. With the shadow layer still selected use the Gaussian Blur filter (Filter>Blur>Gaussian Blur) to make the edges of the shadow less sharp. There are no hard and fast rules about the amount of blur to apply. It is a matter of trying a few settings with the preview option switched on in the filter dialog until you are happy with the results. To make the shadow a little brighter and more transparent I changed the blending mode from Normal to Multiply and dragged down the opacity of the whole layer.

Although not immediately obvious here, changing the blending mode to Multiply will give a more realistic shadow effect when laid over other picture areas. When used in conjunction with the layer's opacity slider the density of the shadow can be adjusted to allow the detail from the picture beneath to show through.

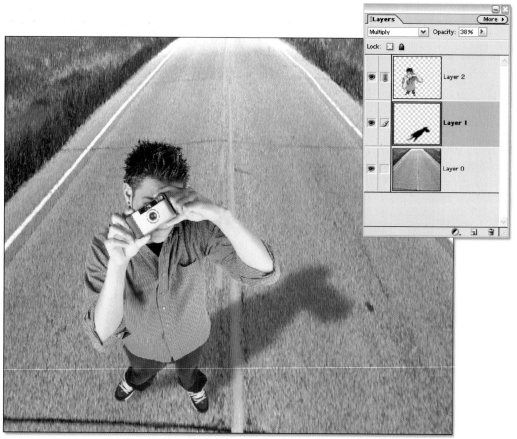

Multiply shadows >> *Switching the blending mode of the shadow layer to Multiply will allow the detail of the layer below to show through, producing a more realistic effect.*
Image courtesy of www.ablestock.com. Copyright © 2003 Hamera and its licensors. All rights reserved.

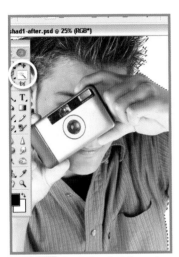

Step 1 >> *Carefully select the main subject using your favorite selection tools. Here it was easier to select the uniform background and adjust the selection around the hair region rather than selecting the model.*

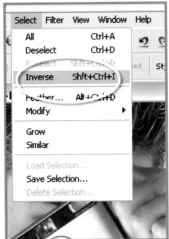

Step 2 >> *Change the selection from the background to the model by inversing the selection.*

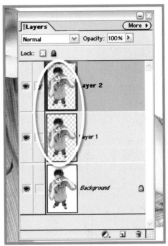

Step 3 >> *Copy the selected area to the computer memory and then paste the contents twice to form two new image layers containing the copied model picture.*

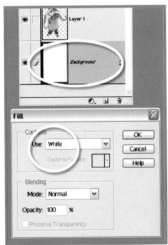

Step 4 >> *Select the background layer and fill it with white.*

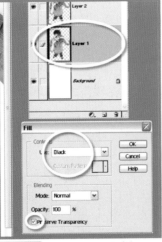

Step 5 >> *Select the lower of the two new layers and fill this layer with black, this time making sure that the Preserve Transparency option is turned on.*

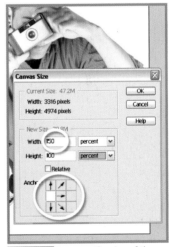

Step 6 >> *Increase the size of the canvas to accommodate the shadow by anchoring the image on the left side and increasing the width by 150%.*

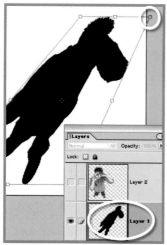

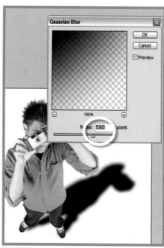

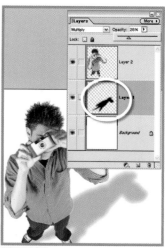

Step 7 >> *With the shadow layer still selected use the Distort tool to squash the shadow into the newly created space on the right side of the model.*

Step 8 >> *Blur the edge of the shadow using the Gaussian Blur filter.*

Step 9 >> *Switch the mode of the shadow layer to Multiply and adjust the opacity of the shadow until the desired brightness is shown.*

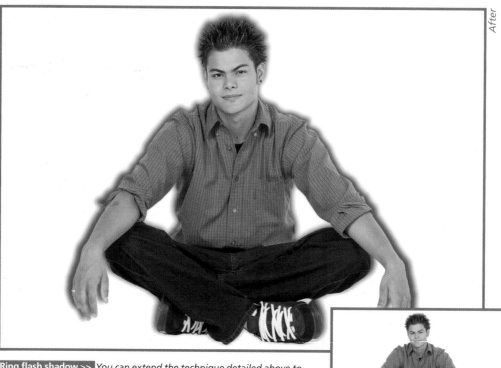

After

Before

Ring flash shadow >> *You can extend the technique detailed above to allow you to create shadow similar to those created when using a ring flash that surrounds the camera's lens.*
Image courtesy of www.ablestock.com.

4.12 Ring flash shadow

Suitable for Elements – 1.0, 2.0 | Difficulty level – Advanced | Resources – Web image 412
Related techniques – 3.01, 3.02, 3.04, 3.05 | Tools used – Selection tools | Menus used – Edit, Filter, Image

You can extend the technique detailed above to create a shadow that is similar to those found in pictures created with a ring flash attached to the camera lens. These pictures are characterized by the model having a shadow projected onto the wall behind. As the light is coming from the same position as the camera the shadow is larger but directly behind the subject.

The first few steps are the same as those found in the previous technique. Start by selecting the main subject and copy and pasting it twice to form two new layers. Next fill the background with white. Select the lower image layer and fill it with black, making sure that the Preserve Transparency option is selected. Blur the shadow using the Gaussian Blur filter (Filter>Blur> Gaussian Blur). With the preview option selected in the filter dialog, adjust the blur radius so that the edge of the shadow is visible as a halo around the top image layer.

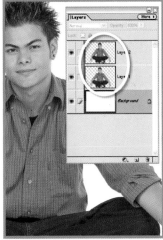

With the shadow layer still selected use the Move tool to shift its location upwards by a few pixels. For accuracy you can use the arrow keys instead of the mouse. Each arrow key press moves the shadow one pixel. To finalize the technique change the blending mode of the shadow to Multiply and reduce its opacity.

Step 1 >> *Select, copy and paste the model twice to create two image layers. Fill the background with white.*

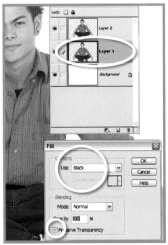

Step 2 >> *Select the lower image layer and fill the image area with black. Make sure that the preserve transparency option is selected.*

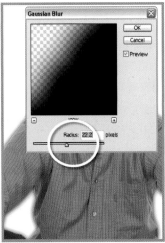

Step 3 >> *Use the Gaussian Blur filter to blur the shadow so that it shows as a halo around the top image layer.*

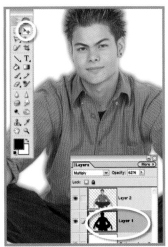

Step 4 >> *Use the arrow keys to move the shadow gradually upwards so that it shows to the left, right and above but not below the model. Change the blending mode to Multiply and adjust the opacity.*

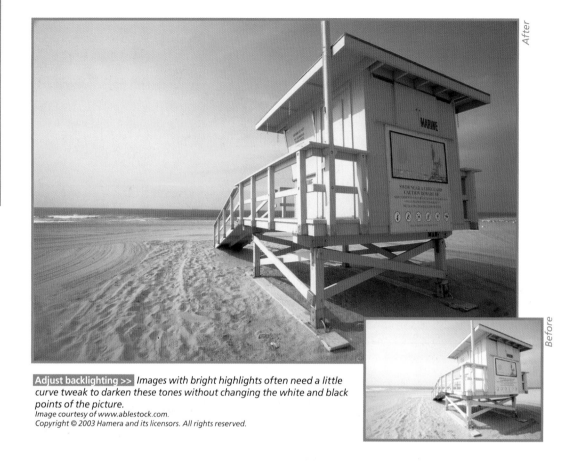

After

Before

Adjust backlighting >> *Images with bright highlights often need a little curve tweak to darken these tones without changing the white and black points of the picture.*
Image courtesy of www.ablestock.com.

4.13 Hidden 'Curves' features

Suitable for Elements – 1.0, 2.0 | Difficulty level – Basic | Resources – Web image 413
Related techniques – 3.01, 3.02, 3.04, 3.05 | Menu used – Enhance

One of the regular complaints from Photoshop enthusiasts trying to put Elements users in their place is that the program 'doesn't contain curves' and so can't really be considered as a serious photo enhancement package. It's true that the Curves feature in Photoshop does offer a great deal of flexibility and creativity over manipulating the tones in your image. In particular, it is a great way to lighten shadow areas and darken highlights and it is precisely these two tasks that I use Curves for most.

With this scenario in mind and not wanting to restrict Elements users from making these types of adjustments, Adobe created two new tools, Adjust Backlighting and Adjust Fill Flash, which can produce similar 'curve-like' results. I call them my 'hidden curves features' as they give me the control over highlight and shadows that I would normally exercise with Curves without the daunting Curves dialog. The 'tonal gain without the dialog pain' so to speak.

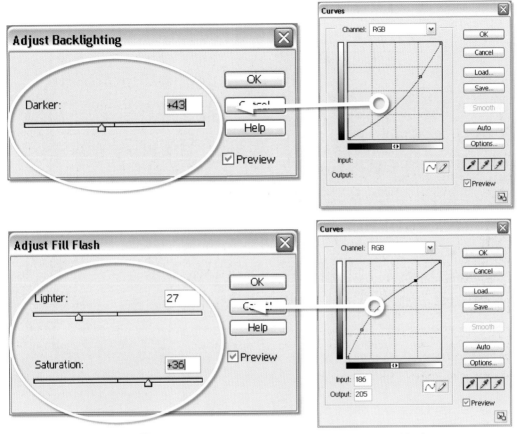

Photoshop curve equvalents >> *The adjust lighting features can be used to provide curve-like changes to your pictures. In this illustration the Elements adjust lighting features are teamed with the Photoshop curves adjustments that produce similar results.*

Adjust Backlighting

The Adjust Backlighting feature (Enhance>Adjust Lighting>Adjust Backlighting) is designed to darken the lighter tones in the image without flattening the highlights or moving the black point. By moving the slider to the right you will darken these tones.

Adjust Fill Flash

The Fill Flash feature (Enhance>Adjust Lighting>Fill Flash) is designed to lighten shadow areas. In version 1 of the program the feature contained a single Lighter slider but with the release of Elements 2.0 Adobe added a Saturation control as well. This tool needs careful application as the effect is easily overdone and when this happens the tonal enhancement become coarse and obvious.

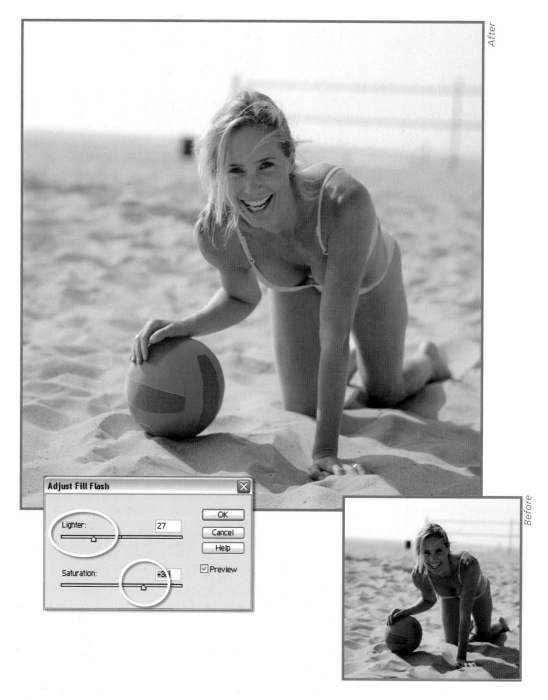

After

Before

Fill Flash >> *The Fill Flash feature is particularly useful for lightening the shadows in backlit images such as this beach example. The feature takes its name from the technique of using an on-camera flash in daylight to lighten the shadows caused by direct sunlight. This way of working is popular with photojournalists who in their haste to capture hard news images have little time to modify the lighting on their subjects.*
Image courtesy of www.ablestock.com.

Before

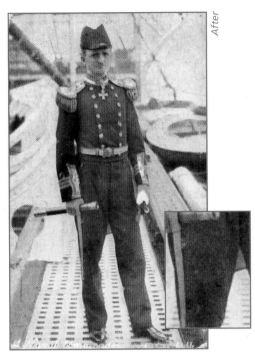
After

Removing dust automatically >> *One of the most tedious jobs for the digital photographer is the removal of dust and scratch marks from a badly damaged slide or print. Using the clone stamp tool to patch each individual mark can take considerable time and effort. A more automated approach that doesn't soften the detail in an image is detailed here. It uses the much besmirched Dust and Scratches filter in conjunction with the layer blending modes to restrict changes to just the areas where it is needed.*

4.14 Dust and scratches be gone

Suitable for Elements – 1.0, 2.0 | Difficulty level – Intermediate | Resources – Web image 414
Related techniques – 3.01, 3.02, 3.04, 3.05 | Menus used – Layer, Filter

The enticingly named Dust and Scratches filter (Filter>Noise>Dust and Scratches) teases us with the promise of a simple solution to repairing the dust and scratches in our scanned pictures. Nearly always the results of using the filter are disappointingly soft or the tones flattened. It is not that the filter doesn't obscure or disguise the problem marks it is just that, in doing so, the rest of the image is also filtered. In areas where there is no dust this causes a deterioration of the picture. If only we could restrict the application of the filter to just the areas where the dust marks appear the results would be more usable.

The Lighten and Darken blending modes in Elements can be used for just this purpose. By applying the Dust and Scratches filter to a copy of the background and then blending this filtered layer using the Darken mode, the layer will only change the light dust marks of the original image and will leave the rest of the image unaffected. Similarly a second copy layer also filtered for dust and scratches could also be applied to the original image using the Darken blending mode to remove the black marks from the picture.

> *Pro's Tips for using the Dust and Scratches filter:*
>
> *1. Always start with both sliders set to 0.*
>
> *2. Move the Radius slider first until the marks dissappear.*
>
> *3. Next move the Threshold slider until the texture of the image returns. Do not move this slider so far that the marks start to reappear.*

Using this technique it is possible to restrict the changes made by the Dust and Scratches filter to just the areas where it is needed.

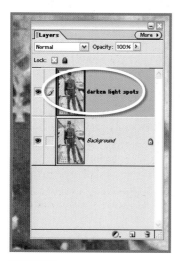

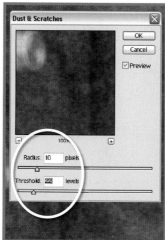

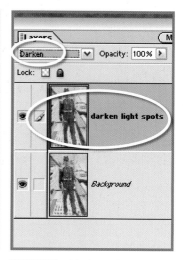

Step 1 >> *Start the technique by copying the base layer by dragging the background to the new layer button at the bottom of the layers palette. Label the new layer Darken Light Spots.*

Step 2 >> *With the new layer selected apply the Dust and Scratches filter. Start with both sliders set on 0. Move the Radius slider first until you see the dust spots disappear. Next gradually move the Threshold slider to the right until the texture returns to the picture. Not so far that you start to see the spots again.*

Step 3 >> *With the Darken Light Spots layer still selected change the mode of the layer to Darken. This will only apply the dust and scratches changes to the areas where this original layer is lighter – the white dust spots.*

Step 4 >> *Create a copy of the background layer by dragging it to the new layer button. Label the new layer Lighten Dark Spots.*

Step 5 >> *Apply the Dust and Scratches filter to the new layer, this time adjusting the settings to concentrate on the black marks on the picture. After filtering change the mode of this layer to Lighten.*

Step 6 >> *You can choose to keep the image as three separate layers or flatten the picture so that it contains only a background layer.*

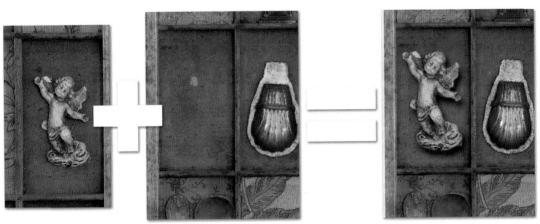

Montaging picture parts >> *Selecting, copying and pasting picture parts from one image to another is a basic skill that most digital photographers should learn. Seamless integration is based on careful selection techniques so it is on developing these skills that you should spend your time.*

4.15 Combining images seamlessly

Suitable for Elements – 1.0, 2.0 | Difficulty level – Intermediate | Resources – Web images 415-1, 415-2
Related techniques – 3.01, 3.02, 3.04, 3.05 | Tools used – Selection tools | Menus used – Select, Layer

One of the most basic yet critical skills for any digital photographer to learn is the art of careful selection of image parts. Whether you need to isolate a portion of a picture so that it is not affected by a filter, or use a selection as a prelude to copying an image section from one photograph to another, being able to manipulate your program's selection tools is a very important skill.

The success of a simple task such as creating a montage from two separate pictures is largely dependent on how well the image parts are isolated and copied. As an example I will add an extra ornament from a separate picture to an existing shadow box image and in the process demonstrate some basic selection and montaging steps that will help you to increase your image editing skills.

With both images open in Elements check to see that they are similar in size by viewing both the images at the same magnification. Make image size adjustments using the Scale feature. This step can also be performed after copying and pasting have occurred. Using the Lasso tool carefully work your way around the edge of the subject to be copied, in this example it is an angel, being sure to pick out as much edge detail as possible. In scenarios where there is more contrast between the edge and the background the Magnetic Lasso could be used instead.

Most selections are not perfect first time round, but rather than scrapping the initial selection try using the modifying keys to adjust your results. To take away part of the selection hold down the Alt (Option – Mac) key and draw around the area. Increase the image magnification to ensure accuracy around areas or detail.

To add to the selection hold down the Shift key and draw around the image part to be included. These keys work with all selection tools and can be used repeatedly to build up a perfect result. Keep in mind that you can switch between any of the selection tools during the modification process.

At this point a lot of digital photographers would copy the angel and paste it onto the shadow box image, but such an action can produce a very sharp edge to the selection, which is a dead give-away in the final montage. The best approach is to apply a little feathering (Select>Feather) to the edge of the selection before copying. In most cases a value of between 1 and 3 pixels will give a realistic result.

With the feather applied copy (Edit>Copy) the selected portion of the image. This action stores the copy in the computer's memory ready for the Paste command.

Switch to the shadow box image and paste the copied angel onto the picture. At this point you should see the object sitting on top of the shadow box picture. Any problems with the relative sizes of the two images will now become obvious. To make small changes in size you can use the Image>Transform>Free Transform tool.

When the angel picture was pasted onto the shadow box image a new layer was created. Keeping these two image parts on separate layers means that they can be altered, edited and moved independently of each other, just keep in mind that the changes will only be made to the layer that is selected. Using the Move tool the angel picture is placed in the spare box space in the shadow box.

Edit>Paste >> *When part of a picture is selected, copied and pasted into a different document Elements automatically creates a new layer to hold the pasted part. Having the element stored separately means that you can easily move, scale, change brightness or even add texture without altering the background image. In the example I added a drop shadow to the separate layer to help unify the new subject with the background.*

Step 1 >> *Open both images into the Elements workspace. Check their relative sizes by displaying them at the same magnification rate.*

Step 2 >> *Carefully select the subject to be copied using your favorite selection tool. Zoom in closer to ensure accuracy.*

Step 3 >> *Feather the selection slightly (1–2 pixels) to ensure that the edge of the copied part is not too crisp to appeal real.*

Step 4 >> *Copy the selected picture part. This places the part into the computer's memory.*

Step 5 >> *Click onto the background document to make it active and paste the copied part. Use the Move tool to position it and if need be, use the Free Transform tool to adjust its size to suit.*

Step 6 >> *To complete the illusion add a drop shadow to the object. Make sure that the size and direction of the shadow is consistent with the others in the background+.*

As a final touch of realism a small drop shadow is applied to the angel using the Layer Styles –Drop Shadow options. The direction and size (shadow distance) of the shadow can be altered via the Layer>Layer Styles>Style Settings dialog box. The shadow helps integrate the new picture element with the other ornaments already in the box.

Typically as your skills increase you will attempt more and more complex selection tasks, some of which may take many minutes to complete. For this reason Adobe has included in version 2.0 of Elements a Save Selection (Select>Save Selection) feature that will allow you to store a copy of your carefully created selection with your image file ready for later use.

Input a name for the selection in the Save Selection dialog. It is good practice to save progress on complex selections as you go. This way if at any point you lose the work you have done you can simply reload the lost selection.

Reinstating a saved selection is as simple as selecting the Load Selection option from the Select menu (Select>Load Selection) and choosing the particular selection name from the drop-down menu.

5

Making Better Panoramas

When Adobe Photoshop Elements was first released one of the real bonuses of the program was the inclusion of the Photomerge technology. Designed to stitch together a series of overlapping images to form a wide vista print this feature really sets hearts racing amongst those of us with a secret passion for panoramas. There is just something about a long thin photograph that screams special to me. I have often dreamt of owning a camera capable of capturing such beauties, but alas the bank balance always seems to be missing the required amount that would be needed to make such a purchase.

And to be honest, the pragmatist in me also has to admit that the comparatively few shots that I would take in this format would not warrant the expense. It was in the midst of such thoughts a couple of years ago that I was first introduced to Photomerge, which has proven to be a solution to my 'wide vista' problems that suited both my budget and my infrequent production.

The feature combines several overlapping images to form a new wide angle photograph. Once in this form the panorama can be treated like any other Elements document, providing photographers with the ability to create truly stuning and interesting, wide, thin, compositions.

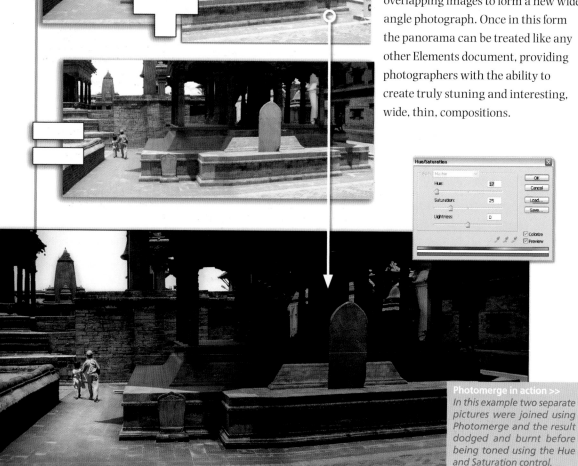

Photomerge in action >>
In this example two separate pictures were joined using Photomerge and the result dodged and burnt before being toned using the Hue and Saturation control.

Photomerge Stitching Summary

Starting a new panorama	Select Photomerge from the File menu (File>Create Photomerge) to start a new panorama.
	Click the Browse button in the dialog box.
	Search through the thumbnails of your files to locate the pictures for your panorama.
	Click the Open button to add files to the Source files section of the dialog.
	Version 1.0 only – Set the Image Size Reduction amount to reduce source file sizes. If you are using images greater than 2 megapixels then a setting of 50% or more should be used.
	Version 1.0 only – To get Elements to lay out the selected images check the 'Attempt to Automatically Arrange Source Images' box for manual layout control; leave the box unchecked.
	Version 1.0 only – If you are using the 'Automatic Arrange' option then you can also choose to apply perspective correction across the whole of the composition. Do not use this feature if the panorama covers an angle of view greater than 120°.
	Select OK to open the Photomerge dialog box. Edit the layout of your source images.
Editing in Photomerge	To change the view of the images use the Move View tool or change the scale and the position of the whole composition with the Navigator.
	Images can be dragged to and from the light box to the work area with the Select Image tool.
	With the Snap to Image function turned on, Photomerge will match like details of different images when they are dragged over each other.
	Ticking the Use Perspective box will instruct Elements to use the first image placed into the layout area as the base for the composition of the whole panorama. Images placed into the composition later will be adjusted to fit the perspective of the base picture.
	The Cylindrical Mapping option adjusts a perspective corrected image so that it is more rectangular in shape.
	The Advanced Blending option will try to smooth out uneven exposure or tonal differences between stitched pictures.
	The effects of Cylindrical Mapping as well as Advanced Blending can be viewed by clicking the Preview button.
	If the source images do not quite line up using the authomatic 'Snap to' setting you can manually drag to reposition or rotate any picture by clicking on the Rotate Image and Select Image tools from the toolbar and then clicking on the image to adjust.
Producing the panorama	The final panorama file is produced by clicking the OK button.

Photomerge basics>>
For those readers who are new to the feature use the workflow in the table aside, to guide you through making your first Photo-merge panorama. Once you are confident with creating simple wide vista images using the feature, work through the advanced techniques discussed in the rest of the chapter to refine your panoramic prowess.

The technology behind the 'Image Stitching' idea is simple. Shoot a range of images whilst gradually rotating a standard camera so that each photograph overlaps the next. Next import the pictures into Elements and then Photomerge and proceed to stitch the images together to form a wide, no make that very wide, panoramic picture.

Pro's Tips for great panoramas:

1. Panoramas are first and foremost a photographic exercise. Composition, lighting and point of view are all critical, although they have to be dealt with differently to traditional photography.

2. Adobe Photoshop Elements is your friend. Use it to fix problem areas in your finished panorama.

3. If possible use a special panorama head to capture your pictures. If you can't afford a commercial model search the net for plans of a DIY version for your camera and lens combination.

From here the photo could be printed, or if the original series of images covered the full 360 degrees of the scene with the first and last pictures overlapping, a special 'wrap-around view', called virtual reality (VR) panorama, could be produced. Programs like Apple's QuickTime use these 360 panoramas and allow the viewer to stand in the middle of the action and spin the image around. It is like you are actually there.

Despite the comparative ease with which the Photomerge feature stitches images together the best quality panoramas are made when attention is paid to every step of the capture, stitch and print process. The following techniques go beyond the basic steps needed to create a panorama and will help you produce the best pictures possible with the Photomerge system.

Photomerge >>
The Photomerge feature in Elements is speciallly designed to stitch together a series of overlapping pictures to form a panorama.

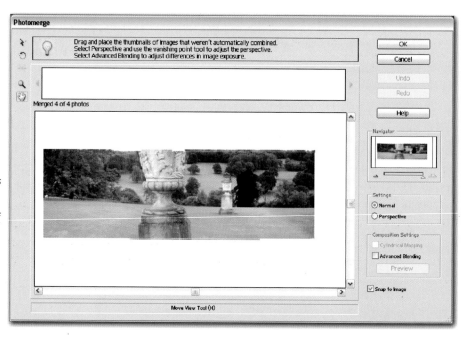

Advanced shooting techniques

When producing great panoramas the importance of the photographic step in the process cannot be underestimated. It is here that much of the final quality of your VR scene is determined. A few extra minutes taken in the setting up and shooting phases will save a lot of time later sitting in front of the computer screen fixing problems.

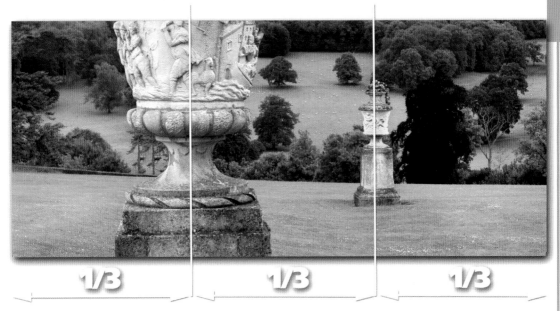

Rule of thirds >> *The same ideas of composition should be followed when making decisions about where to position the camera to capture a panorama sequence of pictures. To ensure that the resultant wide vista picture contains all the drama of a traditional photograph you should ensure that the fore, mid and background details are all present in the final stitched picture.*

5.01 Positioning the camera
Suitable for Elements – 1.0, 2.0 | Difficulty level – Basic
Related techniques – 5.02

Photographers have long prided themselves in their ability to compose the various elements of a scene so that the resultant picture is dynamic, dramatic and balanced. These aims are no less important when creating panoramic images, but the fact that these pictures are constructed of several separate photographs means that a little more thought needs to be given to the positioning of the camera in the scene. For the best results the photographer needs to try and pre-visualize how the final picture will appear once the single images are combined and then select the camera's position.

One common mistake is to move to the center of the environment, set up the equipment and create a sequence of images with most of the subject detail in the mid or background of the picture. This type of panorama provides a good overview of the whole scene but will have little of the drama and compositional sophistication that a traditional picture with good interaction of foreground, mid ground and background details contains.

When deciding on where to position your camera sweep the area whilst looking through the viewfinder. Ensure that the arc of proposed images contains objects that are close to the camera, contrasted against those subjects that are further into the frame.

Camera positioning >> *Unlike traditional photography the panoramic image maker must pre-visualize how the stitched picture will appear when considering where to position the camera.*

Pro's Tip: Extend this compositional idea further by intentionally positioning the nearest and most dramatic objects in the scene one third (or two thirds) of the way into the sequence of images. This will provide balance to the photograph by positioning this point of focus according to the 'rule of thirds' in the final panorama.

5.02 Camera support

Suitable for Elements – 1.0, 2.0 | Difficulty level – Intermediate
Related techniques – 5.02, 5.09

Though not essential for shooting the odd sequence of images, most panoramic professionals insist on using a tripod coupled with a special panoramic head to capture their pictures. The tripod provides a stable and level base for the camera; the panoramic head positions the camera and lens precisely over the pivot point of the tripod and also contains regular click stops to indicate points in the spin to capture a photograph. Each stop is designed to provide optimum coverage for each frame taking into account the required edge overlap.

This setup increases the effectiveness of your stitching software's ability to accurately blend the edges of your images. Companies like Kaidan (www.kaidan.com), Manfrotto (www.manfrotto.com) and Peace River Studios (www.peaceriverstudios.com) manufacture VR equipment specifically for

particular cameras and lenses. You can purchase a tripod head designed specifically for your camera or choose a head that can be adjusted to suit any camera.

Why all this bother with specialized equipment? Photomerge's main task is to seamlessly blend the edges of overlapping images. This is best achieved when the edge details of the two pictures are as similar as possible. Slight changes in the relationship of the objects in the scene will cause problems when stitching, often resulting in 'ghosting' of the objects in the final panorama. Now for the occasional Photomerge user this is not too big a deal as a

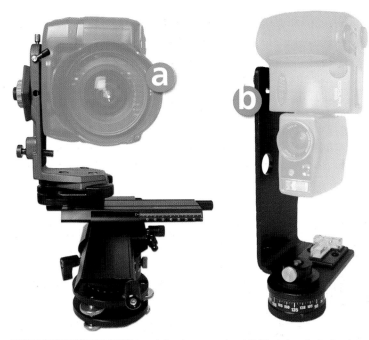

Panoramic tripod heads >> *Specialized panoramic or VR (virtual reality) tripod heads are perfect for ensuring that the lens' nodal point is over the pivot point of the tripod. This precision pays dividends at stitching time as Photomerge will produce much better results when the edges of sequential images can be exactly matched. (a) Adjustable Manfrotto VR head suitable for a range of cameras. (b) Camera specific Kaidan head suitable for a single camera body only.*

little deft work with your Elements editing tools and the picture is repaired (see technique 5.09), but frequent panorama producers will want to use a technique that produces better results faster. Using a special VR (virtual reality) or panoramic tripod head produces such results by positioning the 'nodal point' of the lens over the pivot point of the tripod. Images shot with this setup will have edges that match more evenly, which means that Photomerge can blend these overlapping images more successfully and accurately.

Finding the nodal point

If you have a VR head designed specifically for your camera and lens then the hard work is already complete. Simply set up the equipment according to the manufacturer's instruction and you will be taking 'nodal point correct' pictures in no time. If , however, you are using a fully adjustable VR head or you just want to find the nodal point for a specific camera and lens combination you can use the following techniques as a guide.

Some camera or lens manufacturers provide details about the nodal points of their products, but on the whole, this type of data is hard to find and it is up to the shooter to determine the nodal point of his/her own equipment. For this the main method is usually referred to as the 'lamp post' test and is based on a two-step process. With the camera set up and levelled on a panoramic head use the

step-by-step guide to find the nodal point.

If the lens' nodal point is rotating over the tripod pivot point then the visual distance (gap) will remain the same throughout the movement. If the distance changes then the lens is not positioned correctly and needs to be moved either forward or backwards to compensate.

With a little trial and error you should be able to locate the exact nodal point for each of your lenses, cameras and lens zoom points. VR tripod heads like those made by Manfrotto excel in this area. The fine-tuning controls and setup scales enable the user to accurately locate and note the position of the nodal points for

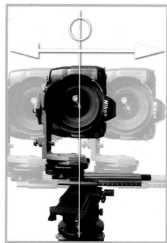

Left to right adjustment >>
The lens and tripod should be viewed from the front and the lens position adjusted from left to right until it sits vertically above the tripod's pivot point.
You can check your positioning skills by turning the camera 90 degrees down (so that the lens faces the tripod pivot) and confirming that the pivot point is located centrally in the ICD preview screen. This is the easy part.

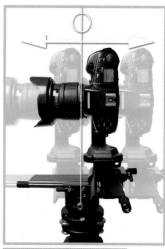

Front to back adjustment >>
Move the camera back and forward to find the nodal point of the lens.
Set camera and tripod up so that there is a vertical object such as a lamp post or sign very near the camera and a similar vertical object in the distance. The closer the foreground object the more accurate the results of the test will be.
Watching the LCD preview screen (or looking through the viewfinder in an SLR camera) rotate the camera and compare the distance between the foreground and background objects.

a variety of lenses and/or cameras. With the tests complete the results should be recorded and used whenever the same camera setup is required again.

Pro's Tip: If you don't have a special panoramic head try rotating the camera around the lens rather than pivoting around your body. Also if you are shooting 'hand-held' use longer focal lengths rather than wide angle lenses; this will help with stitching later.

Handy Guide to Nodal Point Corrections

Use these rules to help you correct nodal point errors:

1) Moving the lens backward, if rotating the camera away from the foreground object, increases the visual gap, or

2) Moving the lens forward, if rotating the camera away from the foreground object, decreases the visual gap.

Nodal point errors >> *Many stitching errors are the result of source images being shot with the camera and lens not being centered over the nodal point.*

5.03 Exposure

Suitable for Elements – 1.0, 2.0 | Difficulty level – Basic
Related techniques – 2.03, 5.11

As the lighting conditions can change dramatically whilst capturing the sequence of images you need to make up a panorama, it is important that the camera's exposure be set manually. Leaving the camera set to auto exposure (Program, Aperture priority or Shutter speed priority) will result in changes in brightness of sequential images, especially if you are capturing pictures throughout a full 360 degree sweep of the scene.

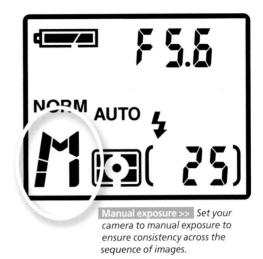

Manual exposure >> *Set your camera to manual exposure to ensure consistency across the sequence of images.*

Take readings from both the shadow and highlight areas in several sections of the environment before selecting an average exposure setting, or one that preserves important highlight or shadow detail. Lock this shutter speed and aperture combination into your camera and use the same settings for all the source images. If the scene contains massive changes in brightness this will mean that some parts of the picture are rendered pure white or pure black (with no details), then you may want to consider using the steps in technique 5.11 as a way of capturing more details in these areas. To ensure that you have sufficient picture data to complete the technique capture two or three complete sequences with varying exposures. The exposure for one sequence should be adjusted to record highlights, one for shadows and if required a third can be used to capture mid tones.

Pro's Tip: Use your camera's exposure bracketing system to shoot the over-, mid and under-exposures automatically.

1/60th f 16

Average exposure>>
To help ensure that your exposure setting is suitable for all the source images take several readings from all over the scene and then change your camera to the average of these results.

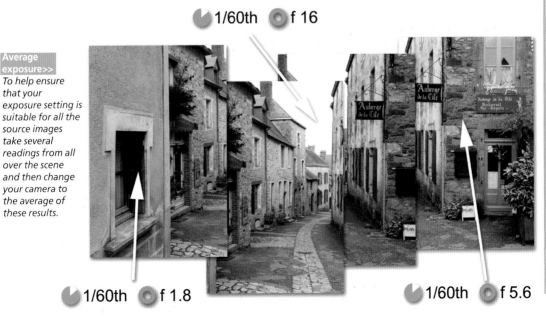

1/60th f 1.8

1/60th f 5.6

5.04 Focus and zoom

Suitable for Elements – 1.0, 2.0 | Difficulty level – Basic
Related techniques – 5.05

A similar problem of differences from image to image can occur when your camera is set to auto-focus. Objects at different distances from the camera in the scene will cause the focus to change from shot to shot, altering the appearance of overlapping images and creating an uneven look in your final panorama. Switching to manual focus will mean that you can keep the point of focus consistent throughout the capture of the source images. In addition to general focus changes, the zoom setting (digital or optical) for the camera should not be changed throughout the shooting sequence either.

Pro's Tip: When setting your focus also consider the depth of field that you desire for the image.

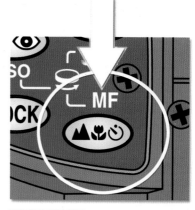

Manual focus>> *Switch your camera to manual focus and then set the distance to encompass the subjects in the scene taking into account 'depth of field' effects as well.*

Focus and DOF >> *Ensure that you consider focus and depth of field at the same time as both these variables will affect the subject sharpness in your source images. (a) Sharp foreground detail. (b) Background unsharp due to shallow DOF.*

5.05 Depth of field

Suitable for Elements – 1.0, 2.0 | Difficulty level – Basic
Related techniques – 5.04

Despite the fact that cameras can only focus on one part of a scene at a time (focus point) most of us have seen wonderful landscape images that look sharp from the nearest point in the picture right through to the horizon. Employing a contrasting technique, many contemporary food books are filled with highly polished pictures where little of the shot is sharp. I'm sure that you have seen images where only one tiny 'basil' leaf is defined whilst the rest of the food and indeed the plate is out of focus. Clearly focusing doesn't tell the whole sharpness story.

This phenomenon of changing degrees of sharpness in a picture is referred to as the 'depth of field of acceptable sharpness' or DOF. When shooting panoramas it is important to know the factors that control this range of sharpness and, more importantly, how to control them.

DOF is controlled by three distinct photographic variables –

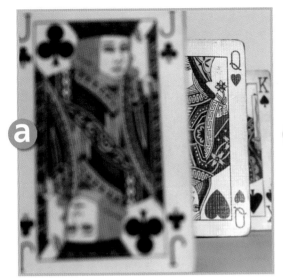

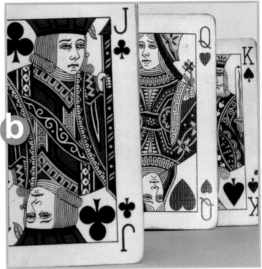

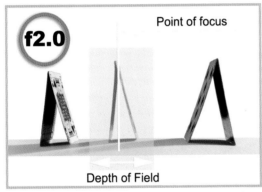

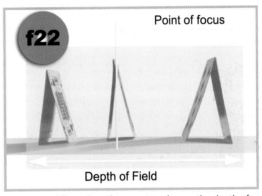

Aperture and DOF >> *Most photographers turn to their aperture control first when thay want to change the depth of field of sharpness in their images. (a) A small aperture number produces pictures with a shallow depth of field. (b) Selecting a large aperture number produces a larger depth of field.*

Aperture – Changing the aperture, or F-Stop number, is the most popular technique for controlling depth of field. When a high aperture number like F32 or F22 is used, the picture will contain a large depth of field – this means that objects in the foreground, middle ground and background of the image all appear sharp. If, instead, a low aperture number is selected (F1.8 or F2), then only a small section of the image will appear focused, producing a shallow DOF effect.

Focal length – The focal length of the lens that you use to photograph also determines the extent of the depth of field in an image. The longer the focal length (more than 50 mm on a 35 mm camera) the smaller the depth of field will be, the shorter the focal length (less than 50 mm on a 35 mm camera) the greater DOF effect.

Distance from the subject – The distance the camera is from the subject is also an important depth of field factor. Close-up, or macro photos, have very shallow DOF, whereas landscape shots where the main parts of the image are further away have a greater DOF. In other words the closer you are to

the subject, despite the aperture or lens you select, the shallower the DOF will be in the photographs you take.

As most panoramic pictures require sharp details in the fore, mid and background you should practise setting up your camera for the largest depth of field possible. This means selecting a high aperture number, wide angle lenses and increased camera-to-subject distances where ever possible. It is also good practice to take a couple of test shots of sections of the scene and review these on the LCD monitor on the back of the camera (using the magnification option) to ensure that you have sharpness in the areas of the picture that you desire.

Use the table below as a quick guide for setting up your camera for either shallow or large depth of field effects.

Depth of field effect required	Aperture number	Focal length	Subject to camera distance
Shallow	Low (e.g. F 2.0, 2.8)	Longer than standard (e.g. 120 mm)	Close
Large	High (e.g. F 22, 32)	Wider than standard (e.g. 24 mm)	Distant

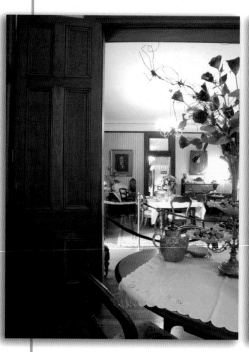

White balance errors >>
Shooting with your camera set to the 'auto' white balance setting can cause inconsistent color between sequential source images. Switching your camera to a mode that suits the dominant light source for the scene will produce more even results.

5.06 White balance

Suitable for Elements – 1.0, 2.0 | Difficulty level – Basic
Related techniques – 2.07

As we have already seen in Chapter 2 the white balance feature assesses not the amount of light entering the camera, but the color, in order to automatically rid your images of color casts that result from mixed light sources. Leaving this feature set to 'auto' can mean drastic color shifts from one frame to the next as the camera attempts to produce the most neutral result. Switching to manual will produce images that are more consistent but you must assess the scene carefully to ensure that you base your white balance settings on the most prominent light source in the environment.

For instance if you are photographing an indoors scene that combines both daylight through a window and domestic lights hanging from the ceiling then the auto white balance feature will alter the color of the captured images throughout the sequence. Switching to manual will allow you to set the balance to match either of the two light sources or even a combination of both using the preset feature (see technique 2.07).

5.07 Timing

Suitable for Elements – 1.0, 2.0 | Difficulty
level – Basic | Related techniques – 5.09

Though not strictly a photographic technique, timing is very important when photographing your sequence of images. Objects that move in the frame or are positioned at the edges of one picture and not the next cause stitching problems when Photomerge tries to blend the edges. The best approach to solving this problem is to wait until the subjects have moved through the frame before capturing the image.

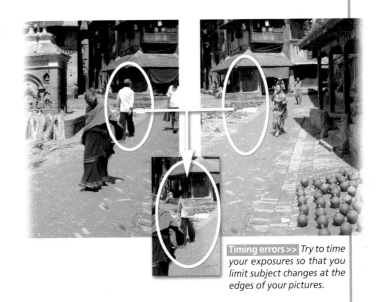

Timing errors >> *Try to time your exposures so that you limit subject changes at the edges of your pictures.*

A similar solution can be used when photographing in changing lighting conditions. For instance, if you start to capture a sequence of images in full sunshine only to find that half way through a rouge cloud shadows the scene, then it is best to wait until the sun is shining again before recommencing the capture.

Even though I present some editing techniques later in the chapter that will help you rectify these types of problems the best solution is always to try and capture the most accurate and error-free sequence of source images. In this situation 'prevention is better than cure' and definitely more time efficient as well.

5.08 Ensuring consistent overlap

Suitable for Elements – 1.0, 2.0
Difficulty level – Basic

As you are capturing, ensure that the edges of sequential images are overlapping by between 10 and 50 percent. The exact number of images needed to complete the sweep of the vista or the full circle will depend on the angle of view of the lens as well as the amount of overlap that you have used.

A quick way of calculating the pictures needed for 50% overlap is to count the number of images required to complete a full 360 degree rotation with no overlap and then multiply this value by 2. Or alternatively you can use the Apple recommendations detailed below as a starting point for the number of 50% overlap portrait images required to construct a 360 degree panorama.

Professional VR heads ensure overlap consistency by placing 'click-stops' at regular points on the circumference of the head. On many models this is a variable feature that allows the photographer to change the interval to suit different lenses and/or overlapping amounts. Those on a more modest budget can mark regular intervals on their tripod head using a protractor or use the grid within the camera's viewfinder as a guide.

Pro's Tip: Some cameras such as the Nikon Coolpix 4500 and 5400 provide a special panorama mode that ghosts the previous shot in the LCD screen so that you can line up or overlap the next picture accurately.

Click-stop heads >> *To evenly space sequential image capture points and ensure consistent overlap some companies like Kaidan (www.kaidan.com) produce panorama tripod heads with a built-in 'click-stop' system. The number of stop points is dependent on the angle of view of the lens used to capture the source pictures.*
(a) Rotating the camera and stopping to capture picture.
(b) A variety of click-stop disks designed for use with different camera lenses or zoom settings.

Focal length in mm (35 mm equivalent)	Number of Images required for 360 degree panorama
14	12
18	12
20	12
24	18
28	18
35	20
42	24
50	28

Number of images for 360 degrees >>
Use the table above to calculate the number of overlapping pictures you will need to capture to create a 360 degree panorama.

5.09 Dealing with the moving subject

Suitable for Elements – 1.0, 2.0 | Difficulty level – Intermediate
Related techniques – 5.07 | Tools used – Clone Stamp, Selection tools | Menus used – Filter, Edit

One of the banes of the panoramic photographer's life is the subject that moves during a shooting sequence. These may be people, cars or even clouds but no matter how good your nodal point selection or stitching is, these moving subjects cause very noticeable errors in panoramas. The stitched picture often features half a person, or object, as a result of Photomerge trying to match the edges of dissimilar pictures.

These problems can be fixed in one of two ways – either remove or repair the problem area.

(a) Remove – To remove the problem you can use the Clone Stamp tool to sample background parts of the scene and paint over stitching errors. The success of this type of work is largely based on how well you can select suitable areas to sample. Color, texture and tone need to be matched carefully if the changes are to be disguised in the final panorama.

Be careful though as repeated application of the Clone Stamp tool can cause noticeable patterns or smoothing in the final picture. These problems can be disguised by adding a little noise (Filter>Noise>AddNoise) to the image.

(b) Repair – In some instances it is easier to select, copy and paste the damaged subject from the original source image into the flattened panorama picture. This approach covers the half blended subject with one that is still complete. If you have used the Perspective option in Photomerge or have resized the

Step 1 >> *Using the Clone Stamp tool, sample the background around the moving subject and paint over the offending area.*

Step 2 >> *As repeated stamping can produce a noticeable smoothing of the treated area, disguise the effects by adding a little texture back to the picture with the Add Noise filter.*

Step 1 >> *Using one of the selection tools, outline the problem area in the original source image.*

Step 2 >> *Feather the selection by a couple of pixels. This will help blend the selected area when it is added to the panorama.*

panorama then you will need to adjust the pasted subject to fit the background. Use the Elements transformation tools such as rotate, perspective and scale to help with this task.

Adjusting the opacity of the pasted subject while you are transforming will help you match its details with those beneath. When complete the opacity is changed back to 100%. Finishing touches can be applied to the edges of the pasted images to ensure precise blending with the background with the Eraser tool.

Step 3 >> *Copy the selected area (Edit>Copy), click onto the panorama document and paste (Edit>Paste) the selection. Use the Move tool to move the copy into position.*

Step 4 >> *Use the Eraser tool set to a soft edge and low opacity to help blend the edges of the pasted selection into the background.*

Pro's Tip: Apply a slight feather (Select>Feather) to the selection before copying and pasting. This will help disguise the sharp crisp edge that is the tell-tale sign of so many repair jobs. A setting of 1 or 2 pixels at the most will be sufficient.

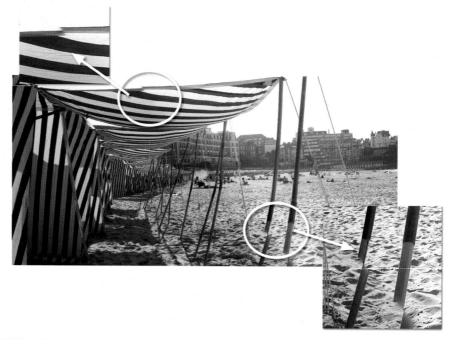

Misalignment >> *When capturing source images by hand, or using a standard tripod, slight changes in perspective and position result in Photomerge having dificulty in matching the edges of sequential pictures. The misaligned picture parts need to be edited and rebuilt using a combination of the approaches outlined in technique 5.09.*

5.10 Fixing misaligned picture parts

Suitable for Elements – 1.0, 2.0 | Difficulty level – Intermediate
Related techniques – 5.09 | Tools used – Clone Stamp tool

Shooting your source sequence by hand may be your only option when you have forgotten your tripod or you are purposely travelling light but the inaccuracies of this method can produce panoramas with serious problems. One such problem is ghosting or misalignment. It is a phenomenon that occurs when edge elements of consecutive source pictures don't quite match. When Photomerge tries to merge the unmatched areas of one frame into another the mismatched sections are left as semi-transparent, ghosted or misaligned.

The affected areas can be repaired using the clone stamp techniques detailed in technique 5.09 but by far the best solution and certainly the most time efficient one is to ensure that the camera and lens nodal point are situated over the pivot of the tripod at the time of capture. A little extra time spent in setting up will save many minutes editing later.

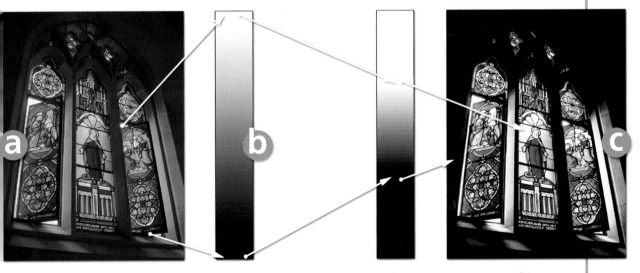

Too much contrast >> *When the contrast range of a scene exceeds the abilities of the camera's sensors, some of the details at the highlight and shadow end of the spectrum are lost. These details are converted to pure white and black. Panoramic pictures that encompass a wide angle of view often suffer from this problem. (a) Range of brightness and detail in the scene. (b) Brightness range of the scene is reduced (clipped) as it is recorded by the sensor. (c) Reduced range of detail and brightness as it is stored in the digital file.*

5.11 Coping with extremes of brightness

Suitable for Elements – 1.0, 2.0 | Difficulty level – Intermediate | Resources – Web images 511-1, 511-2, 511-3
Related techniques – 5.03 | Menus used – Layer

Both film and digital cameras have a limit of the range of brightness that they can capture before details in shadow and highlight areas are lost. For most shooting scenarios the abilities of the average sensor or film is up to the job, but in certain extreme circumstances such as when a panorama encompasses both a view of a sunlight outdoors scene as well as a dimly lit interior the range of tones is beyond the abilities of these devices.

Rather than accept blown highlights or clogged shadows the clever panorama photographer can combine several exposures of the same scene to extend the range of brightnesses depicted in the image. The process involves shooting three (or two for less brightness difference) images of the one scene using different exposures. Each exposure is designed to capture either highlight, mid tone or shadow details. The difference in exposure should be great enough to encompass the contrast in the scene. These exposures can be captured automatically using the exposure bracketing technology that can now be found in most medium to high range digital cameras.

Combining the Three Images: With the three separate image documents open in Elements, hold down the Shift key and drag the background layers of two of the images onto the canvas of the third. Holding down the Shift key will make sure that the new layers are kept in register with the existing background. With the Layers palette open, rename and rearrange the layers so that they are ordered top to bottom – underexposed, normal and overexposed.

Changing the Overexposed Layer: To blend the overexposed image, firstly turn off the topmost layer (underexposed), then change the Normal layer's blending mode to Screen. Now select the overexposed layer and choose the levels function from the Enhance>Adjust Brightness/Contrast menu. Drag the white output slider towards the middle of the control, watching the results preview on screen. When the shadow details are visible and you are satisfied with the effect, click OK.

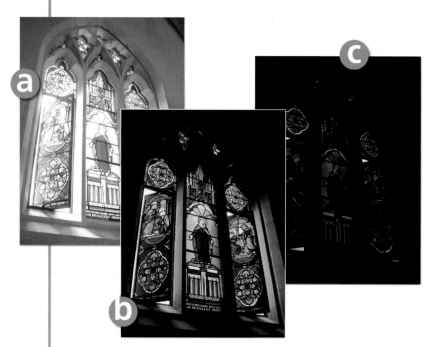

Capturing all the detail >> *With your camera fixed to a tripod, shoot three separate images adjusting the exposure settings to (a) two stops over indicated exposure, (b) indicated exposure and (c) two stops under the settings indicated by your camera.*

Changing the Underexposed Layer: To blend the underexposed image, select its layer and change the blend mode to multiply. With the layer still selected choose the levels function and drag the shadow output slider towards the center of the dialog. When the highlight and shadow details are visible and you are satisfied with the effect click OK. Save a layered version of this image as the original and a flattened (no layers) copy which can be imported into Photomerge as a source image for your stitch.

Step 1 >> *Open the images with different exposures. Tile the documents so that all pictures can be seen (Window>Images>Tile).*

Step 2 >> *Drag two of the pictures onto the third with the Move tool whilst holding down the Shift key.*

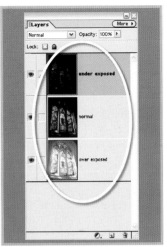

Step 3 >> *Arrange the layers so that from top to bottom they are positioned underexposed, normal and overexposed. Name the layers.*

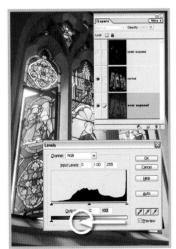

Step 4 >> *Change the normal layer's mode to Screen. With the overexposed layer selected, choose the Levels function (Enhance>Adjust Brightness/Contrast>Levels). Drag the white point output slider towards the center of the dialog.*

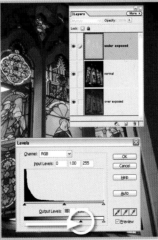

Step 5 >> *Change the mode of the underexposed layer to multiply. Select the Levels feature and move the black point ouput slider towards the center of the dialog.*

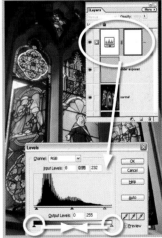

Step 6 >> *To fine-tune the process, apply a levels adjustment layer (Layer>New Adjustment Layer>Levels) to the stack, being sure not to clip newly created highlight and shadows detail.*

5.12 Creating artificially increased DOF

Suitable for Elements – 1.0, 2.0 | Difficulty level – Intermediate
Related techniques – 5.06 | Tools used – Selection tools, Eraser | Menus used – Edit

In some environments it may not be possible to gain enough depth of field to extend the sharpness from the foreground details into the background of the picture. In these circumstances you can still simulate this large depth of field by shooting two different sets of source images, one with focus set for the foreground objects and a second set for the background details. Later at the desktop the sharp detail from the foreground can be cut out and pasted over the background pictures.

As we have seen with other cut and paste techniques, a little feather applied to the selection before cutting helps to ensure a convincing result at the pasting stage.

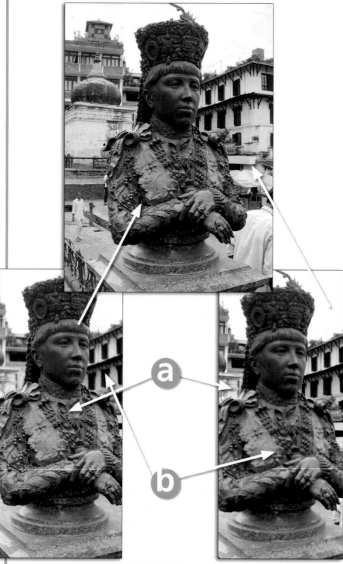

Step 1 >> *Open the two source files. Carfully select the foreground detail using your favorite selection tool. Feather the selection by 1 pixel.*

Step 2 >> *Copy and paste the selection onto the background, using the Move tool to position. Clean up with the Eraser tool if needed.*

Artificially increasing depth of field >> *Increase the amount of your panorama that appears sharp by cutting and pasting between two separately focused and shot sequences. (a) Sharp details. (b) Unsharp details.*

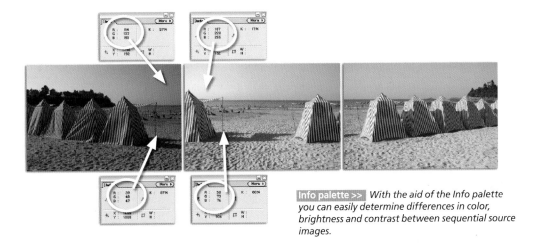

Info palette >> *With the aid of the Info palette you can easily determine differences in color, brightness and contrast between sequential source images.*

5.13 Correcting exposure differences

Suitable for Elements – 1.0, 2.0 | Difficulty level – Intermediate
Related techniques – 5.03, 5.14 | Tools used – Eyedropper tool | Menus used – Image, Window

Changes in density from one source image to the next can occur for a variety of reasons – the sun went behind a cloud during your capture sequence or the camera was left on auto exposure and changed settings to suit the 'through the lens' reading. The images that result vary in density. When these images are blended the change in tone is most noticeable at the stitch point in large areas of similar color and detail such as sky or road surface.

Auto Fixes – Photomerge contains an 'Advanced Blending' feature that tries to account for slight changes in overall density from one frame to the next by extending the graduation between one source image and the next. This 'auto' technique will disguise small variations in exposure and generally produce a balanced panorama, but for situations with large density discrepancies the source images may need to be edited individually.

Advanced Blending >> *The Advanced Blending option in Photomerge can help to disguise slight differences in contrast, brightness and color.*

Manual Fixes – The simple approach to balancing the density of your source images is to open two or more of the pictures and visually adjust contrast and brightness using tools like the Levels feature. For a more precise approach it would be useful to know the exact values of the same section of two overlapping images. The Info palette in Elements displays the RGB values of a specific area in a picture. When used in conjunction with the Levels feature it is also possible to display the values before and after density changes. Knowing the RGB values of the first image, you can alter the values in the second to match, thus ensuring a seamless stitch.

Pro's Tip: This process is time consuming and is a 'work around' for what is essentially a flaw in your shooting technique. So if your source images continually need this level of adjustment revisit the process you use to capture you pictures and ensure that
• you have your camera set to manual exposure and
• you are capturing all the source images under the same lighting conditions.

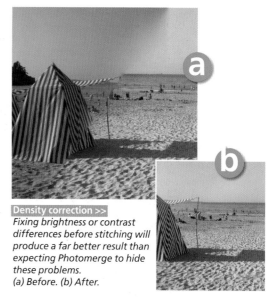

Density correction >>
Fixing brightness or contrast differences before stitching will produce a far better result than expecting Photomerge to hide these problems.
(a) Before. (b) After.

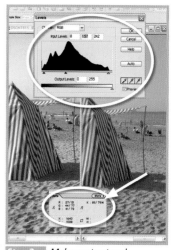

Step 1 >> *Open a picture with good brightness and contrast as well as the picture that needs adjusting. Also display the Info palette (Window>Info).*

Step 2 >> *Click onto several matching points on both pictures taking note of the red (R), green (G), blue (B) and grayscale (K) settings for each.*

Step 3 >> *Make contrast and brightness adjustments to the problem image checking the changed readings in the Info palette as you go until both pictures display similar values.*

5.14 Adjusting for changes in color balance

Suitable for Elements – 1.0, 2.0 | Difficulty level – Intermediate
Related techniques – 5.13 | Tools used – Eyedropper tool | Menus used – Image, Window

Slight changes in the color balance of sequentially shot images can result from using the auto white balance feature to rid images of casts resulting from mixed light sources. As the color of each frame is assessed and corrected independently, changing subject matter can cause such color shifts. More uniform results are obtained if the white balance is set based on the primary light source in the scene and then kept constant for the rest of the shooting sequence.

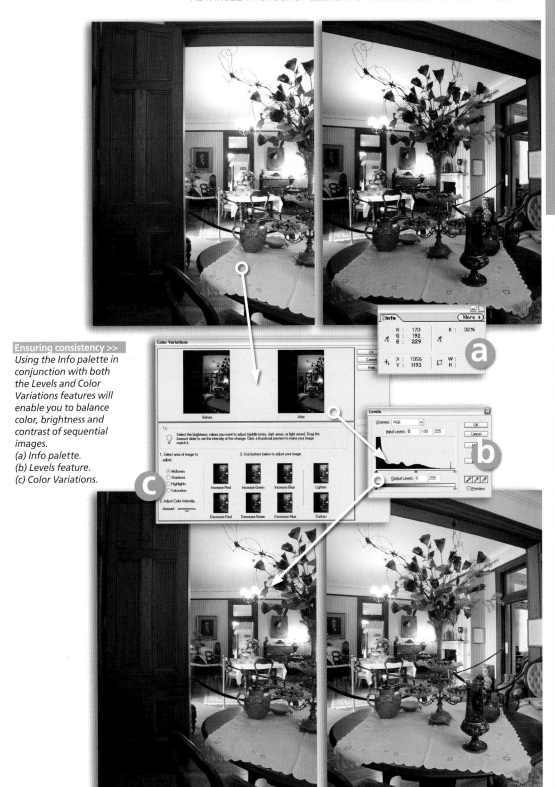

Ensuring consistency >>
Using the Info palette in conjunction with both the Levels and Color Variations features will enable you to balance color, brightness and contrast of sequential images.
(a) Info palette.
(b) Levels feature.
(c) Color Variations.

For slight discrepancies in color, tools such as the Auto Color Correction (Enhance>Auto Color Correction) feature will be able to automatically even out some of the changes, but for big changes in color a frame-by-frame correction technique similar to the one outlined for exposure differences can be used. This time instead of using levels to make your adjustments you can employ a color control feature such as Colour Variations (Enhance>Color Variations), which can be used in conjunction with the Info palette to match different color values in sequential images.

5.15 Vertical panoramas

Suitable for Elements – 1.0, 2.0
Difficulty level – Basic
Related techniques – 5.19

For most of the time you will probably use Photomerge to make horizontal panoramas of wide vistas, but occasionally you may come across a situation where you can make use of the stitching technology to create vertical panoramas rather than horizontal ones. When capturing the vertical source images be sure to follow the same guidelines used for standard panoramas – check exposure, focus, white balance, focal length and shooting position.

Vertical stitching >> *Don't restrict yourself to only stitching horizontal pictures. Why not also use Photomerge to stitch those very tall shots that you just can't capture in a single photograph.*

Step 1 >> *Add your pictures to Photomerge as you would for a horizontal composition.*

Step 2 >> *Photomerge may display an error message as it tries to automatically arrange the pictures.*

Step 3 >> *Manually drag the unplaced pictures into position. Turn on Perspective and Advanced Blending before clicking OK to finish the stitch.*

5.16 High resolution mosaics

Suitable for Elements – 1.0, 2.0
Difficulty level – Basic
Related techniques – 5.19

Another not so familiar use of the Photomerge technology is the production of high resolution picture mosaics. In this application, the photographer captures a series of overlapping images, both vertically and horizontally, of the same scene. These images are then stitched together to form a photograph that is both wider and taller and contains more pixels than your camera would normally be capable of.

This approach is particularly suitable for those scenes where you just don't have a lens wide enough to encompass the whole vista, or situations where detail is critical. The higher resolution of the final stitched result also provides the extra digital information necessary to print big pictures (A3, A3+ or even A2) with little or no loss of quality or detail.

Unlike when you are capturing the source pictures for panorama production, high resolution stitches require pictures that overlap on all sides that are to be stitched. This means that at the time of shooting you need to pay particular attention to edges of the frame and ensure a 20–50% consistent overlap.

Pro's Tip: If your camera contains a grid feature that can be displayed in the viewfinder, position the grid line closest to the edge of the frame on a subject that will be present in the overlap. Next turn the camera and make sure that the same subject is present in the frame on the grid line at the opposite side of the viewfinder.

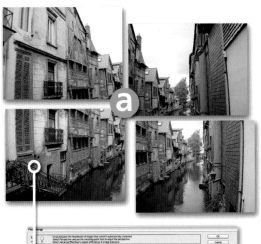

Mosaic stitches >> *Create very high resolution wide angle pictures that contain stunning detail and quality by capturing a series of overlaping pictures and stitching them with the Photomerge feature. (a) Mosaic source images that overlap on all stitching sides. (b) Turn on both the Advanced Blending and Perspective options in Photomerge. (c) Use the cropping tool to trim away the ragged edges that are the result of the perspective deformation. (d) The final mosaic picture is higher resolution and covers more of the scene than would have been possible with a single camera shot.*

5.17 Panoramic printing

Suitable for Elements – 1.0, 2.0 | Difficulty level – Intermediate
Related techniques – 8.01 | Menus used – Edit

Given the format of most wide vista photographs, printing on standard inkjet paper will result in much of the printing surface being left unused. Printer companies like Epson now produce pre-cut panoramic paper in a photographic finish. These sheets are convenient to use and their proportions are stored as one of the default paper settings on all the latest model printers.

Another approach is to use the roll paper format that is now available as an option on several different models. This option provides the ability to print both long and thin and standard picture formats on the same paper, reducing the need for multiple paper types. Using these special roll holders the printer can output different image formats back to back and edge to edge, providing cutting guidelines between pictures if needed.

For those of you with just the occasional need to print panoramas, another approach is to cut standard printing papers lengthways. This action produces very usable wide thin stock that is half the usable dimensions of the standard sheet. See the table below for the different paper types and the panorama print sizes that can be output on each.

With the paper organized it is now necessary to set up the printer for the new sizes. If you are using the pre-cut sheet or roll paper, then these options should be available in the drop-down paper menu of the latest printer driver for your machine. If the options are not present, or you are using panorama paper that you have cut yourself, then you will need to set up a custom paper size to suit your needs. On Epson machines you can do this by opening the printer driver, selecting the Paper tab and choosing the User Defined option. The dialog that is displayed will allow you to create, label and save your own paper size. These newly created paper size options will then be available for you to choose when you next open the Elements print dialog. More printing techniques can be found in Chapter 8 of the book, including instructions for making a panorama friendly Picture Package.

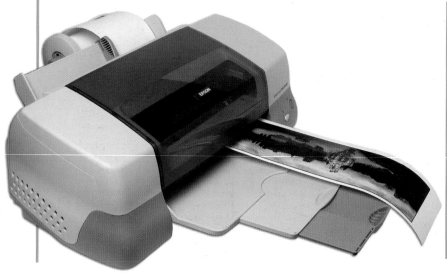

Basic Paper Type	Possible Panorama Print Size
A4	105 x 287 mm (1/2 full sheet)
A3	148 x 420 mm (1/2 full sheet)
A2	210 x 594 mm (1/2 full sheet)
A4 Roll	210 mm x 10 m
100 mm wide Roll	100 mm x 8 m
Panoramic Paper	210 x 594 mm (pre-cut sheet)

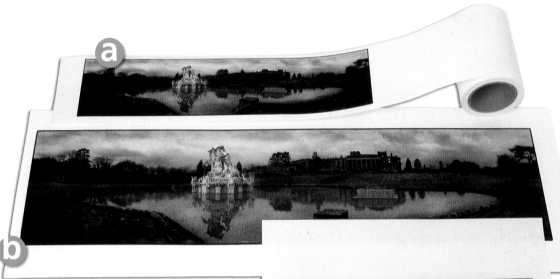

Panoramic print options >> *Because of the wide thin nature of most panoramic photographs, printer companies like Epson have developed special settings for their hardware as well a range of paper sizes to accommodate the unusual format. (a) Roll paper can be customized to suit both standard print formats as well as wide panoramic prints. (b) Special pre-cut papers in 'photo print' finishes are also available. (c) Panoramas can be printed on standard paper sizes, but much of the sheet is left blank.*

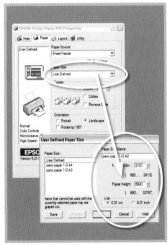

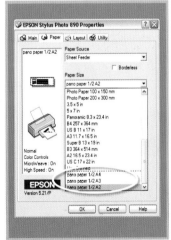

Step 1 >> *Select the Paper tab from the Epson printer driver and choose User Defined from the drop-down Paper Size menu. Input the paper size in the width and height boxes and then save the settings. Click OK.*

Step 2 >> *Once saved the new paper sizes can be found as extra options under the Paper Size menu.*

Step 3 >> *When it comes time to print a panoramic picture you can now select one of your predefined paper sizes and Elements will preview the photograph positioned against the background of the new paper format.*

5.18 Spinning panorama movies

Suitable for Elements – 1.0, 2.0 | Difficulty level – Intermediate | Resources – Web link Pano2Exe
Related techniques – 5.08

Many wide vista photographers choose to present their work in an interactive spinning format rather than as a print. This way of looking at images is often called Virtual Reality (VR) and is used extensively on the internet to give viewers the feeling that they are actually standing in the environment they are seeing on screen. Holiday destinations and real estate previews come to life via this technology. When the VR panorama opens you can navigate around the scene looking left and right with nothing more than simple mouse movements.

Although the ability to output your flat panoramic pictures in a VR format is not an integrated function of the Elements Photomerge feature there are several options for those who want to get their wide vista pictures spinning.

Photomerge output to QuickTime movie format

Macintosh users can convert their Photomerge output to Apple's QuickTime VR movie format using a free utility available from the Apple website (http://developer.apple.com/quicktime/quicktimeintro/tools/). Simply save the stitched image as a Macintosh PICT file and then convert the picture using the Make Panorama tool. The resultant file can be viewed (and navigated) with any QuickTime player and has the added bonus of being able to be uploaded to the web and viewed on-line.

Pano2Exe

Windows users can make similar spinning panoramas using a small, economical utility called Pano2Exe (http://www.change7.com/pano2exe/). The program converts JPEG output from Photomerge to a self-contained EXE file, which is a single easily distributable file that contains the image itself as well as a built-in viewer.

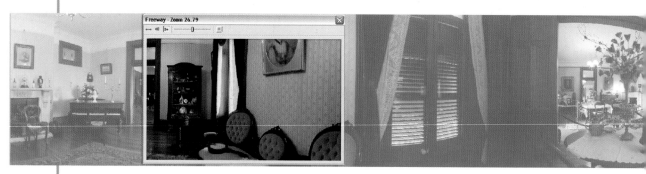

Moving panoramas >> *Photomerge users can take their panorama pictures beyond the static print by converting their stitched images to spinning vistas that can be navigated on screen and distributed via the web. For a complete 360 degree spin overlapping images need to be captured for the whole scene.*

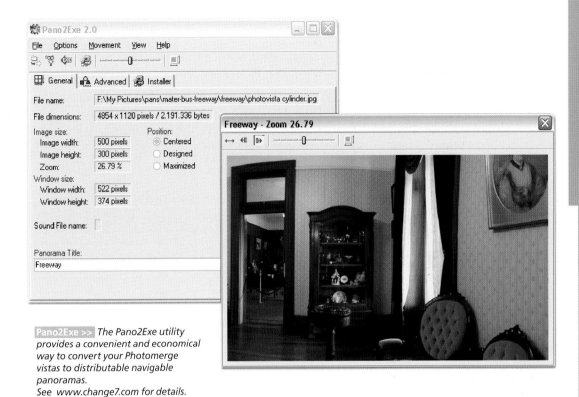

Pano2Exe >> *The Pano2Exe utility provides a convenient and economical way to convert your Photomerge vistas to distributable navigable panoramas.*
See www.change7.com for details.

Step 1 >> *Save completed Photomerge file as a JPEG file (File>Save As or File> Save for Web).*

Step 2 >> *Open picture into Pano2Exe program (File>Open Panoramic Image) and set width and height of navigation window.*

Step 3 >> *Save the spinning panorama as an executable file (.EXE) ready for distribution.*

5.19 Panorama workflow

If the 'proof of the pudding is in the eating' then the success of all your careful shooting, stitching and editing work is in the viewing (of the final panorama). Logical planning and execution is the key to high quality wide vista photographs.

In this chapter I have introduced a range of techniques that will help you make great panoramas, but remembering the techniques and order that they should be used can be difficult. Use the steps in the workflow table (aside) to help you sequence your setting up, shooting, stitching, editing and producing activities.

Recommended Panoramic Workflow

Setting up	Choose camera position to ensure good foreground, mid ground and background distribution of subject		
	Sweep the scene looking through the viewfinder to position points of focus using the rule of thirds layout		
	Use camera hand-held	Mount camera on VR tripod head	
		Adjust camera position to ensure nodal point pivot	
		Adjust 'click-stop' setting to suit overlap and lens	
Shooting	Select Manual exposure mode	Select Manual exposure mode	
		Meter for both highlight and shadow detail	
	Turn off auto white balance feature	Turn off auto white balance feature	
		Select the white balance setting that best suits the dominant light source in the scene	
	Select manual focus mode	Select manual focus mode	
		Preview depth of field to ensure foreground and background objects are sharp	
	Don't alter zoom settings		
	Shoot source sequence ensuring 20–50% overlap	Shoot 2 or 3 source sequences ensuring 20–50% overlap with different exposure settings for highlights, shadows and mid tones.	
		Shoot close-up details to use for artificial depth of field effects	
Stitching and editing	Download and stitch source images using Photomerge	Combine multi-exposure source images	
		Make adjustments for exposure differences	
		Make adjustments for color differences	
		Import corrected source images and stitch using Photomerge	
	Edit misaligned areas		
	Edit moving subject areas		
		Add artificial depth of field foreground elements	
Produce panorama	Print panorama or produce spinning VR image		
Image quality	Good	Best	

6

Extending Your Web Abilities

'm old enough to still remember the ubiquitous 'black' folio case. In fact I think my chiropractor remembers it as well; I have been a regular client ever since. It wasn't just the weight of 30–40 matted prints that made the task difficult; it was the unwieldy size of the case that made touting the folder from office to office a daunting task.

I'm happy to say that there are a new set of image-makers (professionals and amateurs alike) who have no knowledge of my folio-carrying woes. The notion of the folio still exists and remains the stable marketing device of most creative professions, but the black case may be gone forever. In its place is a cyberspace folio, accessible any time, and place, for potential clients or admirers, armed with nothing but a common web browser.

Open 24 7

The web is a 'godsend' for photographers who are eager to display their pictures. An on-line gallery space which contains biographical and résumé details, as well as a folio full of examples of past work, is like having a personal promotions manager on hand 24 hours a day, 7 days a week. Never before has it been possible to share your photographs with such ease or obtain this much exposure of your talent and abilities for such little cost.

Gone are the days where you have to send your precious images to far flung parts of the country in order to share that precious moment of little Johnnie's first step. A few simple clicks from anywhere in the world and Johnnie's agility and prowess can be admired by all – sorry Royal Mail!

Photo site styles

Photo sites come in all shapes and sizes and no matter whether you are part of a multinational imaging company or a weekend shooter who wants a few images on a page, a little design thought early on will

Photo website styles

The style of the site you make will depend on the nature of your work and the content that you wish to share with the world.

Thumbnail and gallery >>

Prolific image-makers who want to keep an archive of their work on-line will need to use a design that allows many images to be previewed before selecting a single picture to look at in higher resolution. Usually referred to as a 'thumbnail and gallery' design, this is by far the most popular form of photo website on the net today.

Used by photographers, galleries and stock agencies, this design is a great way to provide quick access to a lot of pictures. Because of the size of the thumbnails they download quickly and placing a single image on individual gallery pages also speeds up their display time. The format has proved so popular that packages like Photoshop Elements include automated wizards for creating these type of photo sites.

On-line résumé >>

Professional image-makers saw the potential of the web as a marketing tool very early in the life of the net. They frequently use it to hold CV or résumé information including lists of past and present clients, contact details and of course, a few of their images. In fact, most shooters who make a living from their pictures probably have a site that is a combination of the thumbnail/gallery type introduced above and the on-line résumé we see here. This type of web presence is now a necessity rather than a nicety for most photographic businesses.

Slide show >>

In an interesting variation of the thumbnail/gallery folio site, some image-makers have dragged the automated slide show presentation idea of old squarely into the 21st century. Using interactive technologies like the Elements PDF Slide show maker, these photographers have created on-line slide shows that display a changing sequence of their best images.

All on one page >>

The simplest approach to making your own website is to combine your images and text on the one page. Doing so means that there is no need to worry about making and linking extra pages. This approach is handy for those who want to give their audience a taste of their work and then provide contact details for further information, or for the photographer who wants to establish a web presence quickly, before finally linking the thumbnails to a range of gallery pages.

make for a better site. Just as there are various styles of digital imaging magazines there are also different forms of the humble photo website.

A little time spent surfing will have you easily identifying different types of sites made by photographers. There are those that are full of shooting information – facts and figures, others that display a design based approach, and the most popular – the virtual gallery. Time spent on the web will also provide you with the opportunity to see what works and what needs to be avoided when creating your own site.

Using what you learn from your on-line roaming make some decisions about the style of site you want. Are the pages full of information about you, your history and your past work, is the site a sales point for your images or is your web presence designed to 'wow' your friends and family with the vibrancy and energy of your imaging and/or design skills?

Building websites – the basics

All websites are constructed of several different components or elements. These separate pieces which include text, images, buttons and headings are called web assets and are arranged, or laid out, in groups on individual pages. When viewed on screen these pages appear as a single document, much the same as a word processed page. But unlike a typical printed page the components that make up a website remain separately saved files and the web page document itself simply acts as a series of pointers that indicate where elements are to be found and how they look and where they are placed on the page.

You can view the source code or HTML text of any page by selecting the View>Source option in your browser. What you will see is a series of instructions for the location and layout of the page parts and their files. When a viewer looks at the page the browser software recreates the document finding the component files and laying them

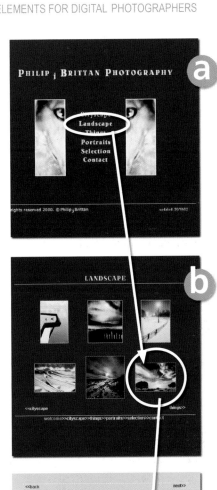

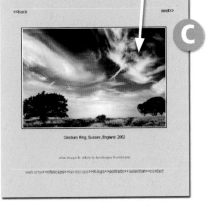

Website styles >> *Most photographers' websites are based around a gallery idea and consist of*
(a) a front or home page,
(b) an index of thumbnails and
(c) a series of individual gallery pages.
www.brittan.demon.co.uk.
Courtesy of Philip J Brittan © 2003, UK.

out as instructed by the HTML code. As you start to make your own pages this is an important concept to remember, as you will need to keep track of all the various files that are used throughout the site and ensure that they are available when requested by the browser.

Creating web pages without writing HTML

Until recently creating your own web pages required budding net designers to have a good working knowledge of HTML. Now there are many software programs on the market including Elements that allow you to create a web page or site without ever having to resort to HTML coding.

You can

• choose to use a package designed specifically for web page production such as Microsoft FrontPage and use Elements to optimize your pictures and make your buttons and headings, or
• employ some of the great automated web production features bundled as extras in Elements. Either way you get to concentrate on the design not the code. Thank goodness! In this chapter we will look at both approaches by firstly creating a multi-page website using Elements' Web Gallery feature and then go on to create all the web assets for a second site in the program before laying them out in a web production program.

Website assets

The various components that are used to make up a web page or site can be broken into several main categories –

Images >>
Images form the backbone of any photo site. Creating image assets is a process where the picture is optimized in size and quality so that it can be transmitted quickly over the net. For a photo-gallery site both thumbnail and gallery images need to be created.

Headings >>
Headings that are present on every page are usually created and saved as a picture rather than text. For this reason the same optimization process involved in the production of pictures for the net is used to create headings for the site.

Buttons >>
Buttons come in a variety of formats, both still and 'roll-over' or animated. The face of the button is created with an illustration or picture using an image editing package. The button function, moving the viewer to another page on the site for instance, is controlled by a small piece of code added later in the layout package.

Text >>
Text can be typed directly into position using the layout software or compiled in a word processing package and then imported. In the example site the photographer's information and details may be able to be taken from an already prepared CV or résumé.

Animation, sound and movies >>
Animation, Sound and Movie assets are usually created in third party dedicated production packages and added to the site in the layout part of the process.

HTML code >> *Web pages are constructed of several different parts including text, images, buttons and headings. The position of each of these components is controlled by the HTML code that sits behind the page. The page parts are brought together using these coded settings when you look at the page in your browser.*

6.01 Web Photo Gallery websites

Suitable for Elements – 1.0, 2.0 | Difficulty level – Basic
Related techniques – 6.02, 6.03 | Menu used – File

Adobe's Web Photo Gallery tool is a purpose-built feature designed to take a folder full of images and produce a multi-page, fully linked, gallery site in the matter of a few minutes. Updated for the version 2.0 of Elements, users now have even more choice and control over the way their site looks and works. The feature creates a website that opens with a front page displaying a thumbnail index. Each of the thumbnails is hot linked and when clicked, transports the viewer to one of several gallery pages. Each gallery page contains a larger, better quality version of the thumbnail together with a range of image information determined by the user, such as title, author and caption details. Viewers can navigate round the site, from image to image or back to the front page via a series of arrow buttons. Overall not bad work for a few seconds spent selecting folders and inputting text.

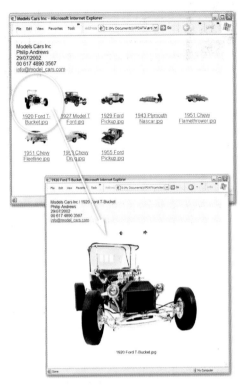

Auto website creation >> *The quickest and easiest way to create a website is to use the in-built Create Web Photo Gallery in Elements. With a few clicks you will have a fully functioning 'thumbnail and gallery' website.*

Select the images folder

The main dialog screen that confronts you after selecting the Web Photo Gallery feature contains all the settings that will be used to create your website. To start the process I usually browse for, and select, the folder that contains the images to be used in the gallery. The feature will incorporate all images that are stored in the folder so it is worth creating a directory for just this purpose to ensure no stray pictures of Uncle Jim sneak into your carefully selected favorites. At the same time, I select a destination folder. This is the place where the completed site will be saved.

Select a website style

When this feature first arrived in Elements it contained a limited choice of styles. Gradually as the version numbers creep up so too do the amount and range of styles available. Some styles use no frames with the viewer moving from one complete page to the next. Others use the frame set technology to display thumbnails in the same browser window as the large pictures. Selecting a style to use for your site is as simple as choosing its entry from the list provided.

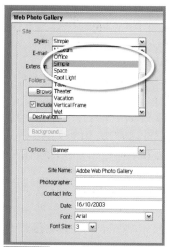

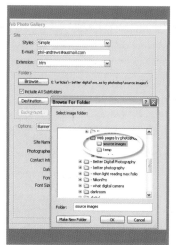

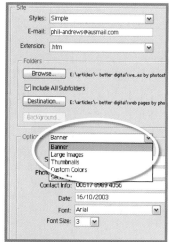

Step 1 >> *Open the Web Photo Gallery feature. Choose the look from the options available in the Style section. Input your email address and select the extension settings preferred by your ISP.*

Step 2 >> *Browse for the source folder that contains the images that you want to use for the site. Select the destination folder that will be used to store the files and folders created during the process.*

Step 3 >> *Select the Banner item from the Options drop-down menu. Input the details for the site. Select the Large Images item. Adjust the size and compression settings to suit your images.*

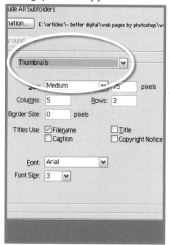

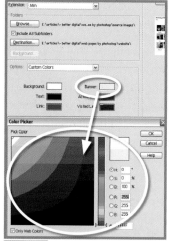

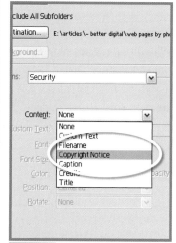

Step 4 >> *Select the Thumbnails item. Indicate if you want the File Name or File Info included with the thumbnails. Select the font style and size.*

Step 5 >> *Select the Custom Colors item. Double click on each of the swatches to activate the Color Picker. Sample the new color from the dialog and click OK to set.*

Step 6 >> *Make changes in the Security section to apply copyright or caption text directly to the image. Click OK to start the site construction process.*

Adjust the website settings

The major settings for the site are grouped into 5 drop-down menu items in the Options section of the Web Photo Gallery feature.

• The *Banner* area is the place to input details like the Site Name, Photographer's Name, Contact Info and site date. These items will be repeated throughout the site as a page heading. The font used, as well as the size that the type will appear on the page, is also set here. The font color and the banner background color are adjusted in the Custom Colors menu.

• Both the *Large Images* and *Thumbnail* sections determine the characteristics of your pictures as they

appear on the site's pages. Special attention should be paid to the image size and rate of compression as these two factors affect the file size and therefore the download speed of your pictures. Ideally none of your web image files should be larger than 30 Kb. For complete control over image size, compression and quality use the Save for Web (File>Save for Web) feature to convert your pictures to JPEG. Then leave the Resize option of the Large Images dialog unchecked. This way the JPEG files will be used as you created them and not altered by the Web Photo Gallery feature. The content of the titles that accompany both the thumbnails and the larger images can be individually set. Items such as caption, credits, title and copyright need to be entered via the File Info (File>File Info) feature for each picture and then saved before the image is incorporated into the website.

• The *Custom Colors* section is used to set the hues that are allocated for page components site wide. Double clicking any of the color swatches will allow you to select a different hue.

• The final step before generating your pages is to set the *Security* options. This feature is designed to deter unauthorized usage of downloaded images from your site. Customized or pre-saved text (use File Info again to input) can be imprinted across the surface of your large images, providing a way to safeguard their use. Apart from the content the size, font, color position and opacity of the text can also be adjusted.

Generating the site

With all the options now set you can click OK and watch as Photoshop/Elements creates your site and all its resources right before your eyes. When complete the results will be displayed in the default web browser for your machine. At this stage, it is a good idea to check spelling, appropriateness of style, as well as things like the selected color scheme. As the Web Photo Gallery feature keeps track of all the options last set, any changes can be made without having to re-enter and re-select site settings before generating a new improved version of the site.

6.02 Customizing Web Photo Gallery templates

Suitable for Elements – 1.0, 2.0 | Difficulty level – Intermediate
Related techniques – 6.01, 6.03 | Menus used – File

For all those 'tinklers' out there the answer is yes. It is possible to 'tweak' both the templates used to generate the web galleries or the set of pages created by the process. I will preface this section with the usual warning that if you are not sure what you are doing with the files mentioned below either don't play or at the very least make a copy and edit the copied file not the original. This said, just what kind of changes can we make?

If you have a basic understanding of HTML coding or own a web page editor like Microsoft FrontPage, then editing the website and its associated pages is a simple matter. Characteristics such as page color, font color, size and typeface are all easily altered and the changes saved. Keep in mind though, that any changes to page, thumbnail or image file names will result in the loss of links between pages. Also keep in mind that the more sophisticated designs make use of a frame set to house both thumbnail and large image pages. Be careful to edit the pages that sit inside the frames and not the frame set itself.

For the die-hards who really want a challenge why not try editing the templates that Elements uses to generate the web pages. The files can be found at \Program Files\Adobe\Photoshop Elements 2\Presets\WebContactSheet. My advice is to copy a complete style folder and then rename the copy. Perform your editing on the copy. This way if things go a little astray then the basic set of styles will still function.

Most of the template designs consist of a series of base pages containing place markers for the characteristics that you enter via the Web Photo Gallery dialog. After inputting your site's details into the dialog, the program collates the information and creates the new pages based on these specific characteristics. Information such as image file names, site title and the photographer's name are passed to the template as variables. For instance, the photographer's name is substituted anywhere in the template's HTML source code where the variable %PHOTOGRAPHER% appears.

With this in mind you can edit the HTML code of the template files choosing to stay clear of these variables, remove them, edit them or simply use them elsewhere in your design. When saved the edited files will create a set of web pages customized for your own needs every time you select your style from the Web Photo Gallery feature. The saved template file will appear as a new option in the styles section of the Web Photo Gallery dialog box when next you open Elements.

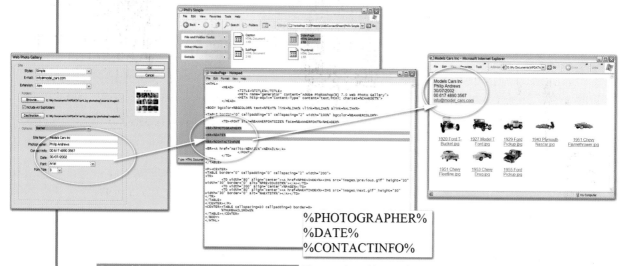

Customizing the Web Photo Gallery feature >> *Those readers with a good understanding of the inner workings of HTML coding can customize the template files that are used to generate the website pages from the Web Photo Gallery feature.*

Creating individual web assets using Photoshop Elements

Now that you have seen how to create pages and their assets automatically using the Web Gallery let's take a little more control of the process by manually creating each of the major assets using Elements. We will then layout the results of our labor in a web production package to create our final site.

6.03 Optimizing photos for the web

Suitable for Elements – 1.0, 2.0 | Difficulty level – Basic
Related techniques – 6.01, 6.02 | Menus used – File

The skill of making a highly visual site that downloads quickly is largely based on how well you optimize the pictures contained on the pages of the site. The process of shrinking your pictures for web use involves 2 steps:

• Firstly, the pixel dimensions of the image need to be reduced so that the image can be viewed without scrolling on a standard screen. This usually means ensuring that the image will fit within a 600 x 480 pixel space.

• Secondly, the picture is compressed and saved in a web-ready file format. There are two main choices here, GIF and JPEG.

The best way to optimize your pictures for web use is via the Save for Web (File>Save for Web) option in Elements. This feature provides before and after previews of the compression process as well as options for reducing the size of your pictures, all in the one dialog. Using the feature you can select the file format, adjust compression settings, examine the predicted file size and preview the results live on screen.

To create a typical 'thumbnail and gallery' site you will need two different versions of your images – full screen size images suitable for use as gallery pictures and small thumbnails that can be laid out together on an index page. To make these resources you will need to size and compress each image

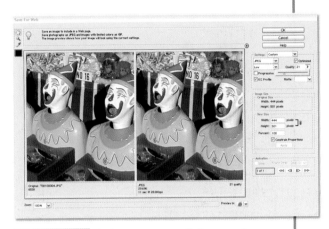

Save for Web >> *The best way to ensure that you are using the best balance between file size and image quality is to preview your compression and file type choices in the Save for Web feature.*

twice and then save the finished files into two separate folders titled 'thumbnails' and 'gallery'. Make sure that the gallery images are no bigger than one full screen and that the thumbnails are small enough to fit several on the page at the one time.

File formats for images on the web

The standard PSD or Photoshop Elements file format is not suitable for web use; instead several different picture types have been developed especially for on-line work. The two most common are JPEG and GIF.

1. JPEG, or JPG, or Joint Photographic Experts Group, is a file format specially developed for photographic web images. It uses a lossy compression technique to reduce files to as little as 5% of their original size. In the process some of the detail from the original picture is lost and 'tell-tale' artifacts, or visual errors, are introduced into the picture. The degree of compression and the amount of artifacts can be varied so that a balance of file size and image quality can be achieved. More compression means smaller file sizes, which in turn have poor image quality. Whereas less compression gives larger files of better quality

JPEG images can contain millions of colors rather than the comparative few available when using GIF. The format has massive support on the net and is the main way that photographers display their web pictures.

2. GIF, or the Graphics Interchange Format, has had a long (in internet terms) history with web use. It has the ability to compress images mainly by reducing the numbers of colors they contain. For this reason it is great for headings, logos and any other artwork with limited colors and tonal graduation. It can also display pictures that contain areas of transparency and can be used for simple 'cell' based animation. This format is not suitable for most photographic images.

How big is too big

When you are producing your first web pages there is always the temptation to keep as much image quality in your pictures as possible, resulting in large file sizes and a long wait for your site visitors. Use the table below to help you predict how long a web picture will take to download to your recipient's computer. Generally a delay of 10–15 seconds for large gallery images is acceptable, but download times longer than this may cause your audience to surf elsewhere.

Balancing Compression and Image Quality >>

Photographers wanting to display their images on the net are caught between the two opposing forces of image quality and image file size. When Adobe created Elements they were well aware of these difficulties and, to this end, they have included sophisticated compression features that give the user a range of controls over the process.

The Save for Web feature contains a preview option that allows you to view the original image after the compression and conversion to web format has taken place. In addition, the dialog also displays predicted compressed image sizes that will allow you to ensure that your web files are not too cumbersome and slow to download.

File size	Download Speed			
	14.4 Kbps (modem)	28.8 Kbps (modem)	56.6 Kbps (modem)	128 Kbps (Cable)
30KB	24 secs	12 secs	6 secs	3 secs
100KB	76 secs	38 secs	19 secs	9 secs
300KB	216 secs	108 secs	54 secs	27 secs
1000KB (1MB)	720 secs	360 secs	180 secs	90 secs

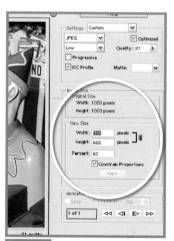

Step 1 >> *Open the original image and select the Save for Web feature. Input the image size into the New Size section, being sure to keep the pixel dimensions less than 600 x 480. Click Apply. Set previews to 100%.*

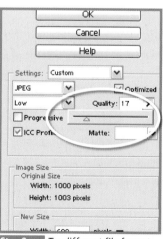

Step 2 >> *Try different file format, compression setting or numbers of colors. Determine the best balance of file size and image quality. Check the download times, click Save to store the image.*

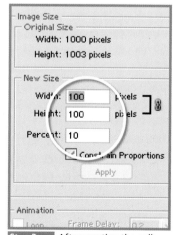

Step 3 >> *After creating the gallery images you can repeat the process using smaller pixel dimensions to generate the thumbnail versions of the pictures. Thumbnails should be between 60 x 60 or 100 x 100 pixels.*

Pro's Tips for good image compression:

• Always use the Save for Web compression tool to preview the side-by-side images of the original and compressed picture.

• For GIF images try reducing the number of colors to gain extra compression.

• Always view the compressed image at 100% or greater so that you can see any artifacts.

• For JPEG images carefully adjust the quality slider downwards to reduce file size.

• Take notice of the predicted file size and predicted download time when compressing images.

6.04 Button creation

Suitable for Elements – 1.0, 2.0 | Difficulty level – Basic | Tools used – Shape tools, Type tools
Menus used – Layer, File,

In their simplest form, the buttons on a web page are nothing more than a small graphic or picture file similar to those that we created as thumbnails in the last technique. The same process of careful sizing and compression used to help keep image files small is employed to ensure that buttons take up very little space and download extremely quickly – so in this regard they should be treated exactly the same as any other image. It is the step after these simple buttons are placed on a web page that makes them different from just another graphic.

During the web page assembly process the button images are positioned onto the page. Each image is then selected and linked to a web page or HTML file. This simple step converts the graphic from a static picture to a working button. When the page is displayed and the mouse point moved over the linked button the standard 'arrow' cursor will change to the familiar 'pointing finger' to indicate a link can be clicked at this section of the page. In essence, buttons are just hyperlinked graphics.

Simple buttons >> *Buttons are small pictures, that when clicked, perform an action or transport the viewer to new web pages.*

Step 1 >> *Using the Rounded Rectangle tool a button shape was drawn and a layer style added to it.*

Step 2 >> *A text layer was also added; the color and layer style changes to suit the button.*

Step 3 >> *The image was then saved as a web picture using the Save for Web feature.*

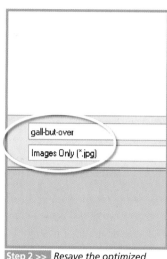

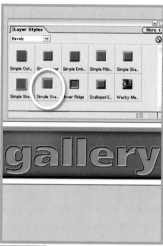

Step 1 >> *Using the button created in the previous technique as a base change the button color.*

Step 2 >> *Resave the optimized picture as the 'butt-over' state.*

Step 3 >> *Change the button bevel and embossing by applying an 'inset' style. Save as 'butt-down'.*

Animated buttons – rollovers'

Not all sites contain simple buttons. In fact there are many pages that make use of animated or rollover buttons. Designed so that the button image changes as the mouse moves over it, this button style requires a little more planning and design. A new graphic needs to be created for each of the different mouse actions or button states and then these images need to be integrated into the web page via some simple 'java scripting'. Don't panic, there is no coding needed here as in most web layout packages. Simply input the file names of the different rollover button states into the dialog and the program handles the rest.

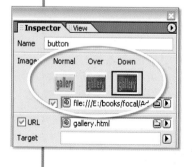

Rollover buttons >> *After making the three button states – (a) normal, (b) over and (c) down – use the Rollover button feature in your web layout package to assign each graphic to each button action.*

6.05 Effective headings

Suitable for Elements – 1.0, 2.0 | Difficulty level – Intermediate
Tools used – Type tools | Menus used – Layer, File

Headings, which are usually placed at the very top of the screen, provide a title for the page, or site, and sometimes include a series of buttons called a menu or button bar. Like buttons this web asset is usually created as a graphic and then positioned on the page using a layout program. Text and images are often combined to create the heading and even though the text remains editable in the original file, the final design is saved as a picture in JPEG or GIF format. In either of these two forms the text becomes just another picture element.

Keep in mind that just as much care needs to be taken when making and optimizing headings as any other graphics as the speed that your page will display will be based on the combined file size of all the page's assets.

Animated headings

In addition to creating static headings it is also possible to make animated banners using the save as GIF features in Elements. Adobe has merged traditional techniques with the multi-layer abilities of its PSD file structure to give users the chance to produce their own animations. Essentially the idea is to make an image file with several layers, the content of each layer being a little different from the one before. The file is then saved in the GIF format. In the process each layer is made into a separate frame in an animated sequence. As GIF is used extensively for small animations on the net, the moving masterpiece can be viewed with any web browser, or placed on the website to add some action to otherwise static pages.

The GIF file is saved via the Save for Web feature. By ticking the Animate check box you will be able to change the frame delay setting and indicate whether you want the animation to repeat (loop) or play a single time only. This dialog also provides you with the opportunity to preview your file in your default browser.

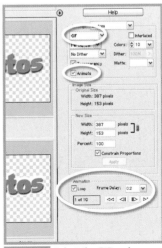

Animated headings >> *Create your own animated text headings by using the Warp Text feature to add a wave to multiple text layers. Saving the file as an animated GIF will loop the text layers, creating the illusion of movement.*

Keep in mind when you are making your own animation files that GIF formatted images can only contain a maximum of 256 colors. This situation tends to suit graphic, bold and flat areas of color rather than the gradual changes of tone that are usually found in photographic images. So rather than being disappointed with your results, start the creation process with a limited palette; this way you can be sure that the hues that you choose will remain true in the final animation.

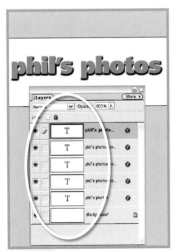

Step 1 >> *Start by inputting some base heading text. Adjust color and style. Create multiple copies of the finished layer.*

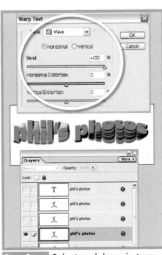

Step 2 >> *Select each layer in turn and apply slightly different settings in the Warp Text (wave) feature.*

Step 3 >> *Select the GIF and Animate options. Adjust the settings in the Animation section, then click OK to produce the animation.*

6.06 Making seamless backgrounds

Suitable for Elements – 1.0, 2.0 | Difficulty level – Intermediate | Resources – recipe 6.06
Tools used – Selection tools, Clone Stamp | Menus used – Filter, File

The HTML language has a specific feature designed for including backgrounds with your pages. As you can imagine using a full size image for a background would greatly increase the file size and therefore the download time of your pages, so in their wisdom, the early web engineers included the ability to tile a small graphic pattern over the whole of the background of each page. Using this method, a small, highly optimized, picture can be repeated in a grid over the expanse of the whole screen, giving the appearance of a seamless background with little download time cost.

Repeating background tiles >> *The tiles that you create using the Elements Offset filter can be used to create repeating backgrounds by selecting them as the background image in your web layout program.*

Using the Offset filter (Filter>Other>Offset) in Elements you can create a special background graphic containing matched edges that will seamlessly tile across a whole web page. Select a section of a suitable image. Copy and paste the selection as a new document. Apply the filter using offset settings that are exactly 50% of the dimensions of the image and choose the Wrap Around option. This displays the edges of the tile in a cross in the center of the image. Use the Clone Stamp tool to disguise the joins by merging similar areas and textures together. To finish save the file in JPEG format using the Save for Web feature. With the tile made you can now select it as the background image in your web layout program.

Step 1 >> *Select an area of an image to use as a base for the tile. Copy and paste the selection into a new document.*

Step 2 >> *Select the Offset filter and input width and height values that are 50% of the image size. Select the Wrap Around option.*

Step 3 >> *Use the Clone Stamp tool to disguise the joins in the picture. Save as a JPEG using the Save for Web feature.*

6.07 Creating downloadable slide shows

Suitable for Elements – 1.0, 2.0 | Difficulty level – Basic
Menus used – File

The PDF (Portable Document Format), or Adobe Acrobat, format has quickly become a favorite way for photographers, graphic designers and printers to share their work. The file format can save text, graphics and photographs in high quality and can be read by viewers with a wide range of computer systems using the free Adobe Acrobat Reader. With this in mind, the Elements engineers had the great idea of including a slide show creator that outputs to the PDF format in the program.

Using this feature a folder, or selection, of images can be ordered, transitions and timing applied between individual slides and the whole sequence saved as a self-running slide show. The resultant PDF file can be saved to disk or CD or uploaded to the web ready for on-line viewing. In this way, digital image-makers can put together a showcase of their work, which they can then share with a range of viewers, irrespective of the computer system they use.

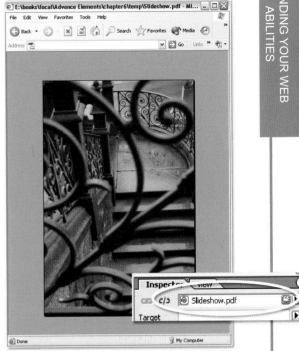

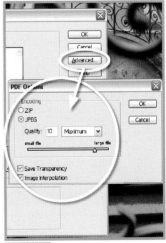

Your ownl on-line slideshow >> *The final PDF file can be linked to a button in your website, allowing the show to be displayed in the browser via the free Adobe Acrobat plug-in.*

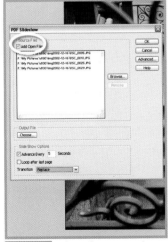

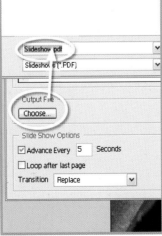

Step 1 >> *Select File>Automation Tools>PDF Slide show. Add image files to the source list using the Browse button. To include images already open in Elements tick the Add Open Files checkbox.*

Step 2 >> *Adjust the sequence of source images to reflect the slide order you want. Nominate a destination folder and slide show file name by clicking the Choose button in the Output File section of the dialog.*

Step 3 >> *For automatic advancement tick the Advance By checkbox. For manual advancement leave the box unchecked. Select the transition style and compressions system via the Advanced button. Click OK to finish.*

6.08 Assembling the site

Suitable for Elements – 1.0, 2.0 | Difficulty level – Intermediate | Resources – Web link Netscape download
Related techniques – 6.03, 6.04, 6.05, 6.06, 6.07

Using the last few techniques you will have created images, thumbnails, page heading, buttons for navigation and a background tile. It is now time to bring all these parts together with the aid of a web page layout program.

The most well known of these types of software packages are Macromedia's Dreamweaver, Adobe's GoLive and Microsoft's FrontPage. They work in a similar way to desktop publishing programs in that they allow the user to lay out images and text before publication. Unlike DTP software though, the end designs are meant to be viewed on the web rather than the printed page.

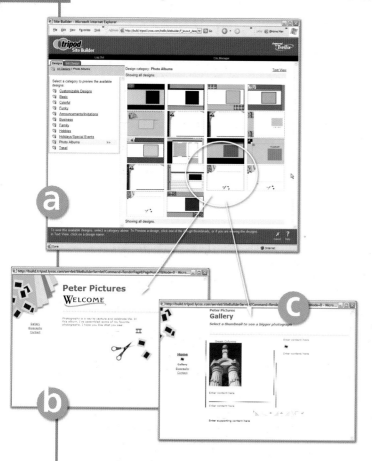

Even though these big name packages lead the field, there are more economical options and even some free programs that provide the basic functions needed to construct the pages. In particular Netscape Composer, which is part of an older release of Netscape browser programs called the Communicator Suite, is a simple web layout package that contains all the features needed to create a simple multi-page website. What's more it can be downloaded and used for free. Alternatively you may find that your well used word processor is now so 'web aware' that it is more than capable of laying out and linking the files and pages in your site.

Some of the larger hosting companies such as www.tripod.com supply basic layout and design features on-line to their subscribers. Using their step-by-step screens you can create and lay out a series of linked pages and then publish the whole site in a single setting. This feature is great for first time web producers as the template driven interface takes a lot of the guess work out of the process. You can customize text, headings and images but the basic design elements and layout are fixed.

ISP page creation tools >> *Some internet hosting companies provide a web based layout feature that can have your site up and running in a matter of minutes. The features are normally template driven (a) and are more than capable of creating linked front (b) and gallery (c) pages. Courtesy of www.tripod.com © 2003.*

Step 1 >> Collect the web assets that you have created and place them into a simple folder structure with different directories for thumbnails, gallery images, pages and common elements like the buttons, background and heading graphics. Ensure that all the files are well labelled and that each file name is 8 characters long or less.

Step 2 >> To create the home page start the Netscape Composer program. The package automatically creates a new page when opened. Next select Format>Page Colors and Properties and under the General tab input the title, author, description and keywords for the page. Under the Colors and Background tab select the background tile that you made earlier. Click the Leave image at the original location and save these settings for new page boxes and click OK.

Step 3 >> Click on the Insert Image button. Under the Image tab find the heading graphic and select OK. Select the heading graphic and click the center alignment button. Deselect the graphic and hit the enter key to move the cursor to the next line under the heading. Using this process insert the button graphics one by one. Save this page as index.html.

Step 4 >> Create a thumbnails, or picture index, page and add the small versions of all the photographs that you want to include in the site. Save as thumb.htm.

On a series of new gallery pages insert the larger images, one per page, saving each using the name of the picture as the file name (pict1.htm).

Step 5 >> To add interactivity to the site double click on a button graphic and click on the Link tab from the Image Properties dialog that appears. Select the Choose File option and locate the page file that relates to the button, i.e. thumbnail button linked to thumb.htm. Complete this linking action for each of the buttons in the site.

Step 6 >> With the site now complete it is essential that you test all the links and image insertions. Do this by opening the index.htm file and clicking the Preview button on the Netscape menu bar.

6.09 Uploading the site

Suitable for Elements – 1.0, 2.0 | Difficulty level – Intermediate
Resources – Web link to www.tripod.com | Related techniques – 6.08

With pages created it is now time to put your site on the web. You will need to secure drive space on a machine that is permanently connected to the internet. Such space is provided by specialized businesses called Internet Service Providers (ISP). They host the files that make up your site. You will also need to obtain a web address. This is used to enable web surfers the world over to locate and view your pages.

Before going out and buying the space and web address check to see if the company you are currently using for access to email and web browsing includes some free space as part of the monthly dial-up charge. Most of the bigger ISPs provide 10–20 Mb as part of their dial-up services as well as a web address which combines their domain and your name, usually in a form such as 'www.isp.com/philipandrews'. If you don't have an internet connection, or you browse via a network at work or school, then you can obtain an address and some storage space from any of the many free hosting companies. Simply search the net using a 'free hosting' as your subject to get a list of candidates. Most provide a few different products at various prices along with their free hosting plan. These companies pay for their free provision by including banner advertisements at the top of your web pages.

With your space and address secured, it is now time to transfer your site with all its images, buttons and pages to the host computer. Until recently this task was handled by an FTP or File Transfer Protocol program. This utility connected your computer with the ISP machine. Files and folders could then be copied from one machine to the other. Most of the larger ISP companies now provide a web page interface for transferring or uploading your files. You simply locate the Upload option in the File Management section of the members pages for your ISP and then browse and select the files to be transferred. Click the Upload button and a few moments later the files appear on the ISP's computer.

Step 1 >> *As a registered Tripod member you will be able to log into your own web space. Use the File Manager option to see a file view of your space. Here select and change the Upload via setting to 'Single Files'.*

Step 2 >> *In the Upload browser select the files you want to transfer. Click the Upload button. Be sure to duplicate the exact file and folder structure of your site. This may mean that you will have to make the Image and Page folders before transferring files to them.*

Step 3 >> *As the last step in the process, check that all components of the site have been transferred and are working properly by viewing your pages in your browser. Check to see that your pages display correctly on a variety of machines and browsers.*

7

Producing Effective Graphics

As well as providing us with a suite of features and options that can be used to edit and enhance photographic images, Adobe Photoshop Elements also contains a variety of painting and drawing tools. These can be used to create new pictures from scratch or to add original artwork to your photographs. The following techniques are designed to take you beyond the basic painting and drawing tasks so that you will be able to create professional looking graphics that can work in conjunction with your professionally edited and enhanced photographs.

Revisiting painting and drawing basics

Although the names are the same the tools used by the traditional artists to paint and draw are quite different from their digital namesakes. The painting tools (the Paint Brush, Pencil, Eraser, Paint Bucket and Airbrush) in Elements are pixel based. That is, when they are dragged across the image they change the pixels to the color and texture selected for the tool. These tools are highly customizable and in particular, the painting qualities of the brush tool can be radically changed via the Brush Dynamics palette.

The drawing tools (the Shape tools) in contrast are vector or line based. The objects drawn with these tools are defined mathematically as a specific shape, color and size. They exist independently of the pixel grid that makes up your image. They usually produce sharp edged graphics and are particularly good for creating logos and other flat colored artwork.

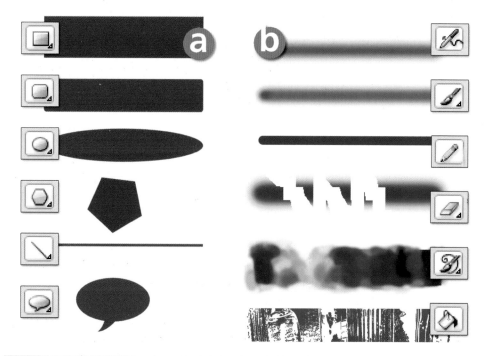

Painting and drawing tools >> *Drawing and painting tools are used to add non- camera or scanner based information to your pictures.*
(a) Drawing tools (from the top) – Rectangle, Rounded Rectangle, Ellipse, Polygon, Line, Custom Shape.
(b) Painting tools – Airbrush, Brush, Pencil, Eraser, Impressionist Brush, Paint Bucket tool.

7.01 Controlling brush characteristics

Suitable for Elements – 1.0, 2.0 | Difficulty level – Intermediate | Resources – Poster 701 (presets and dynamics)
Tools used – Painting tools | Palettes used – Brush Presets, Brush Dynamics

Elements provides users with the ability to change a range of brush options quickly and easily. Color, size, mode and opacity are the most acessible options.

The color of the brush can be altered by changing the currently selected foreground color. Do this by double clicking the foreground swatch located at the bottom of the program's toolbar. Select a new color from the Color Picker that is displayed and then click OK to exit the palette. Any drawing or painting from this time forward will be in the new color.

Brush size, blending mode and opacity are altered by the values set in the brush's option bar. The size of the brush is measured in pixels with higher values producing a brush with a larger diameter. The brush's blending mode controls the way that the color that is being applied interacts with the color already in the document. Notice that the options you have here are the same as the blending modes available in the layers palette. The opacity setting controls how transparent the painted color will be.

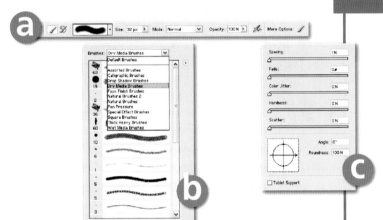

Brush options >> *The style of brush that you use in Elements can be changed by either altering the brush's characteristics manually using the options available in the options bar and the dynamic palette, or by selecting one of the pre-designed brushes that come supplied with the package.*
(a) Brush options bar.
(b) Brush Presets palette.
(c) Brush Dynamics palette.

Elements also comes packaged with a host of pre-designed brushes that can be acessessed by clicking the Presets button to the right of the brush preview thumbnail in the options bar. The designs are grouped under headings that indicate the style of brush – calligraphic, special effect, faux finish. Even though these brushes are supplied with all the major characteristics pre-designed, you can customize any brush by altering one or more of their settings.

In addition to the basic changes of size, color, blend mode and opacity many more brush characteristics can be altered via the Brush Dynamics palette. The palette is opened by clicking the More Options button located in the Brush's options bar. Here you will find controls for a further seven brush characteristics. At first the options and their effects may seem a little strange and confusing. To help you get to know the way that each setting will alter your brush, try drawing a series of brush strokes, changing a single option as you go. This exercise will make the setting's effect more obvious. When you feel confident then try changing the settings for multiple options to provide a mix of different effects.

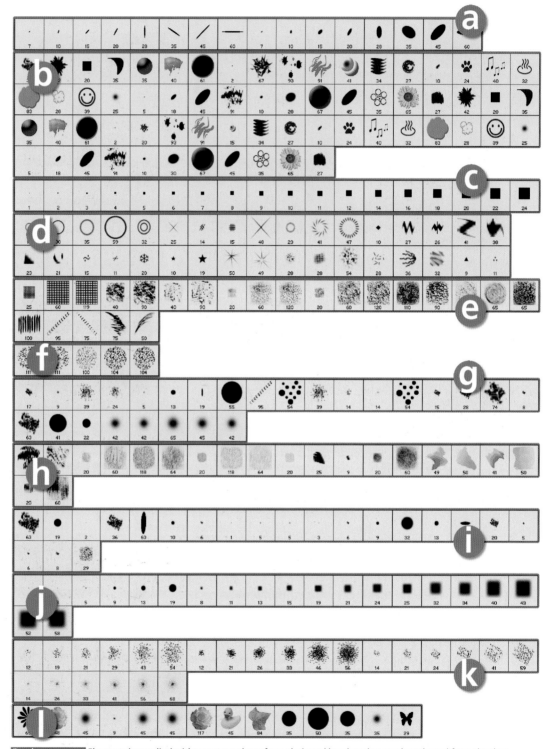

Brush presets >> Elements is supplied with a vast number of pre-designed brushes that can be selected from the drop-down menu in the Presets palette. (a) Calligraphic. (b) Pen Pressure. (c) Square Brushes. (d) Assorted Brushes. (e) Faux Finish. (f) Thick Heavy Brushes. (g) Wet Media Brushes. (h) Natural Brushes 2. (i) Dry Media. (j) Drop Shadow. (k) Natural Brushes. (l) Special Effect Brushes.

Angle >> *Controls the inclination of an elliptical brush.*
(a) 60% (b) 120%

Fade >> *Determines how quickly the paint color will fade to nothing.*
(a) 0# (b) 80#

Hardness >> *Sets the size of the hard-edged center of the brush.*
(a) 100% (b) 50% (c) 10%

Jitter >> *Controls the rate the brush's color switches between foreground and background hues. (a) 0% (b) 100%*

Opacity >> *Determines the transparency of the brush color.*
(a) 100% (b) 50% (c) 10%

Roundness >> *Controls the brush shape. (a) 100% (b) 50% (c) 10%*

Scatter >> *Controls the way that strokes are bunched around the drawn line. (a) 10% (b) 50%*

Spacing >> *Determines the distance between paint dabs.*
(a) 25% (b) 200%

Blend Modes >> *Controls how the brush's color interacts with existing colors. (a) Normal. (b) Darken. (c) Lighten. (d) Hard Light. (e) Difference. (f) Luminosity.*

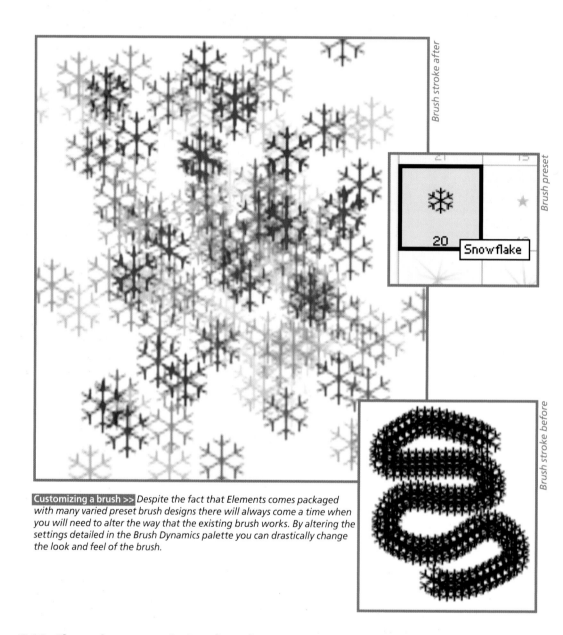

Brush stroke after

Brush preset

Snowflake

20

Brush stroke before

Customizing a brush >> *Despite the fact that Elements comes packaged with many varied preset brush designs there will always come a time when you will need to alter the way that the existing brush works. By altering the settings detailed in the Brush Dynamics palette you can drastically change the look and feel of the brush.*

7.02 Changing an existing brush

Suitable for Elements – 1.0, 2.0 | Difficulty level – Intermediate
Related techniques – 7.01 | Tools used – Brush tool

With the basics now under your belt let's stretch those newly found skills by following the steps needed to customize an existing brush shape. At first the most notable differences between the preset brushes that come packaged with Elements will be the shape of the brush itself. Ranging from simple round or square tips to those that are based on pictures such as flowers or even the humble

Step 1 >> *Select the brush tip shape that you wish to customize from the Brush Presets palette.*

Step 2 >> *Select the New Brush option from the fly-out menu displayed when you click the side arrow at the top right of the presets screen.*

Step 3 >> *Click on the More Options button on the right of the brush options bar and alter the settings in the Brush Dynamics palette. Your brush is now ready to use.*

rubber duck, these shapes form the basis for the brush stoke itself. One click of the mouse button will paint the shape of the brush tip but click and drag the mouse and you will see a brush stroke made up of a repeating pattern of the brush tip shape.

The way that the tip repeats is controlled by the options in the dynamics palette. It is here that you can force the brush to space out the painted shape and change its color, position and opacity dynamically as you stroke.

If when you first select a preset brush shape you find that you don't like the way that it paints then you may find that with a few changes to the brush's dynamics it will be more suited to your needs.

Simply select the brush you wish to change from the Presets palette. Save the brush as a New Brush using this option in the fly-out menu of the palette. Now you can make the changes to the new brush using the slider controls in the Brush Dynamics palette. To check your progress make practice strokes onto a blank document that you have open in the workspace.

Custom brush sets can be saved and shared using the Save and Load Brushes, also located in the Presets fly-out menu.

Sharing your custom brushes >>
If you want to share the brushes that you have customized with other Elements users then you can save your changes using the Save Brushes option in the fly-out menu of the Presets palette. To only save a selection of the brushes in the palette hold down the Shift key whilst you click onto the brushes, then choose Save Brushes.
Your fellow Elements users can then copy the resultant .abr file into the Elements/Presets/Brushes folder and then load your custom brushes using the Load Brushes option in the same fly-out menu.

After

Original source image

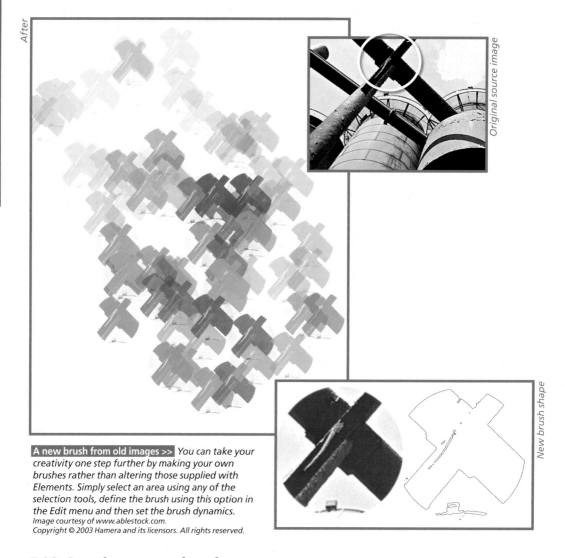

New brush shape

A new brush from old images >> *You can take your creativity one step further by making your own brushes rather than altering those supplied with Elements. Simply select an area using any of the selection tools, define the brush using this option in the Edit menu and then set the brush dynamics.*
Image courtesy of www.ablestock.com.
Copyright © 2003 Hamera and its licensors. All rights reserved.

7.03 Creating a new brush

*Suitable for Elements – 1.0, 2.0 | Difficulty level – Intermediate | Resources – Example brushes 703-1, 703-2, 703-3
Related techniques – 7.01, 7.02 | Tools used – Brush tool*

If modifying existing brush shapes (presets) still doesn't provide the level of creativity that you need for that all important illustration, then why not create your own completely new and original brush shape. Elements provides users with a way that they can create brush tips from sections of photographs or original artwork. It is a two-part process – define and save the area that will be used as the basis of the new brush and then using the newly defined brush shape set the brush dynamics to suit your application.

The success, quality and style of the brush you make will be based on the selection of the artwork at the start of the process. Image parts that are high in contrast work best when used as a brush. Any selection tool can be used to isolate the area of the photograph that will be converted to a brush

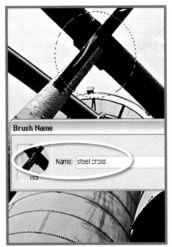

Step 1 >> *Define an area of the source image to be used for the brush using one of the selection tools.*

Step 2 >> *With the selection active choose the Define Brush option from the Edit menu.*

Step 3 >> *A dialog appears that shows a preview of your brush shape and provides a space to enter a new brush name.*

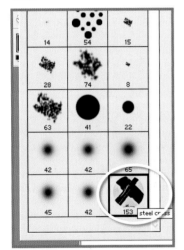

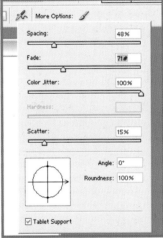

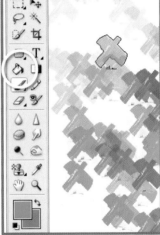

Step 4 >> *The brush is saved to the current Presets palette. To customize, select your new brush from the Presets palette.*

Step 5 >> *Open the Brush Dynamics palette and make changes to the settings that control how the new brush paints.*

Step 6 >> *With the shape and style of brush now designed you can choose your colors, size, opacity and blend mode and paint away.*

shape. If you don't want the edge of the selection to act as part of the overall brush shape then make sure that the picture part that you use is surrounded by white. Dark or black sections of the source picture will convert to a strong color when your brush is used, mid tones will correspond to lighter areas and white parts will paint no color at all.

Once you are satisfied with your selection then you will need to convert the image to a brush format. Do this by choosing the Define Brush (Edit>Define Brush). This process changes the picture to a grayscale and stores the image as a brush tip in the current Brushes Preset palette. Now you can adjust the brush dynamics of your newly created brush using the processes detailed in the previous technique.

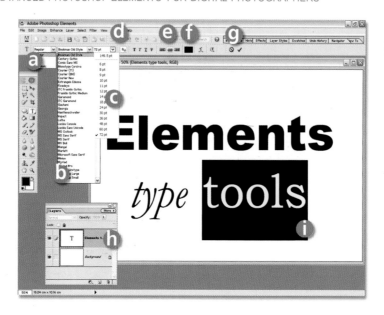

Elements type control >>

Elements' sophisticated text engine is based on the same feature found in its bigger brother Photoshop.
(a) Font style
(b) Font family
(c) Font size
(d) Anti-alias button
(e) Text alignment
(f) Text color
(g) Commit button
(h) Text layer
(i) Selected text

7.04 Text

Suitable for Elements – 1.0, 2.0 | Difficulty level – Basic
Tools used – Type tools

Combining text and images is usually the job of a graphic designer or printer but the simple text functions that are now included in most desktop imaging programs mean that more and more people are trying their hand at adding type to pictures. Elements provides the ability to input type directly onto the canvas rather than via a type dialog. This means that you can see and adjust your text to fit and suit the image beneath. Changes of size, shape and style can be made at any stage by selecting the existing text and applying the changes via the options bar. As the type is saved as a special type layer, it remains editable even when the file is closed so long as it is saved and reopened in the Elements PSD format.

Creating simple type

Two new type tools were added to Elements in version 2.0, over and above the two that were present in the initial release of the program. Now you can select from Horizontal and Vertical Type tools as well as Horizontal and Vertical Type Mask tools.

Of the standard type tools, one is used for entering text that runs horizontally across the canvas and the other is for entering vertical type. To place text onto your picture select the Type tool from the toolbox. Next, click onto the canvas in the area where you want the text to appear. Do not be too concerned if the letters are not positioned exactly where you want as the layer and text can be moved later. Once you have finished entering text you need to commit the type to a layer. Until this is done you will be unable to access most other Elements functions. To exit the text editor, either click the 'tick' button in the options bar or press the Control+Enter keys in Windows or Command + Return for a Macintosh system.

Basic text changes

All the usual text changes available to word processor users are contained in Elements. It is possible to alter the size, style, color and font of your type using the settings in the options bar. You can either make the selections before you input your text or later by highlighting (clicking and dragging the mouse across the text) the portion of type that you want to change.

In addition to these adjustments, you can also alter the justification

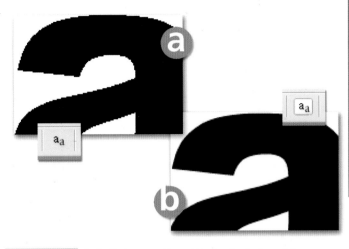

Anti-aliasing >> *Anti-aliasing smooths out the jaggies that result from trying to depict curved edges with rectangular pixels. (a) Without anti-aliasing. (b) With anti-aliasing.*

or alignment of a line or paragraph of type. After selecting the type to be aligned, click one of the justification buttons on the options bar. Your text will realign automatically on screen. After making a few changes, you may wish to alter the position of the text. Simply hold down the Ctrl key (MAC – CMD key) whilst you drag outside of the type area to move it around. If you have already committed the changes to a text layer then select the Move tool from the toolbox, making sure that the text layer is selected, then click and drag to move the whole layer.

Reducing the 'jaggies'

One of the drawbacks of using a system that is based on pixels to draw sharp edged letter shapes is that circles and curves are made up of a series of pixel steps. Anti-aliasing is a system where the effects of these 'jaggies' are made less noticeable by partially filling in the edge pixels. This technique produces smoother looking type overall and should be used in all print circumstances and web applications, the only exceptions being where file size is critical, as anti-aliased web text creates larger files than the standard text equivalent and when you are using font sizes less than 10 points for web work. Anti-aliasing can be turned on and off by clicking the Anti-aliased button.

a he left align, or justification, feature will arrange all text to the left of picture. When applied to a group of sentences the left edge of the paragraph is organized into a straight vertical line whilst the right-hand edge remains uneven or ragged. Right align works in the opposite fashion, straightening the right hand edge of the paragraph and leaving the left ragged. Selecting the center text option will align the paragraph around a central line and leave both left and right edges ragged.

b eft align, or justification, feature will arrange text to the left of picture. When applied to a group of sentences the left edge of the paragraph is organized into a straight vertical line whilst the right-hand edge remains uneven or ragged. Right align works in the opposite fashion, straightening the right hand edge of the paragraph and leaving the left ragged. Selecting the center text option will align the paragraph around a central line and leave both left and right edges ragged.

c left align, or justification. feature will arrange all text to the left of picture. When applied to a group of sentences the left edge of the paragraph is organized into a straight vertical line whilst the right-hand edge remains uneven or ragged. Right align works in the opposite fashion, straightening the right hand edge of the paragraph and leaving the left ragged. Selecting the center text option will align the paragraph around a central line and leave both left and right edges ragged.

Text alignment>> *Text is aligned with a straight edge on the left, right or by centering each line around its middle. (a) Left align. (b) Center align. (c) Right align.*

Alignment and justification

These terms are often used interchangeably and refer to the way that a line or paragraph of text is positioned on the image. The left align, or justification, feature will arrange all text to the left of picture. When applied to a group of sentences the left edge of the paragraph is organized into a straight vertical line whilst the right hand edge remains uneven or ragged. Right align works in the opposite fashion, straightening the right hand edge of the paragraph and leaving the left ragged. Selecting the center text option will align the paragraph around a central line and leave both left and right edges ragged.

Font family and style

The font family is a term used to describe the way that the letter shapes look. Most readers would be familiar with the difference in appearance between Arial and Times Roman. These are two different families each containing different characteristics that determine the way that the letter shapes appear. Arial is a sans-serif font meaning that the letter shapes are more streamlined than the serif based Times Roman design. The font style refers to the different versions of the same font family. Most fonts are available in regular, italic, bold and bold italic styles. You change the style of a font by selecting an option from the drop-down menu in the type options bar. Pressing the style buttons on the bar produce produces a 'faux' version of these styles for those typefaces with limited style options.

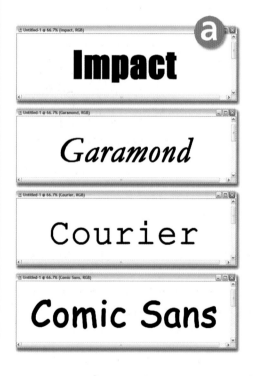

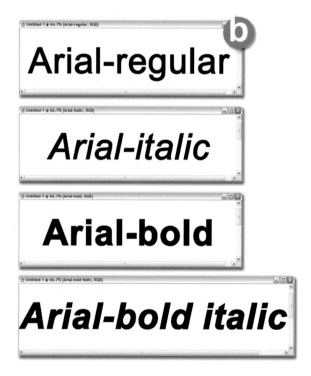

Fonts >> *You can achieve changes in the way that your text looks by altering either the font family (a) or the font style (b).*

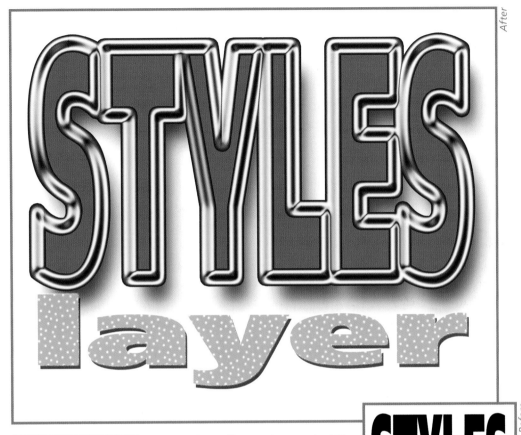

After

Before

Adding style to your text >> *Sophisticated text effects can be created quickly and easily by adding multiple layer styles to your Elements text layers.*

7.05 Adding styles to text layers

Suitable for Elements – 1.0, 2.0 | Difficulty level – Basic
Related techniques – 7.04 | Tools used – Type tools | Menus used – Layer, Edit

Elements' Layer Styles can be applied very effectively to type layers and provide a quick and easy way to enhance the look of your text. Everything from a simple drop shadow to complex surface and color treatments can be applied using this single click feature. A collection of included styles can be found under the Layer Styles tab in the Palette Well or you can view the dialog by selecting the Show Layer Styles option from the Window menu. A variety of different style groups are available from the drop-down list and small example images of each style are provided as a preview of the effect.

Additional styles can be downloaded from websites specializing in resources for Elements users. These should be installed into the Adobe\Photoshop Elements\Presets\Styles folder. Next time you start Elements the new styles will appear in the Layer Styles palette.

Step 1 >> *With the text layer selected click onto a layer style to see the settings applied.*

Step 2 >> *Add a second style by selecting another style from the Layer Styles palette.*

Step 3 >> *Different sets of styles can be applied to other text layers in the image by selecting the layer first.*

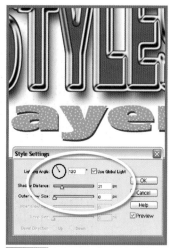

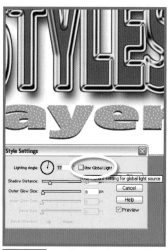

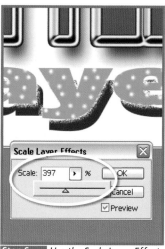

Step 4 >> *Adjusting the options in the Style Settings alters the appearance of the style.*

Step 5 >> *Deselecting the Use Global Light option provides Lighting Angle changes for the selected layer only.*

Step 6 >> *Use the Scale Layer Effects to change the size settings for all styles applied to a single layer.*

To apply a style to a section of type make sure that the text layer is currently active. Do this by checking that the layer is highlighted in the Layers palette. Next open and view the Layer Styles group you wish to use. Click on the thumbnail of the style you want to apply to the text. The changes will be immediately reflected in your image. Multiple styles can be applied to a single layer and unwanted effects can be removed by using the Step Backward button in the shortcuts bar or the Undo command (Edit>Undo Apply Style).

The settings of individual styles can be edited by double clicking on the 'f' icon in the text layer and adjusting one or more of the style settings.

Scaling effects >> *Layer styles settings do not change proportionately when you enlarge or reduce text to fit a composition or design idea. This can mean that the styles become too overpowering for the text or too subtle for the design. You can solve this problem by using the slider control in the Scale Effects feature (Layer>Layer Style>Scale Effects) to adjust the look of all styles interactively. (a) Scale Effects set to 50%. (b) Scale Effects set to 200%.*

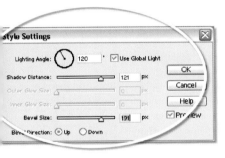

Adjusting styles to suit >>
The look of most layer styles can be adjusted via the controls in the Styles Settings dialog (Layer> Layer Styles>Style Settings). Different options will be available for different styles.
(a) Bevel size 190
(b) Bevel down
(c) Shadow size 100
(d) Shadow angle 160
(e) Shadow angle 60
(f) Shadow size 300
(g) Shadow size 50

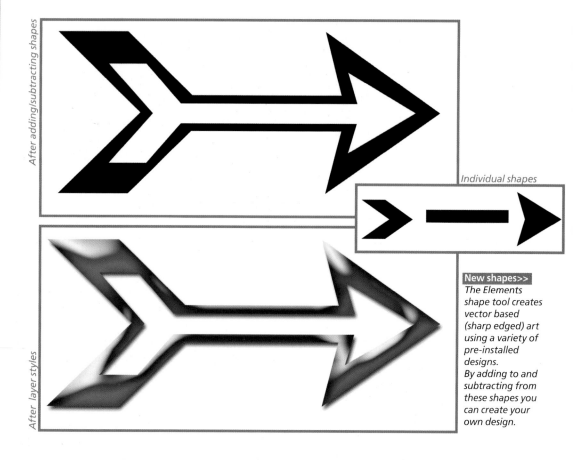

After adding/subtracting shapes

After layer styles

Individual shapes

New shapes>>
The Elements shape tool creates vector based (sharp edged) art using a variety of pre-installed designs.
By adding to and subtracting from these shapes you can create your own design.

7.06 Customizing shapes

Suitable for Elements – 1.0, 2.0 | Difficulty level – Intermediate
Related techniques – 7.05 | Tools used – Shape tools | Menus used – Layer

Photoshop Elements' drawing tools such as the rectangle, ellipse, polygon and line give users the option to create vector based graphics which are stored as separate layers in their Elements document. These tools create their content independent of the pixels that are the base of photographic images. Being vector based means that these graphics can be scaled up and down with no loss in quality. It also means that no matter what printer is chosen for output the shapes will be printed at the best quality available keeping the sharp edges of the graphics sharp.

As well as the predefined shapes such as rectangle and ellipse, Elements also ships with a range of custom shapes that are also vector based graphics. Though the program does not offer the option of creating your own custom shapes you can customize those available by interactively adding extra parts to and subtracting areas from these shapes.

This process is very similar to that used to modify a selection. To start we draw a base shape. Automatically Elements creates a new layer to store the shape. By default each shape that you draw is kept on a separate layer. If you want to add a shape to an existing shape make sure that the shape

Step 1 >> To help ensure the accuracy of the drawing process, start by displaying the Grid in the workspace.

Step 2 >> Select the first custom shape that the other shapes will be added to.

Step 3 >> Click and drag the shape until it is the right size. Use the move tool to reposition the graphic.

Step 4 >> Click the Add to Shape button in the tool's option bar or press the '+' key.

Step 5 >> Select and draw the other shapes making sure that they are positioned correctly. If positioned incorrectly select Edit>Undo and redraw the shape.

Step 6 >> Change the mode to Subtract from Shape by selecting this button in the bar or press the '-' key. Draw the shapes that are to be subtracted from the original.

Step 7 >> The newly constructed shape can now be treated just as any other shape. Here I applied a layer style to the completed graphic.

layer is selected, choose the shape and click the '+' key before drawing the new shape. To remove sections from the shape click the '-' key before drawing.

Both these options can also be accessed from the drawing tool's option bar along with selections to 'Intersect' or 'Exclude' the newly drawn shape from the existing graphic. By working with the drawing tools and these modifying options it is possible to construct very complex vector shapes on a single layer.

PRODUCING EFFECTIVE GRAPHICS

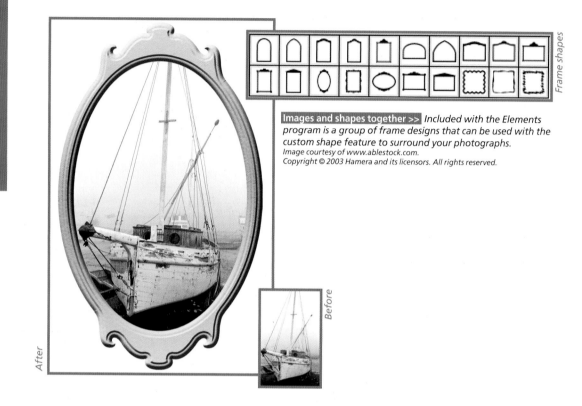

Frame shapes

Images and shapes together >> *Included with the Elements program is a group of frame designs that can be used with the custom shape feature to surround your photographs.*
Image courtesy of www.ablestock.com.

Before

After

7.07 Adding pictures to shapes

Suitable for Elements – 1.0, 2.0 | Difficulty level – Intermediate | Resources – Web image 707
Tools used – Selection tools | Menus used – Layer, Edit, Select

The graphic quality of shapes makes them perfect additions to many photographic compositions. They can be used as a title plate, a border or, as is the case in this example, a picture frame. For the technique to be convincing though, it is important to try to match the scale, texture and coloring of the shape with the photograph. In essence the frame should match the mood of the picture. The example image used here, a sepia nautical photograph, contains an old world charm that needs to be echoed in the frame itself. The best way to achieve this is to add texture, color and pattern to the shape layer using the Layer Style options.

In this example I used a standard custom shape from the 'Frames' group of shapes to surround the boat picture. To help match the frame to the 'look and feel' of the photograph I added a combination of layer styles to the shape and modified their settings to suit. The picture was then copied and pasted into the document as a new layer and dragged beneath the shape layer. Finally the shape was simplified and then used as the basis for a selection to trim away the unwanted excess (corners) of the picture so that image then looked like it was sitting within the drawn frame.

Step 1 >> *Select the desired shape from those in the custom shape palette. Click and drag to draw.*

Step 2 >> *View the Layer Styles palette and select base style from the group. Here I used Painted Wallboard.*

Step 3 >> *Adjust the values in the Style Settings dialog to suit the picture.*

Step 4 >> *Apply a second layer style for the bevels and adjust the setting for this style as well.*

Step 5 >> *Select all (Ctrl + A) of the nautical picture and then choose Copy from the Edit menu.*

Step 6 >> *Switch to the frame document and paste the picture as a new layer.*

Step 7 >> *Click and drag the picture layer beneath the frame shape layer. Resize using Free Transform, if necessary.*

Step 8 >> *With the frame layer selected use the Magic Wand to select inside the frame. Click OK to simplify the shape layer in the process.*

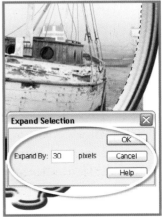

Step 9 >> *Expand the selection by 30 pixels and inverse the selection. Choose the image layer and press the 'Delete' key to remove the image corners.*

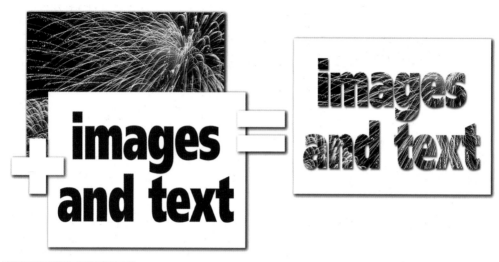

Combining text and images>> *One way to add another dimension to the pictures you create is to skillfully combine the images and text together. Text can be used as a container to hold a picture or as a template used to cut away parts of the image itself.* Image courtesy of www.ablestock.com. Copyright © 2003 Hamera and its licensors. All rights reserved.

Text and pictures

It doesn't take too long before most Elements users want to combine text with their pictures. To start with they simply add a text layer on top of their picture layer and maybe alter the color of the type so that it stands out from the picture background. Those users with a little more adventure in their soul may even add a layer style to the text to really make it jump out.

Nothing wrong with this approach. This is precisely how I started and much of my text and image work still fits into this category, but occasionally there are times when I need to create a text effect that is a little different. The following three techniques are ones that often fit the 'different' bill.

First I will show you how to fill your text with an image (technique 7.08), then I will demonstrate the reverse, extracting the text from the picture (technique 7.09), and finally I will go 'all out', merging text into an existing picture by creating shadows and lighting effects similar to those that already exist in the scene (technique 7.10).

7.08 Images in text

Suitable for Elements – 1.0, 2.0 | Difficulty level – Intermediate | Resources – Web image 708
Related techniques – 7.09, 7.10 | Tools used – Type tools | Menus used – Select, Edit, Layer

We have already been introduced to this technique way back in Chapter 3 when we were reviewing the various masking options that are available in Elements. I think that it is worth revisiting the process in this context as we look at the various ways that we can combine text and images. The technique makes use of the 'Group with Previous' command to place the image into the text. This command uses the text layer as a mask. The black region of the type displays the picture whilst the transparent area allows the white from the background to show through.

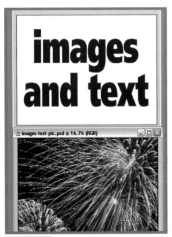

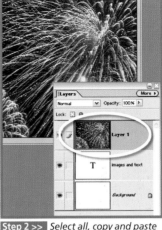

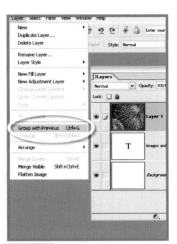

Step 1 >> *Open a suitable image document and create a new document to size for the text.*

Step 2 >> *Select all, copy and paste the image onto the text document so that it forms a new layer.*

Step 3 >> *With the image layer selected and above the text layer choose the Group with Previous option from the Layer menu.*

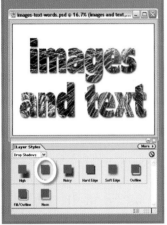

Step 4 >> *Complete the effect by adding a Layer Style drop shadow to the text layer.*

An alternative approach requires you to simplify (Layer>Simplify layer) the text layer first. This converts the text layer to a standard image layer. It is no longer an editable text layer so make sure that you don't need to alter font, style or spelling.

Next switch back to the picture document, select all (Select>All) and copy (Edit>Copy) the image to the computer's memory. Now switch back to the text document and select the type. A quick way to do this is to hold down the Ctrl key (Mac – Command key) whilst clicking into the type layer thumbnail. Now you can paste the picture from memory into the letter shapes using the Paste Into (Edit>Paste Into) command.

Alternative – Step 1 >> *Start by simplifying the text layer. Then select all of the picture and copy to memory.*

Alternative – Step 2 >> *With the Ctrl key pressed and any selection tool active click into the text layer thumbnail to select the type only.*

Alternative – Step 3 >> *Now use the Paste Into command to fill the selected text with the picture.*

Cut away text >> *The text that you input can be used as a basis for cutting away image parts. In this way the words remain visible as a hole in the picture.*

7.09 Text in images

Suitable for Elements – 1.0, 2.0 | Difficulty level – Intermediate | Resources – Web image 708
Related techniques – 7.08, 7.10 | Tools used – Type tools | Menus used – Select, Edit, Layer

In a contrasting text technique we will use the text as a basis for a 'cut-out' in the image itself. Before you begin be sure that the picture is not stored as a background layer. If you have just downloaded the file from your camera or scanner then double click the layer's name ('background') in the layer palette, rename the layer and click OK. Alternatively select the background layer and pick Layer>New>Layer from Background. Either process will convert the background to a standard image layer ready for your text work.

Now to add the text, select the standard horizontal type tool from the toolbox. Select a foreground color that will contrast against the picture. Click onto the image area and input the words that will be the basis for the cut-out. A new text layer appears in the layer stack. With the text layer selected choose a selection tool and whilst holding down the Ctrl (Mac – Command) key click into the thumbnail of the text layer. As we saw in the previous technique this action automatically selects all the type in the layer. Next select the image layer and cut (Edit>Cut) or press the Delete key. This will remove a portion of the image in the same shape as the selection.

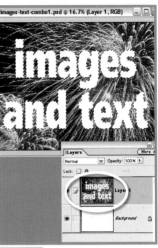

Step 1 >> *With a picture document already open select the type tool and add some text to the image.*

Step 2 >> *With a selection tool active and whilst pressing the Ctrl key click into the type layer thumbnail.*

Step 3 >> *Now select the image layer and cut (Edit>Cut) away the picture in the shape of the selection.*

As the text layer will be obscuring the image layer beneath, the results of your actions may not be immediately obvious, so drag the text layer to the Dustbin icon in the bottom right of the layer's palette to delete the layer. To finish the technique and make sure that the cut-out looks realistic, select the image layer and add a drop shadow layer style. This gives the deleted area real depth.

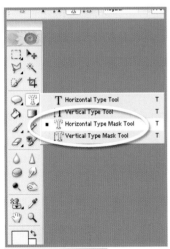

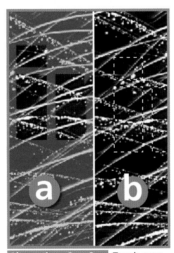

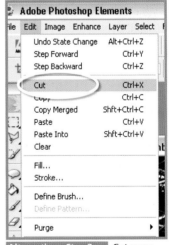

Alternative – Step 1 >> *Select the Horizontal Type Mask tool from the Type options in the toolbar.*

Alternative – Step 2 >> *Type in your words, the letters will appear in mask mode (a). Press the numeric pad Enter key to switch to selection mode (b).*

Alternative – Step 3 >> *Cut away the image parts by selecting Edit>Cut or pressing the Delete key. Add drop shadow.*

An alternative approach that achieves the same results uses the Horizontal Type Mask tool to create the type selection. Simply select this text option from the Type tool choices and input your words directly onto the image layer. Press the Enter key on the numeric pad to change from the mask (red) mode to the selection (marching ants) mode. Cut the selection from the image using the Edit>Cut command and to finalize add the drop shadow to the cut-out.

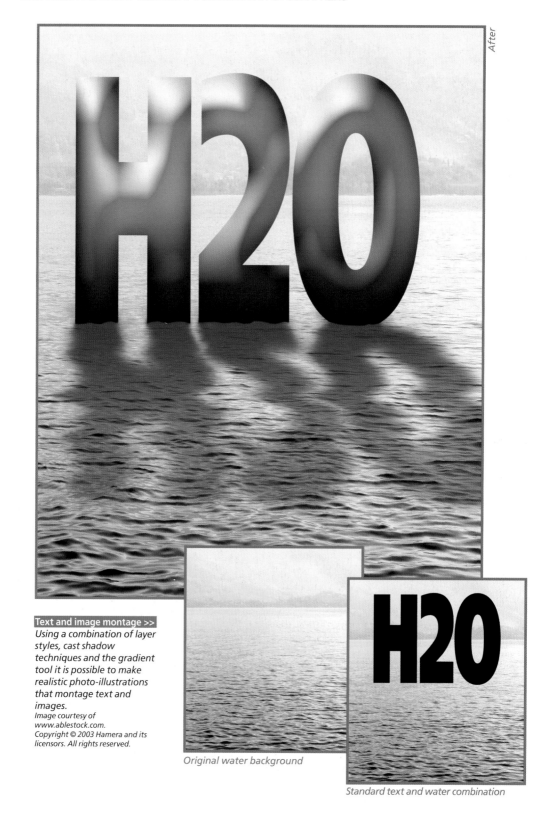

After

Text and image montage >>
Using a combination of layer styles, cast shadow techniques and the gradient tool it is possible to make realistic photo-illustrations that montage text and images.
Image courtesy of
www.ablestock.com.
Copyright © 2003 Hamera and its
licensors. All rights reserved.

Original water background

Standard text and water combination

7.10 Realistic text and image montages

Suitable for Elements – 1.0, 2.0 | Difficulty level – Intermediate | Resources – Web image 710
Related techniques – 7.08, 7.09 | Tools used – Type tools | Menus used – Select, Edit, Layer

The previous two techniques concentrated on combining text and images in a graphic way. In contrast this tutorial aims to seamlessly merge some text into an existing picture. As we have already discussed (see technique 4.15) the success or failure of montage work often relies on matching the texture, light and color of the two components. When combining segments of photographs this means ensuring that the lighting direction and overall contrast are similar for all picture parts that will be used to form the montage. Many of the same concerns are true when you want to add text to an existing picture, the difference being that rather than photographing under the same conditions you must use Elements to recreate these lighting, color and contrast effects in the text.

The example background image of water and mountains has both distinctive color and light. To successfully montage some text into the composition, it too must reflect these qualities. To start the process I added the text to the image and then applied a layer style that matched the color of the background picture. I then proceeded to adjust the position of the highlights in the bevel of the style, using the Lighting Angle control in the Style Settings, so that they matched the direction of the light in the scene, that is from the back left. This created type of the right color and surface texture.

At this point the text feels and looks like it is floating in mid-air over the water. To make the letters look like they were sitting on or a little under the water I decided to add a shadow to the text. A simple layer styles drop shadow would not give the desired effect so instead a directional shadow was added using the duplicate layer, distort and blur technique that we encountered in technique 4.11. To add the sense that the shadow was falling on water the opacity was reduced to allow the water texture to show through and a wave filter was applied.

Step 1 >> *Add suitable layer styles to type. Copy the layer by dragging it to the new layer button.*

Step 2 >> *Select the type copy and convert to a standard image layer with the Simplify Layer command.*

Step 3 >> *With the copied layer still selected flip the layer vertically.*

Step 4 >> Click on the Move tool and drag the copied layer down so that it reflects the type layer.

Step 5 >> Pick the Eyedropper tool and select a dark blue color from the background.

Step 6 >> With the Preserve Transparency option ticked Edit>Fill the copied layer with the foreground color.

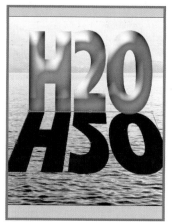

Step 7 >> Distort the filled layer to form a cast shadow using the Image> Transform>Distort feature.

Step 8 >> Blur the edges of the shadow layer using the Gaussian Blur filter.

Step 9 >> Reduce the opacity of the shadow layer to allow some of the water texture to show through.

Step 10 >> Break up the edges of the shadow using the Filter>Distort> Wave filter.

Step 11 >> Simplify the text layer and make feathered wave-like selections at the bottom of the type. Delete these sections.

Step 12 >> Select the text then switch mode to intersect and make a rectangular selection of the bottom of the type.

This provided a broken edge texture to the shadow that made it appear to fall more realistically on the water's surface.

The text layer was converted to a standard image layer using the Simplify Layer command (Layer>Simplify Layer). To give the illusion that the letters are partially submerged at their base, a series of curved selections were made at the bottom of each letter shape. The

Step 13 > *Using a foreground to transparent gradient set to Darken, fill the selection with a linear gradient.*

Step 14 >> *Select the shadow and apply the same gradient from the letter base outwards.*

selection was feathered a little (1–2 pixels) and with the text layer selected, these sections of the letter were then deleted (Edit>Cut).

To complete the technique some minor adjustments were made to the color and tone of both the letter shapes and their shadow. The bottom of the letters need to be made darker and the effect gradually reduced as you move up the letter. To achieve this change the letters were selected first and then with the 'intersect selection' mode highlighted, a rectangular selection was then drawn over the lower section of the letter shapes. This creates a selection of just the bottom half of the letters.

The gradient tool was selected and the mode turned to Darken. A color to transparent gradient was chosen and the color changed to a dark blue, sampled from the background using the Eyedropper tool. A linear gradient was drawn from the bottom of the selection upwards, with the effect that the letters became darker at the bottom than the top. The same gradient technique was applied to the shadow layer, this time making the area closest to the base of the letters the starting point for the linear gradient.

The overall effect of the combination of layer styles, cast shadow, wave filter and gradient darkening has produced a text/picture montage that merges the type more convincingly with the background image.

Gradient Editor >> *The Gradient Editor can be used to alter the color, style and type of gradient that you draw.*
In the example I sampled the background to ensure that the color in the gradient was consistent with those in the scene.

7.11 Hand drawn logos

Suitable for Elements – 1.0, 2.0
Difficulty level – Intermediate
Resources – Web image 711
Tools used – Drawing tools
Menus used – Select, Image, Layer

There will be times when the particular project that you are working on requires a graphic element that can't be sourced from a photograph or created using the custom shape tool. In these circumstances there is no escaping trying your hand at a little drawing. No need to panic though as Elements contains a few tools that can make even the most elementary artist's work very presentable.

For example, let's create a dollar sign symbol that could be used as part of a business presentation. Using the paint brush, set to a soft-edge tip, roughly draw the symbol making sure the basic shape is correct. To clean up the edges of the drawing convert the picture to just black and white (no grays) using the Threshold command (Image>Adjustments>Threshold). With the threshold dialog still open you can alter the point at which a gray tone is changed to white or black by sliding the threshold arrow in

Drawn symbols >> *Using the selection tools in Elements along with a tricky manoeuvre with the Threshold command you can turn a rough hand drawn symbol into a graphical element that you can use in your publications.*
Image courtesy of www.ablestock.com.

Pro's Tip: Graphics tablets to the rescue

If you regularly need to draw freehand shapes then you will quickly find that the mouse, though good for general screen navigation, is quite clumsy for drawing. For years professional artists have forsaken the humble mouse for a drawing tool that is far more intuitive and easy to use – the stylus and tablet.

Working just like a pen and pad these devices are more suited to many drawing and painting tasks. They not only provide a way of working that is familiar but they also allow you to use an extended Elements function set designed to take advantage of the pressure settings of the device. Pushing harder with the stylus as you draw can change the density or thickness of the line or if you are using the dodging tool, for example, changing pressure will alter the degree of lightening.

Step 1 >> *With a soft edged brush draw the base artwork for the dollar symbol.*

Step 2 >> *Convert the drawing to a flat graphic using the Image>Adjustments>Threshold command.*

Step 3 >> *Trim unwanted areas from the graphic by selecting first with the polygonal lasso and then deleting.*

Step 4 >> *Smooth the edges by selecting the symbol, contracting (Select>Modify>Contract) and then smoothing (Select>Modify>Smooth).*

Step 5 >> *Apply a layer style to the finished graphic to give the symbol some depth.*

Step 6 >> *Drop in a background image and use a copied version of the graphic as a shadow to complete.*

the middle of the graph. Click OK to convert. Now the symbol has a hard edge but some of the areas where lines meet are too rounded. Use the polygonal lasso tool to trace the preferred outline for these areas and then delete (Edit>Cut) the unwanted edge sections.

The basic shape is ready but some edges are still a little rough. Make them smoother by firstly selecting the shape and then reducing (Select>Modify>Contract) and smoothing (Select>Modify>Smooth) the selection. Next inverse (Select>Inverse) the selection and delete (Edit>Cut) the unwanted edges. Your basic symbol is now complete. You can add a layer style and a background, like the Euro notes used in the example, to complete the illustration.

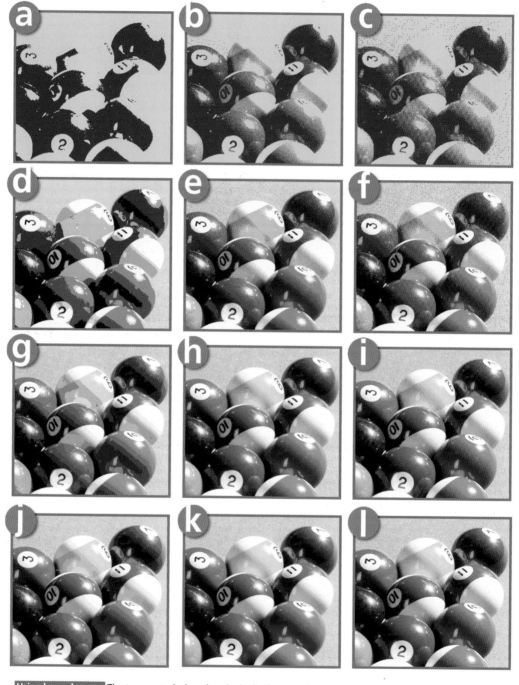

Using less colors >> The two controls that alter the look of your 'reduced-color' images the most are the total number of colors and the type of dithering used to simulate lost hues.

(a) 2 color, no dither.
(b) 2 color, diffusion dither.
(c) 2 color, pattern dither.
(d) 8 color, no dither.
(e) 8 color, diffusion dither.
(f) 8 color, pattern dither.
(g) 64 color, no dither.
(h) 64 color, diffusion dither.
(i) 64 color, pattern dither.
(j) 256 color, no dither.
(k) 256 color, diffusion dither.
(l) 256 color, pattern dither.

7.12 Reducing your picture's colors

Suitable for Elements – 1.0, 2.0 | Difficulty level – Basic
Resources – Web image 712 | Menus used – Edit

For most of us when we consider the colors in our digital images we think about trying to capture and use the most hues possible. After all, the accuracy and quality of digital pictures are based, at least in part, on the number of colors use to construct them. Hence the push of scanner and camera manufacturers towards creating devices that capture in 24, 36 and even 48 bits. This said, there are still times when for aesthetic or technical reasons there is a need to reduce the numbers of colors present in your images.

Limiting the numbers of colors in a picture is one way to make files small enough to display quickly on web pages. The GIF (Graphics Interchange Format) format is a file type suitable for web use that can also store images with different numbers of colors (up to a maximum of 256). A GIF image with 8 colors, for instance, takes up much less space and displays more quickly than one that contains 200 hues. In addition to the small file sizes, 'reduced-color' images have a distinctive look that can suit situations when large areas of flat color are needed.

Elements in its Save for Web (Edit>Save for Web) feature provides a GIF format option which enables you to interactively reduce the number of colors in your image. This feature can be used to convert a full color image (16.7 million colors) to one that contains as few as 2 different hues. At the same time you can also make decisions about how Elements will make the reduction. The 'No Dither' selection will create an image made up of flat colors only, whereas selections of 'Diffusion', 'Pattern' or 'Noise' will try to recreate the removed colors and tones by mixing together various proportions of those hues that are left. Deciding on which combination of settings works best for your application often requires a little experimentation. Use the example images to the left as a guide to how the number of colors and the dither settings alter the way a 'reduced-color' image looks.

Step 1 >> *With an image open, select the Save for Web feature from the File menu. Choose the GIF setting from the File Type drop-down menu.*

Step 2 >> *Pick the number of colors from the presets in the Colors drop-down menu or input the precise number into this space.*

Step 3 >> *Now choose the Dither Type from the drop-down menu on the left of the dialog. Click OK to save the newly created GIF file.*

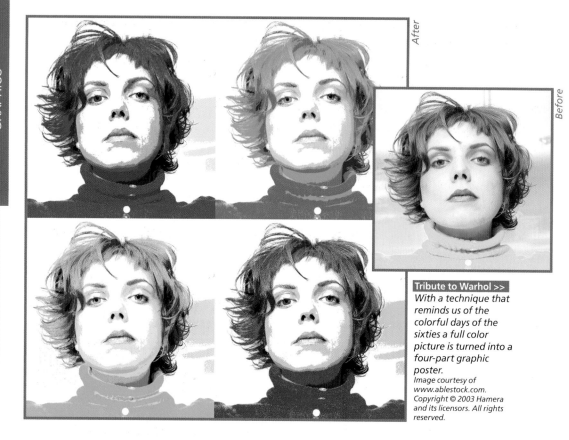

After

Before

Tribute to Warhol >>
With a technique that reminds us of the colorful days of the sixties a full color picture is turned into a four-part graphic poster.
Image courtesy of www.ablestock.com. Copyright © 2003 Hamera and its licensors. All rights reserved.

7.13 Posterized pictures

Suitable for Elements – 1.0, 2.0 | Difficulty level – Intermediate | Resources – Web image 713
Related techniques – 7.12 | Menus used – Enhance, Image, Layer

Andy Warhol made the technique famous with his 'Campbell Soup Cans' and now you can recreate the sixties and this posterized effect using Elements and your own digital camera. Warhol's images were extremely graphic and were constructed of very few colors which were applied in broad flat areas of the picture. Following on from the previous technique here I pay tribute to Warhol by creating flat color images using a reduced color set created with a single filter in Elements.

In the example I started with a standard portrait, increased its contrast and then reduced the numbers of colors used to make up the image with the Posterize feature. To make different color combinations I adjusted the Hue and Saturation sliders in the Hue/Saturation feature.

To start the process the picture will need to contain a little more contrast than normal. I enhanced the contrast with the Levels feature (Enhance>Adjust Brightness/Contrast>Levels) but you could easily use the Contrast slider (Enhance>Adjust Brightness/Contrast>Brightness/Contrast). To increase contrast you need to click and drag the black point and white point triangles towards the center of the levels histogram.

Next I reduced the numbers of colors in the picture using the Posterize feature. Select the feature from the Adjustments section of the Image menu (Image>Adjustments>Posterize). Input the numbers of levels you wish to use for the picture into the Posterize dialog. The smaller the number the less colors in the final picture. Here I used a setting of 4 levels.

This gives you your base colored image. To alter the color mix I employed the Hue and Saturation control. Select the feature from Adjust Color Section of the Enhance menu (Enhance>Adjust Color>Hue/Saturation). You can create many different color combinations by moving the Hue slider in the Hue/Saturation dialog. If the new colors are a little strong then reduce their vibrancy by dragging down the Saturation slider.

You can extend the idea into a poster using four different posterized versions of the original portrait by copying and pasting the picture onto a bigger canvas and then selecting each copy in turn and adjusting the colors.

Step 1 >> *The contrast of the original portrait is increased by dragging in the white and black input sliders in Levels.*

Step 2 >> *The Posterize feature was set to 4 levels to reduce the colors in the picture.*

Step 3 >> *The color combination was altered by moving the Hue slider in the Hue/Saturation control.*

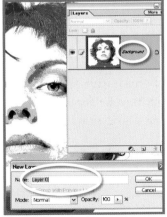

Step 4 >> *The background layer was converted to a standard image layer by double clicking its label.*

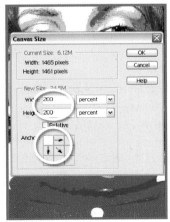

Step 5 >> *To accommodate the 3 other pictures the canvas size was increased by 200% in width and height.*

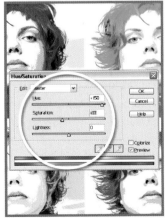

Step 6 >> *The base image was copied three times, the colors in the copies adjusted and then each picture placed in the corners of the composition.*

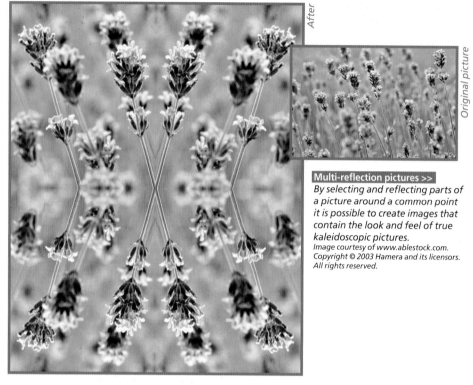

After

Original picture

Multi-reflection pictures >>
By selecting and reflecting parts of a picture around a common point it is possible to create images that contain the look and feel of true kaleidoscopic pictures.
Image courtesy of www.ablestock.com.
Copyright © 2003 Hamera and its licensors.
All rights reserved.

7.14 Kaleidoscopic images

Suitable for Elements – 1.0, 2.0 | Difficulty level – Intermediate | Resources – Web image 714
Tools used – Crop, Move tools | Menus used – Layer, Image, Edit

I can still remember saving my pocket money for weeks to buy my first kaleidoscope. I was fascinated by the way that the images would change and move as they refracted, or is that reflected, inside the small metal tube. Apart from a brief and largely embarrassing period in my imaging career when I owned, and happily used, a 'multi-imaging' filter on the front of my camera, I have not rekindled my interest in these types of images until recently when I started to play with a few photographs in Elements. I found that by copying and pivoting the main image I could create an interesting and dynamic picture that contained several of the kaleidoscope qualities I valued in my youth.

Real kaleidoscope pictures are made with a tube, an eyepiece and a series of carefully arranged mirrors. The distinctive images that we see are produced by the scene at the end of the tube reflecting from the surface of a series of mirrored surfaces. The positioning and number of mirrors alter the style and complexity of the image. The digital version of this technique detailed here repeats an image around a common point allowing the edges to interact, using layer flips to reflect the picture and one pixel cursor movements to ensure that pictures are precisely placed. Though not strictly a kaleidoscope technique, the pictures that are produced do contain similar shapes and textures that we would expect from a picture created traditionally.

Step 1 >> Crop the image to a section that contains good color, contrast and shapes.

Step 2 >> Convert the background layer into a standard image layer by double clicking on the layer label.

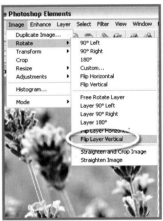

Step 3 >> Open the Canvas Size dialog, anchor the picture in the corner and increase by 200%.

Step 4 >> Duplicate the layer three times so that you have four versions of the original picture.

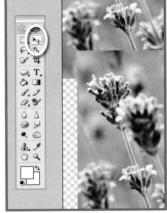

Step 5 >> Use the Move tool to position the three copies in the vacant corners of the canvas.

Step 6 >> Select the bottom layers one at a time and flip them vertically.

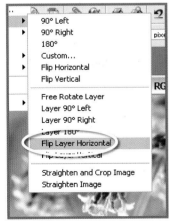

Step 7 >> Select the right hand layers one at a time and flip them horizontally.

Which images are suitable?

The pictures that work best for making striking multi-faceted images are those that contain contrasting color and texture, along with dominant graphic shapes. Strong lines too can provide a basis for making dynamic and exciting designs in your final compositions.

You shouldn't let any preconceptions deter you from trying a range of different images with this technique. You will be surprised at how amazing a photograph, that you would normally discard, can appear as a kaleidoscope montage.

The process outlined above will give you simple, but stunning, images and with a little more effort you can create truly dynamic compositions from your photographs. Use the picture created above as the basis for further copying, flipping and positioning. By repeating the original picture several times you will end up with a multi-image kaleidoscope pattern.

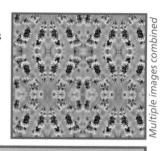

Multiple images combined

Step 1 >> *Merge the four layers in the kaleidoscope picture created in the previous technique.*

Step 2 >> *Open the Canvas Size dialog, anchor the picture in the corner and increase by 200%.*

Step 3 >> *Duplicate the image layer three times and position the copies in the corners of the canvas.*

Another approach to creating repeating image designs is to define an Elements pattern (Edit>Define Pattern) which can then be used to Fill (Edit>Fill) a new document. This technique doesn't contain the sophistication of reflected images but it still works well as a way to achieve patterned pictures.

Patterned pictures

Step 1 >> *Create a selection with the rectangular marquee and then choose Define Pattern from the Edit menu.*

Step 2 >> *Name the new pattern. The pattern will be stored in the Elements patterns folder.*

Step 3 >> *Choose Edit>Fill, selecting the Pattern option as the content. Select the pattern from the thumbnails.*

After

Before

DIY presentation backgrounds>>
Elements provides you with a range of tools that you can use to create stunning backgrounds for your business or school presentations.
Images courtesy of www.ablestock.com
Copyright © 2003 Hamera and its licensors. All rights reserved.

7.15 Presentation backgrounds

Suitable for Elements – 1.0, 2.0 | Difficulty level – Intermediate | Resources – Web images 715-1, 715-2, 715-3
Tools used – Selection, Gradient, Crop tools | Menus used – Select, Layer, Image

One of the most common ways that ideas and information are communicated in the business world today is via the PowerPoint presentation. This program is the digital platform that replaces both the slide and overhead transparency projectors. It is used to sequence a series of 'slides' that can contain text, pictures, sound, video and tables.

People spend many hours putting together the content for these multi-slide extravaganzas, but too frequently, little attention is paid to the background images that are used in the show. These pictures provide a context for the information that is being presented and what better way to emphasize your point than to create and include background graphics that relate specifically to the ideas that you are presenting. Don't reach for the 'clip art backgrounds' that come with the program, think about what type and style of pictures would suit the content of your presentation and either shoot them yourself, or source them from a stock company like www.ablestock.com. With images in hand you can now create your own backgrounds that are customized for your presentation.

Step 1 >> *Set the width, height and resolution values in the Crop tool options bar to suit your slide.*

Step 2 >> *Click and drag out the crop area that you want to use as a background. Press Enter to complete.*

Step 3 >> *Make a rectangular selection just inside the image.*

Elements is perfectly suited for the creation of PowerPoint graphics and in this technique I will demonstrate how to create three different background styles with images that you can take yourself. All the procedures are based on the idea that the picture needs to be visible but not so apparent that it makes the text difficult to read.

Step 4 >> *Feather the selection so the edge will not be hard and sharp.*

Step 5 >> *Drag the black output slider of the Levels feature to the right to lighten the selected area.*

(a) Lightening a softedged selection

To start we must make sure that the background image is the size suitable for the presentation. This value is usually determined by the default resolution of the digital projector you use. Here I used a standard 800 x 600 pixel slide. With the image open I select the Crop tool and input the height and width into the option bar. Now the tool will only allow me to crop with a shape that suits the slide size. With the image now sized, I make a rectangular selection just inside the edges of the picture. This area is where the text of the slide will be placed. The selection is then softened using the feather command (Select>Feather). I then use the Levels feature (Enhance>Adjust Brightness/Contrast>Levels) to lighten the text area of the picture. To achieve this I drag the black output slider towards the right. This converts the dark tones to lighter ones and creates a good area where text can be placed. The picture is then saved as a high quality JPEG file ready for use in the presentation.

An extended version of this technique uses a Levels Adjustment layer in step 5. This approach provides the same results but doesn't change the base image in the process.

(b) Fade to white

The second technique uses the gradient tool set to 'Foreground to Transparent' and Linear to create the text space. The gradient is applied separately to two different rectangular selections to create a place for a heading as well as an area for main points. If not enough lightening is provided by the gradient to make the text readable, apply a levels adjustment, like the one described in the technique above, to the selections as well.

Step 1 >> *To make the heading area create a long thin rectangular selection from the left border to just short of the right border.*

Step 2 >> *With a white to transparent gradient selected use the linear gradient tool to fill the*

Step 3 >> *Reverse the gradient fill then create and fill a larger selection lower on the page for the presentation points.*

(c) Dropped shadow text box

The last technique creates a text area based on a drawn rectangle filled in white that is slightly smaller than the overall slide dimensions. A drop shadow Layer Style is then applied to the white box to make it stand out from the background. As a finishing touch the opacity of the box layer is reduced to allow some of the background image to show through.

Step 1 >> *Draw a rectangle slightly smaller than the size of the background using the Rounded Rectangle Tool.*

Step 2 >> *With the rectangle layer selected apply a drop shadow layer style to the shape.*

Step 3 >> *Lower the opacity of the rectangle by moving the Opacity slider in the Layers palette.*

Microsoft PowerPoint >>
PowerPoint provides an easy way to bring together images, text, tables and videos into a digital slide show format.

Adding your backgrounds to a PowerPoint slide

With your backgrounds now complete you can import them into your PowerPoint presentation. When formatting slides in the program the background and the presentation information such as tables, text and pictures that sit on the background are treated separately. It is possible to construct your whole presentation and then apply a single background image to all the slides or even apply different images for each slide.

To add your newly created background images to an existing slide select Background from the PowerPoint Format menu. Next choose the Fill Effects option from the drop-down menu at the bottom of the Background dialog. Choose the Picture tab from the Fill Effects dialog and click the Select Picture button. Navigate your way through your folders to find the slide backgrounds that you saved as JPEG files. Select the background you want to use for this slide and click Insert and then OK. At the Background dialog click Apply to use the picture for just a single slide or Apply to All to make this image the default background for all slides in the presentation.

Step 1 >> *Choose Background from the Format menu and then pick Fill Effects from the drop-down list.*

Step 2 >> *Choose Select Picture from the Picture tab of the Fill Effects dialog and then find your background pictures.*

Step 3 >> *With the backgrounds now inserted add the content of the presentation.*

8

Finely Crafted Output

I t is one thing to be able to take great pictures with your digital camera and quite another to then produce fantastic photographic prints. In the old days of film most photographers passed on the responsibility of making a print into their local photo store. Most, that is, except for a few dedicated individuals who spent their hours in small darkrooms under stairs or in the attic.

Digital has changed all this. Now more shooters than ever before are creating their own prints. Gone are the dank and smelly darkrooms. Now the center of home print production sits squarely on the desk in the form of a tabletop printer.

Printing basics

There are several different printer technologies that can turn your digital pictures into photographs. The most popular, at the moment, is the Ink Jet (or Bubble Jet) printer, followed by Dye Sublimation and Laser machines.

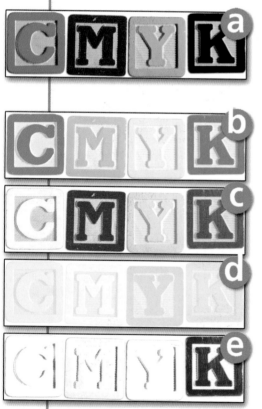

CMYK color >> Most printing systems are based on breaking the full color picture (a) down into several color parts. Here the picture is separated into cyan (b), magenta (c), yellow (d) and black (e), which correspond to the inks of the printer.

Creating millions of colors from as little as four

Each of the printing technologies creates the illusion of millions of colors in the photograph by separating the picture into 4 separate base colors (some systems use 6 or 7 colors). In most cases, these colors are Cyan, Magenta, Yellow and Black. This type of separation is referred to as CMYK (where K stands for the black component), which has been the basis of newspaper and magazine printing for decades.

Once the picture is broken into these four colors, the printer lays down a series of tiny colored dots in a specific pattern on the paper. Looking at the picture from a distance, our eyes mix the dots together so that we see an illusion of many colors rather than just the four that the picture was created from.

Tones and colors made of dots

To create darker and lighter colors the printer produces the colored dots at varying sizes. The lighter tones are created by printing small dots so that more of the white paper base shows through. The darker tones of the photograph are made with larger dots leaving less paper showing. This system is called 'halftoning'. In traditional printing, such as that used to create the book you are now reading, different dot sizes, and therefore tone, are created by 'screening' the photograph. In desktop

digital printing different shades are created using 'simulated halftones'.

This process breaks each section of the image into minute grids. Then as part of the separation process, the printer's software will determine the tone of each image part and decide how to best balance the amount of white space and ink dots in the grid in order to simulate this tone. Sound confusing? Well let's use a simple example.

We are printing a black and white picture with a printer capable of five levels of tone –

• White,
• Light gray (25% gray),
• Mid gray (50% gray),
• Dark gray (75% gray) and
• Black (100% black).

We are using black ink only. Let's say that one part of the image is represented by a grid of two dots by two dots.

If this part of the picture was supposed to be white then the software would print no dots in the grid. If the area was light gray then one dot (out of a possible four) would be printed. If the image was a mid tone then two dots would be printed. If the shade was a little darker then three dots would be laid down and finally if this part of the photograph was black then all parts of the grid (that is, all four dots) would be printed.

Simulated tones >> *Digital printers represent tones in a similar fashion using small grids containing areas of ink color and sections where the paper shows through. (a) White. (b) 25% gray. (c) 50% gray. (d) 75% gray. (e) Black.*

Keep in mind that modern photographic inkjet printers are capable of many more levels of tone than the five used in our example. Also remember that different colored dots are being laid

Color from dots >>
The separate colors are laid down on the paper surface in the form of minute dots which, when seen at a distance, mix together to simulate all the other colors in the photograph.

Image courtesy of
www.ablestock.com.

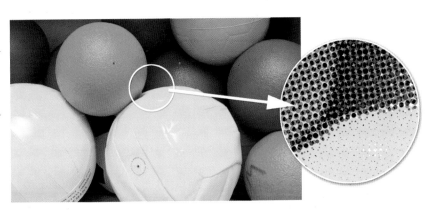

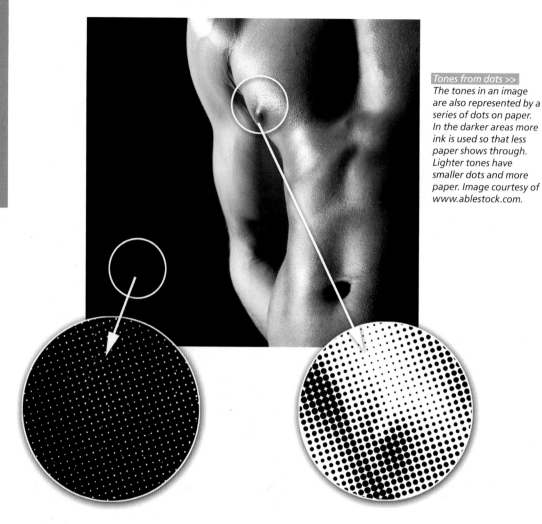

Tones from dots >>
The tones in an image are also represented by a series of dots on paper. In the darker areas more ink is used so that less paper shows through. Lighter tones have smaller dots and more paper. Image courtesy of www.ablestock.com.

down at the same time. In this way both simulated tone and color is created by drawing the picture with a series of dots using a small set of printing inks. The fact that all the current crop of desktop printers handle this type of separation and the creation and application of the dots with such precision and speed is nothing short of a technological miracle.

Now let's look at the three main desktop printing technologies in turn.

The inkjet printer

Costing as little as 70 pounds the inkjet printer provides the cheapest way to enter the world of desktop printing. The ability of an inkjet printer to produce great photographs is based on the production of a combination of fineness of detail and seamless graduation of the color and tone. The machines contain a series of cartridges filled with liquid ink. The ink is forced through a set of

tiny print nozzles using either heat or pressure. Different manufacturers have slightly different systems but all are capable of producing very small droplets of ink (some are 4 times smaller than the diameter of a human hair!). The printer head moves back and forth across the paper laying down color whilst the roller mechanism gradually feeds the print through the machine. Newer models have multiple sets of nozzles which operate in both directions (bi-directional) to give faster print speeds.

The most sophisticated printers from manufacturers such as Canon, Epson and Hewlett Packard also have the ability to produce ink droplets that vary in size. This feature helps create the fine detail in photographic prints. Most photographic quality printers have very high resolution approaching 6000 dots per inch, which equates to pictures being created with very small ink droplets. They also have 6 or 7 different ink colors enabling these machines to produce the highest quality prints. These printers are often more expensive than standard models but serious photographers will value the extra quality they are capable of.

Printers optimized for business applications are often capable of producing prints faster than the photographic models. They usually only have three colors and black, and so do not produce photographic images with as much subtlety in tonal change as the special photo models.

One of the real advantages of inkjet printing technologies for the digital photographer is the choice of papers available for printing. Different surfaces (gloss, semi-gloss, matte, iron-on transfer, metallic, magnetic and even plastic), textures (smooth, water color and canvas), thickness (from 80 gsm to 300 gsm) and sizes (A4, A3, 10 x 8 inch, 6 x 4 inch, Panorama and even roll) can all be fed through the printer. This is not the case with laser, where the choice is limited in surface and thickness, nor Dye Sublimation, where only the specialized paper supplied with the colored ribbons can be used.

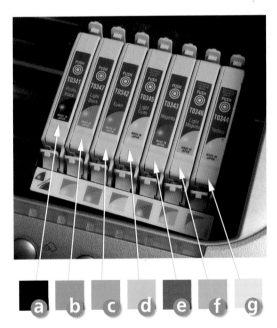

Simulated tones >> *The best photographic printers contain the standard four colors plus light versions of black, cyan and magenta to help create truer colors and smoother graduation of tones.*
(a) Black. (b) Light or Photo black. (c) Cyan. (d) Light cyan.
(e) Magenta. (f) Light magenta. (g) Yellow.

Laser

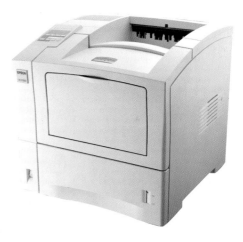

Though most laser printers you see are used for black and white business prints more and more are capable of producing good quality color output. These devices use a modified version of photocopier technology to produce their crisp hard edged prints.

They work by drawing the image or text to be printed onto a photo-sensitive drum using either a laser or a series of LEDs (light emitting diodes). This process changes the electromagnetic charge on the drawn sections of the drum. The drum is then passed by a dispenser and the oppositely charged toner (the 'ink' used by laser printers) is attracted to the drum which then is passed by electrostatically charged paper where the toner is deposited. Color laser printers use four different drums for each of the separation colors – cyan, magenta, yellow and black.

Laser printers >> *Laser printers use photocopier type technology to produce crisp output. Some models can even produce full color prints.*

The strengths of laser printers are their speed, cost per printed page and the sharp edged clarity of the prints they produce. For businesses that regularly produce short runs of color brochures a color laser may be a cost-effective alternative to printing outside, but for the dedicated digital photographer, inkjet printers provide a cheaper way to produce photographic quality prints.

Dye sublimation

Where laser and inkjet technology based printing prowess on the creation of tone and color via discrete dots, Dye Sublimation printers use a different approach. Often called a continuous tone printing system, 'Dye Sub' machines create prints by laying down a series of overlapping transparent dyes to build up the picture.

Expensive when the technology was first released, these printers have gained more popularity as newer models have dropped in price and increased in speed and image quality. Rather than using a set of inks, color is added to the picture using a heating element to transfer dye from cyan, magenta, yellow and, in some machines, black ribbons onto a specially treated paper. The dyes are absorbed

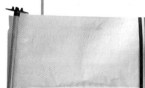
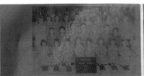

Dye sublimation printers >> *Dye sublimation printers use a multi-colored donor ribbon which is heated to transfer the color to a special receiving paper.*

into the paper surface leaving a slightly blurred edge which blends with adjacent colors and tones. This gives the image a continuous tone (non-dotty) appearance at relatively low resolutions (300 dpi) compared to inkjet technology equivalents.

The dyes are layered on a full paper size ribbon and each color is added in turn. With some machines a protective clear coating is also applied at the last stage in the process. Accurate registration is critical throughout the whole printing process.

Other printing processes

Though less well known, the following processes are also being used to produce photo images.

Thermal wax transfer – Initially designed for use in the graphic design and printing industries this technology uses very small heating elements to melt and transfer color wax from donor sheets onto the printing paper. These printers produce very strong and vibrant colors but sometimes struggle to create truly photographic prints.

Pictrography – Developed by Fuji, this system uses a 3 color laser (red, green and blue) to draw the picture onto a donor paper at a resolution of about 400 dpi. The donor paper is then placed in contact with a printing paper and the image transferred using heated water. The final print is very similar to standard photographic paper.

Offset lithography – Used for printing newspapers and magazines. Typically a color image is separated into the standard 4 base colors (CMYK) and a halftone version of the image created at the same time. This produces four separate versions of the picture, one for each color, which are used to create four different printing plates. The color inks (called 'process' colors) are applied to each plate and the printing paper is fed past each plate with the ink being laid down in registration.

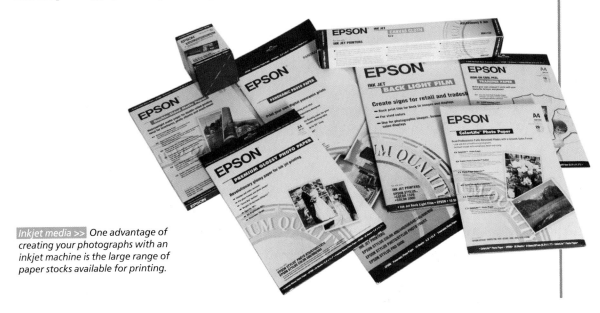

Inkjet media >> *One advantage of creating your photographs with an inkjet machine is the large range of paper stocks available for printing.*

Image resolution vs printer resolution

As we have already seen from our discussions in Chapter 2 the true dimensions of any digital file are measured in pixels, not inches or cm. These dimensions indicate the total number of samples that were made to form the file. It's only when an image's resolution is chosen that these dimensions will be translated into a print size that can be measured in inches or cm.

The image resolution determines how the digital information is spread over the print surface. If a setting of 100 dpi is chosen then the print will use 100 pixels for each inch that is printed. If the image is 800 pixels wide then this will result in a print that is 8 inches wide. If the image resolution is set to 200 dpi then the resultant print will only be 4 inches wide because twice as many pixels are used for every inch of the print. For this reason the same digital file can have many different printed sizes.

With this in mind, the following table shows the different print sizes possible when the same picture is printed at different resolutions:

Pixel dimensions:	Print size at 100 dpi:	Print size at 200 dpi:	Print size at 300 dpi:
640 x 480 pixels	6.4 x 4.8 inches	3.2 x 2.4 inches	2.1 x 1.6 inches
1440 x 960 pixels	14.4 x 9.6 inches	7.2 x 4.8 inches	4.8 x 3.2 inches
1600 x 1200 pixels	16 x 12 inches	8.0 x 6.0 inches	5.3 x 4 inches
1920 x 1600 pixels	19.2 x 16 inches	9.6 x 8 inches	6.4 x 5.3 inches
2304 x 1536 pixels	23 x 15.4 inches	11.5 x 7.7 inches	7.6 x 5.1 inches
2560 x 1920 pixels	25.6 x 19.2 inches	12.8 x 9.6 inches	8.5 x 6.4 inches
3000 x 2000 pixels	30 x 20 inches	15 x 10 inches	10 x 6.6 inches

Printer resolution refers to the number of ink droplets placed on the page per inch of paper. Most modern printers are capable of up to 3000 dots per inch. This value does not relate to the image resolution discussed above. It is a measure of the machine's performance not the spread of picture pixels.

Pro's Tip: Keep in mind that different printing technologies have different optimum resolutions. For example, perfectly acceptable photographic images are produced on Dye Sublimation machines with a printing resolution as small as 300 dpi, whereas the same appearance of photographic quality may require a setting of 1440 dpi on an inkjet machine.

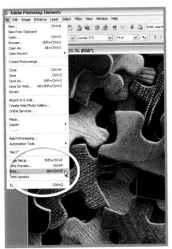

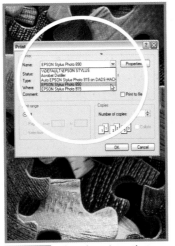

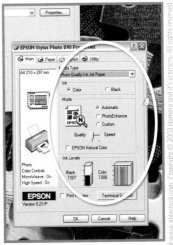

Step 1 >> *With your image open in Elements select Print, or Print Preview, from the Edit menu.*

Step 2 >> *Select the printer that you want to use from the drop-down list in the Print dialog.*

Step 3 >> *Choose the media type and Quality Mode from the Main section of the printer driver.*

8.01 Basic print steps

Suitable for Elements – 1.0, 2.0
Difficulty level – Basic
Related techniques – 8.04 – 8.08
Menus used – File

Let's revisit the basic steps used in printing from Elements before introducing some advanced techniques that will really help you to produce top quality images from your desktop printer.

Make sure that your printer is turned on and your image is open in Elements. Select the Print option from the File menu (File>Print). If the image is too big for the default paper size of your printer then a Clipping warning will appear indicating that part of your image will be truncated if you proceed. You can choose to squeeze the picture onto the paper by checking the

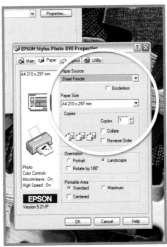

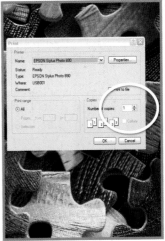

Step 4 >> *Check that the paper size and source are correctly set in the Paper section of the printer driver. Click OK.*

Step 5 >> *As a final step set the number of copies to print in the print dialogue and click OK to print.*

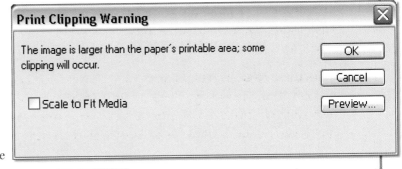

Print Clipping Warning >> *The Print Clipping Warning appears when your image is too big for the default paper size set for your printer.*

Scale to Fit Media box, click Preview to take you directly to the Print Preview dialog or select OK to continue printing the trimmed image. This will open up the printer's control panel, often called the printer driver dialog. The type and style of dialog that you see will be determined by the printer manufacturer and model that you own. Here I have shown a dialog box or printer driver typical for Epson machines.

Basic settings

Check to see that the name of the printer is correctly listed in the Name box. If not, select the correct printer from the drop-down menu. Click on the Properties button and choose the 'Main Tab'. Select the media type that matches your paper, the 'Color' option for photographic images and 'Automatic and Quality' settings in the mode section. These options automatically select the highest quality print settings for the paper type you are using. Click OK.

Select the 'Paper Tab' to alter the paper size and its rotation. Also nominate if the paper is being loaded from the sheet feeder or via a roll. Click OK. Select the 'Main Tab' once more and input the number of copies you want to print. Click OK to start the print process. Depending on the size of your picture and the quality of the print this part of the process can take a few minutes before you will see any action from the printer.

A little more sophistication

The second printing approach that Elements provides is the Print Preview option. With this dialog you preview your picture as it will appear on the printed page. This thumbnail snapshot of picture

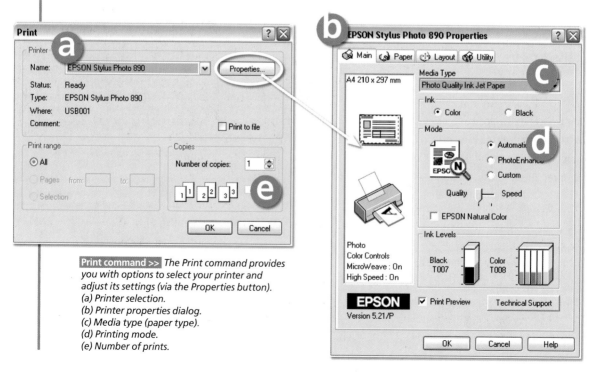

Print command >> *The Print command provides you with options to select your printer and adjust its settings (via the Properties button).*
(a) Printer selection.
(b) Printer properties dialog.
(c) Media type (paper type).
(d) Printing mode.
(e) Number of prints.

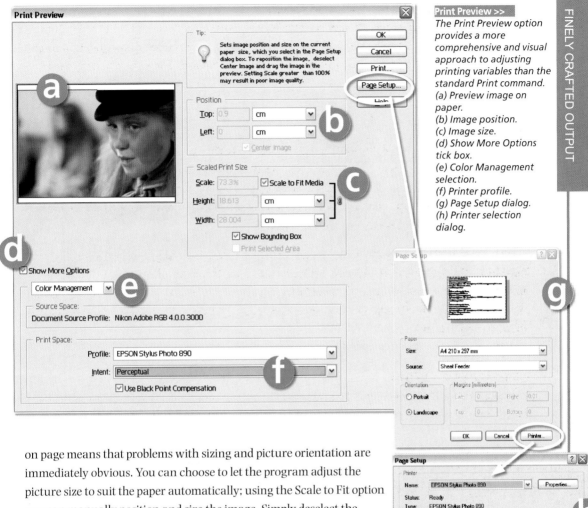

Print Preview >>
The Print Preview option provides a more comprehensive and visual approach to adjusting printing variables than the standard Print command.
(a) Preview image on paper.
(b) Image position.
(c) Image size.
(d) Show More Options tick box.
(e) Color Management selection.
(f) Printer profile.
(g) Page Setup dialog.
(h) Printer selection dialog.

on page means that problems with sizing and picture orientation are immediately obvious. You can choose to let the program adjust the picture size to suit the paper automatically; using the Scale to Fit option you can manually position and size the image. Simply deselect the Scale to Fit and Center Image options and choose the Show Bounding Box feature. Now you can drag the picture around the paper surface and scale the printed image using the corner handles in the thumbnail. To adjust paper size and orientation or change the printer you are using to output your image select the Page Setup button and input the values you require in the Page Setup dialog.

The Print Preview feature also provides the option for users to better control the way that Elements communicates how the colors in the picture will output to the printer. By ticking the Show More Options box and selecting the Color Management item from the drop-down list you can define the precise color profile to use when printing. Most photo-quality printers now include generic profiles that are copied to your system when you install your printer drivers. To ensure the best color reproduction from your printer select the precise profile for your model from the drop-down list. With the color management, paper size and orientation as well as image size and position set, pressing the print button will start the output process.

8.02 Creating contact sheets

Suitable for Elements – 1.0, 2.0
Difficulty level – Basic
Related techniques – 8.03
Menus used – File

With the one simple Contact Sheet command
(File>Print Layouts>Contact Sheet) Elements
can create a series of small thumbnail
versions of all the images in a directory or
folder. These small pictures are automatically
arranged on pages and labelled with their file
names. From there it is an easy task to print
a series of contact sheets that can be kept as a
permanent record of the folder's images. The
job of selecting the best pictures to manipulate
and print can then be made with hard copies
of your images without having to spend the
time and money to output every image to be
considered. This is a real bonus for digital
photographers as it provides a quick tactile
record of their day's efforts.

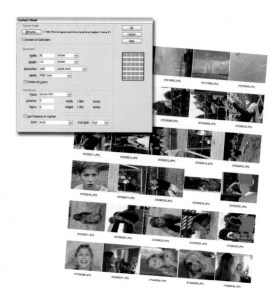

Contact sheets >> *Create prints of thumbnail versions of
your images using the Contact Print feature in Elements.*

The options contained within the Contact Sheet dialog allow the user to select the folder where the
images are stored, the page size and the size and the number of thumbnails that will be placed on
this page.

Step 1 >> *Select File>Print
Layouts>Contact Sheet. Use the
Browse button to pick the folder or
directory containing the images to
be placed on the contact sheet.*

Step 2 >> *Input the values for width,
height, resolution and mode of the
finished contact sheet. Select the
sequence used to layout the images,
as well as the number of columns and
rows of thumbnails per page.*

Step 3 >> *In the final section you can
elect to place a file name, printed as a
caption, under each image. The size
and font family used for the captions
can also be chosen here. Click OK.*

8.03 Multiple prints on a page

Suitable for Elements – 1.0, 2.0 | Difficulty level – Basic
Related techniques – 8.02 | Menus used – File

Picture Package extends the contact sheet idea by allowing you to select one of a series of predestined, multi-print, layouts that have been carefully created to fit many images neatly onto a single sheet of standard paper.

There are designs that place multiples of the same size pictures together and those that surround one or two larger images with many smaller versions. This feature was fully revised for version 2.0 of the program and now provides a preview of the pictures in the layout. You can choose to repeat the same image throughout the design or, by double clicking on any print in the layout, select and add different photographs. Also new in this version of the program is the ability to add labels to the printed images. The Label dialog provides a variety of text options which are added to the picture package when the OK button is pressed.

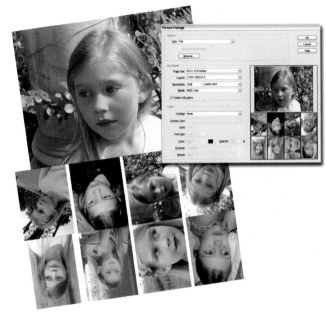

Picture Package >> *Extend your contact sheet capabilities by using the Picture Package feature to print multiple images of different sizes on the one sheet of paper.*

Step 1 >> *Select File>Print Layouts>Picture Package. Select the location of your source images from the drop-down menu.*

Step 2 >> *Choose page size, layout design and specify a resolution and color mode to suit the package. Select images you wish to include.*

Step 3 >> *Select the content, style, size, color and positioning of your label text from the next box. Click OK.*

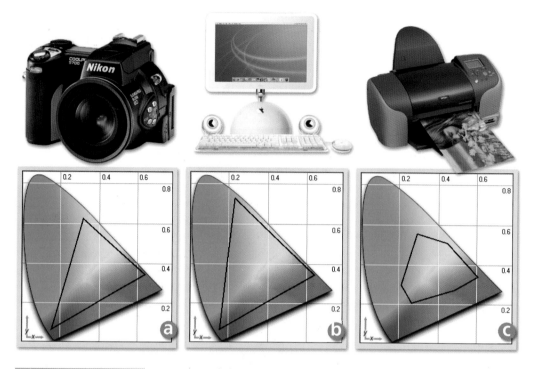

Color and digital devices >> *The devices used to capture, process and output color pictures all respond to color in a different way. Each piece of hardware is only capable of working with a subset of all possible hues. This range of colors is called the device's color gamut. (a) Camera gamut. (b) Screen gamut. (c) Printer gamut. Graph images generated in ICCToolbox, courtesy of www.icctools.com.*

Ensuring color consistency between devices

One of the biggest problems faced by the digital photographer is matching the color and tone in the scene, with what they see on screen and then what is output as a print. This problem comes about because when working digitally we use several different devices to capture, manipulate and output color photographs – the camera, or scanner, the monitor or screen and the printer. Each of these pieces of hardware sees and represents color in a different way. The camera converts a continuous scene to discrete digital tones/colors, the monitor displays a full color image on screen using phosphors or filtered LCDs and the printer creates a hard copy of the picture using inks on paper.

One of the earliest and most complex problems facing manufacturers was finding a way to produce consistent colors across all these devices. As many readers will attest too, often what we see through the camera is not the same as what appears on screen, which in turn, is distinctly different to the picture that prints. These problems occur because each device can only work with a small subset of all the possible colors. This set is called the color gamut of the machine. As the gamut changes from device to device so too does the range of colors in the picture. For example, the range of tones and colors the camera recorded may not be visible on screen and the detail that can be plainly seen on the monitor may be outside the capabilities of the printer.

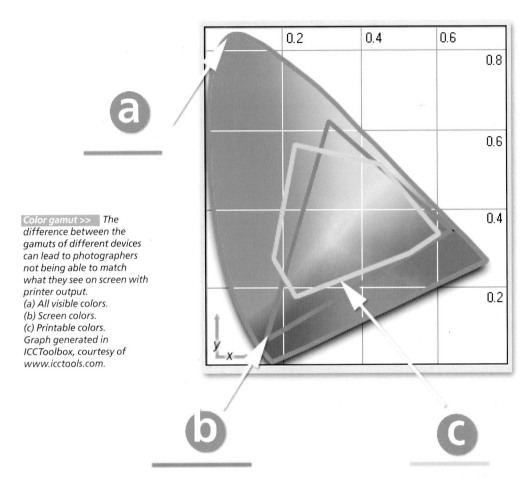

Color gamut >> *The difference between the gamuts of different devices can lead to photographers not being able to match what they see on screen with printer output.*
(a) All visible colors.
(b) Screen colors.
(c) Printable colors.
Graph generated in ICCToolbox, courtesy of www.icctools.com.

Add to this scenario the fact that if I send the same image to three of my friends it will probably appear differently on each of their screens. On one it may be a little contrasty, on another too blue and on the last screen it could appear overexposed. Each of the monitors is interacting with the digital file in a slightly different way.

So with all these complexities are digital photographers condemned to poor color consistency?

The answer is a resounding NO!

Through the use of a color managed system we can maintain predictable color throughout the editing process and from machine to machine.

Essentially color management is concerned with describing the characteristics of each device in the editing chain. This description, often called an ICC profile, is then used to translate image detail and color from one device to another. Pictures are tagged, when they are first created, with a profile and when downloaded to a computer, which has a profiled screen attached, the image is translated to suit the characteristics of the monitor. With the corrections complete the tagged file is then sent to the printer, where the picture is translated again to suit the printer's profile.

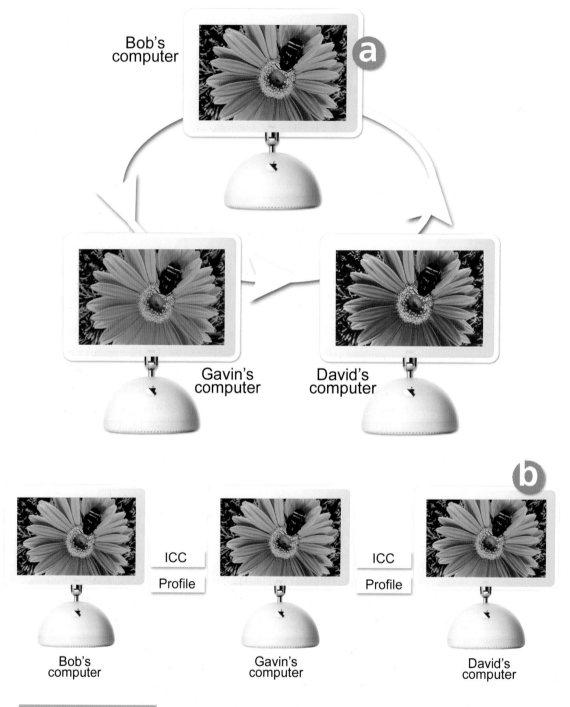

Color managed workflows >>
When color management is not used the same digital photograph can display differently on different screens (a). When a tagged picture is displayed on several profiled monitors the image will appear similar despite the different characteristics of each computer and screen setup (b).

A similar scenario occurs when viewing files on different machines. As the picture is passed around, the profile for each monitor translates and accounts for individual hardware and color changes. The result is a picture that appears very similar on all devices.

Pro's Tip: To ensure that you get the benefits of color management at home, be sure to turn on color management features for your camera, scanner, monitor, software and printer. Always tag your files as you capture them and then use this profile to help keep color consistency as you edit, output and share your work.

Color management and printing

So how does color management impact on our printing workflow. Well as we have already seen when dealing with resolution, so much of how we start the digital process determines the quality of our outcomes. Color management is no different in this respect. It is a fact that the digital photographer who considers color management at the point of shooting (or scanning), and then again when editing, will output better quality (and more predictable) printed images than one who doesn't. So at each stage of the digital process – capture, manipulation (editing) and output – your pictures should be color managed.

Color managed capture – When shooting we should make sure that any color management or ICC profile settings in the camera are always turned on. This will ensure that the pictures captured will be tagged with a profile. Those readers shooting film and converting to digital with scanners should search through the preference menus of their scanners to locate, and activate, any inbuilt color management systems here as well. This way scanned pictures will be tagged as well.

Color managed manipulation – When setting up Elements we should make sure that the Full Color Management option is selected in the Color Settings dialog of the program. This ensures that tagged pictures coming into the workspace are correctly interpreted and displayed ready for editing and enhancement. It also guarantees that when it comes time to print, Elements can correctly translate your on-screen masterpieces into a format that your printer can understand.

Color managed output – The final step in the process is the printer and it is critical, if all your hard work to this point is going to pay off, that you load and use the printer's profile in the Print Preview>Show More Options settings. This step means that the tagged file exiting Elements will be accurately translated into the colors and tones that the printer is capable of creating.

Think of the whole system as a chain. The strength of your color management and therefore the predictability of the process is based on both the integrity of the individual links and their relationship to each other. The ICC profiles are the basis of these relationships. They ensure that each device knows exactly how to represent the color and tones in an image.

8.04 Setting up a color managed workflow

Suitable for Elements – 1.0, 2.0 | Difficulty level – Intermediate
Related techniques – 8.05, 8.06, 8.07, 8.08 | Menus used - File

Now that I have convinced you that a colour managed system has distinct quality advantages over a 'hit and miss' non-managed approach, you will, no doubt, be eagerly wanting to make sure that you are working this way at home. So here are the steps that you will need to follow to put in place a full ICC profile colour managed system for capture, manipulation and print.

Scanners and cameras (a) (b)

Start by searching through the manuals for your digital camera and scanner to find references for 'Changing Color Spaces' or 'Tagging your Scanned File'. Most cameras automatically tag the images they make with the sRGB ICC profile. Even if there is no mention of attaching profiles to pictures in the camera documentation, don't assume that the file is being imported without a profile. It may be that this function is occurring in the background and that your particular camera does not offer the facility to change or manipulate the camera's color profile.

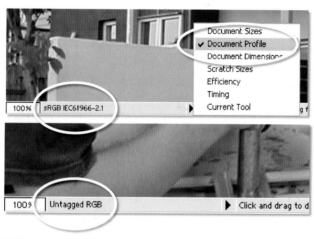

To check to see if your pictures are tagged, open the file in Elements and display the Status Bar (Window>Status Bar) at the bottom of the screen. Then click on the sideways arrow at the left of the bar to reveal a fly-out menu. Choose the Document Profile option from the list. Now to the left of the arrow you will see the profile name attached to your file. If the picture is not tagged then it will be labelled 'Untagged RGB'.

Checking profiles in Elements >> *Use the Document Profile option on the Status Bar to check what profile is attached to your pictures.*

Some more expensive cameras provide the option of altering the default profile settings, allowing the user to select another color space. For the moment just make sure that the camera is attaching a profile to your images. We will discuss 'which profiles are best to use when' later in this chapter.

Do the same type of investigation for your scanner. Unfortunately you will probably find that most entry level scanners don't seem to have color profile options, but this situation is changing. Many more budget models are 'profile aware' so make sure you search the preferences part of your scanner driver carefully to ensure that all color management options are turned on.

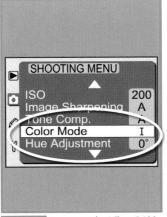

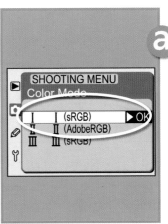

Step 1 >> *The color settings, for cameras with this option, can usually be found in the Set Up or Preferences menu.*

Step 2 >> *For example, Nikon D100 users can access these settings via the Color Mode option located in the Shooting Menu.*

Step 3 >> *In this menu Nikon provides three options for attached color spaces.*

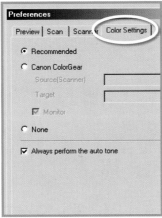

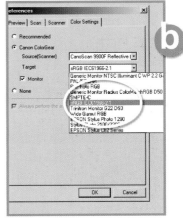

Step 1 >> *Look for the area of you scanner driver that contains the settings for attaching profiles to your scans.*

Step 2 >> *Once in the Settings or Preference area locate the Color Settings defaults.*

Step 3 >> *Activate the scanner's color management features and then select the profile to attach.*

Monitors and screens (c)

Now let's turn to our attention to our screen or monitor. Most manufacturers these days supply a general ICC profile for their monitors that installs with the driver software when you first set up your screen. The default profile is generally the sRGB color space. If you want to check what profile is set for your monitor then Windows users will need to view the options in the Advanced settings of the Display control panel. If you are working on a Mac computer using OSX then you will find a similar group of settings in the Color section of the Display control panel which is located in the System Preferences.

At this stage, simply ensure that there is a profile allocated for your screen. In the next techniques I will show you how to create specific profiles for your screen using either the monitor calibration utility that comes with Elements, Adobe Gamma, or using a hardware tool called a Spyder.

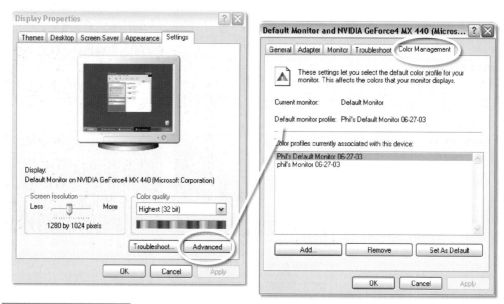

Checking monitor profiles >> *Windows users can check the profile that is being used for the monitor via the Settings>Color Management section of the Display control panel. Mac OSX users will locate the default monitor profile in the Color section of the Display control panel.*

Step 1 >> *Windows users should select the Control Panel option from the Start menu.*

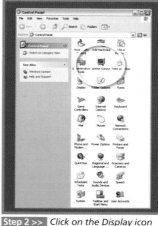

Step 2 >> *Click on the Display icon from those listed.*

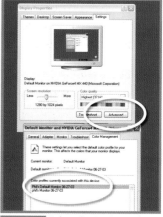

Step 3 >> *Select the Settings tab and then the Advanced settings. Click Add to install a new profile.*

Image editing program – Photoshop Elements (d)

Elements offers three options for color management – *No color management, Limited color management* and *Full color management*. Users can nominate the option that they wish to use for an editing session by clicking on a radio button in the Color Settings dialog (Edit>Color Settings). To use a fully managed workflow you should pick the 'Full color management' option as this is the only choice that makes use of a complete ICC profile workflow throughout.

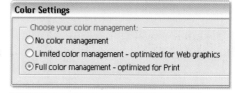

Color Settings

Choose your color management:
- ○ No color management
- ○ Limited color management - optimized for Web graphics
- ⦿ Full color management - optimized for Print

Checking Elements' color management >>
You can check the color management settings for Elements by selecting the Color Settings option from the Edit menu.

Printer (e)

The photo quality of desktop printers is truly amazing. The fine detail and smooth graduation of vibrant colors produced is way beyond my dreams of even just a few short years ago. As the technology has developed, so too has the public's expectations. It is not enough to have colorful prints, now the digital photographer wants these hues to be closely matched with what he, or she, sees on screen. This is one of the reasons why a

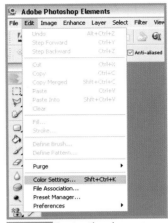

Step 1 >> *To set up the color management options for Elements choose Color Settings from the Edit menu.*

Step 2 >> *Choose Full color management from the three options listed for an ICC managed workflow.*

lot of printer manufacturers are now supplying generic, or 'canned', printer profiles. Using such profiles at the time of printing greatly increases the predictability of your output.

To check that you have a printer profile installed on your system open the color management section of the printer driver and search the list of installed profiles for one that matches your machine. If one is not listed then check the manufacturer's website for the latest drivers or profile updates.

The general nature of these profiles means that for most pictures, on most surfaces, you will get a good result, but for the best prints you will need a different setup for each paper stock that you use. Later in this chapter I will show you how to customize your printer's output specifically for output on different specialty papers.

Step 1 >> *To check to see if you have a printer profile installed, open a picture in Elements and then select Print Preview from the File menu.*

Step 2 >> *Tick the Show More Options feature and choose Color Management instead of Output from the drop-down menu.*

Step 3 >> *Click the down arrow in the Profile section of the dialog and locate your printer profile.*

8.05 Calibrating your screen – Adobe Gamma

Suitable for Elements – 1.0, 2.0 | Difficulty level – Intermediate
Related techniques – 8.04–8.08 | Tools used – Adobe Gamma

The profile that is included with your screen drivers is based on the average characteristics of all the screens produced by the manufacturer. Individual screens will display slightly different characteristics even if they are from the same manufacturer and are the same model number. Add to this the fact that screens' display characteristics change as they age and you will start to understand why Adobe packaged a monitor calibration utility with Elements.

Designed to account for these age and screen-to-screen differences the Adobe Gamma utility provides a way for users to calibrate their monitor and in the process write their own personal ICC screen profile. The program provides a step-by-step wizard that sets the black and white points of the screen, adjusts the overall color and controls the contrast of the mid tones. When completed these settings are saved as an ICC profile that Adobe Gamma loads each time the computer is switched on.

In Windows Adobe Gamma is located in control panels or the Program Files/Common Files/Adobe/ Calibration folder on your hard drive. For Macintosh users with OS9, select the option from the Control Panels section of the Apple menu. OSX users should use Apple's own Display Calibrator Assistant as Adobe Gamma is not used in the new system software.

Regular calibration using this utility will keep the output from your workflow consistent and will also help to ensure that what you see on screen will be as close as possible to what others with calibrated systems also see. Keep in mind though that for the color management to truly work, all your friends or colleagues who will be using your images must calibrate their systems as well.

Pro's Tip: Before you start the calibration process make sure that your monitor has been turned on for at least 30 minutes to warm up.

Step 1 >> *Check that your computer is displaying thousands (16 bit) or millions (24 bit color) of colors.*

Step 2 >> *Remove colorful or patterned backgrounds from your screen.*

Step 3 >> *Ensure that light from the lamps in the room, or from a nearby window, is not falling on the screen surface.*

Step 4 >> *Locate and open the Control Panel menu. Double click the Adobe Gamma icon to start.*

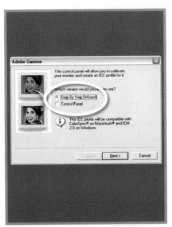

Step 5 >> *Select the Step-by-Step Wizard (win) or the Assistant (Mac) option and click Next.*

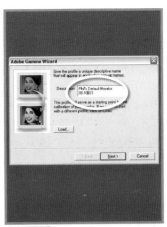

Step 6 >> *Input a description for the ICC profile. Include the date in the title. Click Next.*

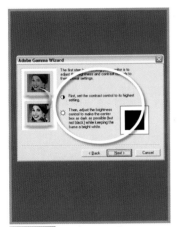

Step 7 >> *Set the screen's contrast to the highest setting and then adjust brightness. Click Next.*

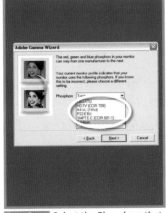

Step 8 >> *Select the Phosphors that suit your screen. Check with manufacturer for details. Click Next.*

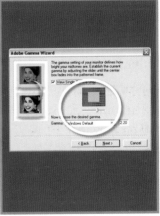

Step 9 >> *With Windows default set adjust the Gamma Slider until the square inside matches the outside in tone. Click Next.*

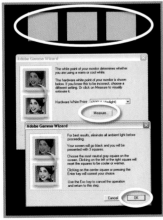

Step 10 >> *Click the measure button and calibrate the screen's white point using the '3 squares' feature. Click Next.*

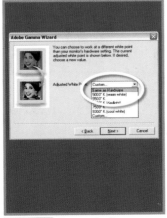

Step 11 >> *Choose the 'Same as Hardware' option. Click Next and then Finish.*

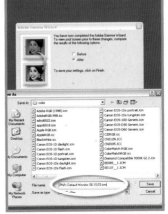

Step 12 >> *Save the completed profile with a file name the same as the profile description.*

8.06 Calibrating your screen – ColorVision Spyder

Suitable for Elements – 1.0, 2.0 | Difficulty level – Intermediate
Related techniques – 8.04–8.08 | Tools used – ColorVision Spyder

For more accuracy when calibrating their screens professional photographers often use a combined hardware/software solution like the well known Spyder from ColorVision (www.colorvision.com). Like Adobe Gamma the system will calibrate your screen so you can be sure that the images you are viewing on your monitor have accurate color, but unlike the Adobe utility this solution does not rely on your eyes for calibration accuracy.

Instead the ColorVision option uses a seven-filter colorimeter attached to the screen during the calibration process. This piece of hardware samples a range of known color and tone values that the software displays on screen. The sampled results are then compared to the known color values, the difference calculated and this information is then used to generate an accurate ICC profile for the screen. Unlike the Adobe Gamma approach this method does require the purchase of extra software and hardware but it does provide an objective way for the digital photographer to calibrate his or her screen. The ColorVision Spyder system is available for CRT (standard) and LCD (flat) screens.

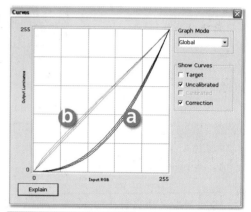

Corrected monitor curves >> *ColorVision's Spyder provides a combined hardware and software solution that measures the inconsistency in a monitor's display and creates correction curves to account for it. (a) Uncalibrated curves. (b) Corrected red, green and blue curves.*

The calibration process contains two parts handled by two separate utilities –

1. *PreCAL*, which is used set the white and black points of your screen as well as balance the red, green and blue components of the display, and
2. *OptiCAL*, designed to calibrate the screen and create a monitor profile that will ensure that colors and tones will be displayed accurately.

Target settings for general digital photography:

Color temp. – 6500
Gamma – 2.2 (Windows)
Gamma – 1.8 (Mac)

Before you start...

1. Set the screen to 24 bit color and a resolution at least 640 x 480 pixels or greater.

2. Make sure that you know how to change the color, contrast and brightness settings of your monitor. This may be via dials or on-screen menus.

3. Ensure that no light source is shining on the screen during the calibration process.

4. Once the calibration process has started don't move the on-screen calibration window.

Step 1 >> Start the PreCAL utility. Set the target color temperature, adjust the brightness and contrast settings.

Step 2 >> Attach the Spyder to the screen. Select the target color temperature using the monitor settings.

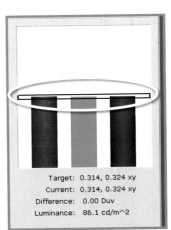

Step 3 >> Adjust the individual red, green and blue settings, updating the readings until they are even.

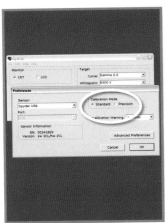

Step 4 >> Start the OptiCAL utility. Select the standard calibration mode from the Preferences menu.

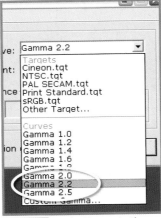

Step 5 >> Set the Gamma to the target value for your system. (2.2 – Win, 1.8 – Mac)

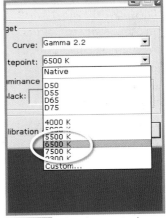

Step 6 >> Select the target color temperature. 6500 is normal for digital photography.

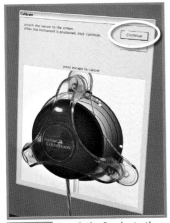

Step 7 >> Attach the Spyder to the monitor ensuring no other light sources are reflecting on screen.

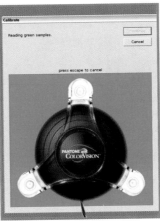

Step 8 >> Press the Continue button and let the Spyder read the color and tone swatches displayed.

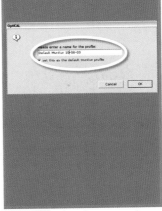

Step 9 >> When the program is finished, save the new profile remembering to include the date of calibration.

Getting intimate with your printer

With the screen now well and truly calibrated and our scanner, camera and printer all ICC profiled terrific prints should be certain to follow, and in most cases this is true. But despite the use of a fully profiled system there are still those annoying occasions where the print doesn't meet our expectations. As long as you keep to standard papers and paper surfaces these occasions won't be too frequent but the more that you experiment with different paper types and finishes the more you will be presented with unexpected results.

The culprit is the generic print profile supplied with your machine. By definition it is designed to provide good results with average images, surfaces and paper types. For those of you who want a little more than 'average' results you can fine-tune your printer profile for different paper and surface types.

As was the case with screens here too we have a couple of different approaches. The first makes use of the extra color controls hidden away in the printer driver to modify your output and the second uses another ColorVision hardware/software solution to create separate print profiles for each paper type and surface that you use.

8.07 Calibrating your printer – resolution, color and tone tests

Suitable for Elements – 1.0, 2.0 | Difficulty level – Intermediate
Resources – Web text images 807-1, 807-2 | Related techniques – 8.04–8.08

Good prints are made from good images, and as we know from previous chapters, digital image quality is based on high image resolution and high bit depth. Given this scenario, it would follow that if I desire to make the best prints possible, then I should at first create pictures with massive pixel dimensions and huge numbers of colors. The problem is that such files take up loads of disk space and, due to their size, they are very, very slow to work with, to the point of being practically impossible to edit on most desktop machines.

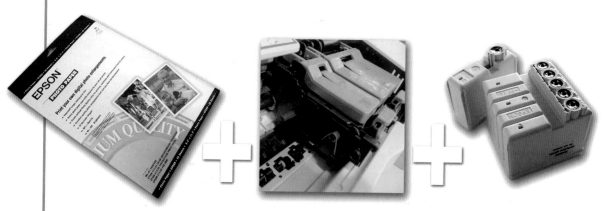

Quality printing >> *Quality printing is based on paper, ink and machine all working together. Changing any of these components can alter the color, shadow, highlight or mid tone rendition of the print. For the best control different setups or profiles are necessary for each of the paper/ink/printer combinations you work with.*

The solution is to find a balance between image quality and file size that still produces 'good prints'. For the purposes of this book 'good prints' are defined as those that appear photographic in quality and can be considered visually 'pixel-less'. As we have also seen the quality of all output is governed by a combination of the printer mechanism, the ink set used and the paper, or media, the image is printed on. To find the balance that works best for your printer setup and the various papers that you use, you will need to perform a couple of simple tests with your printer.

Testing tones (a)

There are 256 levels of tones in each channel (Red, Green and Blue) of a 24 bit digital image. A value of 0 is pure black and a value of 255 is pure white. Desktop inkjet machines do an admirable job of printing most of these tones but they do have trouble printing delicate highlight (values of between 230 and 255) and shadow (values between 0 and 40) details. The absorbency of the paper in combination with the inkset and the printer settings means that some machines will be able

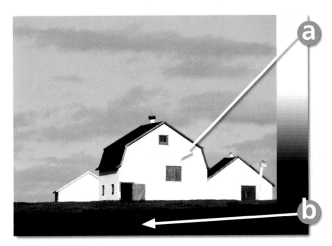

Quality printing >> *When using some paper, ink and printer combinations delicate highlight and shadow details are lost. Being able to account for these output characteristics makes for better prints. (a) Lost highlights. (b) Lost shadows. Image courtesy of www.ablestock.com. Copyright © 2003 Hamera and its licensors. All rights reserved.*

to print all 256 levels of tones whilst others will only be able to output a smaller subset. Being able to predict and account for lost shadow and highlight tones will greatly improve your overall print quality.

To test your own printer/ink/paper setup make a stepped grayscale that contains separate tonal strips from 0 to 255 in approximately five tone intervals. Alternatively download the example grayscale from the book's website. Print the grayscale using the best quality settings for the paper you are using. Examine the results. In particular, check to see at what point it becomes impossible to distinguish dark gray tones from pure black and light gray values from white. Note these values down for later use as they represent the range of tones printable by your printer/paper/ink combination.

When you are next adjusting the levels of an image to be printed, move the output sliders at the bottom of the dialog until black and white points are set to those you found in your test. The spread of tones in your image will now meet those that can be printed by your printer/paper/ink combination.

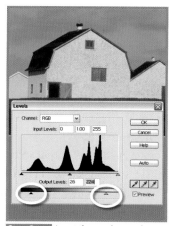

Step 1 >> *Download and print the tone-test.jpg image using your favorite settings and paper type.*

Step 2 >> *Examine the print after 5 minutes drying time to locate the values where you cannot distinguish shadow and highlight detail.*

Step 3 >> *Input these values as the black and white output points in the Levels dialog when next printing with this paper, ink and printer combination.*

Testing resolution (b)

Modern printers are capable of incredible resolution. Some are able to output discrete dots at a rate of almost 6000 per inch. Many users believe that to get the utmost detail in their prints they must match this printer resolution with the same image resolution. Although this seems logical, good results can be achieved where one pixel is printed with several printer dots. Thank goodness this is the case, because the result is lower resolution images and therefore more manageable, and smaller, file sizes. But the question still remains – exactly what image resolution should be used?

Again a simple test can help provide a practical answer. Create a high resolution file with good sharp detail throughout. Using Image>Resize >Image Size makes a series of 10 pictures from 1000 dpi to 100 dpi reducing in resolution by a factor of 100 each time. Alternatively download the resolution examples from the book's website. Now print each of these pictures at the optimum

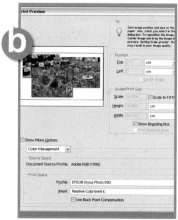

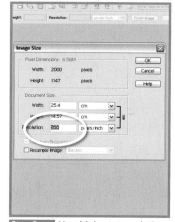

Step 1 >> *Create a high resolution composite image and print the picture at several different image resolution settings.*

Step 2 >> *When complete examine the prints carefully and decide which picture provides the best balance of quality and resolution.*

Step 3 >> *Use this image resolution as the basis of your prints using this ink, paper and printer combination.*

setting for your machine, ink and paper you normally use. Next examine each image carefully. Find the lowest resolution image where the picture still appears photographic. This is the minimum image resolution that you should use if you want your output to remain photographic quality.

For my setup this setting varies from between 200 and 300 dpi. I know if I use these values I can be guaranteed good results without using massive file sizes.

Testing color (c)

For the majority of output scenarios using the ICC profile that came with your printer will provide good results. If you do happen to strike problems where images that appear neutral on screen continually print with a dominant cast then most printer drivers contain an area where individual colors can be changed to eliminate casts.

Wayward color casts often occur when non-standard papers are used for printing. The cause can be the base color of the paper itself, the absorbency of the paper or the type of surface being printed upon. Eliminating all over casts is possible using the color adjustment sliders found in the printer dialog.

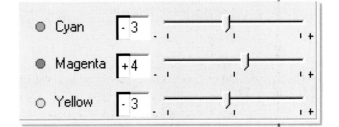

Determine the exact settings you need for a specific paper type by running a series of print tests, carefully adjusting the color settings until the resultant output is cast free. Save the corrective settings for use whenever you want to output using the same paper, ink and printer combination.

Removing color casts with the printer driver >>
Use the following guide when customizing the output from your printer using the color sliders in your printer driver:

- *To subtract red from the print – add cyan*
- *To add red to a print – subtract cyan*
- *To add blue to a print – subtract yellow*
- *To subtract blue from a print – add yellow*
- *To add green to a print – subtract magenta*
- *To subtract green – add magenta*

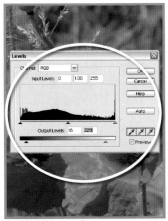

Step 1 >> *Print a full color test image using the tonal and resolution values derived in the two previous tests.*

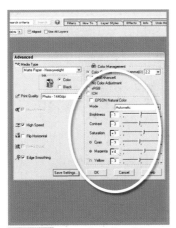

Step 2 >> *Assess the color of the dominant cast and with the printer driver open, alter the color settings to remove the cast. Save the settings.*

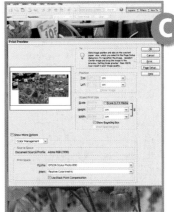

Step 3 >> *Reprint the example image using the new color settings. Assess the results and make adjustments if necessary.*

8.08 Calibrating your printer – ColorVision PrintFIX

Suitable for Elements – 1.0, 2.0 | Difficulty level – Intermediate
Related techniques – 8.04–8.08 | Tools used – ColorVision PrintFIX

Want to take your printer calibration one step further? The dream printing setup for most photographers is a situation where they have a profile created specifically for each of their paper, ink and printer combinations. Until recently this way of working has indeed been a dream as the hardware and software system needed for creating high quality printer profiles could cost well over a thousand pounds. But this year ColorVision (www.colorvision.com) released a more economical option designed specifically for the digital photographer. Just like their Spyder screen calibration system, ColorVision's PrintFIX comprises a hardware and software solution that takes the guesswork out of calibrating your printer's output.

The process involves three easy steps –

(a) Output a set of color test patches from your printer using the ink and paper you want to calibrate,

(b) Read the patches using a modified scanner supplied with the system, and

(c) Use the supplied calibration utility to generate an ICC printer profile based on the scanner output.

Using this system you can build a complete set of profiles for all the papers that you use regularly. The system saves you time and money by reducing the waste normally associated with getting the perfect print on varying paper stock.

PrintFIX recommended print settings

Elements' Print Preview dialog
• *Source Space Document – Document*
• *Print Space Profile – the one you create with PrintFIX*
• *Print Space Intent – Saturation*

Printer driver dialog
• *Colour – No Color Adjustment*
• *Paper – Enhanced Matte or Photo Quality Ink Jet*

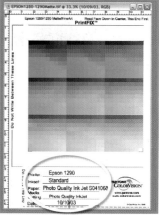

Step 1 >> *Select the PrintFIX option from the Automation Tools section of the File menu.*

Step 2 >> *Choose the Load Calibration Chart option and then select the printer model in the PrintFIX dialog.*

Step 3 >> *Input the details into the spaces provided on the test print image.*

Step 4 >> With the Print Preview option open click Show More Options and select Same As Source.

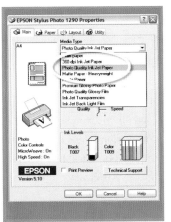

Step 5 >> Proceed to the printer driver and choose Photo Quality Ink Jet paper.

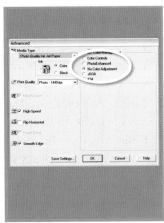

Step 6 >> Select 'No Color Management' and choose the Print Quality required. Print the test.

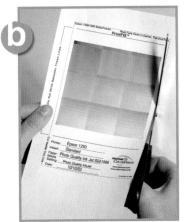

Step 1 >> Wait 5 minutes for drying then cut out the test print, insert it in the plastic sleeve and preload it into the scanner.

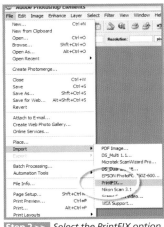

Step 2 >> Select the PrintFIX option from the Import selection of the File menu.

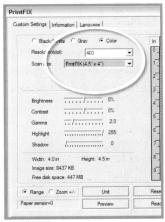

Step 3 >> Set scanner for Color, 400 dpi, 0% Brightness and Contrast, 2 Gamma, 255 Highlight and 0 Shadow. Click Read.

Step 1 >> Use the cropping tool to isolate the color patches from the rest of the scan.

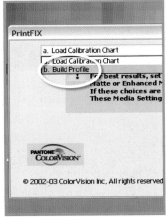

Step 2 >> Select PrintFIX from the Automation Tools options and select Build Profile.

Step 3 >> Save the finished ICC printer profile using a name that combines printer, paper and inkset.

8.09 Making great black and white prints

Suitable for Elements – 1.0, 2.0 | Difficulty level – Intermediate
Resources – Web link www.lyson.com | Menus used – File

Photography has had a long history of fine black and white print making. Practitioners like the famed Ansel Adams took the craft to dizzy heights, inventing the Zone system along the way. It wasn't too long ago that digital prints were judged not by their visual quality but by their ability to disguise their pixel origins. Thankfully, shooting and printing technology has improved to such an extent that we are now released from the 'guess if I'm digital' game to concentrate on more important things, like making great images. After all this is the reason that most of us got into photography in the first place.

But producing high quality black and white prints digitally, even with a fully color managed system, does have its problems. In my experience making great monochrome prints relies heavily on choosing the right paper and inks to print with.

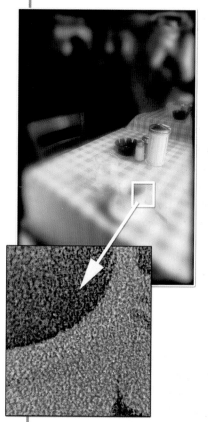

Black and white in color >>
When printing a black and white image using a standard inkjet printer many of the gray tones are produced using a combination of colored ink droplets.

Choosing paper and inks

There is now an incredible range of papers and inks that are suitable for use in desktop printers. The combination you choose will determine the 'look and feel' of your prints. One of the first things that screams quality is the type of stock that your images are printed on. Fiber based papers have always held a special place within the photographic community. Images produced on this type of paper ooze quality and demand respect. Professionals and amateurs alike take a lot of time, and spend a lot of money, choosing the right paper for their photographs.

Selecting which paper to use when you are digital printing is no different. Surface, weight and base tint should all be carefully considered and tested before making your final decision. The papers supplied by your printer manufacturer provide the easiest way to obtain predictable and reliable quality output. The surfaces of these papers are often specially designed to work in conjunction with the inks themselves to ensure the best balance of archival stability and image quality. But this is not the limit of your choices, there are a myriad of other papers available from photographic companies such as Kodak and Ilford as well as paper manufacturers like Somerset. Often specialist suppliers will sell you a sample pack containing several paper types so that you can test the papers that work best for you.

There are also decisions to be made about the inks to use to make your prints. The cartridges supplied and recommended by your printer's manufacturer are specifically designed to work in conjunction with your machinery. These ink sets provide the quickest way to get great photo-realistic images. But these

Yellow/green shadows

Blue/cyan highlights

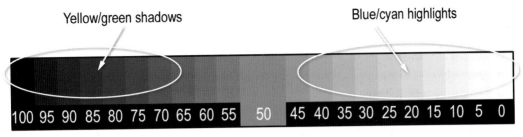

CMYK ink set

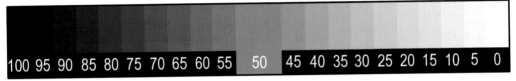

Dedicated Quad Black Neutral ink set

Neutral grays >> *Because many of the gray tones in a monochrome print are created with colored dyes it can be almost impossible to produce completely neutral tones throughout the whole of a grayscale when printing with standard ink sets. Neutral grays are possible, however, if the black and white print is produced using a dedicated monochrome ink set.*

days there are also several specialist ink companies in the market. Each provide slightly different pigments which, in turn, produce images of a different character.

One such specialist ink set is designed specifically for creating great black and white prints. Called the Quad Black ink system, it is produced by Lyson (www.lyson.com) and is fast becoming a favorite with dedicated black and white printers. The system replaces the color cartridges supplied with your printer with an ink set that contains various shades of gray. Using this approach, digital photographers can produce the rich and smoothly graduated monochrome output they have preciously created traditionally without any of the problems of strange and unwanted color casts creeping into their black and white prints.

Be warned though, changing ink sets should only be attempted by those experienced 'tinkerers' who see the whole fine-tuning process as an 'exciting challenge'.

Why use monochrome inks

Most photo quality inkjets use the three colored inks as well as black to produce monochromes. Using the four inks (sometimes six – five colors plus black) provides the greatest range of tonal levels. With dot sizes now being so small it is only under the closest scrutiny that the multi-colored matrix that lies beneath our black and white prints is revealed. Balancing the different colors so that the final appearance is neutral is a very tricky task. Too many dots of one color and a gray will appear blue, too few and it will contain a yellow hue. For most users slight color variations are not a problem, but for image-makers with a monochrome heritage to protect, nothing less than perfection is acceptable.

Paper types >>

There are many papers, on the market, that are suitable for inkjet printing. Most can be divided into two groups – 'coated' and 'uncoated'. The coating is a special ink receptive layer that increases the paper's ability to produce sharp 'photo-realistic' results with a wide color gamut and a rich maximum black (high D-max). Uncoated papers can still be used with most printing equipment but changes in the printing setup may be necessary to get good results.

Apart from coatings, paper surface is the other major factor that discriminates between paper types. The general categories of surface are:-

Glossy Photographic – Designed for the production of the best quality photographic quality images. These papers are usually printed at the highest resolution that your printer is capable of and can produce either 'photo-realistic' or highly saturated colors.

Matt/Satin Photographic – Papers designed for photographic images but with surfaces other than gloss. Surfaces specially coated so that, like the gloss papers, they can retain the finest details and the best color rendition and often produce the best archival results.

Art Papers – Generally thicker based papers with a heavy tooth or texture. Some coated product in this grouping is capable of producing photographic quality images, but all have a distinct 'look and feel' that can add subtle interest to images with subject matter that is conducive. Unlike other groups this range of papers also contains examples that contain colored bases or tinted surfaces.

General Purpose – Papers that combine economy and good print quality and are designed for general usage. Different to standard office, or copy, papers as they have a specially treated surface designed for inkjet inks. Not recommended for final prints but offer proofing possibilities.

Specialty Papers – Either special in surface or function. This grouping contains papers that you might not use often but it's good to know that on the occasion that you do need them they are available. The range in this area is growing all the time and now includes such diverse products as magnetic paper, back light films and a selection of metallic sheets.

Too often the black and white prints produced using a color ink set contain strange color casts. For the most part these errant hues are the consequence of mixing different ink types and paper products and can be rectified with a little tinkering of the printer driver's color settings or by using a profile specifically created using the PrintFIX system. One paper I use, for instance, continually presents me with magenta tinged black and white prints. But as the cast is consistent across the whole of the tonal range, I am able to rid the pictures of this tint by adjusting the magenta/green slider in the printer settings. I saved the setup that produced a neutral image and now use it each time I print to this surface.

It is not these consistent casts that cause much concern amongst the critical desktop printing fraternity, rather it is the way that some printers produce a different cast for highlights and shadows. As we have seen already in this chapter, as part of my printer setup procedure I always output a gray scale to help me determine how the machine handles the spread of tones from highlights to shadows. The test prints remain fairly neutral when they are made with the manufacturer's recommended papers, but as soon as I start to use different stock, the gray tonal scale ceases to be so gray. For the occasional print, I can put up with the strange colors present in my black and white masterpiece, but for the dedicated monochrome producer it is enough to send them screaming back to the darkroom.

Ink types >>

For most of us buying an inkjet printer is a considerable investment. So when the manufacturer's recommendations state to only use 'genuine ink cartridges' in your machine, in 'fear and trepidation' of losing our warranty, we all comply. Well, nearly all of us. There is a small, but growing group of dedicated image-makers, who are using non-genuine ink sets in their printers. They have found that specialist suppliers are able to provide inks that have features not available when using branded cartridges. These products fall into two categories:

Dye Based Inks – Most standard cartridges use this type of ink. They are generally easy to use with fewer problems with streaking, long drying times and puddling than pigmented inks. Some varieties are also capable of a greater range of colors.

Pigment Based Inks – These products last longer than most dyebased inks. They are also more water resistant. But be warned, these ink sets can be more difficult to print with and some particular brands do not have the same color or density range as their dye based equivalents.

Specialist Monochrome Ink Sets – Amongst the third-party inkjet suppliers there are a couple of companies that manufacture highly specialized inks for the dedicated black and white inkjet enthusiast. Four intensities of black are substituted for the normal Cyan, Magenta, Yellow and Black inks. With some simple image adjustments in Photoshop, it is then possible to produce black and white images with tonal graduation that matches traditional silver halide printing.

Caution: None of the third-party inks discussed here will have the same characteristics as your original inks. You will need a certain amount of patience and perseverance to test and set up your printer so that it will make the most of the new ink sets.

Dedicated ink sets – the solution

With just this type of situation in mind several of the bigger third-party ink manufacturers have produced dedicated monochrome cartridges and ink sets for all popular desktop and wide format inkjet printers. The system is simple – pure black and white can be achieved by removing all color from the print process. The manufacturers produce replacement cartridges containing three levels of gray instead of the usual cyan, yellow and magenta or five levels instead of cyan, light-cyan,

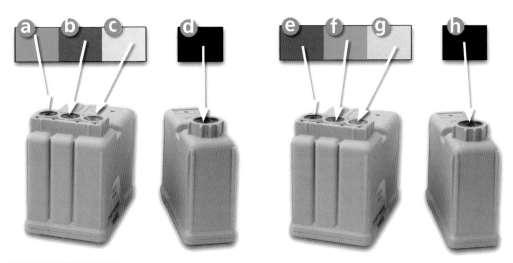

Monochrome ink sets >> *One way that dedicated black and white digital photographers are producing cast-free monochrome prints is to replace their color cartridges with specially designed grayscale equivalents. The replacements contain three separate gray inks of different value instead of the normal cyan, magenta and yellow hues. Standard cartridges – (a) Cyan, (b) Magenta, (c) Yellow and (d) Black. Monochrome ink set cartridges – (e) 75% black, (f) 50% black, (g) 25% black and (h) Black.*

magenta, light-magenta and yellow for five color cartridges. All inks are derived from the same pigment base and so prints made with these cartridges contain no strange color casts. That's right, no color casts! That's no overall magenta tint with my favorite paper, or strange color changes in the shadows and highlights of my grayscales.

Printing with dedicated monochrome ink sets is the closest thing to making finely crafted fiber based prints that the digital world has to offer. Not only are your images cast free, they also display an amazing range of grays. With pictures that have been carefully adjusted to spread image tones and retain shadow and highlight details, the Quad Black system produces unparalleled quality prints on a wide range of gloss, satin, matt and fine art stock.

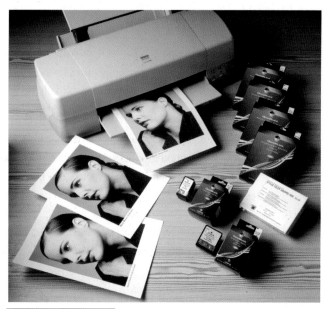

Monochrome ink sets >> *Lyson produces a range of dedicated monochrome ink sets for a variety of Epson and Canon printers. The replacement cartridges produce cast-free black and white prints and are available in neutral, cool tone and warm tone options.*
Image courtesy of Lyson © 2003.

OK. What's the catch?

With such results, and options, you might be forgiven for thinking that all is now 'well with the monochrome printing world', but be warned, the major printer manufacturers don't like you using third-party ink sets with their machines and are unwilling to uphold warranty claims if non-genuine ink has been used in a problematic printer.

It is also not recommended to continually swap between standard color and the monochrome ink sets. Lyson has no qualms about suggesting that you dedicate a printer solely for Quad Tone output but for most of us the purchase of one such machine is expensive enough, two might just break the bank.

Needless to say that the Quad system may well be restricted to the wealthy, or strictly monochrome based image-maker. One option that you might consider though is to group together with some of your interested friends and purchase a dedicated machine between you. Either way if your passion is beautifully crafted cast-free black and white prints, then dedicated monochrome ink sets are definitely worth investigating.

8.10 Preparing your images for professional outsourcing

Suitable for Elements – 1.0, 2.0
Difficulty level – Intermediate

Professional lab services are now expanding into the production of large and very large prints using the latest inkjet and piezo technology as well as digital images on color photographic paper. Now that you are part of the digital fraternity you too have the choice of outputting your humble Photoshop Elements images on these 'big printing beasts'.

Outputting to color print paper via machines like the Lambda and Pegasus has quickly become the 'norm' for a lot professional photographers. Adjusting of image files that print well on desktop inkjets so that they cater for the idiosyncrasies of these RA4 machines is a skill that most of us are continuing to learn. The re-education is definitely worth it – with image quality and archival permanence of our digitally generated imagery finally meeting that of traditional prints as well as the expectations of photographers and their clients. But just when you thought that you could become complacent with your new skills the wide format printing market has really started to take off.

With improved quality, speed and competition in the area, the big players like Epson, Kodak and Hewlett Packard are manufacturing units that are capable of producing images that are not only stunning, but also very, very big. Pictures up to 54 inches wide can be made on some of the latest machines, with larger images possible by splicing two or more panels together. You can now walk into a bureau with a CD containing a favorite image and walk out the same day with a spliced polyester poster printed with fade resistant all-weather inks the size of a billboard. Not that everyone wants their output that big but the occasional poster print is now a very real option.

Getting the setup right is even more critical with large format printing than when you are outputting to a desktop machine. A small mistake here can cause

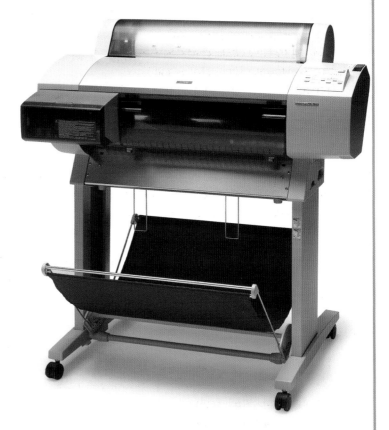

serious problems to both to your 48 x 36 inch masterpiece, as well as your wallet, so before you even turn on your computer, talk to a few local professionals. Most output bureaus are happy to help prospective customers with advice and usually supply a series of guidelines that will help you set up your images to suit their printers. These may be contained in a pack available with a calibration profile over the counter, or might be downloadable from the company's website. Some companies will check that your image meets their requirements before printing, others will dump the unopened file directly to the printer's RIP assuming that all is well. So make sure that you are aware of the way the bureau works before making your first print.

Outsourcing guidelines

The following guidelines have been compiled from the suggestions of several output bureaus. They constitute a good overview but cannot be seen as a substitute for talking to your own lab directly.

Ensure that the image is orientated correctly. Some printers are set up to work with a portrait or vertical image by default; trying to print a landscape picture on these devices will result in areas of white space above and below the picture and the edges being cropped.

Make sure the image is the same proportion as the paper stock. This is best achieved by making an image with the canvas the exact size required and then pasting your picture into this space.

Don't use crop marks. Most printers will automatically mark where the print is to be cropped. Some bureaus will charge to remove your marks before printing.

Convert a layered image to a flat file before submission. Most output bureaus will not accept layered PSD (Photoshop Elements) files so make sure that you save a flattened copy of the completed image to pass onto the lab.

Use the resolution suggested by the lab. Most output devices work best with an optimal resolution. Large format inkjet printers are no different. The lab technician will be able to give you details of the best resolution to supply your images in. Using a higher or lower setting than this will alter the size that your file prints, so stick to what is recommended.

Use the file format recommended by the lab. The amount of time spent in setting up a file ready to print is a big factor in the cost of outsourced printing. Supplying your file in the wrong format will either cost you more as a lab technician will need to spend time converting the picture, or will have your print job rejected altogether.

Keep file sizes under the printer's maximum. The bigger the file, the longer it takes to print. Most bureaus base their costings on a maximum file size. You will need to pay extra if your image is bigger than this value.

8.11 Shoot small print big

Suitable for Elements – 1.0, 2.0 | Difficulty level – Intermediate
Menus used – Image

You know the scenario. You hand over what in a lot of countries amounts to a year's salary for a snazzy new digital camera with all the bells and whistles and a modest three megapixel sensor only to be told by someone like me in the preceding chapters of this book that you can now print great photo quality images – but only up to 10 x 8 inches.

Wrong, Wrong, Wrong.

The thinking behind such a statement is sound. As we saw earlier in this chapter the recommend image resolution for most inkjet and professional digital output is between 200 and 400 dots per inch. So if we take the pixel dimensions of the sensor and divide it by this value we will get the maximum print size possible. For example, if we divide an image produced by a chip that is 2000 x 1600 pixels by a resolution of 200 dpi than the maximum print would be 10 x 8 inches. If a higher resolution of 400 dpi was used then the final print size would be reduced to a mere 5 x 4 inches. Right! Wrong!

What is interpolation anyway?

Interpolation is a process by which extra pixels are generated in a low resolution image so that it can be printed at a larger size than its original dimensions would normally allow. Interpolation, or as it is sometimes called, Upsizing, can be implemented by increasing the number of pixels in the width and height fields of the Photoshop Elements Image>Resize>Image Size dialog.

This approach works by sampling a group of pixels (a 4 x 4 matrix in case of Bicubic interpolation) and using this information together with a special algorithm as a basis for generating the values for newly created pixels that will be added to the image.

The sophistication of the algorithm and the size of the sampling set determine the quality of the interpolated results.

The interpolated results are never as sharp or clear as an image made with the correct pixel dimensions to start with, but when you need a big print from a small file this is a great way to go.

In truth, this is still the way to achieve the absolute best quality from your digital files. But for the average camera owner the promise of superb image quality is no consolation if all you want is a bigger print. When faced with this problem those 'non-professional' shooters amongst us have been happily upscaling their images using the Resample option in the Image Size feature of Elements, whilst those of us who obviously 'know better' have been running around with small, but beautifully produced, prints.

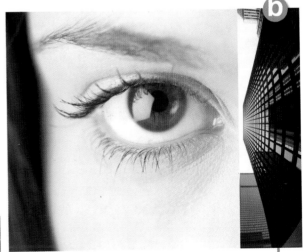

Interpolated big prints >> *To create big prints Images can be resized in Elements using the Image Size dialog (Image>Resize>Image Size). (a) Original test print 5.3 x 3.2 inches. (b) Interpolated print 32 x 24 inches.*

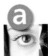

After all it is common knowledge that increasing the numbers of pixels in an image by resampling or 'interpolating' the original data can only lead to unsharp, and more importantly, unacceptable, albeit large, pictures. Right! Well, sort of!

Quietly over the last few years and right under our very noses it seems, a small revolution in refinement has been happening in the area of interpolation technologies. The algorithms and processes used to apply them have been continuously increasing in quality until now they are at such a point that the old adages such as

• *Sensor dimension / output resolution = maximum print size*

don't always apply. With the Bicubic option set in the Image Size dialog it is now possible to take comparatively small files and produce truly large prints of great quality. This process often called interpolation or upscaling, artificially increases the number of pixels in an image so that with more image data in hand, bigger prints can be made.

Upscaling techniques

So what are the steps involved in increasing the size of my pictures. Here I will demonstrate two approaches to upscaling. The first is the simplest and involves inputting new values into Image Size dialog (a) and the second, called 'stair interpolation' (b), uses the same technique but increases the size of the picture incrementally rather than in one jump. Stair interpolation is the preferred approach by many professionals, who believe that the process provides sharper end results. Both approaches use the Image Size dialog and are based on the Bicubic interpolation option.

The results

In the example image skin tones and other areas of graduated color handled the upsizing operation the best. Sharp edged elements evident in the lash areas of the eyes and the straight lines of the buildings tended to show the results of the interpolation more clearly.

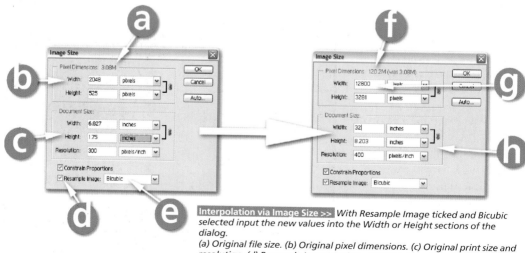

Interpolation via Image Size >> *With Resample Image ticked and Bicubic selected input the new values into the Width or Height sections of the dialog.*
(a) Original file size. (b) Original pixel dimensions. (c) Original print size and resolution. (d) Resample Image option – tick to interpolate. (e) Select Bicubic for quality. (f) Interpolated file size. (g) Interpolated pixel dimensions. (h) Interpolated print size and resolution.

Though not unacceptable at normal viewing distances for big sized prints, image-makers whose work contains a lot of hard edged visual elements and who rely on ultimate sharpness in these areas for effect will need to 'test to see' if the results are suitable for their style of images. For portrait, landscape and general shooters upscaling using either of the two approaches listed here is bound to surprise and excite.

I still cringe saying it, but it is now possible to break the 'I must never interpolate my images rule' in order to produce more print area for the pixels you have available.

I will provide some provisos though –

1. Images captured with the correct number of pixels for the required print job will always produce better results than those that have been interpolated.

2. The softening effect that results from high levels of interpolation is less noticeable in general, landscape or portrait images and more apparent in images with sharp edged elements.

3. The more detail and pixels in the original file the better the interpolated results will be, and a well exposed sharply focused original file that is saved in a lossless format such as TIF is the best candidate image for upsizing.

Step 1 >> With the image open in Elements select Image>Resize>Image Size.

Step 2 >> Tick Resample Image and choose the Bicubic option. Input the new values into the Width and Height areas.

Step 1 >> For Stair Interpolation start the process by opening the Image Size feature.

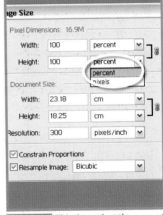

Step 2 >> This time select the percent option for Width and Height. Tick Resample Image and choose Bicubic.

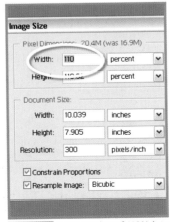

Step 3 >> Input a value of 110% into the Width box and click OK. Open the Image Size dialog again.

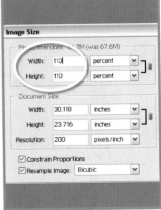

Step 4 >> Input a value of 110% again and click OK. Continue this process until you reach your desired print size.

8.12 Printing workflow

The key to producing good quality prints is knowing the characteristics of your printer. No printer is going to produce perfect results on all paper types with all images. Understanding the strengths and weaknesses of your machine will help you ensure predictable results more often. And the foundation of all such predication is a good color management system.

It may be implemented using the built-in features contained in your camera, scanner and printer controls in conjunction with the color management system in Photoshop Elements or it may take a more sophisticated form relying on customized profiles generated with specialist products from companies like ColorVision.

Either way the important thing to remember is that you need to start thinking about image management right from the time that you shoot or scan.

If you want to enjoy all the rewards of high quality output then it is critical that you employ a wholistic approach to color management.

Just as is the case with factors like resolution and bit depth, decisions about color management need to be made at the point of capture, not left till it comes time to print.

Recommended Printing Workflow

Colour Management Setup	Use 'canned' screen profile supplied with monitor	Calibrate screen using Adobe Gamma utility	Calibrate screen using ColorVision Spyder utility
	Turn on Full Color Management in the Color Settings of Photoshop Elements		
	Activate camera color management		
	Activate scanner color management		
	Perform Resolution test to determine optimum image resolution needed to maintain photo quality output		
	Load 'canned' printer profile that came with print driver.	Use tone and color tests to modify 'canned' printer profile for all printer, ink and paper combinations.	Use ColorVision PrintFIX to create ICC profile for all printer, ink and paper combinations.
Printer Setup	Select correct Media or paper type		
	Choose paper size and orientation		
	Select Quality print setting	Select same settings used for printer tests	Select same settings that were used for ICC profile creation
	Check that 'canned' ICC profile is loaded		Load PrintFIX profile
Image Setup	Adjust image tones and colors to suit		
	Set image resolution to optimum determined from the Resolution test		
	Upscale small image if making big print (if necessary)		
	Apply Unsharp Mask filter		
Print Quality	Good	Better	Better

Windows

Mac

Ctrl + O

Con

Shi

Shift + Ctrl + O

Co

Ctrl + W

C

Ctrl + S

C

Ctrl + Z

Ctrl + Y

Ctrl + T

Shift + Ctrl + L

Alt + Shift + Ctrl + L

on

Shift + Ctrl + B

Ctrl + U

Ctrl + L

Ctrl + A

Ctrl + F

rs

Ctrl + R

ction

Ctrl + H

F1

Ctrl + P

Ctrl + Q

Appendices

Jargon buster

Keyboard shortcuts

Elements/Photoshop feature equivalents

Jargon buster

A >>

Aliasing The jaggy edges that appear in bitmap images with curves or lines at any angle other than multiples of 90°. The anti-aliasing function in Elements softens around the edges of images to help make the problem less noticeable.

Aspect ratio This is usually found in dialog boxes concerned with changes of image size and refers to the relationship between width and height of a picture. The maintaining of an image's aspect ratio means that this relationship will remain the same even when the image is enlarged or reduced.

B >>

Background printing Is a printing method that allows the user to continue working whilst an image or document is being printed.

Batch processing Refers to a function or a series of commands being applied to several files at one time. This function is useful for making the same changes to a folder full of images. In Elements this function is found under the File menu and is useful for converting groups of image files from one format to another.

Bit Stands for 'binary digit' and refers to the smallest part of information that makes up a digital file. It has a value of only 0 or 1. Eight of these bits make up one byte of data.

Bitmap or **'raster'** Is the form in which digital photographs are stored and is made up of a matrix of pixels.

Blend mode The way in which a color or a layer interacts with others. The most important after Normal are probably Multiply, which darkens everything, Screen, which adds to the colors to make everything lighter, Lighten, which lightens only colors darker than itself, and Darken, which darkens only colors lighter than itself. Both the latter therefore flatten contrast. Color maintains the shading of a colour but alters the color to itself. Glows therefore are achieved using Screen mode, and Shadows using Multiply.

Brightness range The range of brightnesses between shadow and highlight areas of an image.

Burn tool To darken an image, can be targeted to affect just the Shadows, Midtones or Highlights. Opposite to Dodge. Part of the toning trio, which also includes the Sponge.

Byte This is the standard unit of digital storage. One byte is made up of 8 bits and can have any value between 0 and 255. 1024 bytes are equal to 1 kilobyte. 1024 kilobytes are equal to 1 megabyte. 1024 megabytes are equal to 1 gigabyte.

C >>

CCD or ***Charge Coupled Device*** Many of these devices placed in a grid format comprise the sensor of most modern digital cameras.

Clone Stamp or ***Rubber Stamp tool*** Allows a user to copy a part of an image to somewhere else. It is therefore ideal for repair work, e.g. unwanted spots or blemishes. Equivalent to Copy and Paste in a brush.

Color mode The way that an image represents the colors that it contains. Different color modes include Bitmap, RGB and Grayscale.

Compression Refers to a process where digital files are made smaller to save on storage space or transmission time. Compression is available in two types – lossy, where parts of the original image are lost at the compression stage, and lossless, where the integrity of the file is maintained during the compression process. JPEG and GIF use lossy compression whereas TIFF is a lossless format.

D >>

Digitize This is the process by which analog images or signals are sampled and changed into digital form.

Dodge tool For lightening areas in an image. See also Burn.

DPI or ***Dots per inch*** Is a term used to indicate the resolution of a scanner or printer.

Dynamic range Is the measure of the range of brightness levels that can be recorded by a sensor.

E >>

Enhancement Is a term that refers to changes in brightness, colour and contrast that are designed to improve the overall look of an image.

F >>

File format The way that a digital image is stored. Different formats have different characteristics. Some are cross-platform, others have inbuilt compression capabilities.

Filter In digital terms a filter is a way of applying a set of image characteristics to the whole or part of an image. Most image editing programs contain a range of filters that can be used for creating special effects.

Front page Sometimes called the home or index page, refers to the initial screen that the viewer sees when logging onto a website. Often the name and spelling of this page file is critical if it is to work on the web server. Consult your ISP staff for the precise name to be used with your site.

G >>

Gamma Is the contrast of the mid tone areas of a digital image.

Gamut The range of colors or hues that can be printed or displayed by particular devices.

Gaussian Blur When applied to an image or a selection, this filter softens or blurs the image.

GIF or **Graphic Interchange Format** This is an indexed color mode that contains a maximum of 256 colors that can be mapped to any palette of actual colors. It is extensively used for web graphics, buttons and logos, and small animated images.

Grayscale A monochrome image containing just monochrome tones ranging from white through a range of grays to black.

H >>

Histogram A graph that represents the tonal distribution of pixels within a digital image.

History Adobe's form of Multiple Undo.

Hot linked This term refers to a piece of text, graphic or picture that has been designed to act as a button on a web page. When the viewer clicks the hot linked item they are usually transported to another page or part of a website.

HTML The Hyper Text Mark Up language is the code used to create web pages. The characteristics of pages are stored in this language and when a page file is downloaded to your computer the machine lays out and displays the text, image and graphics according to what is stated in the HTML file.

Hue Refers to the color of the light and is separate from how light or dark it is.

I >>

Image layers Images in Elements can be made up of many layers. Each layer will contain part of the picture. When viewed together all layers appear to make up a single continuous image. Special effects and filters can be applied to layers individually.

Interpolation This is the process used by image editing programs to increase the resolution of a digital image. Using fuzzy logic the program makes up the extra pixels that are placed between the original ones that were generated at the time of scanning.

ISP The Internet Service Provider is the company that hosts or stores web pages. If you access the web via a dial-up account then you will usually have a portion of free space allocated for use for your own site, others can obtain free (with a small banner advert attached) space from companies like www.tripod.com.

J >>

JPEG A file format designed by the Joint Photographic Experts Group that has inbuilt lossy compression that enables a massive reduction in file sizes for digital images. Used extensively on the web and by press professionals for transmitting images back to newsdesks worldwide.

L >>

Layer opacity The opacity or transparency of each layer can be changed independently. Depending on the level of opacity the parts of the layer beneath will become visible. You can change the opacity of each layer by moving the Opacity slider in the Layers palette.

LCD or **Liquid Crystal Display** A display screen type used in preview screens on the back of digital cameras, in laptop computers and more and more as replace ment desktop screens.

Liquify A tool that uses brushes to perform distortions upon selections or the whole of an image.

M >>

Marquee A rectangular selection made by clicking and dragging to an opposite corner.

Megapixel One million pixels. Used to describe the resolution of digital camera sensors.

N >>

Navigator In Elements, a small scalable palette showing the entire image with the possibility of displaying a box representing the current image window frame. The frame's color can be altered; a new frame can be drawn (scaling the Image window with it) by holding the Command/Ctrl keys and making a new marquee. The frame can be dragged around the entire image with the Hand tool. The Zoom tools (mountain icons) can be clicked, the slider can be dragged, or a figure can be entered as a percentage.

O >>

Optical resolution The resolution that a scanner uses to sample the original image. This is often different from the highest resolution quoted for the scanner as this is scaled up by interpolating the optically scanned file.

Options bar Long bar beneath the menu bar, which immediately displays the various settings for whichever tool is currently selected. Can be moved to other parts of the screen if preferred.

P >>

Palette A window that is used for the alteration of image characteristics: Options palette, Layers palette, Styles palette, Hints palette, File Browser, History, etc. These can be docked together vertically around the main image window or if used less frequently can be docked in the Palette Well at the top right of the screen (dark gray area).

Pixel Short for picture element, refers to the smallest image part of a digital photograph.

Q >>

Quantization Refers to the allocation of a numerical value to a sample of an analog image. Forms part of the digitizing process.

R >>

RGB All colors in the image are made up of a mixture of Red, Green and Blue colors. This is the typical mode used for desktop scanners, painting programs and digital cameras.

S >>

Sponge tool Used for saturating or desaturating part of an image that is exaggerating or lessening the color component as opposed to the lightness or darkness.

Status bar Attached to the base of the window (Mac) or beneath the window (PC). Can be altered to display a series of items from Scratch Disc usage and file size to the time it took to carry out the last action or the name of the current tool.

Stock A printing term referring to the type of paper or card that the image or text is to be printed on.

Swatches In Elements, refers to a palette that can display and store specific individual colors for immediate or repeated use.

T >>

Thumbnail A low resolution preview version of larger image files used to check before opening the full version.

TIFF or **Tagged Image File Format** Is a file format that is widely used by imaging professionals. The format can be used across both Macintosh and PC platforms and has a lossless compression system built in.

W >>

Warp tool A means of creating differing distortions to pieces of text such as arcs and flag ripples.

Keyboard shortcuts

General >>

Action	Windows	Macintosh
Open a file	Ctrl + O	Command + O
Open file browser	Shift + Ctrl + O	Shift + Command + O
Close a file	Ctrl + W	Command + W
Save a file	Ctrl + S	Command + S
Step backward	Ctrl + Z	Command + Z
Step forward	Ctrl + Y	Command + Y
Free Transform	Ctrl + T	Command + T
Auto levels	Shift + Ctrl + L	Shift + Command + L
Auto contrast	Alt + Shift + Ctrl + L	Option + Shift + Command + L
Auto Color Correction	Shift + Ctrl + B	Shift + Command + B
Hue/Saturation	Ctrl + U	Command + U
Levels	Ctrl + L	Command + L
Select All	Ctrl + A	Command + A
Apply last filter	Ctrl + F	Command + F
Show/Hide rulers	Ctrl + R	Command + R
Show/Hide selection	Ctrl + H	Command + H
Help	F1	Command + ?
Print Preview	Ctrl + P	Command + P
Exit Elements	Ctrl + Q	Command + Q
Deselect	Ctrl + D	Command + D
Feather a selection	Alt + Ctrl + D	Option + Command + D
Fill Flash feature	Shift + Ctrl + F	Shift + Command + F

Viewing >>

Action	Windows	Macintosh
Fits image on screen	Ctrl + 0	Command + 0
100% magnification	Alt + Ctrl + 0	Option + Command + 0
Zoom in	Ctrl + +	Command + +
Zoom out	Ctrl + -	Command + -
Scrolls image with hand tool	Spacebar + drag mouse pointer	Spacebar + drag mouse pointer
Scrolls up or down 1 screen	Page Up or Page Down	Page Up or Page Down

Selection/Drawing tools >>

Action	Windows	Macintosh
Adds to an existing selection	Shift + selection tool	Shift + selection tool
Subtracts from an existing selection	Alt + selection tool	Command + selection tool
Constrain marquee to square or circle	Shift + drag selection tool	Shift + drag selection tool
Draw marquee from center	Alt + drag selection tool	Option + drag selection tool
Constrain shape tool to square or circle	Shift + drag shape tool	Shift + drag shape tool
Draw shape tool from center	Alt + drag shape tool	Option + drag shape tool
Exit cropping tool	Esc	Esc
Enter cropping tool selection	Enter	Return
Switch magnetic lasso to lasso	Alt + drag tool	Option + drag tool
Switch magnetic lasso to polygonal lasso	Alt + drag tool	Option + drag tool
Switch from selection to move tool	Ctrl (except hand tool is selected)	Command

Painting >>

Action	Windows	Macintosh
Change to eyedropper	Alt + painting or shape tool	Option + painting or shape tool
Cycle through blending modes	Shift + + or -	Shift + + or -
Set exposure or opacity for painting	Painting tool + Number key(%= number key x 10)	Painting tool + Number key(%= number key x 10)
Display Fill dialog box	Shift + Backspace	Shift + Delete
Perform Fill with background color	Ctrl + Backspace	Command + Delete

Type editing >>

Action	Windows	Macintosh
Selects word	Double click	Double click
Select line	Triple click	Triple click
Decrease font size by 2 points/pixels	Selected text + Shift + <	Selected text + Shift + <
Increase font size by 2 points/pixels	Selected text + Shift + >	Selected text + Shift + >

Elements/Photoshop feature equivalents

Activity	*Elements 2.0*	*Photoshop 7.0*
Lighten shadow areas in an image	Fill Flash feature	Curves feature
Darken Highlight areas in an image	Backlighting feature	Curves feature
Transformation	Image>Transform	Edit>Transform
Rotate Layer	Image>Rotate>Layer 90 deg left	Edit>Transform>Rotate 90 deg CCW
Rotate Canvas	Image>Rotate>90 deg left	Image>Rotate Canvas>90 deg CW
Resize image	Image>Resize>Image Size	Image>Image Size
Resize canvas	Image>Resize>Canvas Size	Image>Canvas Size
Batch Dialog	File>Batch Processing	File>Automate>Batch
Web Photo Gallery	File>Create Web Photo Gallery	File>Automate>Web Photo Gallery
Contact Sheet	File>Print Layouts>Contact Sheet	File>Automate>Contact Sheet II
Picture Package	File>Print Layouts>Picture Package	File>Automate>Picture Package
Auto Levels	Enhance>Auto Levels	Image>Adjustments>Auto Levels
Auto Contrast	Enhance>Auto Contrast	Image>Adjustments>Auto Contrast
Auto Color Correction	Enhance>Auto Color Correction	Image>Adjustments>Auto Color
Hue/Saturation	Enhance>Adjust Color>Hue/Saturation	Image>Adjustments>Hue/Saturation
Color Variations	Enhance>Adjust Color>Color Variations	Image>Adjustments>Variations
Brightness/contrast	Enhance>Adjust Brightness/contrast> Brightness/contrast	Image>Adjustment>Brightness/contrast
Levels	Enhance>Adjust Brightness/contrast> Levels	Image>Adjustments>Levels

Windows

Con

Shi

Co

Co

C

Ctrl + O

Shift + Ctrl + O

er

Ctrl + W

Ctrl + S

Ctrl + Z

d

Ctrl + Y

Ctrl + T

m

Shift + Ctrl + L

Alt + Shift + Ctrl + L

ast

Shift + Ctrl + B

Correction

Ctrl + U

ation

Ctrl + L

Ctrl + A

l

Ctrl + F

st filter

Ctrl + R

Hide rulers

Ctrl + H

Hide selection

F1

Ctrl + P

review

Ctrl + Q

elements

Index

Index

Acquire 2, 126
Adding layers 57
Adding texture 87
Add Noise 2, 126, 127
Add Noise filter 74, 75, 87, 102, 103, 149
Add to a selection 50
Adjustment layer 57, 60, 61, 62, 69, 72, 73, 82, 83, 89, 108, 112, 113, 153, 220
Adjust Backlighting 2, 4, 126, 127
Adjust Brightness 7, 8, 64, 102, 109, 152, 153, 214, 220, 274
Adobe Acrobat 179
Advanced tonal control 7
Airbrush 184
Aperture 18, 19, 20, 72, 74,143, 145, 146
Auto Contrast 5, 6, 7, 274
Auto dust removal 41
Auto Levels 5, 7, 274

Background layer 57
Basic print steps 231
Batch processing 32
Bit depth 10, 30, 33, 248, 264
Black and white printing 43, 76, 99, 114, 254, 255, 256, 258
Blending modes 59, 60
Brightness/contrast 274
Brush Dynamics palette 184, 185, 188, 189, 191

Calibrating
 Printer 248, 252
 Screen 244, 246
Canvas Size 97, 106, 121, 217, 218, 274
Changing an existing brush 188
CMYK 224, 229
Color balance 23, 40, 43, 156
Color Cast 6, 40, 44
Color cast correction 40
Color consistency 236, 237, 239
Color depth 37
Color management 239
Color regeneration 43
Combining images seamlessly 131
Contact sheets 234
Contract 52, 118, 119, 211
Contrast control 20, 47, 48
Converting color to black and white 64
Copy 54, 64, 72, 121, 123, 132, 133, 150, 154, 178, 201, 203, 207, 267
Correcting perspective 104, 105

Creating
 A new brush 190
 Web pages 168
Crop 4, 5, 8, 44, 104, 106, 216, 217, 219, 220
Crop tool 5, 8, 106, 219, 220
Cross-processing effects 112
Custom shapes 198

Darken blending mode 93, 129
Define Brush 191
Define Pattern 218
Depth of field 144, 146
Depth of field effects 116, 117, 146, 164
Desaturate 65, 66, 96, 107
Diffusion 92, 212
Diffusion printing 92, 93
Digital hand coloring 114
Distort 54, 121, 124, 208
Dodging and burning-in tools 67, 69, 70, 75, 103
DOF 117, 144, 145, 146, 154
Dots Per Inch (DPI) 11, 12, 36, 229, 230, 250, 251, 253, 261
Duplicate Layer 70, 94
Dust and scratches 41, 129
Dye sublimation printer 228

Eraser tool 62, 70, 71, 81, 92, 150, 154, 184
Erase back technique 70
Exposure 17, 18, 19, 34, 39, 44, 45, 46, 47, 60, 72, 73, 74, 75, 92, 137, 143, 152, 155, 156, 158, 164, 166, 273
Exposure Compensation 19, 74

Feather 52, 54, 69, 80, 82, 83, 107, 108, 118, 119, 132, 133, 149, 150, 154, 220, 271
File Browser 2, 4, 8, 270
File Format 8, 270
File Transfer Protocol 182
Fill command 2, 52, 61, 74, 89, 121, 125, 126, 127, 128, 208, 218, 222, 271, 273, 274
Fill Flash feature 2, 74, 126, 127, 128, 271, 274
Film and print scanners 35
Focal length 145, 146, 148
Focus 45, 117, 118, 119, 140, 144, 154, 158, 164
Font family 192, 194
Font style 170, 194
Free Transform feature 54, 85, 132, 133, 201, 271

Gaussian Blur filter 92, 94, 117, 118, 122, 124, 125, 208
GIF file format 8, 173, 174, 175, 176, 177, 213, 267, 268
Gradient map 82, iv
Grain filter 88
Grayscale 62, 64, 65, 66, 74, 77, 85, 86, 102, 156, 191, 249, 255, 257
Grayscale mask 85, 86
Grid 55, 104, 199
Group with Previous command 63, 64, 202, 203

Hidden Curves features 126
Histogram 7, 34, 40, 44, 268
HTML 167, 168, 171, 172, 175, 178, 268
Hue Saturation control 65, 77

Image layers 56, 268
Import 4, 8, 164, 253
Importing from a camera or scanner 4
Inkjet printer 225, 226, 228, 254, 257, 260
Ink types 257
Input and output sliders 68
Instant film transfer effect 94
Internet Service Provider (ISP) 170, 180, 182, 267, 268
Interpolation 30, 261, 262, 263
Inverse 69, 80, 82, 83, 108, 118, 211

JPEG file format 8, 29, 30, 32, 33, 34, 162, 163, 171, 173, 174, 175, 176, 178, 220, 222, 267, 269

Kaleidoscopic images 216

Laser printer 224, 228
Lasso tool 82, 107, 131
Layers palette 57, 58, 60, 61, 69, 73, 96, 130, 185
Layer mask 61, 62, 63, 82
Layer shortcuts 60
Layer Styles 58, 60, 121, 195, 197, 198, 200, 206, 207, 209
Levels control 6, 7, 14, 15, 31, 38, 42, 62, 67, 69, 72, 74, 98, 109, 111, 113, 152, 153, 158, 214, 215, 221, 225, 249, 255, 257, 263, 267, 271
Lith printing technique 101, 103
Lith prints 102
Loading selections 51
Load Brushes, 189
Load Selection 51
Logos 210

Magnetic Lasso 82
Manipulating layers 58
Marquee tool 5, 218, 269, 272
Masking 8, 60
Modifying selections 51

Monochrome pictures 74, 102, 257, 258
Montage 131, 132, 206, 207, 209, 217
Move tool 85, 150, 153, 154, 193, 208, 216, 217
Multi-Sample scanning techniques 38

New Brush 189
Nodal point 141, 142, 149, 151, 164
Noise 42, 74, 75, 87, 89, 102, 103, 129, 149, 213
Noise Reduction 42
Non-destructive textures 89

Offset 12, 178, 229
On-line résumé 166
Optimizing photos for the web 173
Options bar 55, 61, 185, 199, 220
Orientate 4
Overexposed pictures 7

Paint Brush 85, 184
Paint Bucket 184
Pano2Exe 162, 163
Panorama 3, 136, 137, 138, 139, 140, 141, 143, 144, 148, 149, 150, 151, 152, 154, 155, 159, 160, 162, 163, 164
Panoramic printing 160
Panoramic tripod heads 141
Paper texture 96, 97
Paper types 256
Paste command 54, 121, 132, 150, 203, 267
PDF file format 166, 179
Pencil tool 184
Perspective command 104, 137, 149, 158, 159
Photomerge feature 2, 136, 137, 138, 141, 147, 149, 150, 151, 152, 155, 156, 158, 159, 162, 163, 164
Photo website styles 166
Pictography printer 229
Picture Package 160, 235, 274
Pixel dimensions 12, 13, 32, 37, 173, 174, 248, 261, 262
Polaroid 94, 95, 96, 97, 98
Polaroid transfer prints 96
Posterize 83, 214, 215
PowerPoint presentation program 219, 220, 222
Preferences 55, 240
Presentation backgrounds 219
Presets 172, 185, 186, 189, 191, 195
Printers
 Dye sublimation 228
 Inkjet 225, 226, 228, 254, 257, 260
 Laser 224, 228
 Pictography 229
 Thermal wax transfer 229
Printing (basic steps) 224
PSD file format 8, 56, 173, 177, 192, 260

QuickTime movie file format 162
Quick Start screen 4

RAW editor 31, 32
RAW format 29, 30, 31, 33
RAW Plug-in 33
RAW processing 31
Rectangular marquee tool 5
Red Eye Brush tool 2
Removing color casts with histograms 40
Resize 106, 121, 171, 201, 250, 261, 263, 274
Resolution 10, 11, 12, 13, 14, 22, 32, 34, 35, 36, 37, 38, 39, 44, 48, 69, 159, 166, 220, 227, 229, 230, 234, 235, 239, 246, 248, 250, 251, 256, 260, 261, 262, 264, 267, 268, 269, 270
Restoring color 109
RGB Color 102
Rotate 4, 5, 8, 44, 122, 137, 274
Rotate Layer 274

Samples Per Inch (SPI) 11
Saturation 21, 22, 31, 65, 67, 77, 102, 107, 108
Save for Web feature 163, 171, 173, 174, 175, 177, 178, 213
Save Selection command 51, 61, 82, 107, 134
Save Selection dialog 51, 134
Scale command 98, 105, 106, 131, 196, 197, 232, 233
Scan 6, 13, 14, 15, 35, 36, 37, 38, 39, 40, 47, 48, 253, 264
Scanner 3, 4, 8, 10, 11, 12, 13, 14, 16, 35, 36, 38, 39, 40, 41, 42, 43, 44, 47, 48, 56, 75, 111, 184, 204, 213, 236, 239, 240, 241, 248, 252, 253, 264, 267, 269
Scanning problems and fixes 47
Seamless backgrounds 178
Selection Brush 61, 82, iii
Selection techniques 50, 53, 79, 131
Selection tools 50, 69, 149, 190, 191, 210
Shape tools 175, 184, 198
Sharpen 6, 8
Sharpening 6
Shooting problems and fixes 45
Shutter 18, 19, 20, 30, 42, 45, 46, 72, 74, 143
Simple borders creation 83
Simplify layer command 203
Slide show creation 166, 179
Smooth command 52, 211
Split toning technique 79
Straighten command 4, 5, 8
Style Settings 121, 133, 196, 197, 201, 207
Subtracting from selections 50

Text 56, 57, 168, 176, 177, 192, 193, 202, 204, 206, 268
Texturizer filter 97, 98
Text editor 192
Text layers 56
Thermal wax transfer printer 229
Threshold command 83, 101, 129, 130, 210, 211
Thumbnail and gallery website 166
TIFF file format 8, 263
Tinted monochrome pictures 76
Tonal range 5, 7, 79, 256
Transform command 53, 54, 85, 104, 121, 132, 133, 201, 208, 271, 274
Transforming a selection 53
Two-layer erase technique 81
Types of layers 56
Type Masks 192, 205
Type tools 175, 176, 192, 195, 202, 204, 207

Units and Rulers 55
Unsharp Mask filter 8, 99, 100, 264

Variations feature 6, 40, 109, 111, 157, 158, 274
Vertical panoramas 158
Viewing layers 58
VR tripod heads 142

Websites 169, 195
 Building websites 167
Web
 Animated buttons 176
 Animated headings 177
 Assembling the site 180
 Button creation 175
 Buttons 168
Web Photo Gallery feature 169, 170, 171, 172, 274
Welcome screen 4
White balance 24, 26, 27, 28, 31, 32, 33, 146, 147, 156, 158, 164
Workflow 2, 8, 33, 44, 137, 164, 239, 240, 242, 243, 244, 264
www.adv-elements.com 3